T0146281

Small Format Aerial Photography

W.S. Warner,
JORDFORSK, Centre for Soil and Environmental Research, Norway
R. W.Graham,
Consultant in Aerial Survey, Dorset, UK
R.E. Read,
Aerial Imaging Systems Ltd., Enschede, The Netherlands

Whittles Publishing

Typeset by
Whittles Publishing Services

Published by
Whittles Publishing,
Roseleigh House,
Latheronwheel,
Caithness, KW5 6DW,
Scotland, UK

ISBN 1-870325-56-7

Printed by Interprint Ltd., Malta

Preface

Since the title of this book suggests that aerial mapping can be undertaken with cameras other than large ones, it is necessary to specify what a *small camera* is in this particular context. And to begin with we must start by saying that mapping cameras are extra large for one particular reason – to provide a large-sized negative that will cover as much ground area (footprint) as possible, regardless of scale.

Well, what do we mean by large then? For most people a 'large format' camera uses film that is 5 × 4 inches in size. Such cameras are used in commercial and technical photography, as are cameras of 6 cm × 6 cm format. But for the majority of photographers, the tourist, amateur and occasional 'snapshot' user it is the highly popular 35 mm camera that is understood to be the universal norm – with a 36 mm × 24 mm format as standard. Imagine the average photographer's alarm, therefore, when we talk about the standard air camera format of 23 cm × 23 cm! Indeed, it is not unknown for an aircraft to be designed for observation and survey and, after prototype production, find it impossible to fit a conventional mapping camera anywhere in the machine!

True enough, in the past we used to use 5 inch × 5 inch (12.5 cm × 12.5 cm) and 18 cm² cameras for military reconnaissance and mapping purposes, and although these could never be considered *small* they were at least considerably less bulky than modern 23 cm formats.

Indeed, those of us used to these massive cameras accept their size, not only for the convenience of being able to record larger areas of ground in one photo, but more importantly for their practical economy. As everyone in the business of mapmaking knows, the photogrammetrist must have known relationships recorded between ground and image, and these are provided from by a number of 'control points' which are accurately surveyed on the ground – to be recognised in the image. And since each successive photo must overlap by at least 60% (to provide a stereoscopic *model* of that overlapping area) it remains obvious that any given model area should cover as large a footprint as possible in order to minimise the number of expensively surveyed control points.

It can be said that provision for an economic distribution of control points has mainly influenced mapping format size in recent decades, and it is only when one tries to balance the advantages of smaller rather than conventional air cameras that (for a given task) the number of control points becomes an obvious problem. In this respect a number of prospective small format air surveys have never been real-

ised simply because of the high number of photos required (to cover a given area at a specific scale) which, in turn, gave rise to an uneconomic amount of ground control. As a consequence the case for large format cameras remains sound for large area mapping.

However, much of the world has now been mapped at small scales (1:50 000 to 1:100 000) and with increasing industrial and urban development there is an associated demand for larger scale mapping and map revision. Most of this work will be covered by conventional mapping cameras of course, but there is a price to be paid for large format primary data acquisition. Since putting a typical survey aircraft into the air is an expensive business there is increasing interest in less expensive methods using, for example, a light aircraft fitted with a small format camera and GPS for navigation.

For small blocks (in the region of a few square kilometres or single line overlaps over roads, railways, etc., small format aerial photography (SFAP) shows great promise and has already been very successful using light aircraft and calibrated metric cameras in the 6 cm format.

It is the purpose of this book to convey the role, advantages and limitations of SFAP used for mapping, GIS (geographic information systems) and remote sensing. The role of small format cameras in military reconnaissance is well established, but since it is outside the scope of this work we shall only refer to 'recce' cameras in context with their use for mapping.

We hope to bring the reader to a complete understanding of these small cameras and their advantages in certain areas of mapping and associated roles, and also remove various misconceptions due to an inappropriate comparison with the larger and more established air camera.

By the very nature of the concept, it could be assumed that SFAP requires only the hire of a light aircraft (or microlight), a 35 mm camera and a map, to provide the basic means of acquiring mapping data. To a large extent there is some truth in this (as we shall see). But in practice this oversimplifies the concept and can easily result in inferior products which are totally useless. The reader must always keep in mind that for very good reasons the large format air camera has been designed to suit demands for image quality in mapping. By comparison, using a smaller format invites problems that only the highest care for technical quality (optical as well as film processing) can overcome.

Finally, for those (like us) who have the very laudable aim of keeping costs to a minimum, take care not to pilot the survey aircraft with a PPL (private pilot licence holder) for any airwork. The pilot must be a CPL (commercial pilot) if the flying is for hire or reward!

WSW, RWG, RER

Contents

Introduction

It can be said that aerial photography made its serious debut with the military in 1912, and since then has been subject to constant development in both technology and application. From military reconnaissance to topographic mapping it was but a short step. There were a number of differences of course, and a need to change designs according to technical progress and economics. Whereas mapping required larger and larger formats, finally culminating in the large (23 cm²) standard of today, reconnaissance and particularly *tactical* reconnaissance went smaller (70 mm) with an accent on high framing speeds to counter the low level high speed flights of modern recce aircraft.

With the advent of space-borne cameras, reconnaissance and mapping technologies shifted a little to accommodate digitised imagery. In addition a new discipline was created to accommodate aerospace data from both imaging and non-imaging sensors. Known as remote sensing, this fresh approach provides earth scientists with a powerful tool that combines high tech computer facilities with well established imaging techniques.

More recently, we have geographic information systems (GIS) which, in terms of a broader geographic concept, appeals to an increasing large community of professional users. Educationalists, civil engineers, town planners and many others now use GIS work stations which, with computer based data management, exploit a wealth of aerospace imagery like LANDSAT, SPOT and conventional air photos.

The following review of current and future technology serves to illustrate the important changes now taking place in aerial photography.

The large format scene

Today our conventional (large format 23 cm²) air cameras have been subject to considerable change – mainly a reflection of available modern technology. Forward-motion image compensation (FMC) is now an accepted standard in all well known air cameras, such as the Wild (RC30) and Zeiss (RMK TOP and LMK 2000) units, usually with image stability reinforced by stabilised mounts. In addition we have GPS navigation integrated with computer terminals such that flight planning, navigation, camera operation and even post-flight analysis can be accessed via sophisticated survey flight management systems (Becker and Barriere, 1992).

Digital small format aerial photography (DFSAP)

Through the agency of electronic scanning devices the air photo can be digitised to form a useful image which can be computer processed, stored and analysed to provide a comprehensive geographic data base. Typically, digital images display less than their full (photographic) potential in terms of resolution and quality, but since the average air photo contains a great deal of redundancy these losses are hardly missed in a system mainly designed to select, file and enhance only important features. Furthermore, the primary data remains intact and is always available for conventional purposes, such as photogrammetry, line mapping, mosaics, etc.

Although it is possible to avoid the scanning process completely, and record a (real time) digital image directly in the camera, digital images unfortunately generate large data files (even with compression) which create problems when trying to emulate the massive amount of data held in a conventional air photograph. Currently the state of the art falls short of being a viable alternative to film – but it's only a question of time before a practical solution is found for storing and processing the vast number of pixels needed to favourably compare with film quality. Typically, we can expect a small format camera (56 mm × 56 mm) loaded with a film such as Kodak Plus-X to yield a resolution in the region of 50 line pairs/mm (point-to-point $r = 20$ μm) which is a pixel size of 10 μm (one line pair = 2 pixels). Assuming an 8 bit grey scale, the required data volume is at least 31 MBytes! But this is only one monochrome frame (multiply by a factor of 3 for colour), and since we may expect a hundred or more frames to complete a typical survey block, we soon find ourselves looking at a total data volume measured in tens of gigabytes!

Despite the restrictions mentioned above there can be no doubt that real time digital air cameras will appear in the future, but for the present it is likely that digital imagery will remain in the scanned-image domain for a few years yet. Indeed, such imagery is already being exploited using the Kodak Photo CD system. In the USA (Landcare Aviation Inc.) digitise their 35 mm SFAP images via the Kodak Photo CD player or provide digitised images which they claim to be only slightly degraded from the 35 mm originals (Stringham, n.d.), and the US Dept of Agric, Soil Conservation Service, has scanned more than 20 000 35 mm images (about 10 years of photos) for 6 counties in Wisconsin (personal correspondence, Brian Huberty, USDA-SCS). It is claimed that over 100 scanned images can be put on a single CD, sufficient to cover an entire county, with hopes for a complete set of CD digital 35 mm photos of the entire USA within the next two years! At its finest resolution (in an 18 MByte file) the Kodak Photo CD is capable of providing 2048 lines each with 3072 pixels on a standard 24 mm × 36 mm format (Shipside, 1993). This turns out to be a pixel resolution in the region of 13μm – not too different from the original (50 line pairs/mm) photo resolution mentioned above.

We can expect typical GIS users to make use of low cost digitised imagery for numerous applications. Image archives can easily be accessed and, with the aid of a photo-editing/visual database manager, provide compressed library images to store low resolution catalog files. Images can also be manipulated or enhanced at will. The Photo CD system is designed to be employed with low cost PCs (about 16

MByte of RAM is a required minimum) and can also be supported by a variety of software packages. It can be operated either with Kodak's own software or with various Windows packages, such as Adobe Photoshop-3, Micrografx PhotoMagic, U-Lead Image Pals or Halo Desk-top Imager 2.0. All of which combine to provide a relatively inexpensive work station with the capability of printing either good quality or compressed images as required.

Air film technology

In recent years there has been little change in air film materials, either in colour or monochrome, except for the welcome addition of new mapping films produced by Agfa-Geveart and the 70 mm films of Fuji. This area has changed relatively little in the multi-disciplined field of aerospace technology. However, we still have a wide range of available air films (in both 24 cm and 70 mm wide sizes) provided by the three major manufacturers, Kodak, Agfa-Geveart and Fuji, and all three produce materials in monochrome, colour negative and colour diapositive films.

The major supplier is Kodak, and whereas Agfa-Geveart steadily increases its range, Fuji only manufactures in the 70 mm size. Kodak still has the edge when it comes to infrared air films. There are the ever useful type 2424 monochrome infra-red and their type 2443 false colour infrared films, both available in 23 cm and 70 mm. Recently Agfa-Geveart has also produced a false colour air film.

With SFAP we can conveniently leave the air film market and exploit an even larger range of 35 mm and 70 mm films, some of which have exceptional qualities not found in the mapping format. In particular there have been considerable advances in 35 mm (monochrome) high resolution films, Kodak type 2415 Technical Pan being most noteworthy (Graham and Read, 1986). When processed in its associated LC (low contrast) developer this remarkable film can yield excellent prints at up to 50 times magnification. Since this can only be achieved when 2415 is rated at the relatively low film speed of 32 ISO, it is necessary to employ a large lens aperture, but with a good quality 35 mm camera this is no problem since f2 is common to most lenses. Apart from which light (and perhaps microlight) aircraft do not travel very fast and so too, the need for a high shutter speed is not a problem.

In addition there are Kodak 35 mm infrared films and a wide range of colour (negative and diapositive) made by a host of manufacturers. Another very useful 35 mm film is the Ilford XP2. This film is unique in that it has a very wide exposure latitude and gives fine grain negatives via the C41 colour process. Although its nominal film speed is 400 ISO, it can also be employed in the range 50–800 ISO under standard C41 development.

Small format aerial photography (SFAP)

Where somewhat radical changes have taken place in the air survey field (primary data acquisition) they have, apart from the changes to large format cameras mentioned above, been mainly in two significant areas:
 • A steady growth in the use of small format cameras for (limited) map intensification, small area mapping and pinpoint photography on a worldwide ba-

sis (Graham and Read, 1986; Graham, 1987, 1988*a*; Xin and Jing, 1992; Adam Technology, 1993).

- The introduction of global positioning systems (GPS) for accurate survey-flight management and navigation (Heimes *et al.*, 1992).

Although SFAP offers obvious economies for small area mapping, these must also be considered against a relatively larger quantity of stereo models required for a given survey block. As a consequence most of the early SFAP applications were restricted to the non-metric field – mainly due to the expense of increased survey control. But recent developments with GPS (particularly differential GPS) have provided additional support for SFAP and together they form an economic concept that shows great promise for future mapping (Heimes *et al*, 1993).

The word *economics* has loomed large in the text so far. In many respects it is difficult to avoid it, for indeed every aspect of small camera mapping is related to economic concepts. After all, since a large format camera has a bigger footprint, what possible advantage can there be for using a small camera when a bigger one can do it better? Unless of course it happens to be much cheaper!

The economic case for using a small air camera

The camera

At a distance it would seem that the advocates of SFAP base their case on the compared price of a simple (best quality) small format camera (6 cm × 6 cm or 70 mm format) and its counterpart in the 23 cm range. Indeed, price differences are very impressive! Whereas a 70 mm metric Hasselblad, complete with calibrated lens, can cost about $14 000 (US), a typical modern 23 cm air camera may cost anything in the region of $300 000, depending on associated fittings. True, the latter will also incorporate many items denied to the small format camera, but are these extras always needed? Perhaps not – so it makes good sense to start afresh and take a look at some of the obvious advantages we have with the small format camera.

Quite apart from size (and cost) the specific advantages can be summarised as follows:

- The maximum aperture for good quality small format cameras is f2. Compared to that of 23 cm mapping cameras (f4) this constitutes an increased light grasp of factor 4.
- A larger variety of films are available.
- Most films can be obtained almost immediately.
- Film processing is simple and inexpensive and can be undertaken by various means including rewind spool for long lengths of 70 mm films (Graham and Dasmal, 1992). For 35 mm colour films (or XP2) in particular, there are numerous minilabs available world-wide, most with half-hour processing.
- A number of small format cameras can be assembled into a compact group for multispectral photography (MSP) applications (Graham, 1980).
- It is possible to purchase calibrated small format cameras, some of which are manufactured, with a reseau plate or even a vacuum back. Alternatively,

they can be calibrated by the user (Warner, 1990).
- Shutter speeds up to 1/8000 s are common and many cameras offer both aperture and shutter priority options.
- A large variety of interchangeable lenses are available. With best quality cameras these include a large range of wide angle lenses of high aperture and good geometric quality.
- Many small format cameras can be fitted with extra large film magazines and nearly all have full (remote) electrical control capabilities.
- A number of desktop photogrammetric work stations are available for small format diapositives (Carto AP-190, Adam MSP-2, Ross SFS-3).

The aircraft

Obviously, a very large camera requires a much larger platform to work from than a small one does. Here we have one of the more important aspects of air survey economy, the aircraft. Every aspect of running an aircraft becomes more expensive as the machine gets bigger, from daily maintenance to periodic (mandatory) inspections, fuel costs, spares, hanger-space, landing fees, insurance, etc. If SFAP can accomplish the task in hand, then the required aircraft costs are proportionally less expensive.

Even when compared to a small twin-engined machine, a small single-engined aircraft can always operate from smaller airfields (either hard or grass runways), so increasing the number of available landing sites per given mission.

Naturally we should not entertain invidious comparisons (e.g. where a larger aircraft may have a greater fuel economy based on its range or endurance, or where the transit time to the survey area is a question of aircraft speed). But in terms of the basic criteria for SFAP (i.e. short flight periods, short transit flights and relatively low altitudes) the cost of putting a small aircraft into the air for a limited period of time will always favour the smaller machine

One of the most favourable things about SFAP is the availability of suitable aircraft. The range of platforms is much greater than that for conventional surveys in that almost any high-wing light aircraft is suitable. The range extends from Piper Cubs through Cessna 150/152s to the popular Cessna 172, 180/182 etc. But whereas the established light aircraft is a proven commodity, the industry has suffered in recent years (due to the crippling U.S. Product Liability Law) with the consequence that well-tried machines such as the Cessna 172 have been out of production for a number of years. However, it seems that this law may be reformed with new bills allowing full production to go ahead with a hope for deliveries around 1996 (Flight International, 1993).

In addition to production light aircraft there are now many kit-built machines available as well as an excellent range of three-axis microlights, many of the latter having properties and performance close to that of light aircraft. Indeed, in some cases a particular aircraft can be defined as either 'microlight' or 'light aircraft' according to its engine and weight (Graham, 1988*b*, Piggott, 1989). It should be remembered that two-axis microlights (trikes) are not sufficiently stable to act as an air survey platform and are generally unsuitable for SFAP.

It is unfortunate that microlights are generally misunderstood, (particularly by elements within general aviation) for although they have their own limitations they can be very useful platforms for SFAP providing they are not flown outside their flight envelope (Graham, 1987, 1988a, 1988b, Piggott, 1989; Graham et al., 1985; Graham and Read, 1987; Hofste, 1985a). It is important for example to discriminate between two-axis types (trikes) and the more conventional three-axis microlights which look and handle much the same as a light aircraft. Whereas three-axis machines are quite stable (under calm air conditions) and can provide a reasonably straight and level survey run, this is almost impossible with trikes.

Being very light, the survey microlight suffers from a good deal of drift and lack of penetration in winds greater than about 28 km/h (15 knots). As a consequence this can restrict operations considerably, depending on the type of microlight employed, time of day and specific area.

In one recent and interesting case in China (Zhang and Cheng, 1992), a microlight even carried a large format (18 cm × 18 cm) air camera (Aero-A-17) for large scale mapping!

Perhaps the greatest advantage of small aircraft, and particularly microlights, is the increased photo opportunity when the machine is based close to the mission area. Under such conditions it is simply a question of taking off when the weather is 'seen' to be optimal! Gone are those typically worrying questions:

- 'Is the weather clear at the survey area?'
- 'Will the weather change by the time we get there?'

In addition it is possible to design flight planning to suit local meteorological conditions, even to the point of changing the focal length of the lens to maintain a given photo scale at lower (below cloud base) levels.

Part I

MAPPING AND MEASURING

All natural resource specialists seem to have at least one thing in common: their information is *geo-referenced*. In the past, most resource managers geo-referenced their information by drawing directly on existing maps. If they wanted to make measurements, they made them off the maps. Today's resource managers tend to geo-reference their data by generating descriptive ground coordinates, usually in a standard Cartesian coordinate system. Why are map coordinates becoming popular? In part it's because more and more natural-resource specialists are capturing digital data with analytical instruments. Computers have replaced slide rules, geographic information systems (GIS) are replacing map cabinets, and soon global position systems (GPS) will replace the compass. Like it or not, we live in a digital world.

There's another thing that natural-resource specialists have in common: they are used to working with aerial photography. If they weren't, you wouldn't be reading this book, right? And despite all the benefits and promises of satellite imagery – not the least of which is that it is in digital form – aerial photography is still the work-horse for most natural-resource managers.

Until recently resource specialist used aerial photographs almost exclusively for interpretative purposes. This *qualitative* information was geo-referenced by transferring photo objects onto a map using analogue instruments. Today's analytical instruments tackle the problem another way: they numerically determine ground coordinates, which can then be computed into measurements (lengths, height, area, slope, and aspect) or made into a map.

In Part 1 we will examine both the simple, analogue instruments that transfer photo images to a map and sophisticated, analytical instruments that transform photo coordinates to map coordinates. We've divided this part of the book into several chapters. The first two chapters deal with the geometry of a single photograph and stereo photographs. The next two chapters focus on making maps and measurements from both mono and stereo photography. In the fifth chapter we discuss some practical considerations when mapping from small format photography. We conclude with some specialised applications for natural-resource specialists.

One of the things that sets this book apart from many others is that it is full of practical advice. We won't go into all the technical details of using photogrammetric equipment. Your equipment manuals will do that. What we will do is help you

1

understand what those manuals are all about and help you get started. In essence, this part of the book is designed to help you through the small traumas of photogrammetry.

Every new experience brings pleasures and pains – but with photogrammetry it seems the pains come first. What is *photogrammetry*? As implied by its name, it's the combined science, art, and technology associated with analysing photographs. Essentially we are concerned with how to gather reliable, *quantitative* information from your photographs. To many the geometry of photogrammetry is much like mathematical alchemy. But you shouldn't let the procedures of photogrammetry turn you off, any more than computer programming would scare you away from a personal computer. The hard work has been done for you.

Chapter 1

Geometry of a Single Photograph

Let us recall that a photograph is *not* a map, for the simple reason that a map has one common scale – a photo hasn't. That is, all objects on a map have the same scale, whereas objects on a photograph have different scales. The reason is this: a photo is a product of perspective or central projection, and a map is the product of orthographic projection (Fig. 1.1).

Scale

Both photographic and map scale are defined as a ratio of distances between corresponding points on the photo (or map) and on the ground. In other words, scale is an expression that states that one unit of distance on an image represents a specific number of units of the actual ground distance. For example, a 1:15 000 scale photograph means that 1 mm on the photograph represents 15 000 mm (or 15 m) on the ground. Often the term 'large scale' and 'small scale' are confused by those not working with the expressions of scale on a routine basis. Intuitively you might think 1:50 000 is larger than 1:5000. This is not the case. A smaller numerical value after the colon represents a larger scale. For instance, a 1:50 000 scale photo – though it has a larger ground coverage than a 1:5000 scale photo – renders ground features

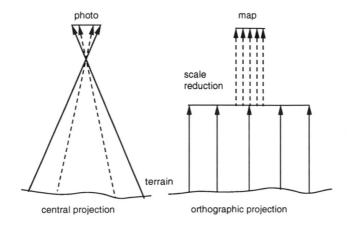

Figure 1.1 *Central and orthographic projections.*

much smaller. A convenient way to make scale comparisons is to remember that the same objects are smaller on a smaller scale photograph than a larger scale photograph.

Average scale and point scale

There are two types of scale – average scale and point scale. When we talk about a desired scale for an aerial photo mission, we refer to the *average scale*. The average scale of a project is rarely identical to any single photograph, because each photograph has unique characteristics that influence scale: tilt, changes in flying height, and terrain variation.

Now if the terrain is flat – like a lake – and the photo direction is perfectly vertical, scale is constant throughout the photo. But that's rarely the case. Consequently, each photograph also has an average scale.

The one time we get a precise scale is when we are dealing with a given point on the ground at a given elevation. This is known as *point scale M_b*:

$$M_b = 1/m_b = 1{:}m_b = f/H_g \qquad (1.1)$$

Where f is the focal length of the lens, H_g is the height above ground and m_b is the Scale Number.

Every point on the photo at a different elevation has a different point scale. In a vertical photograph, the range in these point scales depends on the terrain's elevation variation and the camera's focal length.

Focal length

One of the most important geometric features of an aerial camera is the *focal length*. Focal length is distance from the film plane (commonly referred to as the *focal plane*) to the centre of the lens when the camera is focused on infinity (Fig. 1.2).

Focal length is important for two reasons: ground coverage and scale. Ground coverage is based upon the cone of light rays that pass from the ground through the

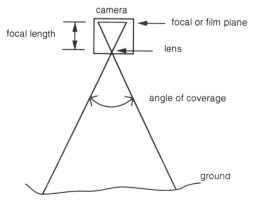

Figure 1.2 *Camera geometry.*

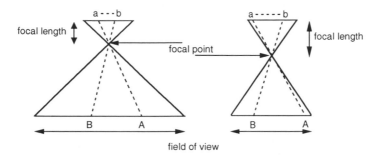

Figure 1.3 *Focal length and field of view.*

lens and onto the film. Notice in Fig. 1.3 that the left camera has a shorter focal length than the right camera. The shorter focal length provides greater ground coverage, but something else happens. The recorded (*ab*) distance is shorter than the corresponding (*ab*) distance on the right camera. Thus we see that focal length influences the ratio of distances between corresponding points on the ground (*AB*) and on the photo (*ab*).

Hyperfocal distance

If the focal length (*f*) is based upon focus at infinity, an appropriate question is: 'Where does infinity begin?' In other words, when you focus your single lens reflex camera on a close object, how close can that object be and still remain at infinity?

The answer is the hyperfocal distance (*HD*) which is a function of camera aperture (*N*). The closest point on infinity can be computed as follows:

$$\text{infinity's closest point} = 1000 \times \text{focal length/f stop.}$$
$$HD = 1000 \times f/N \tag{1.2}$$

So, if you are using a camera with a 35 mm focal length lens, and you're shooting at f16, then

$$1000 \times 35 \text{ mm}/16 = 2.2 \text{ m.}$$

Now, if you set your aperture to f22, then

$$1000 \times 35 \text{ mm}/22 = 1.6 \text{ m}$$

Therefore, at f22 you can focus your camera on an object, say the detail of a building, just 1.6 m away and still be working within your focal length; an important consideration when the camera is calibrated for photogrammetry in an optical laboratory.

5

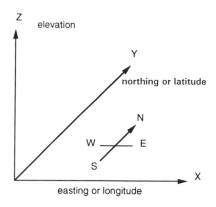

Figure 1.4 *Cartesian coordinate system.*

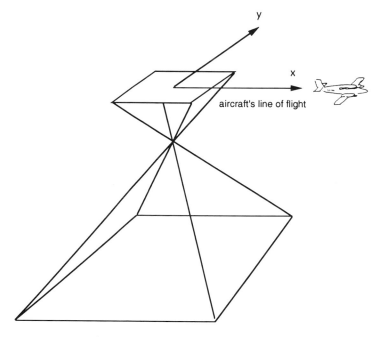

Figure 1.5 *Camera coordinate system.*

Coordinate axes

Similar to a map, a photograph has a coordinate axis system; and like ground or Cartesian axes, photo (or camera) axes follow a standard orientation. The Cartesian axes are established relative to cardinal directions: X runs east–west, Y runs north–south, and Z points up (Fig. 1.4). The photo axis system is relative to the aircraft's flight path, with x parallel to the direction of flight (Fig. 1.5).

6

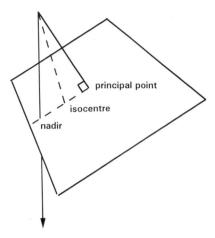

Figure 1.6 *The tilted aerial photograph.*

On large-format (e.g. 23 × 23 cm) aerial survey cameras, reference marks, called *fiducials*, defined the photo's coordinate axes. Fiducials are optically projected fine crosses, dots, or other geometric figures on the corners or sides of the photo's frame edge. Generally speaking, small cameras do not have fiducials. Some of the better cameras, however, can be fitted with a *reseau*, which serves as a coordinate reference system. A reseau is a glass plate engraved with calibrated marks, usually crosses on an orthogonal grid, often 10 mm apart in each direction. The *x* axis remains parallel to the line of flight, and the *y* axis perpendicular; and the calibrated reference marks define the geometric centre of the photograph.

Photo centres

Since photography is based upon central projection, another geometric consideration is the location of the photo's centre. Now this may sound a bit strange, but every photo has *three* centres (Fig. 1.6). On true vertical photography these three centres coincide at the same point.

- *Principal point* is the geometric centre of the photo that coincides with the intersection of lines drawn between opposite corners.
- *Nadir* is the point vertically beneath the camera. Imagine a plumb line dropped from the film and through the lens to the ground.
- *Isocentre* is the point that falls on a line halfway between the principal point and the nadir (for small angles).

Displacement

Because an aerial photograph is based upon central projection, it is subject to distortion and displacement. We define *distortion* as any shift in the position of an image

7

Table 1.1 *Distortion and displacement*

Types of Distortion	Types of Displacement
Film and print shrinkage	Curvature of the Earth
Atmospheric refraction of light rays	Camera tilt
Image motion	Topographic relief (including
Lens distortion	object height)

on a photograph that alters the perspective characteristics of the image. *Displacement* is any shift in the position of an image that does *not* alter the perspective characteristics.

Although all of the factors in Table 1.1 affect the position of an object on a photograph, only a few are of concern to us. Film shrinkage, atmospheric refraction, curvature of the Earth, and image motion are usually negligible or correctable. Lens distortion is less of a problem today than, say, a decade ago, because the quality of small camera lenses has improved considerably in recent years. That leaves topographic displacement and camera tilt as our primary concerns.

Topographic displacement

Topographic displacement, or relief displacement, is a serious concern because it influences scale. Areas of higher elevation lie closer to the camera and therefore appear 'larger' than corresponding areas lying in lower elevation. Therefore, the scale of higher objects, say a mountain top, is larger than that of lower objects, like a river valley. For instance, in Fig. 1.7, you see two lines on the ground, each 1 km long, but at different elevations. The ground distances are the same, but on the photo the line at the higher elevation is much longer than the line at the lower elevation.

Now here is another geometric characteristic of topographic displacement that you should remember. Tall objects radiate (or lean) *away* from the nadir, whilst depressions radiate (or lean) *towards* the nadir (Fig. 1.8).

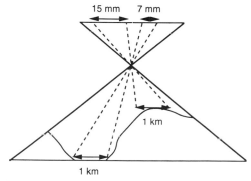

Figure 1.7 *Effect of topography on photoscale.*

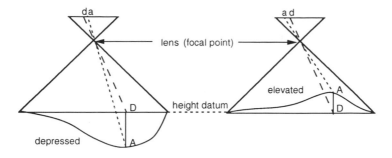

Figure 1.8 *Topographic displacement of object.*

Tilt displacement

Objects are also displaced on the photography by the aircraft, or camera, not being perfectly horizontal at the moment of exposure. This is known as *tilt*. Because tilt is a basic characteristic of all aerial photographs, it is used to classify photographs as either *vertical* or *oblique* (Fig. 1.9).

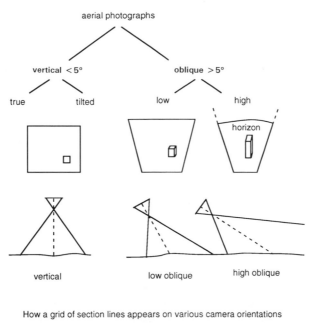

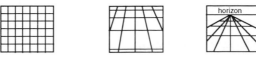

Figure 1.9 *Classification of aerial photographs based on tilt.*

9

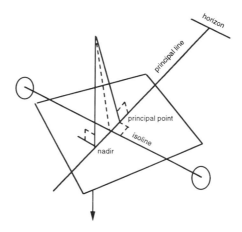

Figure 1.10 *Positive view of tilted photograph.*

When we say 'vertical' we mean the camera's axis does not exceed 5° of tilt, then we call the photograph 'oblique'. Obliques are further classified as either 'high' or 'low'. When the horizon is not visible, the photo is a low oblique, and when the horizon is visible, it's a high oblique (Fig. 1.9).

Like topographic displacement, tilt is a major geometric concern because it affects, amongst other things, scale. That is, objects in the foreground (bottom of the photograph) are at a larger scale than objects in the background (top of the photograph). As with displacement due to relief, tilt displacement radiates from a centre of the photograph. But in this case displacement radiates from the *isocentre* (the point that falls halfway between the principal point and the nadir, *see* Fig 1.10). Specifically, objects on the *upper side* of the photograph appear to be displaced *toward* the isocentre, and images on the *lower side* are displaced radially *outward* or away from the centre.

A matter of balance

For those untrained in photogrammetry, integrating the geometry of displacement, focal length, tilt, coordinate axes and photo centres might seem like mathematical alchemy – a real cauldron of computations. Prior to the advent of computers, it was to a certain degree.

As you begin to study these geometric considerations, try to think of the process not as an act of juggling numbers, rather as a balancing act. That is why it is essential for you – as a new student of photogrammetry – to develop a sense of balance. Just concentrate on the few basic principles and you'll start to get an intuitive feel for photo geometry.

Scale = focal length/flying height

We'll start with the most straightforward expression of scale. Scale is conveniently

expressed in terms of camera focal length, f, divided by the camera's flying height: scale $(M) = f/H_g$.

To sense how the f/H_g ratio influences photo scale, imagine looking through two cameras at a fixed flying height – one with a short focal length, the other with a long focal length. With the long focal length lens, the ground objects appear relatively large whilst ground coverage is relatively small.

Now, what happens if you fly higher with the long focal length camera, such that you have the same photo scale as the low-flying, short focal length camera? Although you could produce identical photo scales, the two images would *not* be identical.

For one thing, tall objects would appear to lean more outward when observed through the short focal length lens. In other words, a short focal length exaggerates relief displacement. Second, a short focal length also tends to introduce more distortion, especially a super wide angle lens like an 18 mm. Does this imply that a long focal length lens will produce better photo measurements? Not necessarily. Increasing flying height introduces another distortion element, atmospheric haze. As we shall explain in the next chapter, extreme displacement is generally desirable for producing accurate photo measurements.

Photo coordinate axes and camera orientation

So far we've assumed that the photograph is tilted in only one direction. But, in fact, a photo can be tilted along any of its three axes: *x*, *y*, and *z*. To illustrate the point, hold your *left* hand as shown in Fig. 1.11. (Simply studying the picture won't prove the point, you should actually follow the exercise.) Your left hand simulates the camera with your middle finger pointing towards the aircraft's direction of flight.

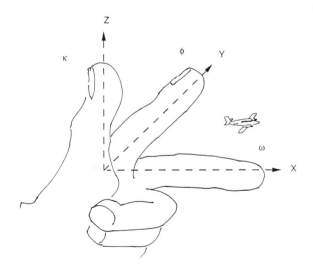

Figure 1.11 *Three rotations of a single photograph.*

11

Notice you can rotate your hand along *three* axes. So can the camera – and it does!

- Rotating your index finger is like the aircraft tipping its nose up and down: the camera rotates on the *y* axis. Rotation about the *y* axis is called ϕ, the Greek letter *phi*.
- Rotating your middle finger is like the aircraft tipping its wings: the camera rotates on the *x* axis. This rotation is called ω (*omega*).
- When you pivot about your thumb you simulate the aircraft crabbing or yawing: the camera rotates on the *z* axis. This is κ (*kappa*).

Intuitively you probably sense that these rotations do not affect the location of the photo's principal point, but they do affect the location of the nadir and isocentre. Recall that relief displacement radiates from the nadir, and tilt displacement radiates from the isocentre.

Angle of depression and ω (omega)

In 35 mm oblique photography it's common to get a bit confused about the small camera's orientation. To simplify matters, we assume that the long axis of the frame (the 36 mm perforated edge) is parallel to the direction of flight and remains the camera's *x* axis. If the operator raises the near-vertical camera so that the horizon becomes visible, this would be a high oblique photograph. If the camera is depressed, such that the horizon is no longer visible, then we have a low oblique photograph. This *depression angle* is complementary to the camera's ω: depression angle + ω = 90° (Fig. 1.12).

Scale variation and ϕ (phi) or κ (kappa)

Phi (ϕ) means *tipping* a vertical camera towards the front or back of the aircraft. Tipping the camera during oblique photography would be the same as having the aircraft pitch (i.e. lift or drop its nose) during vertical photography. Figure 1.13 illustrates how even a slight tip can affect a 35 mm wide angle lens, which has an

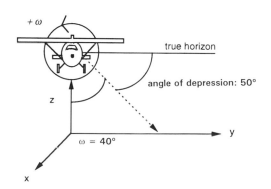

Figure 1.12 *Oblique depression angle.*

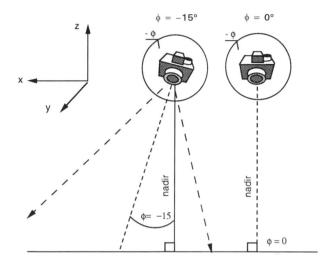

Figure 1.13 *Effect of φ (phi) on scale.*

angle of view of 62°. Consequently, we can see how φ influences scale variation.

Finally we come to κ, or rotation about the z axis. This does not influence scale variation in a vertical photograph, but it does in oblique photography. As the angle of depression decreases, κ rotation increases scale variation in the image. For example, in Fig. 1.14 we see that rotation adds additional large scale imagery in the foreground (shaded area of right drawing).

Orientation summary: the nine elements

In all, there are nine orientation elements of an aerial photograph (Table 1.2). There are six elements associated with the camera in space, which include the three posi-

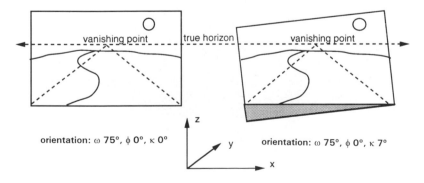

Figure 1.14 *Relationship between scale variation and κ (kappa).*

Table 1.2 *The nine elements of orientation*

Outer Orientation
Three positions
(or translations) *three tilts (or rotations)*
 1. *X* 4. nose up or down = ϕ (phi)
 2. *Y* 5. wing up or down = ω (omega)
 3. *Z* 6. swing, crab, yaw = κ (kappa)

Inner Orientation
 7. camera's focal length
 8. photo's principal point *x* location
 9. photo's principal point *y* location

tions of the camera relative to the ground (*X, Y, Z*) and three rotations of the camera (ϕ,ω,κ). These six elements are referred to as photo's *outer orientation*.

In addition there are three elements associated with the internal geometry of the camera and photo, which include the focal length and the *x* and *y* positions of the principal point. These three elements determine the photo's *inner orientation*.

Ground coordinates to photo coordinates

This concluding section is presented for a single purpose: to show how the nine orientation elements alter the images of a three-dimensional landscape. We are not presenting any formulae – it is merely a graphic representation of how ground coordinates appear on an aerial photo. If you like, consider it as a 'wrap-up' of the geometric variables presented so far.

The variables fall into four categories:

1. The characteristics of the camera itself:
 focal length, three photo centres, three coordinate axes

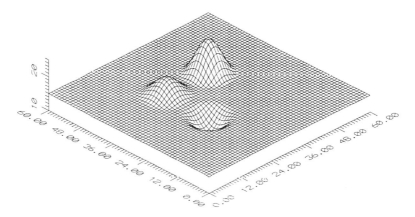

Figure 1.15 *Example terrain.*

2. The location of the camera with respect to the ground: X, Y, Z
3. The angular orientation of the camera with respect to the ground: ϕ, ω, κ.
4. The three-dimensional characteristics of the ground: *terrain relief*

Example terrain

We've discussed the first three variables at length. For the fourth, the terrain itself, we'll present a hypothetical landscape. Our **example terrain** consists of two knolls, a dip, and level ground. The elevation of flat terrain is 15 m (above datum). One knoll rises to 25 m, the other to 20 m; and the bottom of the depression is at 10 m. So we have a landscape with 35 m difference in elevation. The perspective illustration (Fig. 1.15) defines elevation points on a 60 m × 60 m grid, with a 1 m resolution (1 m separating each grid line).

Example map grid

We've also created a map grid covering the centre portion of our example terrain, (Fig. 1.16). The axes also frame two diagonal lines, which pass through the *centre* of the **example map grid**, coordinates $X = 30$, $Y = 30$, and $Z = 15$. These diagonals radiate to the four frame-edge corners and the landscape features.

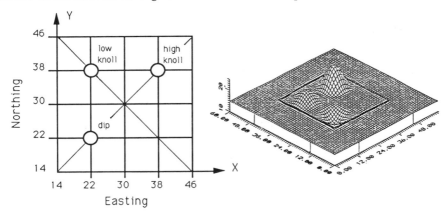

	Coordinates		
	X (easting)	Y (northing)	Z (elevation)
Frame-edge corners			
lower-left	14	14	15
upper-left	14	46	15
upper-right	46	46	15
lower-right	46	14	15
Landscape features			
low knoll peak	22	38	20
high knoll peak	38	38	25
dip bottom	22	22	10

Figure 1.16 *Example map grid.*

Projecting map coordinates on the photo

The essence of this exercise is to illustrate what happens to a map grid when photographed from different angles and positions. It shows you how the camera's focal length, position in space and orientation produce a *specific* grid pattern of the example map grid on the example terrain.

First, let's explain the format of the caption displayed above each diagram. It will read like this:

fl 35 *X* 38 *Y* 38 *Z* 50 ω 0 ϕ 8 κ 0 flat

The numerical sequence covers the camera's:
 focal length (in the above example, 35 mm)
 position (*X* = 38, *Y* = 38, Z (flying height above datum) = 50 m)
 angular orientation (ω = 0, ϕ = 8, κ = 0)
Following the camera description is the landscape description, which will describe the photo coverage of the example terrain as either flat or relief.

Map grid superimposed on flat terrain

To begin with, let's first see our example map grid photographed over flat terrain (Fig. 1.17). Note that this is a true vertical photograph with no tilt or rotation.

In Figure 1.18 we tilt the camera. Here, only ω is introduced (ϕ and κ maintain their base value of zero): the camera is rolled 8° at the moment of exposure. Figure

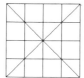

Figure 1.17 *Map grid over flat terrain: 35, 30, 30, 50, 0,0,0, flat*

Figure 1.18 *Camera tilted (ω) rolled through 8°: 35, 30, 30, 50, 8,0,0, flat.*

Figure 1.19 *Camera pitched (ϕ) through 8°: 35, 30, 30, 50, 0, 8,0, flat.*

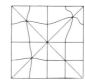

Figure 1.20 *Camera yawed (κ) through 8°: 35, 30, 30, 50, 0, 0, 8, flat.*

Figure 1.21 *Camera combines ω, ϕ and κ, all at 8°: 35, 30, 30, 50, 8, 8, 8, flat.*

Figure 1.22 *Relief (terrain) displacement: 35, 30, 30, 50, 0, 0, 0, relief.*

1.19 shows a similar image with all variables at their base value except ϕ: the camera is pitched 8 at exposure. Figure 1.20 shows the influence of κ: the camera yawed 8°.

Finally, Figure 1.21: combines ω, ϕ, and κ: all at a value of 8° at the moment of exposure.

Now that you have a basic idea of how the camera's orientation influences the example map grid, consider what happens when you alter the focal length. If we change the camera's focal length, we merely alter the scale. For instance, changing the focal length from 35 mm to 70 mm decreases photo scale from 1 m/mm to 0.5 m/mm.

What about shifting the tilted camera's projection centre, (i.e. the nadir)? Moving the nadir away from the centre of the example map grid simply shifts the location of the map grid on the photograph. What if we change the projection centre Z, i.e. alter flying height? It's the same as changing the camera's focal length: we simply alter scale.

So far the relationship between a flat landscape and the landscape images on a photograph seems quite straightforward. If the ground has no relief, the images are displaced from their plan position in a predictable manner. *The images of a two-dimensional object (e.g. a flat terrain) are a geometric function of focal length, projection centre, and orientation.* As we will see in the remaining figures, it is only the terrain's relief that complicates the images of our simple example map grid.

Map grid superimposed on terrain with relief

Figure 1.22 is our first representative picture of the example terrain. You can 'see' the knolls: two grid points displaced radially *from* the nadir. You can also see the dip: the grid point displaced radially *towards* the nadir.

Figure 1.22 is more complex than the flat pattern of Fig. 1.17, because of relief. But *relief displacement* shows that the object has a three-dimensional quality. And it illustrates a fact: relief will displace the object's image either away or towards the nadir, depending upon the object's elevation relative to the ground–nadir elevation. It is this fact that allows us to determine three-dimensional shapes from photographs.

...superimposed at different camera angles

Let's take this concept one step further and explore the influence of the *camera's orientation*, as we did in Figs. 1.18–1.21. Figures 1.23–1.26 illustrate the influence of ω, ϕ and κ upon a landscape with relief. Note, however, that the lower-right quadrant in corresponding figures (Figs 1.18 and 1.23, Figs 1.19 and 1.24, Figs 1.20 and 1.25, Figs 1.21 and 1.26) remain the same, because the landscape is flat (in this area).

By now you should appreciate the influence of object relief and camera angles. Now consider what happens when we shift the camera's projection centre over our example map grid. What we're doing is altering the nadir.

Figure 1.27 shows the results of a level exposure *with the nadir over the highest knoll*. The nadir has shifted from $X = 30$, $Y = 30$ to $X = 38$, $Y = 38$. Note that

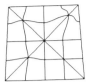

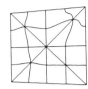

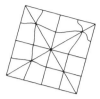

Figure 1.23 *Terrain relief and camera orientation: 35, 30, 30, 50, 8, 0, 0.*

Figure 1.24 *Terrain relief and camera orientation: 35, 30, 30, 50, 0, 8, 0.*

Figure 1.25 *Terrain relief and camera orientation: 35, 30, 30, 50, 0, 0, 8.*

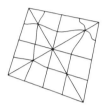

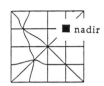

Figure 1.26 *Terrain relief and camera orientation: 35, 30, 30, 50, 8, 8, 8.*

Figure 1.27 *Shift or nadir.*

there is no apparent relief displacement around this nadir; the quadrant appears the same as the level quadrant. Why? Relief displacement is evident along the lines radiating from the nadir. But since the nadir is placed precisely over the top of the knoll – and our sample knoll is a symmetrical cone – relief displacement is not perceptible. If you moved the nadir's location, even slightly, displacement would be evident.

Figures 1.28 and 1.29 show how dominant the nadir location is. In Fig. 1.28 we tilt the camera with ω, and still the relief displacement is not apparent along the radial lines emanating from the nadir. Figure 1.29 includes 15° of ϕ, and makes the same point again. It can be compared to Fig. 1.24, but note how a different nadir alters the grid pattern.

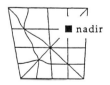

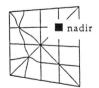

Figure 1.28 *Nadir dominance over tilt (ω): 35, 38, 38, 50, -15, 0, 0, relief.*

Figure 1.29 *Nadir dominance over pitch (ϕ): 35, 38, 38, 50, 0, 15, 0, relief.*

Summary

- A map has one scale – a photo has many.
- A map is based upon orthographic projection – a photo upon central projection.
- Displacement of images on the photo is caused by tilt and ground relief (including height of objects).
- Focal length and flying height affect scale and ground coverage.
- Scale = focal length/flying height.
- Camera coordinate axes are expressed in lower-case letters (x,y,z) where x is parallel with the direction of flight and y is perpendicular.
- A photo has three centres:

 principal point, where principal axis intersects the film plane, determined by intersection of lines coming from diagonally opposing corners.

 nadir – the point vertically beneath the camera.

 isoline – the point on the line halfway between principal point and nadir
- There are nine elements of orientation (*see* Table 1.2)

The inherent problem with aerial photographs is that ground objects are disfigured: *features are displaced, therefore their planimetric positions are not correct.* The problem is clearly seen when one reviews the figures presented so far. But there's a benefit of this 'problem': *because of these displacements, photogrammetry allows us to determine the three-dimensional shape of all features.* This will be explained in the next chapter, on the geometry of stereo photography.

Chapter 2

Geometry of Stereo Photography

You know that in three-dimensional space you can move in three ways – to left or right, backwards or forwards, up or down. Every direction is either one of these three or some combination of them. Now notice this. If you're using only one dimension, you can draw only a straight line. If you're using two dimensions, you can draw only a plane. If you're using three dimensions, you can build a cube, sphere, pyramid, etc. Do you see the point? As you advance to more and more complicated levels, you don't leave behind the things you found on the simpler levels. You still have them, but combined in new ways – in ways you couldn't imagine if you knew only the simpler levels. As you'll see, stereo photography involves this same principle.

To begin with, let's recall that all aerial photographs exhibit displacement, and the *cause* of relief displacement is traced to the camera's perspective view and the landscape. For example, if the vertical camera is looking at a tall object directly beneath its nadir, we don't *see* any relief displacement. The top of a flag pole might appear like a grapefruit. But if the flagpole is at the edge of the photo – ah! then it's seen as a tall object.

Now the actual height (or depth) of an object and its distance from the nadir will influence the amount of relief displacement. (That's why tall objects at the edge of the photo exhibit maximum displacement.) In other words, there is a correlation between actual height and distance from the nadir. If we could find some way to determine this correlation, then we could use displacement to determine the actual height of objects.

Principle of stereoscopy

The phenomenon of stereoscopic vision involves both mechanical and physiological principles. Our vision is so natural that we seldom stop to analyse it. Except by association with other objects, a single eye cannot accurately determine whether an object is nearer or farther than another object. But with two eyes we can perceive depth.

Before you go on any further, put this book down. Stretch out your arm, close one eye and sight your thumb on a target in the room, like the edge of a door frame. Now switch eyes. Notice how your thumb appears to move to the side of the door-frame? This apparent displacement is *caused by a change in the point of observation*,

and is the basis for our three-dimensional vision. Each eye, because it is separated, receives a slightly different view of the same object. Thus, stereoscopic vision enables you to view an object simultaneously from two different perspectives, or points of observation.

In stereo photography we emulate this phenomenon by taking two photographs from different camera positions. A *stereo pair*, sometimes called a *stereomodel*, consists of two adjacent, overlapping photos in the same flight line. The stereoscopic view is seen only in the overlapped portion of the photos.

Parallax

We've demonstrated that if a nearby object is observed alternately with the left and right eye, its location will appear to shift from one point to another. This apparent displacement, caused by a change in the point of observation, is known as *parallax*. Parallax is a normal characteristic of overlapping aerial photographs, and is the basis for three-dimensional viewing.

You can observe this phenomenon while looking at objects through the window of an aircraft or automobile. With the moving window as a frame of reference, the view of objects far from the window (such as mountains on the horizon) appear to change very little, in contrast to closer objects that appear to change more. (The above analogy does not imply parallax is movement: parallax is merely caused by a change in viewing position.) In the same way, when the point of view changes between successive vertical photographs, terrain features close to the aircraft's camera, such as building tops, will appear to move relative to the lower elevations, like street corners. These *relative displacements* form the basis for three-dimensional viewing of overlapping photography.

Now comes the geometry. Parallax can be measured accurately and used to compute the elevations of terrain points. As Figure 2.1 illustrates, point A is higher (closer to the camera) than point B, consequently the angle of parallax of point A is greater than point B. Figure 2.1 also illustrates another geometric fact: the amount of parallax of any point is directly related to the elevation of the point and the distance between the two exposures. Let's examine this relationship in depth.

Heighting accuracy: base:height ratio

The *heighting accuracy* of stereo measurements is a function of the distance of observation (flying height) and the distance between points of observation (air base). The *accuracy* of height measurements, therefore, depends primarily on this *base:height* (*B/H*) ratio. Generally speaking the larger the value of the base:height ratio, the more accurate the measurement.

To illustrate the point, try putting your finger 20 cm in front of your nose. You're accuracy will probably be within a couple of centimetres. Now move your finger to 60 cm. Are you still within 2 cm accuracy, or is it more like 5 or 10 cm? You see, there is a functional relationship between the distance between your eyes and the distance from your eyes to your finger. The same notion applies to photogrammetry.

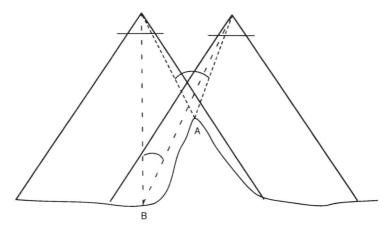

Figure 2.1 *Parallactic angle is a function of object height.*

To determine the base:height ratio try another exercise. Shut your weaker eye. Take a pencil and hold it at arm's length so you're looking right down on the eraser: all you should see of the pencil is the eraser top. This is similar to the camera's view of a flagpole under the nadir. Now open the other eye. With both eyes open you can see the depth of the pencil. Your eyes are functioning like a stereo pair. Repeat this exercise with the pencil at arm's length and again 30 cm away. Notice what happens: parallax increases the closer you hold the pencil (Fig. 2.2). It's a function of base (in this case the distance between your eyes) and the distance you hold the pencil from you eyes.

Let's compute the base:height ratio for our pencil trick. Say the distance between your eyes is 6 cm, and the pencil is held 12 cm away: the base:height ratio would be 6/12 or 0.5. By the way, this is the average base:height ratio aerial photographers try to achieve for stereo photography. If you move the pencil to say, 60 cm, your base:height ratio drops to 6/60 or 0.1 and your parallax decreases. As you can literally see, parallax is proportional to the base:height ratio. This phenomenon is illustrated in Fig. 2.3. Note that the illustration on the left has a greater base:height ratio and a greater parallactic angle than the illustration to the right; therefore it will provide the most precise height measurement.

Figure 2.2 *x Parallax increases as viewing distance decreases.*

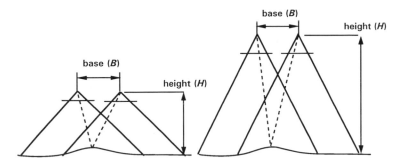

Figure 2.3 *Parallactic angles increase with base:height (B/H$_g$) ratios.*

Another geometric consideration is that $H/B = f/b$ (focal length/aerial base in image scale)

$$B/H = b/f \qquad (2.1)$$

Whereas f is fixed, b can vary from its maximum down to nearly zero depending on the overlap chosen. For precise heighting accuracy, photography is preferably taken with a short focal length camera so that a large base:height ratio is obtained.

Figure 2.3 also illustrates another geometric characteristic about heighting measurements. Since parallax occurs parallel to the direction of flight, parallax measurement must be parallel with the direction of flight. Knowing the direction of flight is important because it establishes the stereo pair's axis system and enables us to distinguish x parallax from y parallax.

Axis system

To see stereoscopically you need to orient the stereo pair so that the direction of flight lies along a common straight line. This flightline defines the x axis of the stereo pair. Determining the x axis is called flightlining (also called baselining); and the object is to orient the photographs' relative alignment at the time of exposure. The x axis is defined as the line that passes through the principal points and conjugate principal points (Fig. 2.4). The *conjugate principal point* is the corresponding principal point of adjacent photo.

Thus by drawing a line between the principal points (PPs) and conjugate principal points (CPPs), we define the flight line of the photos. For tilted photographs it would be more precise to use the nadirs and conjugate nadirs.

x parallax and *y* parallax

We've seen that the apparent elevation of an object is due to differences in its image displacement on adjacent photographs, which is caused by a change in the point of observation along the x axis. We measure this x parallax to determine the height of object. To determine object height, we need to know three geometric characteris-

23

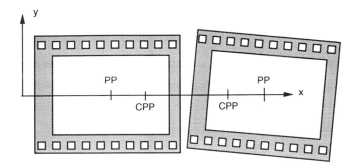

Figure 2.4 *Coordinate axes of a 35 mm stereo-pair.*

tics of the stereo pair: the flying height of the camera and two measures of *x* parallax.

The first measure of *x* parallax is *absolute parallax*, and it is equal to the *x* coordinate of a point on the left photo minus the *x* coordinate of the point measured on the right photo. Figure 2.5 illustrates an absolute parallax value of 17 mm. The *x* coordinate value of left photo is positive (13 mm) and the right coordinate value is negative (–4 mm). Therefore, the absolute parallax of point A is 13 mm minus negative 4 mm, or 13 + 4 = 17. *Note*: the above definition of absolute parallax assumes two perfectly vertical photos taken at the same altitude. Therefore, we could also use the measured air base (at photo scale) for the value of absolute parallax.

The other *x* parallax measurement we need is *differential parallax*, which is merely the difference in the absolute parallax at the top and base of the object being measured. Figure 2.6 illustrates a 35 mm stereo pair oriented under a stereoscope, with a differential parallax of 0.5 mm.

To compute the height of the object in Fig. 2.6 we use the basic formula:

$$\text{height of object} = \frac{\mathrm{d}P}{P + \mathrm{d}P} \times H \qquad (2.2)$$

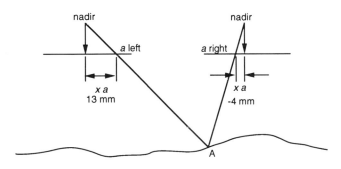

Figure 2.5 *Absolute parallax.*

24

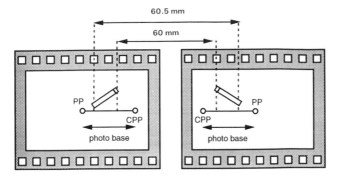

Figure 2.6 *Differential parallax* (Not to scale).

where *H* is the flying height of the camera, *P* is the absolute parallax at the base of the measured object and d*P* is the differential parallax. Flying height should be expressed in the units desired for the object height, and absolute and differential parallax must be in the same units. If we assume that Fig. 2.6 represents a true vertical stereo pair taken at a flying height of 1000 m, and the absolute parallax (or photo base) is 15 mm, then the height of the object is:

$$H = 1000 \ (0.5/(15+0.5)) = 32.26 \text{ m}$$

y Parallax

y Parallax is the displacement of an object measured along the *y* axis, hence the name. The existence of *y* parallax is an indication of tilt in either or both photographs and/or a difference in flying height (Fig. 2.7). The top illustration in Fig. 2.7 shows *y* parallax caused by a reduced flying height in the right photo. Note that the principal points and the nadirs are identical, which indicates true vertical photography. The bottom illustration shows *y* parallax caused by a tilt in the right photo.

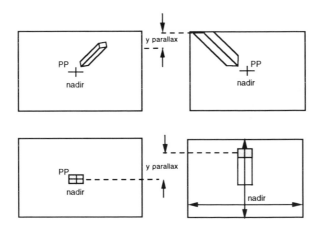

Figure 2.7 *y Parallax caused by different flying heights (upper) and tilt (lower).*

The left photo is a true vertical photo, with the top of the building (shaded area) directly in the photo's centre. The right photo has maintained the same flying height, but the camera tipped. Notice how tilt displacement radiates from the nadir.

In our normal vision we don't experience y parallax, but in stereo photography we do – and this poses a problem. The amount of y parallax varies throughout the model. Thus, if you want to see stereoscopically at different locations, or if there is great elevation difference, you have to shift the photos to remove y parallax. This can, of course be done, but it's rather tedious when making photo measurements with analogue measuring instruments, which we'll discuss in another chapter.

Summary

- Photo base is the distance between nadirs of two adjacent (stereo) photos. For vertical photography we can measure the distance between the principal point (PP) and the conjugate principal point (CPP).
- B/H is a ratio that determines heighting accuracy, where B (air base) is the displacement of the camera between two overlapping photos and H is the height of the camera above the object being photographed.
- The x axis of a vertical stereo pair is defined by the flightline, and it is determined by aligning the principal points and conjugate principal points. With tilted photos the x axis is determined by aligning the nadir and conjugate nadir.
- Parallax is the apparent change of an object or scene as the viewpoint is shifted. There are two types:
- x parallax, which is parallel to the flightline and used to determine height
- y parallax, which is perpendicular to the flightline and is an indication of tilt or difference in flying height.

Chapter 3

Mapping and Measuring from Single Photographs

The objective of this chapter is to explain to you how to make maps and measurements from single photos. Unlike most photogrammetry textbooks that focus on just theory, we'll outline both principles and practical applications. We'll begin with an overview of some easy-to-use, low cost equipment for map revision, followed by a few simple techniques for making height, length and area measurements. Then we'll introduce mapping and measuring using analytical instruments.

Map revision

If you recall, photographs are not like maps because of scale variation. But, if you're using vertical photographs of flat terrain, photographic scales can be estimated with reasonable accuracy for many natural resource surveys. *Direct print tracing* may serve some useful purposes, but such tracings cannot be technically referred to as true maps unless your terrain is perfectly flat (like a body of water) and level with the camera's film plane at the moment of exposure. These are quite rare circumstances. Consequently direct print tracing introduces systematic errors.

An alternative is to *transfer* photographic detail to a base map of uniform scale. These can be *planimetric maps* that show the correct horizontal positions of ground features or *topographic maps* that also show elevation differences (i.e. contour lines).

The most straightforward method of supplementing existing base maps with photographs is to simply fit a photo to a map, then trace the image. It requires nothing more than a single photograph (print or slide), a corresponding map, and, of course, a suitable instrument. The accuracy of transferring detail using the fit and trace methods will vary according to the nature of the original photograph (print or slide) and the instrument (print reflector or slide projector).

Print reflectors

An instrument that superimposes a print and map is called a *camera lucida*. Essentially it transfers details and changes scale, but does not remove tilt or topographic displacement. That means it is not suitable for tilted photography nor for vertical photography of a terrain with considerable elevation differences.

There are several types of camera lucida that are inexpensive and portable. One of the most popular types is the vertical sketchmaster (Fig. 3.1). Your enlarged small format print is placed face up on the platform, directly under the mirror.

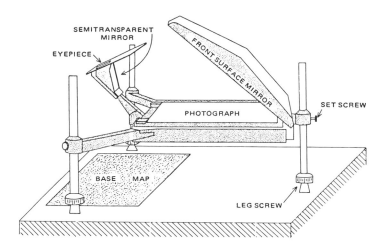

Figure 3.1 *Schematic diagram of a vertical sketchmaster (Adapted from Avery, 1977).*

Photo images are reflected from the mirror into the eyepiece so the reflected photo image and base map are viewed simultaneously.

To transfer photographic detail, the instrument can be raised or lowered by adjustment of the legs until both map and photograph appear the same scale. Any combination of three common control points is carefully matched; features that fall within the triangle thus formed are traced on to the base map. Planimetric detail is then transferred on to the map. The instrument is then shifted, the legs are readjusted until three more control points can be superimposed, and another triangle area is mapped. This procedure is repeated, one triangle at a time, until the base map is completed.

Photo image displacement due to tilt or topography might result in slightly offset features (e.g. a river) along common sides of a triangle. Such discrepancies are resolved by compromising the location until continuous lines are obtained.

Most sketchmasters provide for relatively narrow range of scale changes, ranging from 0.5× to 3.0×. Therefore, your prints and base maps should be approximate, which might pose a problem if your small format prints are larger than 1:5000 and your base maps are smaller than 1:15 000. (Remember, when we talk about photo scale we're referring to the scale of the enlargement, not the original negative.)

Zoom transfer scopes are more sophisticated than a sketchmaster, and more expensive. Generally speaking, they provide greater scale changes and offer binocular viewing of both the basemap and the photograph. Zoom transfer scopes provide image rotation and can stretch imagery with differential magnification ratios in the X and Y direction. A practical advantage of these instruments is that they can also be used for stereoscopic work. For those committed to a considerable amount of map revision work, the zoom transfer scope offers many attractive features.

Slide projectors

Unlike simple instruments that reflect prints, *slide projectors* work with the original imagery. Basically they function like photographic enlargers. A transparency is placed near a light source and the photo image is projected on to a tracing surface. These instruments offer a great range of scale adjustment and more working space than vertical sketchmasters. Most projectors that are designed for large format photography are rather sophisticated, and consequently expensive.

However, innovative designs for small format slides are rather simple, and you can construct your own at a nominal cost. Popular front projection systems suspend a slide projector vertically over a desktop mapping surface and the operator adjusts the image scale (Fig. 3.2, top). Fitting the imagery to the map is merely a matter of properly orienting the projector.

Many users prefer rear screen projection because no hand shadows are cast on to the mapping surface, nor are eyes strained by glare from the reflected front projection. However, image details begins to blur at about 8× to 9× enlargement, whereas front projection systems can enlarge as much as 20× before detail significantly degrades. A favoured 'do-it-yourself' technique is to mount a standard slide projector underneath a table. The image is simply projected on to a mirror inclined at 45° and then reflected upward to the underside of a translucent tracing glass mounted on the table top (Fig. 3.2, centre). Another rear screen technique is a direct projection to the mapping surface (Fig. 3.2, bottom). This minimises the distortion and light loss when using an angled mirror.

Another rear screen device is a microfiche projector, the type commonly found in libraries. These desktop units are compact and can handle single 35 mm or 70 mm frames. Some can be fitted with 35 mm film holders to feed continuous (unclipped) rolls of film. A drawback to the microfiche projector is that it generally offers limited magnification, set at two powers of enlargement, e.g. 15× and 30×.

Unfortunately, none of the methods described compensates for displacement, which is a problem when viewing uneven terrain or using oblique photos. But if your vertical slides cover relatively flat areas, such as wetlands, the systems mentioned are especially appealing to those with limited budgets.

Slides or prints?

Deciding whether to use a print reflector or a slide projector is partly a practical matter of costs, available equipment, and your interest in developing a new skill. But the decision must also consider your accuracy requirements. That is, what level of quality are you seeking in your photo information?

The trade-off between image quality and image content can be grossly contrasted when comparing slides and prints. In a future chapter, (Chapter 5, Practical Considerations) we will discuss the systematic errors introduced by enlarging: image loss (cropping) and image distortion. But for now let's consider the qualities associated with slides. Similar to commercially enlarged prints, mounted slides also crop the original image. Moreover, detail can be lost in slide projection due to inherent distortions in the projector lens, which diffuse light unevenly across the screen. As a

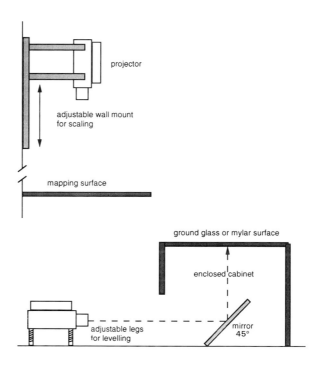

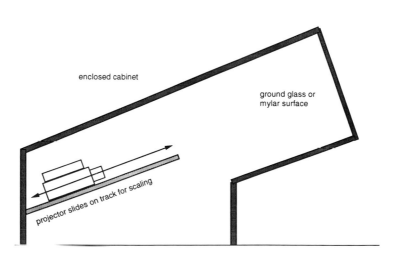

Figure 3.2 *Schematic diagram of forward-projector (top) and rear-projector (centre and bottom).*

result you get fuzziness. The surface coarseness of the ground glass on which the image is projected also influences resolution. One reason why prints have better resolution than images projected on ground glass is the uniformly smooth surface on the photo paper. If an acetate sheet is substituted for glass, the warping on the image-forming surface can also cause distortion. Finally, if a mirror is used to redirect light from a horizontally mounted projector, image quality will depend on the evenness of the mirror's surface and the uniformity of it's coating. Of course, the mirror also reduces the intensity of light reaching the ground glass.

Although projection systems cannot be expected to yield the image quality available from either the original film strip or prints made from it, they can nevertheless provide information adequate for a wide range of studies, particularly when used in conjunction with direct viewing. For each project, a balance must be sought between the need for maximum image quality and the importance of cost savings.

Measuring

There are a number of simple techniques for making measurements off a single photo, but all are crude. We'll begin with measurements captured off a vertical photo, using both prints and projected slides. Then we'll introduce techniques for oblique photography. In all cases, however, we must remember that a single photograph has inherent problems associated with relief displacement, so these measurements are suited for landscape with little differences in elevation, such as wetland for small scale photography or fairly level ground for large scale imagery.

Vertical photography

Meyer and Grumstrup (1978) suggest a simple method for making *distance and area measurements* from a projected slide. To begin with, at least two ground points a known distance apart must be located on the projected image. If the projected image is not to be brought to a specific scale, it should be stabilised at an acceptable size on the screen. The two ground points of known separation are measured and used to compute the scale of the screen image. For instance, let's assume we know the distance between two bridge crossings is 1000 m, and the distance between the bridges on the screen is 0.5 m. In this case the projected image scale is 1:2000. Once the scale of the screen is known, area can be calculated by placing a dot grid over the screen, or from a tracing made from the screen image.

An advantage of this technique is that the scale of the photography is always recoverable and adjustable. When, for example, long-term sequential coverage of the same area is to be compared, the scale of the photography from different dates might be different. The photography of different missions can be matched with a map merely by adjusting the ground control points.

For measuring *object height* (H_0) there are two basic methods, but both are generally used for large-scale photography The first uses topographic displacement, which follows this basic formula:

$$H_0 = d(H)/r \qquad (3.1)$$

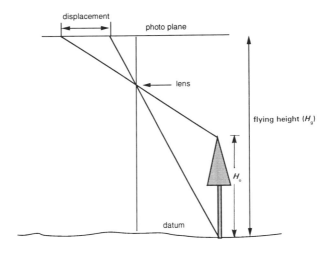

Figure 3.3 *Geometry of topographic (relief) displacement for measuring object height.*

where *d* is photo displacement, H_0 is flying height above datum (nadir of base of the object), and *r* is the radial distance on the photo from the nadir to the displaced point (Fig. 3.3). This method can only be used with photography that meets three criteria:

• The object being measured must be vertical from bottom to top, like a tree, which rules out measuring differences in elevation between two points on the ground that are not directly over one another.
• The distance from the nadir must be great enough to create measurable displacement.
• Both the top and the bottom of the object must be visible.

For additional information about using this method refer to Paine (1981).

The *shadow method* can be used in two ways. First, if you can measure the length of the shadow and know the angle of the sun, the height can be determined by simple trigonometry. But this assumes that the ground on which the shadow falls is level, and that the object is perfectly vertical. In addition, you must see the top of the object as a sharp point on the ground, which is a problem for measuring broadleaf trees rather than conifers. Now you might imagine this technique ideal for winter photography of conifers in an open terrain; but bear in mind, deep snow will shorten the shadow. Finally you must know the angle of the sun, so if you plan to use this method it's recommended that the date and time of photography is recorded on the original negative.

The other shadow method compares a known shadow length with one that is unknown. So, if we know the height of one feature in the photo, and we measure it's shadow length, then we can figure out the height of other objects simply by proportion. Say a fire tower is known to be 100 m high, and it's shadow length on the photo is 10 cm. If a neighbouring tree casts a shadow 2.5 cm, then 2.5/10 of 100 m is 25 m. Does it matter if the tree is at a different elevation to the fire tower?

No; nor does the ground have to be level as long as the shadow conditions are the same for the known and unknown objects. For additional information on shadow measurements refer to Avery (1977).

Oblique photography

Because of inherent scale changes associated with oblique photography, some form of perspective correction is required in order to make scale, area, and distance measurements. Evans and Malta (1984) detail a method for creating a perspective grid for an oblique photograph by locating the principal point and isocentre and various lines:

- principal line
- visible and true horizons
- nadir line
- isoscale line
- a scale line

The following is a review of Evans and Malta's (1984) method based upon a procedure developed by Strandberg (1964). Although you can use projected slides, it is recommended that you begin with a print that is enlarged at least 6×.

Figures 3.4, 3.5 and 3.6 illustrate how to construct a perspective grid for an enlarged 35 mm print. The following steps should be followed in sequence:

1. Place a *large* piece of transparent paper or film over the photograph. It must be large because some lines that you'll draw might extend beyond the photograph.
2. Locate the *principal point* by drawing the intersection of lines from diagonally opposing corners, and label it P (Fig. 3.4).
3. Locate the *true horizon* (TH) line by:

 a) If a *level* horizon can be seen (e.g. smooth terrain or water surface), simply draw a line along it, and label it VH.

Figure 3.4 *Perspective relationships on an oblique photograph (Adapted from Evans and Malta, 1984).*

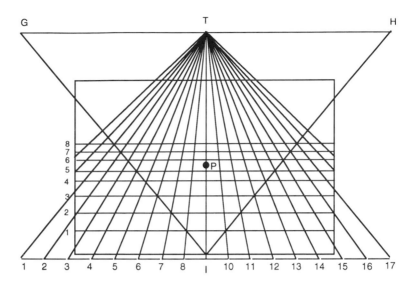

Figure 3.5 *Construction of a perspective grid (Adapted from Evans and Malta, 1984).*

b) If a level horizon cannot be seen, which is the case in a low oblique, or if the horizon is irregular, the TH can be determined by extending lines from buildings or fields with straight edges. The points on the TH where these lines converge are called *vanishing points*. If the lines are extended from two or more sets of parallel lines, the position of the TH can be found by drawing a straight line through all vanishing points (VX). For low obliques the TH will be drawn above the photograph. Label TH on the overlay (Fig 3.4).

If this method can be used to locate the true horizon, steps 5 and 6 can be eliminated. In place of these steps, measure the distance along the principal line (found in step 4) from the true horizon (TH) to the principal point (P). Divide this distance by the focal length of the camera times the enlargement factor. The answer is the tangent value of the depression angle.

4. Draw in the *principal* line, which passes through the principal point and meets the true horizon at a right angle, and label it PL.

5. Calculate the *depression angle of the photograph*, which is the camera's angle down from the true horizon, as follows:

a) If a level horizon (VH) is present, the angle at which the camera was depressed below the visible (or apparent) horizon (VH) must be determined. You do this by dividing the distance from the VH to P by the focal length multiplied by the enlargement factor. This is the tangent of the depression angle.

b) Determine the size of the *angle between the visible and true horizon*. This angle acts as a correction factor, which must be added to step 5a. This angle is calculated (in minutes of arc) by deriving the square root of the flying height in feet. For example, if the angle in step 5a was determined to be 12°, and the

photograph was taken at 2500 feet, the size of the depression angle is 12° plus 50 minutes of arc (12° 50')

6. Locate the *true horizon line* (TH). By referring to trigonometric tables or using a calculator, find the tangent of the total depression angle (found in step 5b). Multiply the tangent of this angle by the focal length of the camera times its enlargement factor. Then place a point at this distance up from the P, parallel to the VH.

7. Calculate the tilt angle, and plot the position of the isoscale line and the nadir (Fig. 3.5).

 a) *Tilt angle* = 90° minus angle found in step 5b.

 b) *Isoscale point* (I) is located by measuring down from P along the PL the following distance: multiply the focal length times its enlargement factor by the tangent of one-half the tilt angle. For example, if the depression angle is 25°, the tilt is 90° minus 25°, or 65°. One-half of the tilt angle is 32° 30', and the tangent of that is 0.63707. Thus, if the camera used a 50 mm focal length lens and the original photo was enlarged 6.35×, then the distance from P to I is computed as follows:

$$50 \text{ mm } (6.35) \ (0.63707) = 202.27 \text{ mm}$$

So measure 202.27 mm down from P on the PL and label it as I.

8. Make two ticks (G and H) on either side of T (the intersection of TH and PL) at the same distance as TI.

9. Draw the *isoscale line*, which is a line through I perpendicular to the principal line (TI). Distances measured along this line are at the same scale (as if the photograph were a vertical photograph taken with the same camera from the same altitude). After this is done, the basic scale formula f/H_g can be used to calculate distances.

10. Using the basic scale formula, calculate and place a series of tick marks along the isoscale line equal to 100 m on the ground. (If you are used to working with feet and acres, use 209 feet, since a square acre is approximately 209 feet on the side.) For example, if the photograph were taken with a 35 mm camera fitted with a 50 mm lens, from an altitude of 500 m, the contact scale along the isoscale line would be calculated as follows:

$$\text{scale} = f/H_g = 0.5 \text{ m}/500 \text{ m or } 1{:}10\ 000.$$

However, because your original photo has been enlarged, say 6.35 times, the enlarged scale is actually 1:1574. Reduced to a scale of 1:1574, 100 m is equal to 63 mm. Consequently, the tick marks should be placed 63 mm along the isoscale line in both directions from point **I**.

11. Draw a series of lines, one from each tick mark, which converge at **T**. The resulting fan-shaped array of lines should extend far enough to the sides so that the entire picture area of the photo is included within the array. These lines will become the *Y* axis margins of the final perspective grid squares.

12. As shown in Fig. 3.5 draw 45° diagonal lines GI and HI across the fan-shaped array of lines. These diagonal lines establish the *X* axis of each of the perspective grid squares.

13. With a straightedge, draw lines across the array of lines through each intersection of GI and HI with the *Y* axis lines drawn in step 11. These parallel lines form the *X* axis lines of each individual perspective grid squares.

sky
horizon
ground

usable portion
of photograph

P

Figure 3.6 *High oblique perspective grid (Adapted from Evans and Malta, 1984).*

As seen in Fig. 3.6, the spacing between successive lines – and therefore the scale of the photograph – decreases considerably as you progress from the principal point toward the top of the photograph. Because of the rapid decrease in scale, little is gained by extending the X axis lines more than a few centimetres above the principal point of a high oblique.

After you've completed the grid drawing of the 1 ha (or 1 acre) perspective grid, you can make area measurements. Linear measurements can also be made by using the isoscale line as a reference scale. Figures 3.6 and 3.7 illustrate perspective grids constructed for high and low oblique aerial photographs.

Though less accurate than the perspective grid, quick estimates of size and scale can also be made by using various scale factors listed in Table 3.1. Sb, Sc, and St in the table represent the photographic scale at the bottom, centre and top. Scale in these areas is determined by multiplying the flying height (H_g) by the appropriate factors.

P

Figure 3.7 *Low oblique perspective grid (Adapted from Evans and Malta, 1984).*

Table 3.1 *Flight values for oblique photography (adapted from Fleming and Dixon, 1981).*

		High oblique (δ=α)							Low oblique (δ=45°)							Vertical (δ=90°)	
		Ground Distance				Scale No.*			Ground Distance				Scale No.			GD=SN	
f	α°	D/H	C/H	B/H	P/H	Sb/H	Sc/H	St/H	D/H	C/H	B/H	P/H	Sb/H	Sc/H	St/H	P/H	Sc/H
18	33.7	.42	1.08	1.50	∞	15.3	30.5	∞	.20	.80	1.0	4.8	14.4	23.9	71.8	1.33	16.9
21	29.7	.59	1.16	1.75	"	14.6	29.3	"	.27	.73	"	3.39	13.1	20.5	47.9	1.14	14.5
24	26.6	.75	1.25	2.0	"	14.2	28.4	"	.33	.67	"	2.67	12.0	18.0	35.9	1.0	12.7
28	23.2	.95	1.38	2.33	"	13.8	27.6	"	.40	.60	"	2.10	10.8	15.4	26.9	.86	10.9
35	18.9	1.29	1.63	2.92	"	13.4	26.9	"	.49	.51	"	1.55	9.17	12.3	18.7	.69	8.71
40	16.7	1.52	1.82	3.34	"	13.3	26.5	"	.54	.46	"	1.32	8.29	10.8	15.4	.60	7.62
50	13.5	1.96	2.20	4.16	"	13.1	26.1	"	.61	.39	"	1.02	6.95	8.62	11.3	.48	6.10
55	12.3	2.18	2.40	4.58	"	13.0	26.0	"	.64	.36	"	.92	6.43	7.84	10.0	.44	5.54
85	8.0	3.47	3.61	7.08	"	12.8	25.6	"	.75	.25	"	.58	4.44	5.07	5.90	.28	3.59
100	6.8	4.11	4.23	8.34	"	12.8	25.6	"	.79	.21	"	.49	3.85	4.31	4.90	.24	3.05
110	6.2	4.53	4.63	9.16	"	12.8	25.5	"	.80	.20	"	.44	3.53	3.92	4.40	.22	2.77
135	5.1	5.58	5.67	11.3	"	12.8	25.5	"	.84	.16	"	.36	2.93	3.19	3.50	.18	2.26

f is focal length in mm.
*Sb, Sc, St are photo scale numbers at the bottom, centre and top edges (respectively) of the photo.
Note: δ = depression angle of hand-held camera and α° = arc tan x/2f (semi-field angle). Use this value as the depression angle for specific focal lengths for high obliques.

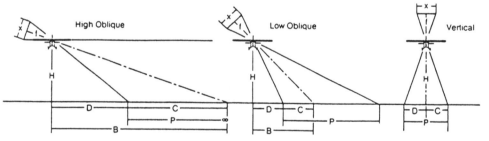

Keep in mind that the factors in Table 3.1 apply to the original 35 mm slide or negative. Therefore, to determine various scale and distance relationships for a print, the appropriate enlargement factor must also be applied.

Although these measurements are generally used for estimations, they can be quite precise if the landscape is relatively level. Provided careful attention is given to the procedures detailed by Evans and Malta (1984), applications for natural-resource specialists taking hand-held photographs are promising.

Analytical mapping and measuring

The concept behind analytical instruments is quite different from analogue devices. Here coordinates are captured off the photograph and transformed into ground coordinates. The process is entirely *numerical*: objects on the photograph are digitised and through conventional photogrammetric equations these photo coordinates (x, y) are transformed into familiar Cartesian coordinates (X, Y, Z).

The heart of the operation – transforming photo coordinates to ground coordinates – is based upon knowing the camera's geometry (focal length and principal point) and characteristics at the moment of exposure (position and orientation relative to the ground – outer orientation).

In order to transform photo coordinates to ground coordinates we need at least three ground control points. *Ground control points* are located positions that have known Cartesian coordinates (e.g. UTM X, Y, Z values). For this purposes grid coordinates of points within the photographed area must be obtained, and we do this either with a field survey, which is generally slow and expensive, or by *digitising* coordinates off a map, which is fast and inexpensive. (If you're not familiar with digitising, see 'What's a Digitising Tablet?' on page 41.) Control points become the framework on which the photograph is oriented, and to a great extent determine the accuracy of the mapping project.

The underlying principle of digital monoplotting is *space resection*, a computational procedure for determining the position and attitude of the camera at the time of exposure. Space resection is based upon collinearity, the geometry related with rays of light converging at the camera's focal point: that is, ground object, photo object and perspective centre align. To perform space resection at least three X, Y, Z ground control points must be known: for example street intersections, building corners, bridge crossings. Theoretically, any three points will do; but practically speaking, it's best to have four or more points *widely distributed*. It might help to think of the photo plane as a three-legged table: widely distributed legs are more stable than clustered ones. If extra control points (analogous to table legs) are present, the procedure produces statistics that indicate the relative accuracy of the mathematical fit. Again, one might think of the table analogy: a well-built table with four or more legs does not wobble.

In space resection, collinearity formulae serve to make the photo coordinates and ground coordinates parallel. In order to solve these collinearity equations, it's necessary to linearise the equations and to apply a least-squares iterative adjustment for solutions, a relatively simple task for a computer. The angles of camera's three rotations (ϕ, ω, κ) (x axis, y axis and z axis) and the coordinates of the perspective centre (X, Y, Z) are numerically adjusted through iterations until they replicate the orientation of the camera relative to the ground. In short, the photo coordinates of the control points are matched with the ground coordinates to determine the photo's position relative the Earth.

When a single photograph is used for measurement purposes, the elevation of all features on the image must be known. If the image object is flat, such as a lake, projective transformation between the two planes (i.e. the film plane and the object plane) is straightforward. In these circumstances, projective transformation is determined with the aid of four control points, three of which may not lie on a common straight line. Nohara (1991) used 35 mm oblique photography in this manner for mapping floating-leaved plants in a lake.

If the landscape has relief, however, then the elevation of each image point on the landscape must be known and accounted for. Therefore, in addition to knowing the camera's characteristics at the moment of exposure, a *digital elevation model*

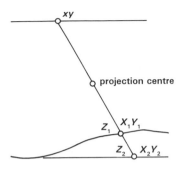

Figure 3.8 *Knowing the photo coordinates (x, y) of a point (and the outer orientation of the camera) we can determine the ray in the X, Y, Z system if we know the X, Y, Z coordinates of the point. A known Z leads to a knowledge of X and Y.*

(DEM) must be tied to the photo, which will determine the elevation of any photo object. A DEM – sometimes called a DTM (digital terrain model) – is a digital representation of a terrain surface. It comprises a grid of regularly spaced X, Y, Z coordinates; and its purpose in monoplotting is to provide the elevation (Z) for a given planimetric point (X, Y); see Fig. 3.8.

DEMs can be obtained in different ways. You can purchase them from a mapping authority, a national forest service, or a soil or geological survey. In the past, the most serious limitation of digital monoplotting was that DEMs were not always available. This is not the problem any more, at least in the United States, because more and more government agencies are using DEMs for a variety of purposes.

Another way to obtain a DEM is make your own. For example, you can simply digitise contour lines off a topographic map and enter the data into a PC-based software program for making DEMs (e.g. Golden Software's SURFER program). Some monoplotters generate their own DEMs. Warner (1993) details how the Carto MDSD creates a DEM in two ways:
- from ground control points.
- measuring the elevation of numerous objects on two overlapping photographs.

Operating procedures

Operating procedures for digital monoplotting generally consist of two basic steps: photo orientation and photo measurement. Since the format of the original negative or slide is quite small, it is generally enlarged. Enlargement can be done with a traditional optical enlarger or a colour copier equipped for enlarging slides.

The first step formulates the transformation of the photo to the ground. The second step digitally records a two-dimensional point (x, y) and queries the DEM for elevation (Z). From a collection of three-dimensional ground coordinates (X, Y, Z), a variety of measurements can be generated: line length, area, slope and azimuth can be computed to ground coordinates in near real time. Let's examine these procedures in depth.

Orientation

Since the heart of the system is based on knowing the position and angular orientation of the camera's perspective centre relative to the ground, we need to have precise information about the camera itself. Specifically, we need to know the exact location of the principal point and focal length. *Consequently, calibrated camera data is mandatory.* Provided you have these data, orientation is a simple two-step process.

- *Inner orientation* The procedure consists of securing the photograph to the digitiser and digitising photo reference points (fiducials or frame edges). The system's software then matches the digitised photo reference coordinates to the true (calibrated) reference coordinates in the camera's file. The transformation will determine scale change and compute the principal point.
- *Outer orientation* analytically determines the position of the camera station and attitude of the camera at the instant of exposure. It scales and levels the photograph to the ground by matching ground control points to corresponding points on the photograph. This match also determines the photo's planimetric accuracy.

Data collection

The system's *point collection* mode ties the oriented photo to a DEM and transforms (x,y) photo coordinates into (X,Y,Z) ground coordinates. In other words, as the digitiser's cursor moves to a point on the photo, the software queries the DEM for elevation and computes the point's three-dimensional Cartesian coordinates.

Conceptually, the process is quite straightforward. Imagine a light ray projecting from the film plane, through the perspective centre on to a flat surface. Since we know the camera's position over the earth (X,Y,Z) and its angular orientation (ϕ, ω, κ), we can determine the line projection of that ray. There are an infinite number of X,Y, coordinates along that line *until* it intersects the ground. The point where the ray intersects the ground (Z) is supplied by the DEM. Once Z is known, X and Y are computed.

One might ask, 'Given the photo coordinates (x,y), how does the measurement system determine Z without knowing ground coordinates (X,Y), and how can it calculate X,Y still not knowing Z?' It appears a chicken-and-egg question: which came first? To begin with, Z is estimated – based upon the mean Z value of all control points. Then the system performs a series of iterations until a solution is determined.

When the operator digitises a point, the feature is stored in the system, and frequently displayed on the computer's graphics screen. These data can then be plotted out in the form of maps, or formatted to a variety of standard mapping systems, such as GIS (geographical information systems).

What's a digitising tablet?

If you're not familiar with *digitising* you should read this for two reasons. First, in most analytical applications you'll need to capture ground coordinates for control purposes (levelling and scaling your photo). Here you'll digitise points off a map. Second, some photogrammetric systems capture photo coordinates with a digitising tablet (e.g. Rolliemetric or Carto MDSD).

A digitiser is a computer *input device* that is specially designed to help you put graphic information into a PC. In one sense, a digitiser is to graphics what a keyboard is to text. Basically it consists of a hand-held cursor, a flat tablet and some sophisticated electronics. As you move the cursor over the tablet surface, the digitiser's electronics determine its precise location.

The tablet itself is something like a piece of graph paper. Each point on the tablet (or graph) may be described by a unique *X* coordinate and *Y* coordinate. See how it nicely suits digital monoplotting?

Figure 3.9 shows the coordinates at the corner of a 45 × 63 cm digitiser tablet. The point shown in the illustration is a photo's corner. It's represented by the *XY* coordinate 23.000 cm, 23.000 cm. The digitiser represents any location of the cursor with pairs of numbers, which it sends to the PC.

A digitiser offers two primary benefits for graphic input. First, it generates graphic data in two dimensions simultaneously. Secondly, it generates graphic data virtually instantaneously. Best of all, you never get involved in the complicated details of how the graphic data get generated.

Application software is the central part of any graphic system. A digitiser without software is useless, and software is designed specifically for the tasks at hand. The data coming into the software from the digitiser is in numeric form. It is not inherently graphic data, but is a representation of the position of the cursor on the tablet.

The digitiser is a completely independent system component. It doesn't directly drive a display, a plotter, or any peripheral. All it does is supply position information which the software can use in several ways. The point is, the digitiser is com-

Figure 3.9 *Coordinates of a digitising tablet.*

pletely unaware of where its data are going or how the data are being used.

A digitiser consists of three elements, or subsystems: the controller, the tablet, and the cursor. Each has a special function in the digitiser operation.

- The *controller* contains electronic circuits to drive the tablet, to process the cursor signal, and to communicate with the outside world.
- The *tablet* itself contains no active electronic components – just two independent sets of wires, one for the X axis and one for the Y axis, spaced at, usually 1 inch intervals.
- The *cursor* records an object.

How does it work? There are different technologies used in graphic digitisers to generate coordinates, but the most widely used today are *electromagnetic*. An electronic timer begins counting when the wave front starts across an axis. A coil inside the cursor senses the passage of the wave front and stops the timer at that instant. There is a linear relationship between distance and the time of arrival of the wave front at the coil The count is converted to distance by further processing. A microprocessor controls the system's complex internal operations: it performs mathematical operations on the coordinates data, assembles the data into formats, and sends the formats out through the system's communication ports.

Most digitisers have a resolution of 0.001 inch (25 μm) with an estimated accuracy of ±100 μm. Note the difference between these two terms. *Resolution* refers to the smallest increment that a digitiser can detect. It is similar to precision. *Accuracy*, however, is the degree to which it is free from bias. So let's concentrate on accuracy, after all that tells us just how far we can trust recorded coordinates. Considering all the influential 'errors' we'll encounter, 100 μm is an acceptable accuracy limit.

Summary

- Analogue instruments, which cannot correct for tilt or relief displacement, are used primarily for map revision:
 print reflectors:
 sketchmasters (0.5× to 3.0× magnification)
 zoom transfer scopes (<12× magnification)
 slide projectors:
 rear projection (<9× magnification)
 forward projection (<20× magnification)
- Height measurements can be made from shadows and topographic displacement on a large scale vertical photo.
- A perspective grid superimposed on an oblique photograph provides area and length measurements.
- Analytical instruments numerically transform photo coordinate to ground coordinates and are used for map revision, direct mapping and measuring (point location, length, area, slope, azimuth).
- Digital monoplotters require:
 at least three, well-distributed ground control points and a DEM (digital elevation model) to provide elevation data.

• Digital monoplotting procedures consist of:

inner orientation: transforming photo coordinates to measurement system coordinates.

outer orientation: transforming measurement system coordinates to ground coordinates.

data collection: when a point is recorded (x,y) the DEM is queried for Z, and X,Y,Z ground coordinates are computed and stored.

Chapter 4

Stereoscopic Mapping and Measuring

Viewing the stereo pair

Getting comfortable with stereo imagery is a bit trickier than using a single photo. But once you get used to stereo you'll find it easier for interpretation than relying on a single image – in the same way that it's easier to walk with two eyes open than with one. Therefore, before we start using the stereomodels for mapping work, it is best to get used to simply viewing them. We'll begin by examining your photos at their original scale, as a film strip.

Lens stereoscope

To maintain high quality imagery, the best way to interpret your 35 mm stereomodels is with a lens stereoscope over a light table. The *lens stereoscope* is the simplest and least expensive piece of equipment for viewing stereo pairs (Fig. 4.1 *upper*). It consists of two magnifying lenses mounted with separation equal to the average interpupillary distance of the human eye, though most provide for adjustment. It's recommended to use a 4-power stereoscope because a 2-power simply doesn't magnify the detailed information. Better yet, a 7-power stereoscope gives simultaneous field of view, encompassing nearly the entire frame of the 35 mm. An advantage of the lens stereoscope is that unlike high power mirror (Fig. 4.1 *lower*) and zoom stereoscopes, there are no additional reflecting and transmitting components to introduce optical interference.

Since the 35 mm format is not square it is possible to view stereo pairs without cutting the film. To do this, however, the photography must meet these criteria:
- The photos must be taken with 80% forward overlap.
- The camera must be in *longitudinal mode*, that is, with the long (36 mm) axis parallel to the direction of flight.
- The film must be wound in the direction of flight.

The 80% overlap between consecutive frames provides an overlap of 60% between every second frame (frames 1,3,5, etc.) and an eye/photo base of 62 mm (Figs. 4.2 and 4.3).

If, however, your camera was in the *transverse mode* (i.e. film's long axis perpendicular to the direction of flight), or if the film was wound against the direction of flight, then you must cut the film into individual frames, and position them for

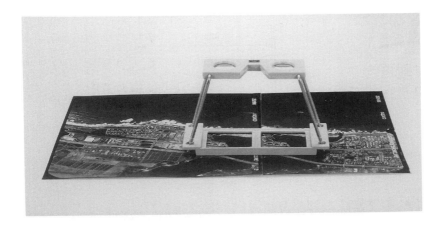

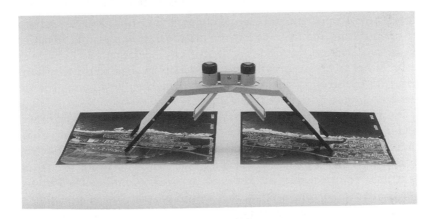

Figure 4.1 *upper: The Zeiss lens stereoscope. lower: The Zeiss mirror stereoscope.*

Figure 4.2 *Interpretation of a 35 mm film under a 7× stereoscope.*

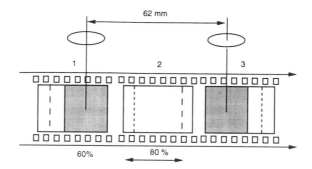

Figure 4.3 *Stereoscopic viewing of uncut 35 mm film in longitudinal mode.*

proper stereoscopic vision. To avoid clipping your film, you can make a copy of the original film, and use it as a stereo mate. Or, if you plan in advance, you can record two identical transverse mode strips by operating two cameras simultaneously. Either technique provides stereo overlap by aligning the first frame on one strip with the second frame on the other strip, then positioning the stereoscope over both film strips at once (Fig. 4.4).

It's worth making a short digression here to balance the advantages of transverse and longitudinal modes. The transverse camera mode is particularly useful for medium and small scale missions, because the 36 mm frame length offers a significant advantage over the 24 mm frame width in the size of the swath covered along each flight line. The frequency of exposures required to obtain 60% forward overlap over the 24 mm picture width is well within the mechanical capability of motor-driven cameras, operating at the interval required for medium and small scale photography (Zsilinszky, 1969/70).

The longitudinal mode, however, increases heighting accuracy because x parallax is increased. By having the 36 mm edge parallel to flying direction, the base:height ratio will be 1.5 times greater than in the transverse mode, thus measuring heights will improve substantially. And – provided the film is wound in the direction of flight with 80% overlap – you can view the exposures stereoscopically without clipping the film.

If aircraft always flew perfectly straight and level, using stereoscopes would be quite simple. A major problem, however, is that an aircraft (especially a light aircraft flying at low altitudes) changes its orientation between exposures. Under these circumstances, to see properly in stereo, you need to orient the photos to reproduce their *relative alignment* at the moment of exposure. This is called *flightlining* or *baselining*, and to do this you must clip your two frames from the film strip.

To flightline your stereo pair place each photo under the stereoscope so that the PP and the CPP defining the flightline all lie along a straight line. If your photography makes it difficult to determine the CPP – the terrain is densely forested, say – here's a little trick that might help flightlining. Simply tape two human hairs across adjacent corners of each mounted slide. If your slides are not mounted, you can

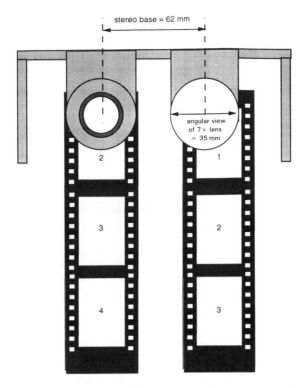

Figure 4.4 *Stereoscopic viewing of two identical films taken with two different cameras in transverse mode.*

make templates to lay over each image. To make a template, photograph a large sheet of white paper on which a 24 cm × 36 cm frame is finely drawn in black (including the intersecting lines that designate the principal point). Then photographically reduce it to fit a 35 mm frame. With the PP identified on each slide, position the stereo pair under the stereoscope and orient it so that the PPs and CPPs all lie along a straight line.

A lens stereoscope can be used with prints as well. Here's a step-by-step process for flightlining prints. Locating the PP is easily accomplished by projecting lines from diagonally opposing corners, then drawing a light cross where they intersect. Then prick the PP with a fine needle. One photo is taped down, and the adjacent photo is moved along the flightline until the PPs and CPPs of the two photos are on a straight line, and corresponding images on each photo are about 6 cm apart (Fig. 4.5). Now place the stereoscope over the photos, parallel to the line of flight. You may need to adjust the stereoscope to your proper interpupillary distance, the width between your pupils. Gross features should overlap, and image shadows should fall away from the observer. If they fail to fall away from you, there is the tendency to see relief in reverse. The area directly under each lens should then appear as a three-dimensional picture.

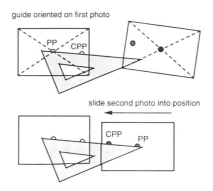

Figure 4.5 *Orientating 35mm enlargements (longitudinal mode) for proper steroscopic viewing.*

A problem when using a lens stereoscope is that enlargements are viewed so closely that it is usually necessary to 'peel' the photo on top – by gently lifting and bending it – so that you can see the detail on the photo underneath. An alternative to doing this is to use a mirror stereoscope.

Mirror stereoscope

Mirror stereoscopes are advantageous when working with enlarged prints, but they are structurally more complicated than lens stereoscopes, and consequently more expensive. They consist of a pair of small eyepiece mirrors and a pair of larger wing mirrors, each of which is oriented 45° with respect to the plane of the photographs (Fig. 4.6). There are many variations on the mirror stereoscope, but all of them offer magnification. For instance, there is the *scanning mirror stereoscope* that allows

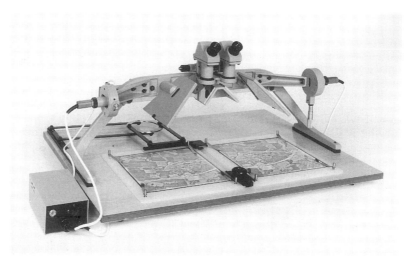

Figure 4.6 *Cartographic Engineering Modular Stereoscope: SB 185.*

the viewer to scan the stereoscopic image in both X and Y directions without moving the instrument or the photographs. This is an advantage when 35 mm negatives are substantially enlarged. There is also the *zoom stereoscope* that provides variable in-focus magnification from 2.5 to 20 power with a single set of eyepieces. One model is available with 360° image-rotation capability.

When using a mirror stereoscope you follow the basic procedures of flightlining. Separate the two photos in the direction of the flightline until the conjugate images are about the same distance apart as are the centres of the large wing mirrors, whilst still maintaining a straight line between principal and conjugate principal points (Fig. 4.5). Then place the stereoscope over the pair of photos and adjust the photo separation to permit you to see a stereoscopic image. Do not alter the photo alignment. If the image is out of alignment, rotate the stereoscope clockwise or counterclockwise until the three-dimensional model is sharp. For detailed operations of a mirror stereoscope refer to the instrument's user manual, Avery (1977) or Paine (1981).

If you wish to work with slides, Zsilinszky (1969/70) offers two simple and economical alternatives. Both methods project a stereo pair so that the images can be viewed with a mirror stereoscope. The techniques use any adjustable lens projector that can be focused on a screen at close range.

Method 1: Two 35 mm slide projectors

Two identical slide projectors, with the same type of lens, are mounted together (side-by-side) to project a stereo pair onto a ground glass from behind (Fig. 4.7). The projectors are mounted under or built into a table with the ground glass flush with the tabletop. The projectors can be positioned to project the photos upward, or you can insert a mirror to reflect the images in the desired direction.

The model is then viewed using a mirror stereoscope without magnification, because the projectors magnify the images. The reduction in the field of view (which results from the use of mirror stereoscope's magnifying lenses) is thus avoided. To be compatible with the mirror stereoscope, the projector lenses are separated by about 27 cm. If only one film strip were recorded, it is necessary to cut the frames from the strip and mount them as slides. Some 35 mm projectors, like the Kodak Carousel series, can be equipped with a lens adapter to accommodate film rolls instead of mounted slides. A convenient method of projection to allow uninterrupted viewing of consecutive stereo pairs, is to run identical uncut film rolls, offset by one frame, in two projectors at the same time.

Method 2: A 70 mm slide projector

Slides for 70 mm projectors (for instance, the Beseler Slide King II) have a format of 54 mm × 54 mm. Fortunately a 35 mm stereo pair with 60% overlap fits this format nicely (Fig. 4.8). In fact, a stereo pair can be oriented in either the longitudinal or transverse mode. Consequently, consecutive frames on a single film roll are used, thus avoiding the expense of reproducing copies needed for the two-projector method.

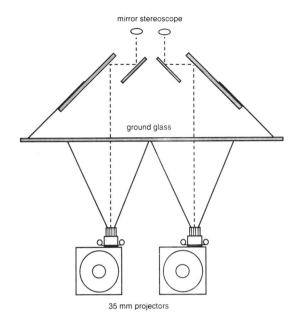

Figure 4.7 *Two 35 mm slide projectors used with a mirror stereoscope (not to scale).*

Unless the 35 mm film feeds into the projector in roll form, it is necessary to cut the roll and insert consecutive frames separately.

The single-projector system is constructed in a manner similar to the pair of 35 mm projectors. The mirror stereoscope is placed above a sheet of ground glass placed so that images are separated by 27 cm.

The ten commandments of stereoscopic study

Beginners who have difficulty mastering a stereoscope should be aware of the following factors that may affect stereo vision. The recommendations of Avery (1977) are a set of working rules well worth remembering.

1. A person's eyes may be of unequal strength. If you normally wear eyeglasses for reading, you should wear them when using a stereoscope.
2. Poor illumination, misaligned photos, or uncomfortable viewing positions may result in eye fatigue.
3. Illness or severe emotional stress may create sensations of dizziness in using a stereoscope.
4. An error in reversing photos will often cause pseudoscoptic view, i.e. the topography will appear reversed. A similar image may be created if shadows fall away rather than towards the viewer.
5. Objects that change position between exposures, such as a moving automobile, cannot be viewed stereoscopically. Consequently, slow-moving objects, such as cows

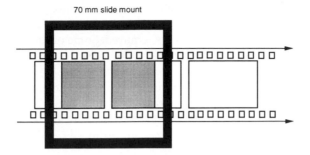

Figure 4.8 *Placement of two 35 mm frames within 70 mm slide mount.*

walking across a pasture, sometimes appear to be floating over the terrain.
6. In areas of steep terrain, scale differences of adjacent photographs may make it difficult to obtain three-dimensional vision.
7. Dark shadows or clouds may prohibit stereoscopic study by obliterating detail.
8. Individuals who have continued difficulties in using the stereoscope should not attempt to master the art of stereoscopic vision with unaided eyes.
9. At the beginning, do not attempt to use the stereoscope for more than 30 minutes out of any given 1 hour period.
10. Keep the stereoscope lenses clean, properly focused, and separated to the correct interpupillary distance. For most individuals, interpupillary distance is about 62–64 mm.

Methods of mapping and measuring

We'll approach the subject of stereoscopic mapping and measuring starting with the simplest methods. Though crude, these techniques often provide adequate accuracy for many natural resource studies. We'll begin with the simplest approaches to map revision and distance and area measurements, followed by somewhat more complicated methods for making height measurements with traditional analogue instruments. The conclusion of this chapter will deal with PC-based analytical instruments for mapping and measuring with surgical precision.

Map revision

Now that you are comfortable working with stereo pairs we can begin our first task, recording your interpretation. When working with enlarged prints, you can simply annotate directly on the hard copy. An annotated print is then transferred to a basemap using a reflecting device such as a sketchmaster.

There are stereoscopic transfer instruments – a lot of them. Most are designed for photogrammetrists working with traditional large format photography. That doesn't exclude them from small format work, it just requires a higher level of skill. Moreover, many are beyond the range of the small format budget.

Nevertheless, it is a good idea to become familiar with what a few of the simpler stereoscopic transfer instruments can do. Two basic advantages of such instruments are that many can remove tilt and topographic displacement, and prior delineation of detail with a stereoscope is not always required. Some of the more sophisticated instruments can even remove lens distortion. For instance, the stereo zoom transfer scope has the same capabilities as the zoom transfer scope (described when we discussed single prints); however, it superimposes a three-dimensional image on the map. You then make your revisions directly on the basemap. For a review of other stereoscopic instruments refer to Paine (1981). There are also stereoscopic transfer instruments for projecting slides, but they are primarily designed for the professional map makers and are quite expensive. Therefore we'll focus on stereo projection systems that are more suited to natural-resource specialists.

Small format stereo projection systems need a surface for marking interpretation results. To accomplish this, Zsilinszky (1969/70) outlines a practical solution. A transparent sheet serves as an overlay for the projected stereoscopic model. On this overlay, mark at least five registration points, well distributed across the model and representing clearly identifiable land forms, such as road intersections. After marking references, the thematic information is delineated and annotated. Recording the reference marks and thematic information in different styles or colours makes the transparency more legible. The data on the finished overlay is then used like a print and transferred to the basemap with a reflecting optical device (e.g. a sketchmaster).

A more direct method is to place a transparent basemap – or if the projection light is strong enough, a paper basemap – on the ground glass to which the 35 mm image is projected. You will need to adjust the projector lenses to match the focus of the photography with the map scale. By this method, you can delineate features directly on to the map. To use this method of projected stereoscopic transfer, you should use original photo scale that conveniently matches the map scale. That means careful flight planning prior to map work!

Measurement

Projected slides

Meyer and Grumstrup's (1978) technique, designed for single slide projection, can also be used for making distance and area measurements from stereoscopic projections. The advantage with stereoscopic projection is that you are no longer restricted to flat terrain such as wetlands.

To make measurements we need to determine an average scale for the projected model. At least two ground points a known distance apart must be located on the projected model. If the projected model is not to be brought to a specific scale, it should be stabilised at an acceptable size on the screen. The two ground points of known separation are measured and used to compute the average scale of the screen image. If, for example, we know the distance between two points is 1000 m, and the distance between the corresponding images on the screen is 0.5 m, then we know

the average scale of the projected image scale is 1:2000. Once the scale of the screen is known, area can be calculated by placing a dot grid over the screen, or from a tracing made from the screen image.

Although the length and area measurements are planimetric, like a map, keep in mind that a map has one scale and your projected image has many because of relief displacement. So, if the control points are at a low elevation, say two bridge-crossings, and the area you wish to measure is higher, like a mountain top, then the scale factor is going to be smaller than it should be. For this reason, the system is more suited for terrain with little elevation difference, such as wetlands. And scale variation within the stereoscopic image will be less if you work with small rather than large (original) photo scale.

Enlarged prints

If you recall, displacement can be used to compute the height of objects. Now we'll tell you how to measure height off prints with a simple engineer's scale. But first we must make four assumptions about your vertical stereo pair.

- Parallax is great enough to measure with a simple scale-rule.
- Both the top and base of the object are clearly visible.
- The principal points will be accepted as nadirs.
- We know the flying height of the camera, relative to the base of the object.

When all of these conditions are met, object heights may be determined using:

$$\text{height of object} = H \times (d/r) \qquad (4.1)$$

where H is the flying height above the base of the object, d is the length of the displaced image and r is the radial distance from the nadir to the top of the displaced image (Avery, 1977). Measurements of d and r must be in the same units, and H is expressed in the units desired for the height of the object. But keep in mind, this formula only applies to the four conditions above, which isn't the case very often.

Usually you'll have slightly tilted photos, your flying height will be relative to datum (e.g. mean sea level) not the base of the object, and displacement measurements of < 0.5 mm will require an instrument more precise than an engineer's scale. Under these conditions you'll use the following formula:

$$\text{height of object} = (H) \times ((dP)/(P+dP)) \qquad (4.2)$$

where H is the flying height of the camera, P is the absolute parallax at the base of the measured object and dP is the differential parallax. To measure parallax you'll use a *stereometer*.

Stereometry

A stereometer is a device for measuring differential parallax, and there are two basic types, the parallax bar and the parallax wedge. The parallax bar is often preferred to the parallax wedge because it is easier to manipulate. Typically, a parallax bar, pre-

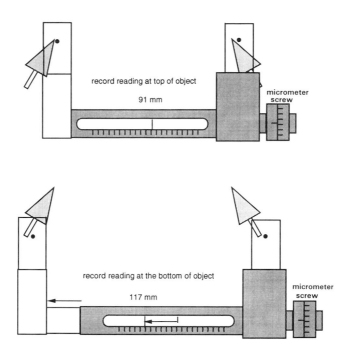

Figure 4.9 *Measuring differential parallax with a parallax bar.*

cise to within 0.01 mm, consists of a metal bar with a graduated metric scale and glass plates at each end. One glass plate is etched with a reference dot and remains fixed; the corresponding reference mark on the other plate is moved laterally with a micrometer screw. To operate the bar, first orient the stereo pair under the stereoscope. Both photos should be securely fastened to the tabletop to prevent slippage during measurement. The parallax bar is placed over the stereoscopic image parallel to the direction of flight (Fig. 4.9). Position the fixed dot beside one of the image tops (say a tree) and adjust the micrometer screw so that the movable dot is beside the image top on the other photo (do not use the stereoscope). Now read the recorded increment. In this case the reading is 91 mm. Then look through the stereoscope and the two tree images fuse and the dots appear as one, floating at the tree top. Turn the micrometer screw and the fused dot appears to rise and fall. Lower the dot until it touches the ground at the base of the object, then record the second reading (117 mm in Fig 4.9). The difference between the two readings is the differential parallax (d*P*), which for Fig. 4.9 is 26 mm. For more detailed use of a parallax bar consult an instrument manual or Avery (1977) and Paine (1981).

The *parallax wedge* is a piece of glass or transparent film consisting to two rows of dots or graduated lines beginning about 6 cm apart at the bottom and converging to about 4 cm. These gradations function like a series of parallax bars and are often in millimetre increments. To read the parallax difference of an object, the wedge is

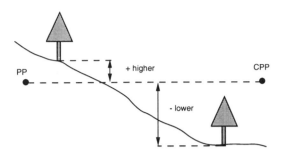

Figure 4.10 *Vertical stereo pair used in computing object height.*

viewed through the stereoscope and moved about until the sloping line appears to intersect the ground at the object's base. The first reading is made. Then the wedge is moved until the sloping line cuts across the object's top, and a second reading is recorded. The difference between measurements determines differential parallax. Avery (1977) and Paine (1981) detail the use of a parallax wedge, and the instructions generally accompany the simple tool.

Whether one uses a parallax bar or parallax wedge, height determination still follows the rudimentary formula previously covered:

$$\text{Object height} = \frac{(\text{flying height}) \times (\text{differential parallax})}{\text{absolute parallax} + \text{differential parallax}} \tag{4.3}$$

If we assume the stereo pair illustrated in Fig 4.10 is *vertical, and the elevation of the aircraft over the PP in each photo did not change*, then computing the height of the tree is straightforward. Why? Because we know that absolute parallax is equal to the distance between the PP and CPP, and this distance can be measured with the parallax bar as well. All we need to know is the flying height of the camera relative to the object, which we can determine if we know the photo scale and focal length of the camera.

These conditions are rarely met, however, especially in mountainous terrain. One of the greatest obstacles is determining the absolute parallax, the reason being this: we cannot assume the flying height of the camera over the PP will be the same because of differences in terrain elevation. So, we compute an *average* absolute parallax, which is based upon the difference in elevation between the base of the object and the average of the two PPs (plus if higher and minus if lower). As a general rule, we do not have to compute and average absolute parallax *if difference in elevation between the base of the object and the average elevation of the two PPs is less than 5% of the flying height above the base of the object* (Paine, 1981).

Analytical measurement systems

Like it or not, we all live and work in a computer world. Less than 20 years ago many photogrammetrists carried out calculations by hand or with the aid of a slide

rule and log tables. In the late 1960s digital computers began to solve our problems, but patience, perseverance, and extensive training were required to obtain results. During the 1970s and 1980s smaller, yet powerful mini- and microcomputers were introduced allowing easy access and faster programming techniques. Still, the inexperienced were put off by the computer's lack of user-friendliness. In the past few years software vendors and computer hardware manufacturers have improved this considerably. As in the automobile industry, trends come and go, and trying to predict next year's model is a risky business. But the interest in standardisation has kept the DOS operating system in the lead when it comes to integrating photogrammetry with desktop mapmaking through simple computer aided drafting (CAD) systems and sophisticated geographic information systems (GIS).

Simple digital instruments

Equipment developed for small format photo measurements is innovative and varies in terms of capabilities, cost, speed of operation and ease of use (Spencer, 1974). Most rely on the basic principal of *digitising*: using numerical characters to express the coordinates of imagery data. The principle aim of the digitising device is to input quickly and accurately the coordinates of points and bounding lines seen on the photographs.

The simplest systems for measuring height consist of a stereoscope and a parallax bar with encoder for semiautomated recording of measurements (Spencer and Hall, 1988). These affordable, simple systems are particularly useful to natural-resource managers and may be adequate to complete the small format aerial photography system.

Others, however, may find they need a more complete measurement system: one that offers better built-in facilities for parallax measurement as well as automated recording and data processing for mapping. These requirements lead us to various alternatives. For example, if you have access to the popular Bausch and Lomb Zoom Transfer Scope you might consider outfitting it with a vertical measurement module (ZTS-VM). This easy-to-assemble retrofit kit enables you to link precise measurements with a PC.

The Zeiss Stereocord is a popular instrument for small format photogrammetry (e.g. Roberts and Griswold, 1986). Most agencies and firms in Canada using controlled-scale photography initially adopted the Zeiss Stereocord with a digitising unit and PC (Befort, 1988). Manuals prepared by specific users such as the British Columbia Ministry of Forest and Lands describe its use for forest measurements.

The Wild AVIOPRET APT2 is another portable desktop device that handles all format sizes. Its zoom optics and interchangeable wide field eyepieces provide magnification up to 31×. Whatever the magnification, the image remains sharp and special light source keep it colour-correct right out to the edge. Modular accessories, such as video system, make it a flexible system to build on.

Although all of these instruments are useful and relatively precise, they have a common weakness: they cannot *automatically* correct the problems associated with *y* parallax. To do that, we need to use some type of *plotter*.

Stereoscopic plotting instruments

Stereoplotters (often simply called *plotters*) are instruments that provide solutions for object point positions from corresponding image positions on the stereomodel. Basically, they can be classified as either analogue or analytical. Analogue instruments rely on a mechanical gear system and work on the principle of measuring by proportional similarity, as distinguished from measuring image coordinates and numerical analysis (as in digital computing). Analogue plotters can, however, interface with a digital computer. For instance, the Kern PC-PRO System connects directly to an analogue plotter for digital mapping. Its hardware, software and documentation costs around $5000 US. Although analogue plotters are used for small format work (e.g. Rhody, 1977), they are not recommended for the novice since they require months of specialised training before the user can become a confident operator.

Analytical plotters, however, measure and use mathematical analysis to solve relationships between stereo photo image coordinates (which are in two dimensions) with ground coordinates (which are in three dimensions). So they function on a different principal: they digitise, then resolve problems by analysis. Operating some analytical plotters is similar to operating analogue plotters, that is, they require special skill. There are, however, a few analytical instruments that do not require extensive training.

Comparing analogue to analytical plotters is somewhat like comparing analogue and digital watches. The analytical instruments can be mechanically simpler, more compact and more precise than their counterparts that measure by gears, rods and mechanical movement. In the same way that a digital stopwatch can measure time in milliseconds, the sophisticated analytical plotters are generally more accurate than analogue plotters, measuring the point location of photo coordinates within a few micrometres.

Most importantly, analytical instruments can handle a greater variety of photography and present more information than traditional analogue devices. Essentially an analytical plotter forms neither an optical nor a mechanical stereomodel on which to measure or trace. Rather, a *mathematical model* is developed. Because they have fewer optical and mechanical limitations, analytical plotters are capable of handling vertical, tilted, low oblique, convergent, high oblique, and panoramic photos. In addition, many can accommodate any focal length lens and can correct for any combination of systematic errors caused by lens distortion, film shrinkage, atmospheric refraction, and Earth curvature. Their major advantages, however, are that they provide straightforward, semiautomated procedures for orientation and recording digital data. They also allow the operator to read, record, and store ground or other coordinates and to recall data at any stage with the PC.

How does an analytical plotter work? Basically it passes encoded coordinate information from the photographs to the computer where it's converted into digital form. In essence, the analytical plotter performs three basic functions:
- it *orients* the photographs,
- it *computes* ground coordinates from photo-measurements,
- it *displays* collected information graphically or digitally.

Let's take a closer look at these functions from the operator's point of view. First, the photos are placed on the viewing stage under fixed, magnified optics. Camera focal length and calibration characteristics (such as the photos' format size) are fed into the computer. Now an *interior orientation* is performed: that is, photo coordinates of the frame edges (or fiducials) are registered (digitised), whereupon the computer *calculates* the principal point locations. This first orientation mathematically describes photo coordinates (fiducials or frames edge) in terms of the instrument's measurement coordinate system, and tells the computer where the photos are located on the viewing stage.

Then the operator initiates a *relative orientation* to determine the position and attitude of one photograph with respect to the other. This is accomplished by measuring the y parallax of six or more well distributed, common points, called *orientation points* or *pass points*. The computer then calculates the elements of relative orientation, to remove parallax and mathematically 'lock' the photographs together.

Although relative orientation creates a three-dimensional model of the terrain, the scale and level of the model remain unknown. Therefore, an *absolute orientation* uses statistics to fit photo measurements to known ground coordinates, called *control points*. For this procedure, several model coordinates are measured and their corresponding control points (coordinates either surveyed on site or registered from a map) are fed into the computer. The computer then fits the model to the ground.

Once oriented, measurements may be taken from the model or a map may be compiled. One of the attractive features of these instruments is that they rapidly solve analytical equations for each model point. That is, as the viewer repositions the model under the measuring mark, y parallax is removed in real time, thus the viewer always sees any portion of the model in stereo. Moreover, measurements such as point location, height, length, and even the area of irregular shapes, are displayed immediately on the computer screen.

Functionally, the instrument creates maps and calculates measurements from coordinate information captured directly from the photographs (based on control point datum and orientation information). It operates this way. The model is moved on a carriage, and the relative motion of one photograph (to maintain a stereo image) is managed through an electronic system. Actually it's the computer's software that manages the electronics of the encoder. That is, the analytical solutions remove y parallax in real time and control the oriented stereomodel.

When you look through the optics, this is what you see: a small dot of light appears to float above the terrain. The dot can be lowered to the ground by turning a control knob. When the dot is at the point to be counted, say the top of a tree, a record button is pressed and the coordinates ($X, Y,$ and Z) of the point are sent to the computer and stored. The tree top has been digitised.

The coordinates of any boundary or feature in the stereo model can be obtained by simply tracing it with the floating dot. Or, to measure the distance between two points – say the top and bottom of a tree for a height, or the beginning and end of a road for a length – each point is recorded. The stored coordinate data file can then be analysed, plotted or digitally transferred to another computer system for further analysis (e.g. a CAD or GIS system).

Figure 4.11 *Adam Technology MPS-2.*

Although most analytical plotters follow these basic procedures, they differ in complexity and ease of use. The manufacturer's manual will explain how each instrument is actually operated. In the end, you'll be the one to determine 'user-friendliness'.

Software for many PC-based analytical plotters is becoming more 'user-friendly' – which finally opens up the world of photogrammetry to those with limited training and knowledge. The hardware is also becoming more affordable though still relatively expensive compared to the mirror stereoscope and parallax bar. Currently there are only a few PC-based analytical plotters that fit a limited budget. Many instruments are in the price range of $100 000 US or more; the more affordable models cost $30 000 to $40 000 US.

For example, the Adam Technology MPS-2 is a desk-top analytical plotter designed exclusively for small-format negatives or slides (Fig. 4.11). It offers superb 35× zoom optics and is quite precise: 4 μm at the scale of the photo. It cannot, however, handle large format photographs unless the original image is reduced to a diapositive. The system offers the facility to observe and restore reduced SPOT images in stereo with no apparent loss of accuracy (8/10 m in elevation and 15/20 m in planimetry). One very attractive feature of the MPS-2 is that it does not require calibrated camera data; the software provides a self-calibration routine. Details of the MPS-2 are given by Elfick (1986) and Weir (1988). The MPS-2 has demonstrated its usefulness in geological studies (e.g. Sarossy, n.d.; Sarossy and Jones, n.d.) and a variety of urban mapping projects (Jones and Schoch, n.d.; Schoch and Jones, n.d.). The MPS-2 costs $35 000 US, and more than 200 systems have been sold worldwide. Based upon a questionnaire sent to 40 MPS-2 users, Uren and Thomas (1992) evaluated the feasibility of the MPS-2 for those with limited background in photogrammetry and offer a worthwhile appraisal.

Another portable plotter designed exclusively for small format work is the SFS-3 Comparator from Ross Instruments Ltd (Fig. 4.12). This highly accurate (2 μm resolution) analytical plotter offers 8× magnification, with a digitising interface designed for prints or transparencies of up to 100 mm format. The system, com-

Figure 4.12 *Ross SFS-3 Stereocomparator.*

Figure 4.13 *Rolleimetric MR-2.*

plete with calibration kit and carrying case (air portable) sells for about $28 000 US. The Ross SFS-3 has demonstrated its value in a variety of innovative small format projects, such as fixed-based aerial photography for forest inventory (Spencer and Hall, 1988) and microlight surveys for map revision (Graham, 1988*a*). Details of the SFS-3 are given by Ross (1986).

An innovative system for capturing three-dimensional measurements with a digitising tablet is the RolleiMetric MR2 (Fig. 4.13). The system operates as follows. A sequence of oblique photographs is taken with one of the small format RolleiMetric cameras, ensuring that the object area is completely captured in at least three or

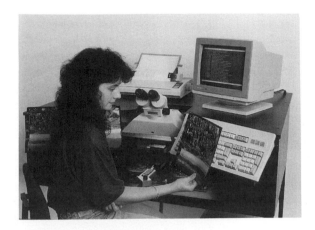

Figure 4.14 *Carto Instruments AP-190 Analytical Plotter.*

more exposures from different viewpoints. Standard photographic enlargements are made and placed on a digitiser. Seven or more points on the object area common to three or more photographs are digitised. Two of these points must define the scale distance. Three-dimensional coordinates are calculated by identifying the same points in three or more photographs. RolleiMetric offers three MR2 systems: the entry level 'Basic Version' $4700 US, which includes a calibrated 35 mm camera fitted with a 40 mm lens (Rollei 35 Metric); the 'Standard Version' $10 000 US which allows multiple camera–lens combinations (15 mm–85 mm)with a 35 mm camera (Rolleiflex 3003) for more complex applications; and the 'Plus Version' $15 500 US, which includes a bundle adjustment module with the 66 format survey camera (Rolleiflex 6006). All RolleiMetric cameras feature calibrated lenses and a built-in reseau plate which imprints a grid of very accurately measured crosses on to the film. Translators between RolleiMetric MR2 and popular CAD formats are available.

For those desiring an instrument that handles all format sizes – using original imagery or enlargements – there are several on the market. One such system is the Carto AP190 stereo digitiser (Fig. 4.14), which can also function as a monoplotter. The system follows the traditional photogrammetric orientation procedures (interior, relative and absolute) and has a measuring accuracy of around 15 µm. Data can be exported in a number of GIS formats. It has proved useful for a variety of natural resource tasks using both small and large format photography, e.g. Warner and Carson (1989), Warner (1989*a*). Warner's (1988) evaluation of the system for forestry application outlines of AP190's functions; however, numerous modifications have been made to the AP190 since the report. The AP190 sells for about $40 000 US.

Carto Instruments also offers the MDSD, which is a standard digitising tablet driven by the AP190 software. It serves as both a mono digitiser and a stereo digitiser (hence the name), and has proved suitable for a variety of small format projects: see

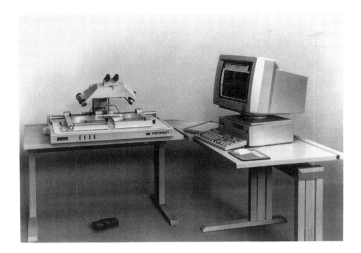

Figure 4.15 *Zeiss VISOPRET*

for example Warner and Carson (1992); Warner et al. (1993); Warner (1994*b*). Designed primarily for natural-resource specialists with no photogrammetric background, the MDSD outputs data in a variety of GIS formats. The system sells for about $40 000 US, excluding the digitising tablet, which generally has a resolution of 25 μm and an accuracy of about 100 μm.

Zeiss manufacture the VISOPRET (Fig. 4.15) which is especially suitable for simpler tasks. For viewing stereo images with a mirror stereoscope and zoom optics, this instrument is an effective solution. Both the VISOPRET 10 DIG and 20 DIG are equipped with measuring systems for digitising image coordinates and parallaxes. The software packages AutoCAD, MicroStation PC and VISOMAP are available for digital mapping and data acquisition for GIS/LIS. The V-CAP data management and orientation software is based on the long-standing experience of Zeiss in analytical plotters and modern PC software. A comfortable user environment is available in the form of Microsoft Windows. Due to the self-explanatory user guidance, help functions and programmable input keys, even unpracticed operators can use the system efficiently after a short training period. The VISOPRET costs around $50 000 US.

Another analytical system that handles all formats is the APY. The APY is an innovative instrument with binocular superimposition of an existing map or satellite imagery. Special attention is given to topographic and thematic data compilation such as densification of control points by bundle block adjustment, orientation and measurements of two-dimensional photos, maps, and stereomodels, and data exchange with GIS systems. Photos of any focal length, and size up to 300 × 300 mm, can be used, including prints from a CCD. Of particular interest to small format users, the APY does not require calibrated camera data. Nor does it require the operator to perform interior or relative orientations. Absolute orientation is performed independently for each photo. The APY sells for $30 000 US.

For additional information on any of these instruments we recommend that you contact the manufacturer directly. You can find their addresses in cartographic, remote sensing and photogrammetric journals such as *The Photogrammetric Record*, *Photogrammetric Engineering and Remote Sensing*, and the *ITC Journal* (see Appendix 6).

Summary

- Lens stereoscopes are the simplest and least expensive instruments for viewing stereo pairs. Use 4 to 7 magnification.
- 35 mm longitudinal mode:
 - 36 mm frame is parallel with direction of flight
 - provides large x parallax, base:height ratio and height accuracy
 - can view stereoscopic, unclipped film if film is wound in direction of flight with 80% overlap
- 35 mm transverse mode:
 - 24 mm frame edge is parallel with flight
 - must clip film to view stereo mate
- Mirror stereoscopes:
 - preferred for enlargements
 - can view slides with two side-by-side 35 mm projectors
 - can view two 35 mm slides in 70 mm projector
- Stereoscopic transfer instruments are suitable for map revision work, provided you have a basemap.
- Projected stereoscopic slides can be used for making crude planimetric measurements.
- Two inexpensive stereometers for measuring height off a stereo model are the parallax wedge and parallax bar.
- Analogue stereoplotters are essentially mechanical and are based upon proportional measurements. They are not suited for oblique photography and require extensive training to operate.
- Analytical plotters pass encoded coordinate information from the stereomodel to a computer to solve measurement problems with a mathematical model. Advantages include:
 - automatic removal of y parallax
 - handle a variety of photography, including obliques
 - correct systematic errors
 - can enter photo data directly into GIS

Chapter 5

Practical Considerations

Up to now we've discussed the direct application of your small format aerial photographs for mapping and measuring, including mono and stereo, vertical and oblique, slides and prints. At this point your head might be swimming with ideas; and rightly so, because researchers and natural-resource managers have been using small format aerial photographs for a variety of tasks for the past few decades. But to keep things in perspective, you have to approach small format mapping with healthy scepticism. Failure to recognise the limitations of the small format photogrammetry will lead to frustration. To help you balance the pros and cons of small format photogrammetry, we've outlined a few practical considerations. To begin with, we'll summarise the limitations of the small camera. Then we'll discuss the balance between accuracy and costs. Finally, we'll conclude with a few key issues that should be addressed before you consider purchasing any equipment. At the end of the chapter you should have a basic understanding of the practical considerations associated with using your small format photography for photogrammetric purposes.

Limitations of small cameras

To accurately map and measure from small format aerial photographs one should appreciate their two major limitations: geometric instability and film size.

Geometric instability

A major problem with small cameras is their lack of geometric stability. Your *standard* (i.e. uncalibrated) camera is manufactured for pictorial quality, not for photogrammetric quality. Conventional aerial survey cameras have near-perfect lenses, calibrated focal lengths and principal points, and devices that correct for image motion and lack of film flatness – all of which assure precise photo measurements. Although off-the-shelf cameras do not have these features, do not lose heart. A small standard camera can still provide reliable measurements, with reasonable precision, for many natural resource applications.

Imperfect lens system

Compared to large format aerial cameras, your small camera lenses are far from perfect. The reasons are many. For one thing, the amount of lens distortion in

64

small cameras varies considerably from one camera to another. Mapping cameras have nearly perfect perspective image, capable of being used to determine the position of an object with accuracies of approximately 1/10 000 (0.1‰) of the flight altitude. This means that photography taken 1000 m above the terrain can be used to measure the correct position of an object on the ground to within 10 cm. A good aerial survey camera will limit radial lens distortion to around 10 µm (1–2 µm for the newest lenses). Lens distortion for standard cameras is 100–1000 µm.

Another consideration is that a small camera lens consists of many elements, and sometimes these elements are not glass but plastic. These elements can have either a converging or diverging effect on the light rays. Converging (convex) elements produce a poor image on their own, and lens manufacturers compensate for this by including weaker diverging (concave) elements. These extra elements improve image quality, but increase the cost of the lens. However, too many elements can reduce the lens performance, because they absorb some of the incoming light.

Lenses usually have a transparent coating, or *blooming*, that aids the passage of light. It also helps reduce *flare* (the result of reflected light being scattered in the lens) and improves contrast. But this coating might introduce distortion, albeit limited. Fortunately, the quality of much modern glass makes blooming less necessary.

Keep in mind that there are two factors which control lens quality and image sharpness. These are the ability of the lens to show fine detail and the power to produce good image contrast. A lens must work well in both these areas if it is to produce an acceptably sharp image on the film. Some cheaper lenses produce uneven sharpness. This effect is more noticeable when you use a long focal length lens rather than a standard lens.

By strict definition of the term, a *standard lens* for a 35 mm format has a focal length in excess of the diagonal of the 35 mm film (Fig. 5.1). This measurement is 50 mm for SLR (single lens reflex) cameras. Standard lenses are relatively inexpensive and give good image quality, and their large maximum apertures are useful in low light. But a drawback is the limited angle of view, which is typically 38°.

Why is this angle of view a drawback? For one thing it limits your ground coverage, compared to a wide or super-wide angle lens. Does that mean you are better off with a wide angle lens? Not necessarily. Generally speaking, the wider angle lenses, like 28 mm and 18 mm, have more radial lens distortion than a standard lens; therefore, short focal length lenses introduce more geometric error, especially at the outer edge of the lens.

When you look at your SLR camera lenses you might get a little confused about focal length, because their apparent lengths might appear very similar. For instance, if you examine an 18 mm lens and a 105 mm lens, the difference between focal lengths might not appear to be 87 mm. In reality, wide angle SLR lenses have retrofocus construction (Fig. 5.2, top). Front and converging rear elements give a lens–film distance greater than focal length. This accommodates the SLR's mirror, shutter, and meter cells. The design of a telephoto lens, say an 85 mm or a 105 mm, allows for a short lens barrel (Fig. 5.2, bottom). The front elements of the lens make the incoming light rays converge. The rear elements make them diverge, bringing the image to a sharp focus.

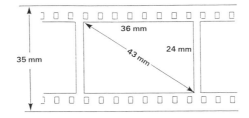

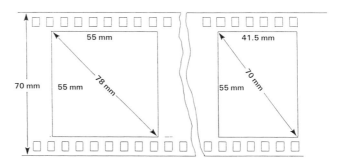

Figure 5.1 *A camera's standard lens has a focal length approximately equal to the diagonal of the film format.*

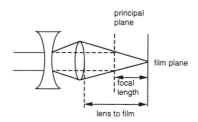

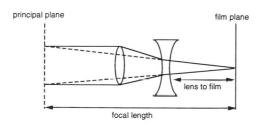

Figure 5.2 *Construction of a wide-angle retrofocus lens (top) and telephoto lens (bottom).*

Unknown geometry: focal length and principal point

A rudimentary limitation with a *standard camera* is that you do not know the precise focal length. The stated focal length of your lens system is a mere estimation by the manufacturer. Keep in mind that the focal length of the lens is fixed at infinity. Therefore, although the length of the lens appears to change when focusing, focal length is permanently established when it is manufactured. When working with precision photogrammetric instruments, the difference between an estimated focal length of 35 mm and 35.41 mm can be critical. Depending on the original photo scale, your ground measurements could be off by a few metres or tens of metres. Of course, a *variable focal length lens*, like a 35–105 mm zoom, is out of the question for photogrammetric purposes.

Not only do we not know the *true* focal length, the exact position of the principal point is also unknown for a standard camera. Since photo measurements are based upon central projection, it is imperative to know the principal point's precise location.

The camera's focal length and principal point are determined by camera calibration. Now you might be asking, 'Do I need to calibrate my standard camera? And if so, how do I do it?' The answers to these questions depend on how you'll use your photographs. If you're going to simply transfer the photo image on to a map, or make height measurements with simple analogue equipment, then camera calibration is not necessary. But if you want to make reasonably accurate maps and measurement, the answer is *probably* yes. We say 'probably' because some photogrammetric instruments calibrate your camera characteristics (focal length and principal point) based upon the photography you supply. However, if you plan to use a photogrammetric system that requires calibrated camera data, then you must provide it. You have two options. You can send your standard camera to a commercial calibration laboratory or a university that provides this service. For instance, University College London, Department of Photogrammetry and Surveying, Gower Street, London WC1E 6BT, UK, specialises in calibrating small cameras. Alternatively, you can purchase a small calibrated camera, such as the Rolliemetric 35 or 70 mm. Most of these calibrated cameras are designed for terrestrial photogrammetry, but they are suitable for aerial photography. These small metric cameras are expensive compared to standard cameras, but they assure accurate measurements. The reason these metric cameras are expensive is that many are fitted with reseau plates, and some are equipped with a device to ensure film flatness.

Film flatness

Experience over the years has shown that one of the weakest links in the overall photogrammetric process is the possible lack of film flatness at the moment of exposure. But the small format camera, properly designed and constructed, should be capable of stable geometry for photogrammetric purposes. This is, because, generally speaking, when you consider the factors of resolution, measurability and detectability, the properties of film are more dominant than those of the camera.

To some extent the problem of film flatness is related to the rigidity of the film material and the size of the format. And this rigidity, due to the small frame size, gives an advantage to small cameras.

Why should this be? The thickness of the film is the same whether it's in a large, medium or small format camera, but the surface area of film differs due to frame size. Consequently, the film is more rigid in a 35 mm or 70 mm than in a traditional 23 cm × 23 cm aerial survey camera. Burnside (1985) states that it is likely that some small format cameras have produced results better than anticipated simply because of this favourable effect.

Apparent image motion

Even with the shortest possible exposure time, of the order of 0.001 or 0.002 seconds, there is always some image motion due to forward velocity of the aircraft, and this is detrimental to image quality. That is why commercial aerial survey cameras have devices to mitigate forward motion. *Forward-motion compensation* is critical when more than 30 µm of translated image motion is evident on the photograph, which causes less-than-sharp images.

The relatively simple camera mounts used in small format surveys do not provide forward motion compensation. Is this a problem? Not necessarily, because, generally speaking, the speed of aircraft used for a small format surveys is less than the speed of aircraft used for conventional aerial surveys. Thus, we can solve the image motion problem simply by reducing air speed.

But how slow should one fly? It depends on your camera's focal length and flying height. And it is quite straightforward to compute:

$$AIM = \frac{fV}{H_g} \tag{5.1}$$

where f is the focal length, V is the ground speed, and H_g is the height of aircraft above ground. The degree of image blur b for a given exposure time t is:

$$b = \frac{f \times V \times t}{H_g} \tag{5.2}$$

Take, for example, an aircraft flying at 100 knots, which is 52 m/s. Assume it is flying at about 350 m, because the focal length is 35 mm and we want a photo scale of 1:10 000. The shutter speed is set at 1/500s. The amount of image blur is:

$$b = \frac{(35\text{mm})\ (52\text{ m/s} \times 1/500\text{s})}{350\text{m}} = 0.010\text{mm or }10\mu\text{m}$$

The degree of image blur is acceptable. But if we were to fly at 104 m/s (200 knots), at 200 m above the ground, with a 150 mm lens, the amount of image blur would be unacceptable for photogrammetric purposes:

229 mm

229 mm

36 mm

24 mm

55 mm

56 mm

41.5 mm

55 mm

Figure 5.3 *Comparison of different film formats.*

$$b = \frac{(150\,\text{mm})\ (104\ \text{m/s} \times 1/500\text{s})}{200\ \text{m}} = 0.156\,\text{mm or } 156\mu\text{m}$$

Small format

Another major handicap with small format aerial surveys is their film size. Compared to conventional 23 cm × 23 cm aerial survey cameras at the same photo scale, 35 mm and 70 mm cameras cover little terrain (Fig. 5.3). This becomes critical when one tries to capture stereoscopic imagery where only 60% of an image can be used stereoscopically. The small film size is also a problem because often we need to enlarge the original imagery, and this introduces photogrammetric problems.

Limited ground coverage

Let's first consider the problems associated with limited ground coverage. To cover the same terrain as a 23 cm × 23 cm aerial photo, at the same photo scale, we need to take 61 exposures with a 35 mm camera. The number of exposures becomes worrisome for two reasons: the aerial survey itself and later mapping and measuring. Regarding the aerial survey, keep in mind that if there is much yaw between successive photos, the limited usable area will be reduced, due to κ (kappa) rotation. Now we can reduce the loss of ground coverage by simply flying higher. Of course this will decrease our photo scale. Using a longer focal length lens won't help matters because, obviously, we'll be back to the problem of limited ground coverage and rotation.

Regarding mapping and measuring, you have to orient dozens of 35 mm stereo pairs to equal the ground coverage of a single large format stereomodel, at the same photo scale. Considering it takes anywhere from 15 minutes to an hour simply to

Table 5.1 *Image loss caused by enlarging 35 mm negatives to standard print sizes. Information supplied by Eastman Kodak Company (Needham and Smith, 1984)*

Print size (cm)	(inches)	Enlargement factor	Effective film format (mm)	Image area lost in printing (%)
9×13	3.5×5	3.84	23.151×33.073	13.82
10×15	4×6	4.40	23.106×34.636	9.92
13×18	5×7	5.44	23.379×32.684	13.99
20×25.5	8×10	8.64	23.520×29.399	22.17
20×30.5	8×12	8.80	23.092×34.6346	9.97

orient a stereomodel, the task of cobbling together numerous stereomodels for a large aerial survey is quite time consuming.

Enlarging

Capturing accurate measurements generally requires working with the original small format negatives or diapositives, because commercial enlargement changes some basic photogrammetric properties of the original image. Enlarging the film by conventional printing operations not only changes scale, but it also eliminates (crops) a portion of the image.

Needham and Smith (1984) detail two factors that account for this reduction in image area. First, the film aperture in an enlarger is smaller than the size of exposed film. This permits high speed production printing to proceed without requiring each negative to be precisely centred in the film holder. The second reason for cropping is known as spillover: it eliminates edge problems on the prints by projecting the image beyond the edges of the paper. For 35 mm enlargement, these photographic procedures reduce image content 10 to 22%, depending on film size (Table 5.1).

The photogrammetric implications of enlargement are critical.

- •Determining the principal point may be difficult, if not impossible, because the film is rarely centred in the film holder.
- •Distortion caused by the enlarger's lens system introduces systematic errors.
- •Enlarging may change the tip and tilt orientation imparted to the original image if the planes of the film and photographic paper (on to which the enlarged image is projected) are not parallel.

This does not mean enlargements cannot be used for photogrammetric purposes. Experience with custom enlarging has proven successful, provided the image is not cropped (i.e. entire frame edge is exposed) and the enlarger has reasonably

good lenses (Warner and Blankenberg, 1995). With the emergence of colour copiers that digitally scan an image (rather than relying solely on optical projection), using small format enlargement for photogrammetric purposes holds great promise. Warner and Andersen's (1992) study showed that enlarging 35 mm colour slides and 645 prints 12× with a colour copier did not introduce significant image deformation, and it was one-tenth the cost of commercial enlarging. The enlargements, however, cropped 15–20% of the original imagery.

Balancing cost with accuracy

Regardless of the photogrammetric method or instrument that you use, an assessment of potential errors must be made if a sound analysis is to result. Consider transfer instruments: the more you transfer information, the greater the chance of error. We've all seen the results of a photocopy, of a photocopy, of a photocopy...

We have similar problems in photogrammetry when we make a large print from a small format negative, then transfer the photo image to a map and trace it, followed by digitising the traced lines. Every step introduces potential error, such as scale adjustment, image distortion, human error. You will appreciate why professional photogrammetrists work directly off original imagery. It provides greater accuracy. But to exploit the accuracy of an original image one must use very precise instruments, which are also very expensive.

So we come to the issue of trade-offs: balancing the instrument's accuracy with its cost. The old adage 'You get what you pay for' is generally true, but remember there is little sense in buying an instrument that provides accuracy you don't need.

How accurate is an instrument or a method? The question is so basic to the way we conceptualise measuring that it's not easy to see that we imply a certain bias. That is, the very question suggests that accuracy is a quality dependent on various factors – namely the precision of the system (or method) and the system's ability to determine the correct measurement.

Accuracy and precision

Though the terms are often used synonymously, the distinction between precision and accuracy should be clearly understood. *Precision* is a measure of dispersion (in statistical terms, the standard deviation). *Accuracy*, however, is the extent to which an estimated value approached the true value, i.e. the degree to which it is free from bias. With this distinction in mind, you can see an imprecise instrument can provide accurate measurements, just as a precise instrument can provide inaccurate measurements. For instance, let's assume we have 35 mm imagery at say, 1:15 000 scale. An analytical plotter with a point location accuracy of 10 µm will generate an estimated accuracy of 1.5 m. Now, let's say we enlarge that original imagery 10 times to 1:1500 scale and use it with a digitising tablet that has a point location accuracy of 100 µm. Assuming the enlargement process does not introduce any error, the expected accuracy will be the same. If the analytical plotter costs ten times as much as the digitiser (fitted with photogrammetric software) a practical question of economics is in order. 'Is the price difference of the instruments worth

introduction of enlargement error?' Of course, there are other considerations, but the point is this: accuracy and precision are not one and the same.

There is another point about accuracy to be made. When considering the accuracy of photo measurements we must always keep in mind the two distinct types of accuracy:

- *Absolute accuracy* relates the position of a given point on the photo to a surveyed ground position usually given in a standard X,Y,Z coordinate system
- *Relative accuracy* compares measurements on the photo to measurements of corresponding objects on the ground (usually using conventional surveying equipment).

The distinction between the absolute and relative accuracy is important to understand, because of their applications. The former is primarily geodetic and of particular interest to those dealing with surveying and metric mapping. Relative accuracy, however, is only partially geodetic and is of particular interest to those dealing with nature.

A question of scale

A common bond between the two forms of accuracy is that they both rely upon the geometry of points, lines and planes, which is the heart of photogrammetry. Euclidean geometry has a very desirable property: it is invariant under change of scale. But when we move to the anomalies of nature, scale must be viewed differently, because it gives bias towards accuracy. An example proves the point.

Think of a person taking normal strides walking along an irregular curve, with each new step starting where the previous one left off. The number of steps multiplied by the length of the stride is an approximate overall length, L. Now, as the measuring length (i.e. the stride or l) becomes smaller and smaller, we have been taught to expect L to settle rapidly to a well-defined value called *true length*. But, in fact, what we expect does not happen: the observed L tends to increase without limit. The reason is obvious. When a forest edge on a 1:100 000 photo-scale is re-examined on a 1:10 000 photo scale, fragmented edges become visible. On a 1:1000 photo scale, sub-fragmented edges appear, and so forth. Each adds to the measured length. So, it's easy to see how length can not only increase, but can increase infinitely.

Scale selection, therefore, will bias accuracy. This leads to two important considerations for photo surveys of nature, where lines and planes are quite fragmented. First, to make a comparison between two irregular features, say a forest edge, we need to use the same photo scale. Second, to measure a feature of nature we should chose a scale that relates directly to the purpose of observation. For example, if we are interested in the effect of forest edge on wildlife habitat, then the scale of measurement should be as closely related to the scale of the animal as is operationally possible. Say we are interested in the total length of a forest edge available to deer; then a deer's measuring increment may be a scale of 2 m, whereas a rabbit's may be 1 m, a mouse's a matter of centimetres and so on. The point is simply this: it doesn't

make much sense to focus on the camera's geometric instability or the measuring instrument's precision, then select the wrong photo scale or measurement scale. Generally those dealing with observations of nature are familiar with their scale of interest and select the proper photo scales. But all too often the measurement scale is overlooked; consequently, the photo measurements may be of little value.

In essence, quibbling over gains of a few centimetres of accuracy provided by a metric mapping camera means little if the natural feature of interest is a matter of metres. The practical influence of fragmented shapes on photo measurements may swamp the theoretical influence of photogrammetric geometry related to the choice of the camera or measurement system (Warner and Fry, 1990). In practical terms, the accuracy of photo measurements is based upon variables, not the least of which are precision of the camera and photogrammetric instrument, the photo scale from which measurement will be taken, and, of course, the inherent nature of the photo survey.

Decision making

If you wish to use a photogrammetric instrument for your small format photos, the obvious question is: 'Where to begin?' The best advice is to seek help from a photogrammetrist. A trained professional will best be able to evaluate your particular situation and steer you in the right direction, towards the right instrument. Before seeking advice, however, first consider some basic guidelines. Sometimes the most obvious questions are the most difficult:

- *Decide how the photo data will be used.* For instance, do you wish to count, measure or map objects? Is there only a small amount of data to capture, or do you intend to generate thousands of points for a computer system? Will you be mapping entire areas, or merely sampling a few sites?
- *Establish your accuracy requirements and estimate the size of your area under investigation.* Will you be satisfied with ground location accuracy of a few metres, or are you looking for height measurements within a few centimetres? Your accuracy will depend upon, amongst other things, photo scale and available ground control. If your site(s) are small, say a few square kilometres, that's one thing; if they are large, say hundreds of square kilometres, that is another – even at small photo scales.
- *Determine the costs your organisation is willing to bear.* Photogrammetric equipment ranges from a few hundred dollars to tens of thousands, and the cost of training usually escalates with the cost of an instrument.
- *Evaluate your office assets.* What is the existing equipment, staff knowledge of data handling and photogrammetry, supply of maps, and access to aerial photographs?

It is simply not sufficient for an organisation to purchase a photogrammetric instrument, a computer with some software, and hire or retrain one or two enthusiastic individuals and then expect instant success. Just as in all organisations dealing with complex products, in the manufacturing industry, for example, new tools can

only be used effectively if they are properly integrated into the whole work process and not tacked on as an afterthought.

Whether the tool you need is an inexpensive parallax bar or an expensive analytical plotter, the cost of the instrument will be justified by the degree of use it receives. The problem is that many organisations do not have sufficient work to justify the cost of any particular instrument. Consequently, when considering the purchase of an instrument, give careful consideration not only to *how* it may be used but also to *how often*.

Buyer beware

A final comment on two marketing buzz-words in a highly competitive market: *user-friendliness* and *capability*. Virtually all manufacturers of photogrammetric equipment claim their products are user-friendly; and just as many promote the capability of their instruments to perform of many labour-saving tasks while assuring the highest accuracy.

As you probably know, the word 'user-friendly' has as many meanings as there are users. What's friendly to the software programmer or the professional photogrammetrist may be totally antagonistic to you. If a person who is unfamiliar with photogrammetry and computers is expected to cope with a complex instrument that works in milliseconds, something has to give. Inevitably, it's the user. Frustration, anxiety and desperation build until the expensive investment is chalked up as a bad investment. Fortunately, some manufacturers of photogrammetric equipment are coming to realise that there is much more to gain from making application development *easier* than merely making it faster and more accurate.

Regarding the word 'capable', just because an instrument is *capable* of performing a function, say, entering data into a GIS system, does not necessarily mean that it does it – at this time. It merely means it has the capability. On one hand 'capability' may simply mean a no-cost operation, like switching a cable. On the other hand, it may imply major software modification and/or purchasing some hardware like another PC, a digitising tablet, or a plotter, which might exceed the cost of the instrument.

If you're considering investing in any PC-based instrument, select the equipment with care and first invest the time to see one in operation, preferably by a user at your skill level. Find out from the manufacturer who is using their equipment, then visit the user (e.g. government agency, university, or private firm) the way a parent visits a school: if the 'students' look bored or confused, they probably are.

Summary

- Small cameras can produce geometrically unstable photographs because of :
 imperfect lens system (especially super wide angle lenses)
 unknown focal length and principal points
 lack of film flatness for 70 mm
 image motion.
- Small-film size introduces problems associated with:

limited ground coverage, and the time-consuming task of orienting numerous stereomodels.

- *Accuracy* is the degree of conformity with a standard; relates to the quality of the result, and is distinguished from *precision* which relates to the quality of the operation by which the result is obtained.
- Accuracy of photo measurements is based upon many variables, including precision of the camera and photogrammetric instrument, the photo scale from which measurement will be made, and the inherent nature of the photo survey.

Chapter 6

Survey Techniques for Small Format Photography

Plotting the location of large scale photos

A large scale photo, say 1:1500 to 1:5000, resolves considerable detail, but often it's difficult to determine exactly where the photo was taken. This is a particular problem when trying to determine the precise location of a test site in a monoculture crop, a sample plot in a forest, or a building site in a dense urban area. Just look at a 1:1000 scale photo and you'll see it's not easy to match the image of a small landscape segment with a smaller scale photo. Although the site may have been preselected and marked on a flight plan, the discrepancy between the plan and the actual flight coverage is a common problem because many small format surveys use primitive navigational systems.

Zsilinszky (1972*b*) developed a simple and economical method to overcome this problem. His technique is easy to master provided that you have a mount that carries two cameras. One camera uses a long focal length lens for the large scale photos, the other camera uses a 7.5 cm fisheye lens. The two cameras are mounted side by side and fired simultaneously. Now, since the optical axes are parallel and their separation is small (say, less than 30 cm) the principal point of the large scale photo corresponds with the small scale fisheye photo. Of course, the spherical perspective of the fisheye provides no scale to match, but it provides excellent interpretability in pattern identification.

Locating the large scale image on a reference photo or basemap is simply a matter of transferring the principal point of the fisheye photo. Here are the three steps to plot the locations (see Fig. 6.1):

1. Pin prick the PP (principal point) of the fisheye photo (Fig. 6.1*b*).
2. Draw a straight line across the PP so that it goes through two points that are identifiable on both the fisheye photo and the reference photo. (On a reference photo these points can be distinct landscape features, like the corner of a field or a church steeple. If you're using a basemap, try to find maybe a road intersection, railroad crossing, or bridge.) Naturally the line on the reference photo (Fig. 6.1*c*) will pass through the point corresponding to the PP on the fisheye photo.
3. The procedure is repeated for another line, ideally as nearly perpendicular as possible to the first line. The intersection of the lines on the reference photo or map (Fig. 6.1*c*) coincide with the PP of the large scale photo (Fig. 6.1*a*).

Figure 6.1 *Point transfer from large scale photo to reference photo by fisheye lens. (Zsilinszky, 1972).*

(a) Large scale photo (enlargement from 35 mm camera with 55 mm lens). This photo was exposed simultaneously with the fisheye photo (b), and its Principle Point O taken from (b) and the reference photo (c).

(b) Fisheye photo (7.5 mm lens) corresponding to (a). The lines AB and CD are drawn through O from identifiable points on both fisheye (b) and reference photo (c).

(c) Reference photo (large format contact print, here), with points AB and CD identified. Where AB and CD intersect they identify the location of the large scale photo (a). (Reproduced with kind permission from Photogrammetric Engineering, August, 1972, p. 774).

If your aerial survey is a continuous flight of overlapping photos, it's not necessary to take simultaneous fisheye photos for every large scale exposure. In fact, you can take a fisheye photo for every fourth large scale exposure (i.e. frames 1, 5, 9, 13, etc.). The other large scale photos (e.g. frames 2, 3, and 4), can be located systematically by measuring one-quarter, one-half, and three-quarters of the distance along the line drawn between the located PPs of photos 1 and 5.

Measurements by aerial point sampling (APS)

For the monitoring of vast tracts of land, small format surveys often seem inappropriate if not totally unthinkable. This is understandable, but it's not necessarily true. Small format often comes into its own through sampling. *Aerial point sampling* (APS) was a method developed in East Africa for *quantifying* land use patterns over vast tracts of lands. This small format system should be of particular interest to natural-resource managers monitoring large areas. The basic advantage of APS is that equipment requirements are modest and easier to use than conventional photogrammetric instruments. In addition, it overcomes the problem of interrupted flying schedules due to weather conditions, such as rain, because surveys are made at low flying heights (400–1200 feet above ground level).

In APS, vertical sample 35 mm photos are taken at a large scale then analysed either by projecting the slides on a dot grid, or by projecting a dot grid on to enlarged prints. Areas are then determined by the *proportion*, expressed as a percentage. Densities of objects such as infrastructures are found by determining the numbers counted per area. That's a thumbnail sketch of APS. Now let's take a close look at how easy and precise the operation is.

Photo acquisition

Flight planning for APS is based upon sampling rather than total coverage. Developed for surveying tracts between 20 000 and 50 000 km², the architecture of the system is based on three levels:
- flight lines (primary units)
- vertical point samples photographs taken along the flights lines (secondary units)
- sample estimates of land cover taken off the photographs.

Sample design is a subject in itself, a specialised topic that goes beyond the range of this manual. Whether you follow the practical advantages of unstratified, systematic sampling or the theoretical advantages of stratified random sampling is a decision best left up to you and the advice of APS specialists (e.g. Norton-Griffiths, 1973, 1988).

An important aspect in treating each photograph as a sample is to fix their exact location. Norton-Griffiths (1988) recommends that every time a photo is taken, you should record the distance along the flight line, and the distance left or right of track with a navigation system (e.g. OMEGA/VLF). From these two parameters it's possible to plot the location of each sample photo on a map overlay to within 200–300 m. Of course, it is possible to interface the camera to an on-board GPS unit (via the camera's electronic flash port) and expect positional accuracy around 100 m.

Any camera mount, external or internal, is suitable as long as it takes vertical photos. A standard 35 mm camera with a 50 mm lens works perfectly well. Scale determination can be estimated by a radar altimeter for monitoring height above ground level. If you don't have access to a radar altimeter you should control flying height based upon known topographical relief of each exposure. Generally speaking, nominal image scale is around 1:7000–1:10 000, so flying will be relatively low.

As for film, prints can be used; however, enlarging many negatives 10× for a dot grid overlay can be expensive. A more affordable alternative is to use colour transparencies with a rear screen slide projector, which superimposes a dot grid on the imagery. If you have a camera fitted with a bulk back, consider using a microfiche projector, the type commonly found in libraries. As you'll see, this method is ideal for those with limited budgets.

Photo evaluation

Perhaps the best way to understand the APS method is to illustrate it through a step-by-step example. This 'how to' example will give an idea not only of the ease of point sampling but also its accuracy.

1. For an APS medan size of 260km^2 (approx. 16 km × 16 km) then, for a 35 mm format (long edge leading) and scale (m_b) of 7000, the ground sides are : $S_1 = m_b$, $S' = 7000 × 36$ mm $≈ 0.25$ km, and $S_2 = 7000 × 24$ mm $≈ 0.17$ km. For a Primary Sampling Fraction (x) of 10% then the distance between flight-lines is: $a = S_1/x = 0.25$ km/0.1 = 2.5 km. Similarly, for a Secondary Sampling Fraction (y) of 17% the distance between frames is: $b = S_2/y = 0.17$ km/ 0.17 = 1 km.

2. For interpretation we superimpose the imagery (say a nominal image scale 1:7000, representing 4.2 ha per photo) on the dot grid. At a ×10 enlargement we now have an interpretation scale of 1:700. The semi-random dot grids

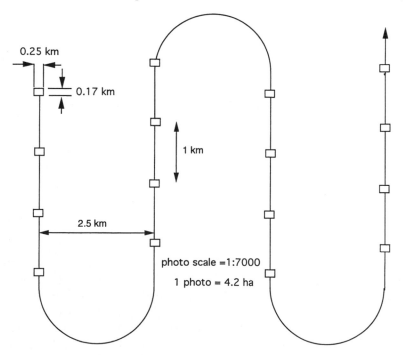

Figure 6.2 *Aerial point sampling (APS) photo interpretation procedures.*

79

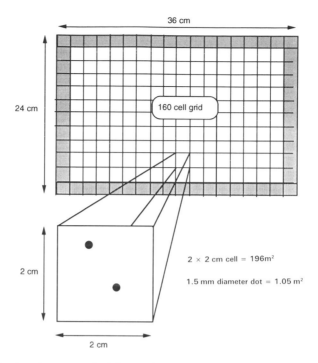

Figure 6.3 *Projected 1:7000 scale slide 10× for 1:700 interpretation.*

consist of an array of 18 × 12 cells, each 2 × 2 cm in size (Fig. 6.3). To over-come interpretation problems associated with the edges of the field of view, we'll eliminate the outer border of cells, thus giving us an array of 16 × 10 = 160 cells. In each cell there are two randomly located dots 1.5 mm diameter (Fig. 6.4, bottom). These dots are equivalent to 1.5 m on the ground, and they form the basis for making measurements.

3. Quantification can be in the form of counting or area measurement. Count-ing is rather straightforward: merely recording the type of object projected on a dot, such as houses or roads. Area data are measurements of the *propor-tional* area of different kinds of land cover, expressed in terms of the number of dots falling within each land cover class.

The beauty of APS surveys is that you can make them as detailed and com-plex as you wish. For instance, let's say we're doing a land use study and we have a list of 60 different classes: 15 classes covering *agricultural uses* like cultivated fields, non-productive forests, bogs and so on; 15 classes of infra-structures such as houses and roads; 15 classes of tree species; and 15 miscel-lancous classes that describe recreation sites and conservation activities.

After visually identifying the object under each of the 320 dots (per slide) you record data directly on a tally sheet. A skilled interpreter can process between 30 and 40 slides a day (Norton-Griffiths, 1988).

4. The data are then transferred to a computer data base for statistical processing. *Survey estimates* can be projected in the form of 'total numbers' or 'densities' for different area units, e.g. counties or townships. Total numbers (or hectares) express the total within the defined area unit. Densities express the numbers per square kilometre of, say, houses or recreation sites. But when applied to vegetation, they express hectares per square kilometre, which is equivalent to percentage cover.

The survey estimates are calculated using a derivation of the *ratio method*. This method is designed for unequal sized sampling unit and eliminates the influence of sample unit size on the sample estimates and sample variance (Norton-Griffiths, 1973, 1988).

One of the most important features of APS is the flexibility with which data can be integrated within a spatial context. For instance, once the coordinates of each sample are known, they can be assigned any spatial domain imposed upon the data, such as calculating the distance between sample points.

Accuracy

Precision of any estimate from an APS survey is influenced by the absolute size of the sample and by the size of the stratum. Obviously, a sample of many units will always be more precise than a sample of a few units, whatever the sample fraction. The abundance of an attribute under study will also influence the precision. For example, an estimate of a crop with 10% cover will always be more precise than an estimate of a crop with only 5% cover. For a given sample fraction, however, an estimate from a large area will always be more precise than will be an estimate from a small area. Norton-Griffiths (1988) presents us with a table showing the influence of these factors on sampling intensity (Table 6.1). The columns of the table represent areas of different sizes (in square kilometres) such as regions, districts, counties or townships, and the rows of the table represent means densities of attributes, such as houses and vegetation areas. Each cell in the table shows, for a given mean density and area, the standard error (percentage of the mean) of 95% of all survey estimates. You can use the table as a handy reference for assessing the precision of any survey estimate.

What about the shape of an area influencing measurements? Norton-Griffiths' (1988) evaluation of bias control shows that the mean estimate of a size–shape combination does not differ significantly from the expected value. In fact, the dot grid provides acceptably precise and apparently unbiased estimates of areas of different shapes. For properly controlled APS surveys, the shape of an area has no influence at all on the number of dots being counted – the only influence comes from the size of the area.

Capturing ground control

Throughout this manual we've thought of photos as potential maps. But in order to realise this potential, to compile an accurate map, your aerial photographs must be related to established horizontal and vertical datum. This photogrammetric con-

Table 6.1 *Standard error of survey estimates (expressed as a percentage of the estimate) (Norton-Griffiths, 1988)*

Ha/	Area (km²)										%
km²	50	100	200	400	600	800	1000	2500	500	>5000	
0.02	95	68	50	36	30	27	24	17	13	11	8
0.04	68	50	36	27	23	20	18	13	11	9	3
0.06	57	41	30	23	19	17	16	11	9	8	3
0.08	50	36	27	20	17	15	14	11	9	7	2
0.10	45	33	24	18	16	14	13	10	8	7	6
0.20	33	24	18	14	12	11	10	8	7	6	9
0.40	24	18	14	11	10	9	9	7	6	6	7
0.60	21	16	12	10	9	8	8	6	6	5	5
0.80	18	14	11	9	8	8	7	6	6	5	5
1.00	17	13	10	9	8	7	7	6	5	5	9
2.00	13	10	9	7	7	6	6	5	5	5	10
4.00	10	9	7	6	6	6	5	5	5	5	7
6.00	9	8	7	6	6	5	5	5	5	4	3
8.00	8	7	6	6	5	5	5	5	5	4	2
10.0	8	7	6	5	5	5	5	5	4	4	5
20.0	7	6	5	5	5	5	5	4	4	4	7
40.0	6	5	5	5	5	4	4	4	4	4	4
60.0	5	4	4	4	3	3	3	2	2	1	2
80.0	5	4	3	3	3	2	2	2	2	1	3
%	10	19	29	14	10	5	3	6	3	1	100

trol, or *ground control* as it is commonly called, orients the aerial photographs to the ground. Almost every phase of photogrammetric work requires some ground control. Basically, what we want to do is link our photographs to established ground coordinates.

Ground control can be established either before or after the photographs are taken. The choice is primarily a matter of operational economy. Depending upon conditions, the cost of establishing ground control can be expected to constitute between 20% and 50% of the total mapping cost.

Here's why control is expensive. Traditionally, coordinate positions, and elevations for selected ground features on aerial photographs are established by going to the field and establishing surveyed points. If your aerial survey is of an urban area you can use a power pole, a building corner, or a road intersection for photo identification. If, however, your area is void of any distinctive features, say a vast tract of forest, ground control targets may have to be placed in the field before the mission. Various material, such as fabric crosses or sand-filled plastic bags, can be used.

Either pre- or post-flight procedure works well; but extreme caution must be exercised in locating and marking objects because mistakes are common. Pre-flight markers deteriorate quite rapidly, can be moved (wilfully or accidentally), and are lost in shadows. If the aircraft cannot be positioned immediately, or if weather

grounds the mission, the survey team will have to check and maintain the marks continually until the photography is completed. Also, if a detailed map is not kept for post-flight identification of permanent structures, it is easy to make costly mistakes (e.g. the wrong corner of the right house or the right corner of the wrong house).

Digitising control from a map

It is possible to obtain control points with less effort and less expense than a ground survey, but the penalty is less precision. Here's how you do it: you identify features on your aerial photographs and link them with features on a topographic map. The contact photo scale, the map scale, and degree of accuracy you require will determine the suitability of this method.

1. Locate several features on the photographs that are also marked on the map (e.g. road intersection, building, bridge crossing, etc.). The number of control points and their optimum location depends on how the photos will be used. For making reliable measurements, redundant vertical and horizontal control is necessary. As a practical minimum, each stereomodel should have three horizontal and four vertical control points. The horizontal points should be widely spaced and the vertical points should be near the corners of the model, with one in the middle.

 An important point in this operation is the map scale. You want your map scale as large as possible, preferably larger than your contact photo scale. Now this poses a problem if your aerial survey was flown at a large scale, say 1:10 000, over a remote area that has only been mapped at, say, 1:50 000. For this example, therefore, let's assume we're working with a photo scale of 1:10 000 and a map scale of 1:5000.

2. Place the (1:5000 scale) map on a digitising tablet, and after registering it (i.e. digitising the four corners of the map), digitise the control points. The state plane coordinates $(X, Y,)$ of the horizontal control will be measured by the digitiser. The elevation (Z) of the vertical control you'll enter from reading the map's contour lines.

3. To determine how precise your digitised control points are you can use a statistical procedure: a least-squares, two-dimensional affine fit that corrects for map distortion. Many digitising systems include this program in their software. For the sake of illustration, let's assume the location accuracy of digitised control points was 0.1 mm. If the map scale was 1:5000, the average difference between ground-surveyed points and digitised location would be 0.5 m. This value is misleading, however, because you must also consider the inherent error of the map, which is typically 0.3–0.4 mm. Therefore your expected accuracy is around 2 m.

Digitising control from photographs

One of the obvious problems with capturing control from a map is that often features on the photos don't show up on the map. This is especially true if your survey

is of a remote area where the only map features are the odd road or building. And even when identifiable features are present, rarely are there enough control points to cover the stereomodel properly.

Under these circumstance you can capture control points from large format aerial photographs, provided:
- you have access to a stereoscopic plotter capable of handling large format photographs.
- you have control points for orienting the large format model.

At the same photo scale, a 35 mm stereomodel will cover less than 2% of the area of a large format model. Therefore, the likelihood of finding ground control for the large format model from a map increases.

The process of collecting photogrammetric control is called photo point densification. Wolf (1983) explains the principles of this method, but we'll outline how it works by taking you through a step-by-step example:

1. Orient the large format stereomodel. An analytical plotter will issue expected accuracies for fitting the stereomodel to the ground control points. For this example, lets say we're working with 1:15 000 scale large format photography, and the expected accuracy for determining a point on the ground is 75 cm.

2. Select control points that can be identified on both the small and large format stereo models. To do this, examine your small format model with a magnified pocket stereoscope, then switch back to the large format model. By switching back and forth between the plotter's optics and the pocket stereoscope, you should be able to locate some identifiable features such as a distinctive tree or a large rock. Be careful about points along a shoreline because the water level might have changed between the time of the large format photography and your small format mission.

3. Digitise 6–8 well-distributed control points. The X,Y,Z coordinates of each point will be recorded and stored in the large format model's job file. You now have ground control for your small format model.

Estimated error and acceptable accuracy

Although you have ground control, and are using an analytical plotter, your accuracy will remain significantly inferior to working with a large format model, at the same photo scale. The reason is this: the average distance between control points will affect your accuracy. An explanation is in order. Let's assume control points are located on a 35 mm stereomodel, and the points are measured to within 0.01 mm of their correct location. In other words, the measurement accuracy of your instrument is 10 μm. Assume also the control points are widely distributed and the average distance between points is 250 m. If the maximum error in photo coordinates were 75 cm at ground scale, the expected error in scale would be about 3%. Compare this error with the same tolerance spread over the large format's area, where control points are spaced, say 1000 m apart. With the same tolerance of uncertainty (75 cm) the expected error in scale would be 0.08%.

If we consider capturing ground control from a topographic map, this expected error increases, for two reasons. First, the digitiser's point location is one-fourth to one-tenth that of an analytical plotter. Second, vertical control relies on reading contour lines. To obtain a 1 m estimate for your elevation, you would probably have to use a map scale of 1:1000.

Although the expected error of your 35 mm stereomodel might be relatively large, you should ask yourself the fundamental question: is the error significant from a statistical standpoint or an operational perspective? For most work dealing with natural-resource investigation, the operational considerations are probably of greatest concern.

Bundle adjustment for blocks of photographs

Since a small format camera covers so little ground, one of the greatest operational considerations for many photographs is ground control. Thus far we've talked about control extension through a strip of photographs; but what about two or more side lapping strips, commonly called *blocks*? In dealing with blocks, a number of pass points can be carefully selected so that they appear in the side lap area of adjacent strips. These points, called *tie points*, make it possible to tie the individual strips together to form a continuous block.

Using numerical methods, the strips are successively joined by matching tie points and the block is adjusted to available ground control. Consequently, you only need several control points for the block rather than several control points for every model (Fig. 6.4). As you might expect, the strongest solution is obtained when horizontal ground control points are located near the periphery of the block. Vertical control, however, must be distributed uniformly throughut the block.

With the aid of a computer, collinearity equations for an entire block of photographs are formulated and solved instantaneously. This is called a *bundle adjustment*. By solving both control and pass point collinearity equations simultaneously, a numerical relative and absolute orientation of all the stereomodels in the block is achieved. After the adjustment has been performed, the pass points serve as control points. The very large system of highly redundant equations is mathematically rigorous and has proved to produce reliable results (Wolf, 1983). Standard bundle adjustments are available, and with the aid of a photogrammetrist you can integrate such a program into most analytical instruments.

The choice of going to the field for a ground survey, or using a digitising tablet with a map, or an analytical plotter with other photography, will depend upon your accuracy requirements and budgetary constraints. For urban surveys where large scale topographic maps are available, a digitising control off a map is a cost effective method. When working in rural sites where maps are limited, photogrammetric control might be a possible method. But in some cases you'll have neither maps nor an analytical plotter for photogrammetric control. Do not lose heart. As we shall explain, there are alternative ways of capturing reliable measurements off photos *without control*.

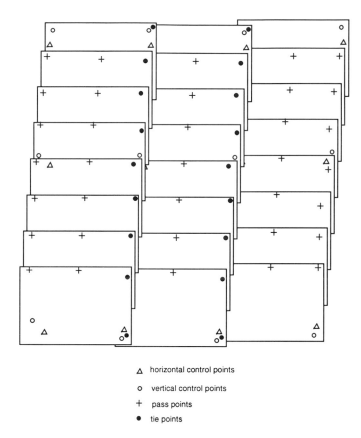

△	horizontal control points
○	vertical control points
+	pass points
●	tie points

Figure 6.4 *Block of photographs prepared for bundle adjustment.*

Controlled large scale photography

Which is your biggest headache: finding a calibrated camera or finding control points? If you want to make photo measurements and you're missing either one, you still have possibilities. If you're working with large scale photography, ranging from 1:500 to 1:3000, there are methods to determine scale and make accurate photo measurement when you have neither ground control nor a calibrated camera.

Precision altimeters

If you remember, scale of a vertical photo is determined by the ratio between the camera's focal length and the camera's altitude above the ground, f/H_g. It seems natural to assume that if we know f, then we can simply determine H_g by reading the aircraft's altimeter. Unfortunately, it's not that easy because of the comparatively poor reliability of barometric altimeters for determining low flying heights.

Errors in flying height can give rise to proportional errors in scale. For example, an error of 40 feet in a flying height of 200 feet will generate a 20% error in photo scale. Graham and Read (1986a) clearly explain why settings on barometric altimeters will not give an altitude correct enough for determining photo scale.

If we could, however, rely upon an accurate altimeter, determining photo scale wouldn't be such a problem. That's exactly what's been done using radar and laser altimeters. One system developed at the Canadian Management Institute in Ottawa is based on a precision altimeter that registers flying height on each photo frame at the moment of exposure, via one of the camera's secondary optical systems. The system uses a *laser* altimeter that fits nicely into a standard aerial camera ring mount. Unlike the earlier precision radar altimeters that are incapable of penetrating forest canopy (thus recording the aircraft's height above the trees rather than the ground) the laser's narrow beam passes through gaps in the forest canopy.

In addition, the system uses a gyroscopic indicator that continuously senses the camera's altitude within a half a degree. At the moment of exposure, the tilt reading is recorded on the edge of the photo frame. This known degree of tilt is used for photogrammetric correction when making measurements from stereo pairs. Using this method, heighting measurements have been found to be more precise than conventional ground measurements.

The tragic flaw in this system – and most methods that rely on precision altimeters – is expense. Until recently the cost, as well as the size and power supply, limited the application of laser altimeters.

Fixed base systems

There is another technique you can use for making accurate photo measurements without worry about supplying ground control, *fixed base systems*. This is how it works: two cameras separated at a known distance (the fixed air base) are fired simultaneously. This system produces matched pairs of stereo photos, one from each camera, rather than strips of continuously overlapping photographs. It's a technique research scientists have been using for decades (Avery, 1959; Lyons, 1961, 1966, 1967), and is currently finding a useful role in forest measurements (Befort, 1988; Spencer, 1979).

Over the years researchers have experimented with different orientations and various lengths of twin camera boom techniques. Some experimented with cameras in a fixed wing aircraft (e.g. Panzer and Rhody, 1980; Williams, 1978), but most perfected booms are suspended to a helicopter and fixed base helicopter booms are commercially manufactured.

Befort (1988) and Spencer (1979) review the development of a variety of fixed base systems, but each relies on the same basic principle. If both cameras are fired at exactly the same time – and if their lines of sight are exactly parallel – scale determination and parallax measurement can be made. Because each photograph includes the principal point of the other, the distance between photo centres can be measured on film and compared to the known camera-to-camera distance to obtain photo scale. More simply put, you can determine the photo scale directly by dividing the camera separation by the photo base. The relationship between this scale and the

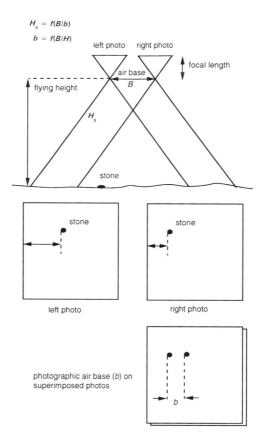

Figure 6.5 *Geometry of a fixed base system (Adapted from Spencer, 1979).*

focal length then provides a simple method for determining flying height, without ground control. Besides eliminating ground control, fixed base systems also eliminate the problem of relative orientation.

Figure 6.5 illustrates the geometry of a fixed base system. Flying height is computed as $H_g = f(B/b)$, where H_g is the flying height, f is the focal length, B is the air base (distance between cameras), and b is the photographic air base. Photographic air base can be measured by pinpointing a distinct ground feature (e.g. stone in Fig 6.5), then measuring its distance from the edge of each photograph and determining the difference between the two measurements.

We should point out the importance of the camera in fixed base work. First, most systems rely on 70 mm cameras because a 35 mm camera simply doesn't provide enough ground coverage at such a low flying height. Also keep in mind the importance of knowing the camera's focal length. Most fixed base systems use 80 or 100 mm lenses at very large photo scales (e.g. 1:500). Although it would be best to

know the true focal length, the difference between calibrated and nominal focal lengths will influence height measurements by only a few centimetres.

The principles of fixed base systems are good in theory, but they are difficult to achieve in practice. Here are some practical considerations:

- A disadvantage of the method is that the fixed base controls the amount of overlap at each scale, thereby affecting differential parallax, and consequently the accuracy of photo height measurement.

- If the camera boom is mounted perpendicular to the line of flight, it is difficult to maintain parallel lines of sight between the two cameras unless the boom is very rigid. Since rigidity dictates a larger diameter tubular boom, this means added weight. For example, one system uses a 25 cm diameter boom weighing 60 kg (150 lb), less cameras.

- If the boom is mounted parallel to the line of flight, the air base is *unknown* if the two cameras do not fire at precisely the same instant – and we're talking about milliseconds. Delay between shutter trips either stretches or shrinks the fixed base on which the design is set. This is truly critical because the air base is so small. If the helicopter is stationary the cameras do not have to be fired at precisely the same moment; however, the vibrations of a hovering helicopter might cause image blur.

 Spencer (1979) compared the accuracy of estimating flying height with camera's boom mounted parallel and perpendicular to flight. He found that the parallel mount determined flying height $\pm7\%$ of 200 feet (61 m) and $\pm17\%$ at 500 feet (152 m). In the perpendicular mount the accuracy of estimating height doubled (3.5% and 8.5%).

- Although a rigid boom ensures absence of differential tilt between photos, maintaining the cameras' horizontal orientation to the ground is another matter. If the photos are tilted, the degree of tilt must be known and photogrammetrically corrected in order to obtain accurate height measurements; though in practice this *absolute orientation* has not proven significant in vegetation sampling studies (Befort, 1988). Some commercial boom mounts compensate tilt by rotating the boom along its own axis (controlled from inside the helicopter).

- The inherent shortness of the photo base limits the altitude from which precise height measurement can be made. The accuracy of height measurements really goes back to stereoscopic perception, which depends on the B/H_g ratio. If the cameras are separated by 8 m and you fly at 100 m, your B/H_g ratio is 1:12.5 – which is quite inferior to commercial aerial surveys that try to achieve a B/H_g ratio of 1:2.

- Image motion becomes a problem when flying low. Since image motion is proportional to the aircraft speed and to the photo scale, it has greater effect at very large scales. Helicopters mitigate this problem by flying at low speeds (usually around 30 knots, 55 km/h), but hovering vibrates the boom beyond the absorption capacity of the rubber shock absorbers.

Despite these obstacles, fixed base systems have proved to be effective tools for precise photo measurements. For forest surveys, they can actually be more accurate

than traditional ground measurements (e.g. Lyons, 1967). It is worth noting that fixed base systems eliminate the effect of wind-sway of tree crowns. In time interval photography the swaying of treetops between exposures can considerably effect the differential parallax (Aldred and Hall, 1975).

In conclusion, the fixed base system is neither a novelty nor a research effort still on the drawing boards. It's an operational system proven to be most cost effective where ground control is unavailable and where information needs to be sampled, usually in remote or hard to access areas.

Part II

AERIAL PHOTOGRAPHY OPERATIONS

Chapter 7

Small Format Instruments and Photographic Films

Camera principles

Before we can discuss which cameras to use for aerial photography (mapping), we need a rudimentary understanding of how a camera functions. So let's start with the basics. A camera is basically a light-tight box incorporating a lens, a shutter, a lens aperture and some means for holding the film. It also has a viewing system through which you can sight and compose the picture.

One of the most critical components of the camera is the lens, which forms an inverted image of the subject on the film. Adjustable lenses have a focusing control enabling you to sharpen the image by altering the distance between the lens and the film plane, a condition necessary for all ground photography and satisfied by the well-known equation

$$1/f = 1/v + 1/u \qquad (7.1)$$

where u is the distance between object and lens, v is the distance between lens and film plane and f is the focal length of the lens.

Although the distances u and v are variables, the focal length of a lens is fixed (although a zoom lens allows for an entire range of focal lengths within its zoom range, equation (7.1) still prevails for any selected focal length).

In aerial photography it is very rare that equation (7.1) is employed, except for highly exceptional conditions (the aircraft is flying very low and the camera employs an unusually long focus lens). Under normal circumstances the distance between lens and object (u) is very large and may be considered as infinity, i.e. $u = \infty$. From equation (7.1) we have

$$1/f = 1/v + 1/u = 1/v + 0.$$

In other words $f = v$, and as a consequence ordinary cameras used for air-to-ground photography are set at infinity, where the distance between film and lens (v) is equal to the focal length (f). In order to maintain this essential condition it is usual for camera operators to secure the camera focusing ring at the infinity position with strong tape.

Note: Large format (23 cm × 23 cm) mapping cameras are always fixed at the infinity position and cannot be focused.

93

As you know, when you press the shutter release the shutter opens to expose the film to light. As this happens, light passes through the shutter aperture (either a hole or a slit) for a period of time set by the camera shutter speed. Shutter speed and lens aperture are adjustable so that you can vary the duration and intensity of the image light reaching the film. Usually you control the shutter speed with a dial marked in fractions of a second, and the lens aperture with a ring calibrated in a series of numbers, commonly called f stops. By using these controls you can compensate for variations in subject lighting and produce correctly exposed pictures under a wide range of conditions. Most modern cameras have an exposure meter to measure the incoming light and to either advise you on the correct exposure or set it for you automatically.

What you photograph is observed through a viewing system. Viewing systems either use a separate viewing window (direct vision) or show you the image formed by the lens. Most of the better cameras use the latter with a mirror system and are called *single lens reflex* (SLR) cameras (see Fig. 7.1).

Another integral component of the camera system is the film. Film characteristics are discussed in detail later in this chapter, but for now it is appropriate to consider two simple aspects about film: its size and its 'speed'. Film size determines the camera format, and usually the *format* for most 35 mm cameras is a frame size of 36 mm × 24 mm. All manner of film types are available for this popular format and they can be purchased in either cassettes holding 24 or 36 frames, or in bulk rolls capable of providing hundreds of frames for special camera 'backs'.

Although 35 mm represents the truly small format camera, the term also includes cameras which employ roll films. Roll films have a format of either 6 cm × 9 cm or 6 cm × 6 cm or 6 cm × 4.5 cm. They are commonly designated as 120 films (providing either 8, 12 or 16 frames) or 220 (providing 16, 24 or 32 frames). Some roll film cameras can be supplied with 70 mm film magazines (holding about 70 frames of 6 cm × 6 cm format). The 70 mm film is supplied in bulk rolls of sprocketed film and is usually employed in specialised cameras designed for either

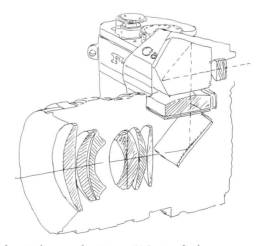

Figure 7.1 *Typical optical system for 35 mm SLR viewfinder.*

photogrammetry or military reconnaissance. Although the term medium format is generally used to define 120, 220 or 70 mm cameras, it is common to refer to *all* 35 mm, 120/220 and 70 mm instruments as small format cameras when talking about aerial photography – simply because the standard mapping camera format (23 cm × 23 cm) is large format by comparison!

Some films react to light more quickly than others. The speed of a film's reaction to light is expressed in terms of international standards, either ASA/ISO or DIN number. The higher the number the 'faster' the film. For example, a film rated at 100 ISO would require twice as much exposure as one rated at 200 ISO.

In mainstream (mapping) aerial photography there is a more specific system for expressing film speed known as the effective aerial film speed (EAFS). The EAFS has slightly different criteria than ISO and is easier to evaluate, but for most SFAP cameras (where the exposure is determined and controlled by integral calculations based on ISO) there is little point in adopting EAFS for the majority of SFAP applications (see Chapter 12, under Processing Control).

That's a thumbnail description of the small format camera. Now let's examine two camera systems most commonly used for small format aerial photography (SFAP).

SFAP with 35 mm cameras

The 35 mm camera is the most versatile of all still cameras, and (if we disregard the larger format advantage of 6 cm × 6 cm cameras) it represents the most popular system for SFAP because it offers the most for the least cost.

Although the advantages of small format cameras (see Introduction) make a compelling argument for their use, they do have a rather obvious disadvantage – the image area is small, and particularly so with 35 mm cameras. As a consequence, the ground coverage is very limited for a given scale. Indeed, why else have heavy, expensive 23 cm × 23 cm mapping cameras? So the argument for 35 mm cameras must always take ground coverage into account, and we must always seek means to overcome this single, but important, disadvantage.

Optimising the 35 m image for SFAP

If we use the finest quality lens, and if this lens has a large aperture (f2 at least), we can always employ a slow speed fine grain film (say, 30 ISO) and enlarge the image without fear of losing image quality (resolution of detail). And if this same lens is a wide-angle (say 24 mm) we can gain the necessary ground coverage as well!

As we know, the photo scale m of an airborne camera image is given by

$$m = H_g/f = S/S' \tag{7.2}$$

where H_g is the height above ground, f the lens focal length, S the side of ground covered and S' the side of the image format. From equation (7.2) we can usefully compare 35 mm SFAP with conventional 23 cm format photography.

For example, at a flying height of 1000 m (3280 feet), a 35 mm camera fitted

with a 24 mm lens will be able to provide a photo scale of 1000 m/24 mm = 1:41 666. If we take the useful image size to be 24 mm × 24 mm (to compare with a 23 cm × 23 cm format) the ground coverage works out to be 1000 m².

By comparing the above 35 mm system with a conventional 23 cm mapping camera we begin to see how important scale and ground coverage are in SFAP. And if we assume the same requirements for ground cover (1 km²) a standard mapping camera fitted with a 15 cm wide angle lens would cover the same area at a height of 652 m (2138 feet) and an associated scale of 1:4346.

If we wanted to make a direct comparison between the two images we would need to enlarge the 35 mm photo by the scale ratio: 41 666/4346, an enlargement in the region of 9.58 times. And the big question is; 'what differences can we expect to see'?

If we simply talk about image quality it's possible to say that, providing the best camera lens, the best film, the best enlarger and the best processing are employed – it is possible to make a match that is visually equal to the quality of the 23 cm photograph. But the geometric accuracy of the 35 mm enlargement will certainly not be good enough to match that of the larger format. The main problems are the metric quality of both camera lens and enlarging lens, the stability of the enlarger and, to some extent, the image structure of the negative.

Nevertheless, by understanding these limitations it is possible to work within them and 35 mm SFAP is still a viable alternative for a number of applications.

35 mm SLR cameras

The 35 mm SLR camera (Fig 7.1) is the most versatile of still cameras and a popular choice for small format aerial photography because of its wide range of available lenses, reliability and accurate through the lens (TTL) exposure metering system, plus a host of advantages not found in any other popular camera. The formidable range of advantages listed in the Introduction to this book are, of course, directly equated with the price of the camera. Since prices can range from less than $100 US to about $4000 US, it is necessary to take a sensible view of these cameras in relation to their cost and effect.

For SFAP our essential camera requirements are simple. But unfortunately these few essentials are usually only common to the more expensive instruments. Al-

Table 7.1 *Minimum requirements for a 35 mm SFAP system*

- Interchangeable lens facility
- The best quality lenses in 24 mm, 28 mm and 50 mm focal lengths
- Large maximum aperture lenses (at least f2)
- Shutter priority exposure facility
- An available minimum shutter speed of 1/2000
- Electrical (remote control) shutter and motorised film wind
- A strong camera back capable of keeping excellent film flatness within the photo frame (ideally a vacuum back)

though they are available in many 35 mm SLR cameras they also come with numerous unwanted facilities which, even for ground photography, are unnecessary, confusing and costly.

There is little to be gained from employing a camera of inferior quality. By the time you have costed the mission, aircraft, fuel, personnel, etc, the result has to be worth while, and with 35 mm images, this means the best – there can be no compromise with quality when the image is so small!

The minimum acceptable requirements for a useful 35 mm SFAP system capable of being employed for photogrammetry as well as remote sensing and general applications are given in Table 7.1. Cameras capable of providing all of these essentials are available – at a price! Most good quality 35 mm SLRs will offer them, except for the Vacuum back. However, since 35 mm film is relatively stiff over the 24 mm × 36 mm frame, film flatness is not too difficult a problem for metric purposes.

Naturally, for non-metric applications a few of the above requirements can be relaxed somewhat, but image quality can never be sacrificed.

The focal plane shutter

On all cameras, the shutter allows you to control exactly when you take the picture, and also control the period of time during which light falls upon the film. A *focal plane shutter* is used on 35 mm SLR cameras and usually consists of two blinds, metal or cloth, which pass across the film during exposure. A metal shutter moves vertically (sometimes with three blades), and a cloth shutter horizontally.

When you release the shutter, the first blind moves over the film plane, allowing image light to fall on the film; and the second blind follows close behind. The gap between the blinds, and their rate of travel, determines the exposure time (see Fig. 7.2).

Note: See Appendix 7 for a simple TV method for calculating 'horizontal blind' shutter speeds.

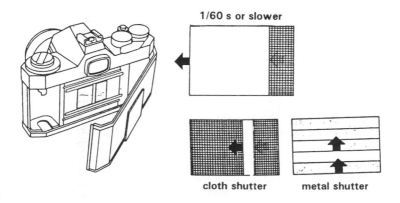

1/60 s or slower

cloth shutter **metal shutter**

Figure 7.2 *Two types of focal-plane shutter for 35 mm SLR cameras.*

Exposure metering

Almost all 35 mm SLR's use a TTL meter to measure image light, and a light sensitive cell is built into the camera for this purpose. Typically such a system enables the meter to read incident light intensity (I) as it falls upon the film, and input this value into an electronic circuit which also takes into account film speed (ISO), lens-aperture (N) and selected shutter speed (t).

Metering systems usually work on the principle of a Wheatstone bridge circuit (shown in Fig. 7.3) where, for example, a meter needle can be controlled to indicate correct exposure as the parameters N, ISO and t are adjusted to form an 'equation of balance' through associated variable resistors.

This simple system is employed in less expensive SLR's (such as the Pentax K 1000) where (for a pre-set ISO value) aperture or shutter are varied until a needle (visible in the viewfinder) is centred to indicate correct exposure. With more sophisticated cameras the shutter speed can be automatically adjusted to give a correct balance under what is known as *aperture priority* exposure control. In this mode, the operator has only to adjust lens aperture and the shutter speed is automatically altered to provide correct exposure.

With even more expensive cameras the lens aperture may also be automatically adjusted under *shutter-priority* control. Here, our operator pre-sets the shutter speed to a desired position and the lens aperture is automatically changed to provide the correct exposure.

The *shutter-priority* mode is of great importance to SFAP because it allows cameras to adjust automatic exposure (AE) without changing a pre-set shutter speed.

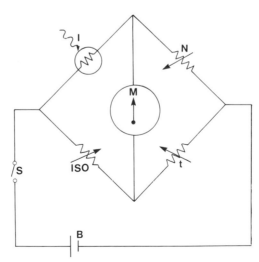

Figure 7.3 *Basic (Wheatstone bridge) circuitry for automatic exposure metering. B, camera battery; S, exposure switch (usually the first pressure on shutter release button); I, photo-electric cell (to measure incident light); ISO, film speed (set for speed value of film: ASA/ISO); N, lens aperture (f no.); t, shutter speed; M, meter.*
Equation of balance is $(R_I + R_{ISO}) \cdot (R_t + R_N) = 0$.

For example, we can anticipate overcoming problems such as camera vibration, or apparent image motion, by setting a high shutter speed (say 1/2000 s) then, as the aircraft flies over changing terrain, or cloud-shadow, it is the aperture N that is automatically adjusted to maintain correct exposure.

If the camera has only aperture-priority (as the majority do) then automatic exposure changes can only be made by adjusting the shutter – with an even chance that some frames will be exposed at a low shutter speed, resulting in blurred images.

Recommended cameras and lenses for 35 mm SFAP

It goes without saying that any lens used for aerial survey should be of the highest possible quality. It is not always appreciated that the most popular 35 mm lenses, such as the autofocus and zoom types, are designed solely for convenience and not for top quality. Whereas an autofocus lens is perfectly good enough for ground photography it is never as good (in terms of resolution) as the ordinary manual focus type of lens. Similarly, the zoom lens is a variable focal length lens, ideal for many applications – but only at the expense of ideal image quality.

Since the greatest problem with 35 mm images is the small format (and correspondingly small ground coverage) the obvious lens is a wide angle manual focus type of the highest quality.

The well-known 35 mm camera manufacturers, such as Canon, Nikon, Minolta, Zeiss, Leica and Rollei, all produce high quality cameras with a range of high quality manual focus lenses. Although it is not the purpose of this book to produce a merit table of various instruments, there are a few cameras which are known to be among the best and can be safely recommended from practical experience.

Yashica Contax RTS III

The Contax RTS III is expensive (in the region of $3000 US) but has just about everything to recommend it fro SFAP applications.

This high quality SLR has a 5 frames per second (FPS) motordrive and autorewind, 1/8000 shutter, centre-weighted and spot metering, a databack and a choice of either manual, aperture or shutter priority. In addition is has a unique vacuum system to hold the film perfectly flat, a facility that not only makes the RTS III ideal for metric SFAP, but also the world's first RTV (real time vacuum) for motor-driven 35 mm cameras.

The vacuum system not only complements the high resolution of the Contax lens (by ensuring that the film is flat to the focal plane) but also satisfies basic photogrammetric requirements for geometric accuracy. The RTV system works by employing a suction rubber configuration with a moving coil to suck the film against a perforated ceramic pressure plate.

Carl Zeiss lenses are among the very best in the world and the Contax range is truly impressive, with focal lengths extending from 15 mm to 1000 mm. Among those suitable for SFAP are the Distagon T* f2.8 25 mm, and 28 mm and the Planar T* f1.4 50 mm lenses.

The Contax RTS III has been the subject of intense SFAP research undertaken by Professor Franjo Heimes and his colleagues at the Fachhochschule Bochum, Germany. By modifying the camera with eight fiducial marks in the focal plane, and flying the camera in a specially made stabilised mount, the resulting modifications provided a perfect SFAP system. In order to utilise the full potential of the camera, very slow speed ultra fine grain film/processing is employed which requires camera forward-motion compensation (FMC). The Bochum stabilised mount therefore has a digitally controlled FMC applied by pitching the camera during exposure according to the actual *V/H* ratio. Practical tests show a very high accuracy for photogrammetry with a system resolution up to 300 line pairs/mm (Heimes *et al.* 1993).

Rollei Rolleiflex 3003 metric (35 mm) survey camera

Another German manufacturer of classic cameras is Rollei. They are known mainly for their 6 cm × 6 cm Rolleiflex cameras, and the 3003 model is little known outside the photogrammetric community. Nevertheless, although mainly designed for terrestrial photogrammetry, the metric 3003 is a SLR camera capable of high accuracy when used for SFAP (Fig. 7.4).

Whereas the Contax RTS III has its unique vacuum back, the Rollei 3003 relies upon a grid plate (with 35 highly accurate reference crosses) to correct for any image distortion due to non-flatness of the film during exposure. The grid plate is built into the camera in front of the film plane so that the reference crosses are photographed with every exposure. Any errors which could arise from distortion of the film, from non-flatness of the film during exposure as well as any other image deformation occurring after exposure, are eliminated by subsequent photogrammetric programming.

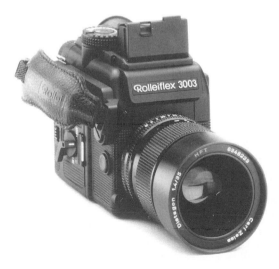

Figure 7.4 *The Rolleiflex 3003 35 mm metric camera with built-in grid plate.*

The Rollei 3003 is normally fitted with the same range of Zeiss Distagon lenses as the Contax RTS III, and will take all of the usual types of 35 mm film load. The camera is motorised to 3 fps and has a top shutter speed of 1/2000 s. Exposure control can be either manual or aperture priority. A further advantage of the 3003 camera is an option to fit the Rollei 25 Data unit to the camera. This is a databack version of the 250 exposure magazine which allows the user to imprint the time (day/hour/minute), date (year/month/day), or a frame number on each frame.

When fitted with the Rollei 250 Data unit it is likely that the 3003 will come into the same bracket as the RTS III, and the entire system has to be considered almost perfect for SFAP – but for the absence of a shutter priority option. This option deserves further explanation.

Although the 3003 is ideal for 'close range' photogrammetry it was not designed for SFAP and this is never more obvious than its lack of shutter priority in the auto-exposure mode. Whereas exposure on the ground can be easily controlled, in aerial photography exposure conditions are constantly changing due to terrain differences, cloud-shadow and so on. Normally these changes can be easily tolerated within the exposure latitude of the film, but for SFAP negatives the tolerance is very narrow since high densities have to be avoided in the best interests of image resolution and geometric accuracy. Most certainly aperture priority will control exposure in each frame, but only at the expense of the optimal shutter speed – and as we know, there is always image motion to be considered! This is why shutter priority has to be seriously considered when selecting a camera for SFAP.

Leica R7 35 mm SLR

Leica have a 35 mm pedigree that is second to none, but the cameras tend to be rather overpriced! They are nevertheless excellent cameras and the R7 model is a typical example that can be recommended for SFAP. It has the usual manual as well as auto-exposure functions, the latter carrying both aperture priority and shutter priority options. The top shutter speed is 1/2000 and an excellent range of lenses are available from 15 mm wide angle to 800 mm focal length.

Canon F-1 AE and EOS-1

The Canon E-1 AE (automatic exposure) is a development from the earlier f-model and, like the original, is one of the finest 35 mm SLR cameras ever made. Whereas the F-1 wasn't wholly dependent upon battery power and required add-ons, such as the 5 fps motor drive or the 2 fps motor wind in order to provide AE shutter priority, the F-1 AE model has both shutter priority and aperture priority installed as standard. For SFAP however, a motorised film wind is essential and this must be purchased as an extra. The F-1 AE has a top shutter speed of 1/2000 and is backed up with a wide range of high quality lenses such as the Canon FD 24 mm f2.8.

The Canon EOS-1 is more expensive (about $2200 US at time of writing) but has a top shutter speed of 1/8000 s, shutter priority and aperture priority AE, and a built-in motor drive. Like all Canons, the EOS-1 camera is highly recommended

for SFAP, not only for the truly excellent lenses, but also for its known reliability and robust engineering.

Minolta Dynax 7xi and Dynax 9xi

Although Minolta are strong on their innovative 'fuzzy logic' computer controls and very high shutter speeds, these are not necessarily useful to SFAP. Nevertheless, the 7xi and 9xi models are very good cameras with every required facility to make them suitable for aerial work. Both cameras have excellent AE facilities, with both shutter and aperture priority options. The 7xi has a top shutter speed of 1/8000 and the model 9xi has (at 50% extra cost) an astonishing 1/12000 s. Both cameras are fitted with a 4 fps motor drive.

Nikon F-801s and F4

From the large range of Nikon cameras we have selected two, both having common facilities such as AE aperture/shutter priority, a top shutter speed of 1/8000 and a motor wind in the region of 4 fps.

The main difference between these models is the price. The F4 is over twice the price of the F-801s (F4 in the region of $2400 US) but, considering they both use the same quality of lens, there is little reason to recommend purchasing the F4 if money is tight.

The F-801s is an altogether good value for SFAP and although the Nikon 24 mm f2.8 lens is very expensive, the authors have used (and can recommend) a much cheaper Sigma 24 mm (f 2.8) for SFAP. For the F-801s there is also a dedicated databack, the Nikon MF21 Control Back.

An interesting modification to the F-801s is the digital version. Known as the Nikon F-808s, this version also carries the Kodak DCS 200 (digital camera system) pack. The DCS 200 is a 1.5 Megapixel unit designed for the F-808s camera, and it is important to note that it is not an add-on option to the basic F-801s camera.

Geometric Nikon FM2; F-801; F-601 conversions

Although the Nikon F-808s has been converted into a digital version from the basic Nikon 801s, the Geometric Nikon conversions are not *manufactured* variants of these popular 35 mm cameras. The Geometric range are specially modified versions of the FM2, F-801 and F-601 cameras, designed to be suitable for photogrammetry applications.

Each camera is supplied with a regular grid of 35 crosses marked in a glass plate to within 2 m of accuracy. In this way, any image deformation (such as film shrinkage or lack of flatness) can be compensated. Every modified camera comes with its own calibration report and can be obtained from GE Design, Westwall 8, 47608 Geldern, Germany. The Nikon Geometric FM2 is currently priced (1995) at around $3350 US plus tax and shipping. This same company also supplies an interval timer and mini video system for navigation.

SFAP with (medium format) roll-film cameras

As mentioned earlier, it is convenient to refer to all formats smaller than the standard 23 cm × 23 cm as small format. As a result we can include the larger, but less widely marketed, medium format cameras which take either 120, 220 or 70 mm size film rolls. For this reason they are often called roll film cameras.

Traditionally, roll film cameras were twin lens reflex (TLR) types. But for many years now we have had various SLR roll film cameras, mainly purchased by professional photographers for their larger (nominally 6 cm × 6 cm) format. The actual format size varies from one type to another, but the usual square format will be in the region of about 56 mm × 56 mm. Some roll film SLRs have a rectangular format of 4.5 cm × 6 cm or 6 cm × 7 cm (mostly favoured by photographers concerned with aesthetic composition) but although these cameras are quite useful, the square format is better for SFAP for obvious reasons.

Advantages and disadvantages of roll film cameras for SFAP

Advantages

- The larger format (S) gives greater coverage per frame. For a given scale the 56 mm format will cover 3.63 times as much ground cover (S) as its 35 mm counterpart. Furthermore, the cover is more usefully applied with a square format.
- Since the format is larger than 35 mm there are more opportunities to fly photography at a greater scale than would be advisable with a 35 mm camera. As a consequence the image quality is better.
- There are a small number of 56 mm format cameras that are designed for either aerial work or photogrammetry, and once these cameras are calibrated they are capable of providing good quality metric images without further modification.
- Many SLR roll film cameras have lenses fitted with inter-lens shutters; as a result they avoid the metric distortions possible with focal plane shutters.

Disadvantages

- Due to their limited market, most of the quality roll film SLR cameras are much more expensive than 35 mm types.
- Many of them have inter-lens shutters with (nominal) top shutter speeds of only 1/500 s, and always less than this in practice. (At altitude, inter-lens shutters are subject to cold temperature problems which slow them down even further.)
- There can be problems with limited magazine capacity and in some cameras the magazine–focal plane interface is too weak for reliable operations in aircraft.
- Compared to 35 mm cameras the roll film types do not generate large enough market to allow manufacturers to economically exploit the latest technol-

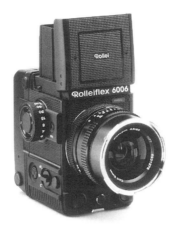

Figure 7.5 *The Rolleiflex 6006 (6 cm × 6 cm) metric camera with built-in grid plate.*

ogy in their medium format cameras, for instance, AE shutter priority.
• With its larger format (larger than 35 mm) there is greater concern for film flatness during exposure. Unless an optical grid plate is fitted under the focal plane a suction back is necessary for metric applications.

Although most of the recommendations for both 35 mm and roll film cameras follow criteria essential to topographic photogrammetry, it has to be remembered that SFAP also covers non-metric applications, such as cover for photo interpretation and multispectral photography (MSP). Indeed, in the latter category roll film cameras have been established for many years now.

Recommended cameras and lenses for roll film SFAP

Rollei Rolleiflex 6006 Metric

Although we have called attention to some typical disadvantages of roll film cameras, such as shutter speeds which exhibit 'actual' speeds significantly longer than their nominal values, and the general lack of AE technology, there are always exceptions. A most welcome one is the Rollei 6006 camera, and its metric version the 6006 Metric (Fig 7.5).

In the 6006 all camera functions are electronically controlled and the Zeiss lenses, with their electronic inter-lens shutters, have not only AE but also shutter priority as well! Being inter-lens shutters they are limited to 1/500 s, but, since they are controlled by two direct drive linear motors, the conventional mechanism of springs, gears and levers is replaced by an all-electronic system which provides realistic and consistent shutter speeds.

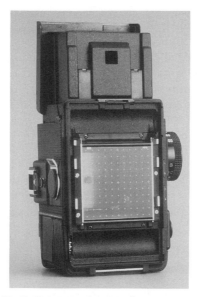

Figure 7.6 *Rear view of Rolleiflex 6006, showing the 11 × 11 array of reseau crosses.*

The basic Rollei 6006 has a range of interchangeable magazines for 6 cm × 6 cm format, including 120 size (12 frames), 220 (24 frames) and a type 70 (70 mm perforated film) magazine which can take up to 70 frames.

The Metric version has a built-in grid (reseau) plate with an 11 × 11 array of highly accurate crosses (Fig 7.6) and is available with a large range of calibrated Carl Zeiss metric lenses from 49 mm to 350 mm focal length.

Each Metric 6006 camera and lens comes complete with calibration data for the reseau plate reference crosses, principal distance, principal point (to within 50 m) and radial distortions For SFAP it would be suitable to look at the following range of lenses:

- Distagon f4 40 mm wide angle
- Distagon f4 50 mm wide angle
- Distagon f3.5 60 mm wide angle
- Planar f2.8 80 mm standard lens.

The Rollei Metric is not cheap, but it represents the best when it comes to high quality imagery and metric accuracy.

A complete and typical metric system, comprising the Metric 6006, reseau plate, 50 mm (f1.8) lens, 70 mm film back, NiCd battery pack with (100–240 V, 50/60 Hz) recharging unit and RC 120 electrical remote release will come to about $10 000 complete with full calibration data. When fitted into a suitable (custom made) drift mount, the 6006 camera can be installed in a light aircraft and flown with differential GPS to provide a complete self-contained photogrammetric system. The high quality primary data can then be processed in a machine such as the Zeiss Planicomp C100.

Hasselblad roll film cameras

Although various Hasselblad cameras have a long and useful history of development, and have often been used for SFAP, none of the various models compare with the Rollei 6006 in terms of efficiency or accuracy. All Hasselblad models have the usual 56 mm × 56 mm format, the usual 120, 220 and 70 mm (70 frame) magazines and, until the model 2000 FC (early 1980's), all were limited to the Hasselblad inter-lens shutter with maximum (nominal) speed of 1/500 s. None had AE shutter priority.

Hasselblad model 500 EL/M

Powered by two rechargeable DEAC NiCd batteries, the motorised EL/M has for many years occupied a special place in aerial photography. Very often this camera has been used for MSP in groups of three or four, each lens being fitted with an appropriate spectral filter matched to its 70 mm film load. At one time a 500 exposure 70 mm magazine was available, but it was found to be unreliable and is no longer made. Indeed, even the 70 exposure magazine has its problems: the weak interface between camera and magazine can result in torn perforations in the 70 mm film, and consequent stoppage.

Hasselblad 200 FC/M

The 200 FC/M camera was built with a focal plane shutter (1/2000 s) and so removed one of the barriers to the use of non-Hasselblad lenses. The motor drive is an add-on feature which operates on six VDC rechargeable batteries. Normal Zeiss CF lenses can be used providing their inter-lens shutters are disengaged.

Hasselblad 553 ELX, 205 TCC and 201F

Modern Hasselblads, such as the 553 ELX still only have manual exposure. Although fitted with motor wind, it is overpriced at $6000 US.

The model 205 TCC does have AE aperture priority, but at £10 000 US (motor wind is an optional extra) is no match for the Rollei Metric 6006, either in value for money or in terms of its value for SFAP. The latest 'Blad' is the 201F which, with TTL, motor drive and 1/1000 FP shutter, is a good camera for SFAP, particularly since it has a large range of lenses (type C and CF lenses have inter-lens shutters), although it is best matched with TCC and F series lenses. But once again, it's expensive!

Hasselblad MK 70

Although the MK 70 is old by today's standards, it is unique in the Hasselblad range since it was designed specifically for metric applications, originally for NASA's early lunar landing missions. It features a motor drive using rechargeable 6 V NiCd

batteries and an etched reseau plate. Lenses are manufactured by Carl Zeiss with inter-lens shutters. Available focal lengths are 60 mm, 80 mm and 100 mm.

Magazines are available for 70 frame, 100 frame and 200 frame capacity. From practical experience it is found that great care has to be taken in loading the 70 mm magazine: the tin cassettes tend to allow the film to unwind and bind against the inside of the casing, resulting in torn perforations and stoppage.

The MK 70 is a reliable metric instrument, however, and it has given good service in terrestrial photogrammetry and limited but good results in metric SFAP (Graham, 1988).

Vinten 70 mm reconnaissance cameras

Vinten cameras are designed for military reconnaissance and specifically for high speed tactical reconnaissance at low to mid level altitudes. They are very ruggedly built and incorporate design features that allow them to cycle 70 mm perforated film at up to 16 frames per second. There are several models, but we describe only two because the others are highly specialised or beyond the reasonable budgets of most small format aerial photographers.

Vinten type 260 camera

The first Vinten 70 mm reconnaissance cameras appeared in the Royal Air Force in the early 1950's. Designated as the F95 it was the basic design for what is generally known as the type 360 camera.

Designed for high speed jet aircraft operation the F95 totally replaced the then 25-year-old F24 camera which, with its 5 in × 5 in format and relatively slow recycling rate, was inadequate for modern tactical reconnaissance. The F95 (Marks 1–10) has been produced in great numbers (over 10 000 are in service world wide in over 30 countries) and can be fitted with a wide range of lenses (Fig 7.7).

Figure 7.7 *Vinten 360 (70 mm format) air camera. Here shown with an attached video camera, to provide a forward-looking display of the terrain for monitoring in the cockpit.*

The F95 can operate at either 4 pps (1/1000 s) or 8 pps (1/2000 s) and is usually installed in groups to afford both forward and side facing exposures. Today, many of the camera configurations are within reconnaissance pods fitted under the wing.

Many early versions of the F95 (without exposure or forward-motion compensation) are available on the government surplus market and can be purchased at rock bottom prices for SFAP – if you are lucky!

Being all-electrical in operation (it is designed for standard 28 V DC aircraft supply) the F95 can also be operated from small 24 V portable power packs, and is easily modified to single shot operations. As a cheap and efficient means for MSP these F95s are often purchased in threes or fours and sometimes returned to Vinten for installation of new shutter blinds (with larger slits to bring the shutter speed down to 1/500 s) and so allow for the high spectral filter factors employed.

Vinten camera calibration: an example

A large variety of lenses have been available for the type 360 (F95) cameras and among them the 4 inch Taylor Hobson f2 is exceptional. One of the authors has an old F95 (Mk 7) fitted with such a lens and a recent calibration proved the lens to be of very high metric quality, even without the use of a vacuum fitted magazine!

Given that Vinten cameras are designed for reconnaissance and not for mapping, it comes as no surprise to find that there are no fiducial marks available with the format. However, by carefully using the corners of the imagery it is always possible to carry out an interior orientation of the camera/lens combination as shown in Table 7.2.

Good as the calibration figures shown in Table 7.2 may be, it is important to remember that one of the main advantages of SFAP is to be able to undertake map revision economically. Much of this work may only involve small areas, but it is likely that heighting accuracy will be an important requirement. Since heighting accuracy is a function of B/H ratio (see Part 1) the shorter focal lengths become important. For example, at a flying height (H_g) of 500 m a 100 mm lens would cover a ground side (S) of 280 m (the image format is 55.5 mm × 57 mm) and with a forward overlap (p) of 60%, the airbase $(B = S(1 - p))$ would be 112 m. The B/H ratio is 0.224. If we now employ a 50 mm lens and fly at a height of 250 m, for the same scale and ground coverage we get a B/H ratio of 0.448, and improved heighting accuracy! So, although the lens itself may be of the highest quality, its focal length must also be taken into account.

As a military camera the type 360 is built to withstand high G loadings and, out of necessity, has a very reliable film transport system – regardless of air turbulence, platform vibrations or shock. From an early date a simple but effective vacuum system has kept the film flat (even at 4 or 8 pps) and, as we can see from Table 7.2, the metric quality can be excellent even without the vacuum applied. The modern type 360 has automatic exposure, FMC, and vacuum backed magazines in either 100 feet (500 frames) or 200 feet (1000 frame) capacities.

Table 7.2 *Vinten F95 and Taylor Hobson 4 inch (f2) lens (without vacuum back)*

Principal distance:	102.07 mm	
P.D. standard deviation:	± 0.149	
Principal point position:	$X = -0.038$ mm	$\sigma X = \pm 0.053$ mm
	$Y = 0.720$ mm	$\sigma Y = \pm 0.105$ mm
Radial distortion parameters:	$K_1 = 0.000$	
	$K_2 = 0.632 \times 10^{-3}$	
	$K_3 = -0.103 \times 10^{-5}$	
Radial distortion:	$\Delta R = K_1 R + K_2 R^3 + K_3 R^5$	
	(where R is the radius in mm)	

Radial distortions

radius (mm)	ΔR (μm)	radius (mm)	ΔR (μm)
5.0	0.0	25.0	0.0
10.0	1.0	30.0	−8.0
15.0	1.0	35.0	−27.0
20.0	2.0	40.0	−65.0

Coordinates of image corners

	x (mm)	y (mm)
1	−28.190	−28.303
2	−29.008	27.403
3	28.184	28.298
4	29.020	−27.414

Vinten focal plane shutters

As mentioned earlier, there is always a question of focal plane shutter distortion where medium format cameras expose film to a moving image via a focal plane shutter. The Vinten is such a camera, and although the fixed slit of its focal plane shutter travels rapidly across the 56 mm format (in excess of 2 m/s for 1/1000 s exposure time) it was necessary to determine the extent of linear image distortion due to the rapid (but nevertheless incremental) transit of the blind over a moving image. The variables include aircraft ground speed, height and focal length of the lens. Although scale distortions can be calculated from theory they are small enough to require an airborne check.

This research was carried out as part of an MSc program within the Department of Photogrammetry, University College London, and is explained further in Appendix 7.

Briefly, the idea was to determine the accurate shutter exposure times (nominally, 1/500 and 1/1000 s) and respective blind speeds for the F95 mentioned in

Table 7.2 above. From this information it was possible to calculate the theoretical image distortions for any given aircraft ground speed. But in order to find the significance of these small distortions it was necessary to position a camera at about 3000 feet (900 m) over a surveyed area (with known ground control points) to provide an airborne image that could be used for critical evaluation.

The results showed that for normal light aircraft ground speeds, in the region of 120 knots (200 km/h), focal plane shutter distortion was insignificant.

Pentax 645 SLR Cameras including 645P and 645V metric models

One of the more encouraging products to come on the market is the Pentax 645 camera. The 645 format is a rectangular 56 mm × 41 mm, and although unconventional in terms of flight planning it is sometimes useful to employ the camera with its longer dimension aligned along the axis of flight, to gain increased B/H ratio for example!

The 645 includes a motor drive built into a pistol grip, and runs on six 1.5 V AA batteries. The framing rate (under single shot) is 1 fps, and in continuous mode 1.5 fps. It has a vertical run focal plant shutter (with a top speed of 1/1000 s) and excellent exposure controls including manual, aperture priority AE or shutter priority AE.

Lenses are available in focal lengths of 35 mm (f2), 45 mm (f2.8), 75 mm (f2.8), 150 mm (f3.5) and 300 m (f4). There are 120 (15 frames), 220 (30 frames) and 700 mm (90 frames) magazines, the latter providing a very useful capacity for SFAP.

For photogrammetry Pentax also offer two models: the 645P and 645V. Both cameras feature calibrated lenses and etched reseau plates with corner fiducials at the focal plane. The 645P has a pressure platen for the 120 and 220 magazines, while the 645 model has a vacuum platen for the same type of film magazines. The Pentax 645 is good value for money and highly suitable for SFAP.

Image quality and the total SFAP system

Whereas photogrammetrists are mainly concerned with the geometric accuracy of image points (with respect to ground control) optical physicists and photographers are more concerned with the *quality* of an image, that is to say with its sharpness or resolution.

Before we go much further into this subject we must first take a look at the nature of small format photographic images.

The final SF image is either a reflection 'print' or a diapositive, usually it is a paper print. But the system that provides us with the final image quality comprises:
- the *subject*, which will have certain qualities, such as terrain contrast, lighting and atmospheric haze
- The *camera lens quality*
- The type of *film* used granularity and tonal quality
- The exposure and *film processing*
- The degree of *apparent image motion*
- The *print quality* (instrumentation and skill)

Subject

Aerial photography is either oblique or vertical. With obliques the camera angle will determine if the photograph is to be a high oblique (including the horizon) or a low oblique (without horizon). In the case of high obliques, image quality will be poor in regions close to the horizon because of excessive sky light spreading over the terrain. The azimuth sun angle (with respect to illumination of terrain detail) will also be highly important to image quality.

With vertical photography, however, the major influences on image quality are haze and terrain contrast. It is not always appreciated that from 10 000 feet (3000 m) and above the average terrain contrast is very low – often as low as 1.6:1.0!

Camera lens

It is practical to express lens quality in simple terms of lens resolution, and since (in aerial photography) we are not concerned with focusing the lens on to a particular object, we can avoid human errors.

The theoretical resolution limit of a lens is proportional to the size of the relative aperture (f number) and the mean wavelength of the incident light (λ):

$$r = \lambda N \tag{7.3}$$

where r is the spatial resolution (distance between two image points that can be resolved by the human eye), λ is the mean wavelength of light employed by the lens. If a filter is used in front of the lens the dominant wavelength is used. With no filter, the average daylight wavelength of 550 nm is used. N is the relative aperture or f number.

A good example is to look at the theoretical resolution of a *perfect lens* (which doesn't exist) at f2 in daylight. We can see that, at its best, the resolution will be about 1 μm.

Naturally enough, manufactured lenses are never perfect, and the quality is mainly a question of price!. In general, all lenses will only give their best resolution in the central field, and as the resolution gets finer so the contrast in the image gets less. Sophisticated analysis can only be done with what is known as the *modulation transfer function* (MTF) which plots modulation (contrast) against resolution. But in practical terms this is both time consuming and unnecessary (although scene contrast should always be taken into account when reading quoted resolution figures for lenses and film) and a more simple, if approximate, method is usually employed for estimating the total system resolution in aerial photography.

In photography it is usual to quote spatial resolution in terms of line pairs/mm (R) where a line pair is the distance between the centre of one bar to the next in test targets such as those shown in Fig. 7.8.

If we photograph an array of nine such targets (Fig. 7.8), distributed so that they cover the entire image field, we can measure the width of the smallest line pair resolved in the image, and we express this value in terms of how many similar line pairs we could pack into 1 mm in that particular area. This will give us the resolution of the lens (R_l).

Figure 7.8 *Negative and positive versions of the standard USAF 3-bar resolution target. Ten groups (G) spiral to chart centre, each group contains six 3-bar patterns (n) with a given contrast. Spatial frequency (k) in Line/Pairs/mm is given by k = $2^G \times (2^{n-1})^{1/6}$.*

Such targets can be either white on black (negative) or black on white (positive) and can be of any contrast or modulation. If the brightest part of the target is L_1 and the darkest is L_2 then contrast (C) and modulation (M) are given by

$$C = L_1/L_2 \qquad\qquad (7.4)$$

whereas

$$M = (L_1 - L_2)/(L_1 + L_2). \qquad\qquad (7.5)$$

It is more convenient to use modulation as an expression of subject contrast since, regardless of the values employed M is always < 1.0 and the expression allows for universal comparison of optical systems.

Original values for $L_1{:}L_2$ (as shown in Fig. 7.8) are 4:1 (negative) and 28:1 (positive) giving modulation values of 0.6 and 0.93 respectively. Whereas 0.6 is representative of a typical urban scene, 0.93 is only found in extreme cases, such as snow-covered landscapes with deep shadow areas.

Film

When image light strikes a photographic film it forms a 'latent image' within a gelatin emulsion containing millions of microscopically small grains of light-sensitive silver salts. This image only becomes visible when developed and (before leaving the darkroom) all unwanted silver salts have been dissolved out (fixed), then washed and dried to form a permanent image.

The various degrees of light intensity form corresponding image densities (D) which are defined as the common logarithm of opacity:

$$D = \log O = \log I/T \qquad\qquad (7.6)$$

Figure 7.9 *A simple printing-frame sensitometer.*

where I is the intensity of incident light upon a silver (film) deposit, T is the transmission of light through a silver deposit, and O is the opacity of a silver deposit ($O = I/T$).

Densities are easily found by measuring the amount of light passing through an opacity and taking the common logarithm of that value. Instruments that do this are quite simple and are called densitometers. Just as transmission densities are found by measuring the transmitted light, reflection densities are found by measuring the reflected light from photographic prints.

Sensitometry

By measuring densities and plotting them against the actual or relative exposures that gave rise to them, we can learn much about the character of a given film, paper, developer and processing system. This analysis is called *sensitometry*. The instrument that provides a range of increasing exposures to a film (or paper) under test is called a sensitometer and, in its simplest form, need be nothing more than a contact printing frame with a Kodak No. 2 Step Tablet taped to the underside of the glass cover, as shown in Fig 7.9. When the test film is exposed to a weak light source there should be just sufficient light (controlled by distance) to afford a noticeable density under the darkest step of the sensitometer master Step Tablet. The *relative* log exposure scale is actually the densities of the master Step Tablet and these are then plotted against the test film densities as soon as the test film has been processed.

The graph shown in Fig 7.10 illustrates a typical plot of D versus log H curve, where H is the relative exposure to light.

For more sophisticated analysis a calibrated flash sensitometer (such as the E.G & G Mk.6) can be used. This instrument follows the basic design shown in Fig 7.11, but has a consistent and accurate amount of light (calibrated in lux-seconds) incident upon the master Step Tablet. It also has a spectral light output similar to that

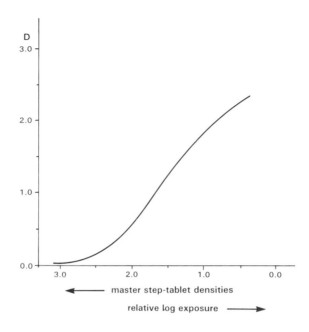

Figure 7.10 *A typical D-Log H curve of a film. Note: The 'master step-tablet' densities increase in opposition to the relative log exposure scale.*

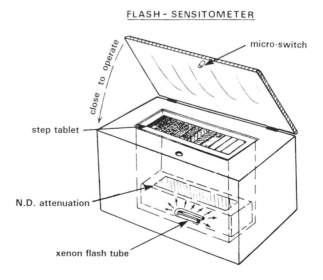

Figure 7.11 *Basics of a calibrated flash sensitometer. The best-known version is the E.G & G Mk. 6 which uses a neutral density (ND) filter to balance the light output according to the sensitivity of the film.*

of daylight. Further use of this type of instrument is explained in a later section.

The sampling area used in normal densitometers is a light spot of a few millimetres diameter, but if the scanning spot is reduced to a few micrometres the instrument is capable of measuring microdensities and is known as a *microdensitometer*.

Granularity: Photographic noise

Just as an electrical signal has 'noise', so does a photographic emulsion – due to the granular structure of the silver grains (silver halides) that make up its composition. It is this noise that limits the enlargement of a negative according to its granularity. In general, fast films have more granularity than slow films, and to some extent *granularity* is also a function of the type of developer employed. Granularity is a major factor in the overall quality of films and is fundamental to the choice of material employed in SFAP.

With a microdensitometer scanning spot diameter of 48 μm, Kodak look at the microstructure of their films by taking the standard deviation (σ) of a microdensitometer plot at a density level of 1.0 (a transmission of 10%) and assessing the root mean square (RMS) granularity (G) of a film from

$$G = 10^3 \times \sigma(D) \tag{7.7}$$

where $\sigma(D)$ is the standard deviation of microdensities.

Values of granularity extend from about 10 for very high definition (slow speed) films, to about 40 for (high speed) coarse grained films. Granularity is highly important in SFAP since it is the dominating factor that governs film resolution (R_F). It is also highly important when considering the required scanning aperture for digitising films.

Film resolution

It is not possible to quote film-resolution (R_F) without mentioning camera exposure and film development. Although the manufacturer is able to quote film resolution for a given film/developer combination, this can only be done on the premise that the film was correctly exposed.

It is possible that climatic or temporal conditions may force the operator to employ a fast film (500 ISO) such as Kodak Tri-X for SFAP. This film represents the worst possible choice in terms of resolution, but it may be the only option available. In the event, we are looking at R_F = 80 line pairs/mm (high contrast targets), or 25 line pairs/mm (low contrast targets), for G = 33. At the other end of the scale we have the low speed (30 ISO) high resolution Kodak 2414 Technical Pan Film which, when developed in its LC (low contrast) developer, is capable of 400 LP/mm.

Although film resolution is of great concern in SFAP, we must also take care to ensure that the film/development combination is capable of recording detail in both the shadows and the highlights ('shadows' being a term to describe all low density

areas, just as 'highlights' describe high density image areas). Whereas good 'tonality' is easily recorded from low contrast scenes, tonal quality is often difficult to preserve, particularly with high contrast urban areas recorded at a large scale. This is why SFAP film processing should ideally be carried out by the camera operator, who is the only person with first hand knowledge of scene conditions, and who can take full responsibility for controlling the tonality of the image by adjusting development to suit the scene contrast.

Film exposure and development

Critical evaluation of the terrain, its lighting, prevailing atmosphere, ground speed of aircraft, flying height above ground, film speed, lens aperture, filter and shutter speed, all contribute to the calculation of exposure in aerial photography. With large format work there is an allowable tolerance, but there is none with SFAP!

It cannot be too highly emphasised that incorrect exposure is the main cause of poor quality in SFAP. If the photograph is underexposed then there is no detail in the shadows – an obvious failing. But what is not so well understood is that an apparently robust negative (with lots of contrast) is not going to help film resolution one bit! With small format negatives the density range should be no greater than about 0.9 to 1.0, with full detail in the shadows. This range is controlled by exposure *and* development, and since development controls film speed, it is essential that the correct value is applied in exposure calculations.

If negative densities are too black, fine detail and resolution are lost due to 'irradiation' (a spreading of image light into adjacent image areas). This condition is just as fatal to colour negatives as it is to monochrome ones since image colour dyes are formed proportional to the amount of developed silver (which is then bleached away).

Film types and their characteristics

Since 35 mm and roll films are available on the worldwide amateur market, there is the significant advantage of always being able to purchase a film suitable for SFAP in a much shorter time than that required for specially ordering a large format air film.

A wide range of colour films, both negative and diapositive, are marketed by Kodak, Agfa-Gevaert and Fuji. Colour films can be purchased from all manner of shops, particularly 35 mm rolls, but it is usually necessary to purchase monochrome and special films from a specialist photographic retailer.

The complete range available from a good photographic retailer includes all types of colour and monochrome in 35 mm and 120 size. For 220 and 70 mm there will normally be a short delay, since these films will need to be ordered from the manufacturer. Similarly, special order films such as Kodak monochrome infrared, or false colour infrared, will usually require a special order.

A list of useful SFAP films is shown in Table 7.3 (monochrome) and Table 7.4 (colour).

Table 7.3 *Monochrome films suitable for SFAP*

Film	Type	ISO speed
Kodak 2415	High definition pan	32 (LC developer)
Agfa Pan 25	Extra fine grain	25
Kodak Panatomic-X	Fine grain panchromatic	50
Ilford Pan F	Fine grain panchromatic	50
Agfa AviPhot Pan 50[a]	70 mm air film	50
Agfa Pan 100	Medium grain panchromatic	100
Kodak plus-X	Medium grain panchromatic	125
Ilford FP4	Medium grain panchromatic	125
Ilford XP-2[b]	Variable speed (C-41 process)	50–400
Agfa AviPhot Pan 200S	70 mm air film (variable speed)	100–500
Ilford HP5	Fast (coarse grain)	400
Kodak Tri-X	Fast (suitable for MSP)	500
Kodak Infrared[c]	Fast (haze penetration/MSP)	50 (87 filter)
Konika 750 Infrared	Use an IR 87 or ×8 red filter	32 (IR 87)

[a] AviPhot pan films are dedicated air films available in 70 mm widths.

[b] XP-2 film is a special monochrome dye film processed in C-41 colour process. It provides variable film speeds and soft fine grain negatives according to processing. Suitable for high enlargement.

[c] Kodak monochrome infrared has a basic speed of 400 ISO, but it is always used with a visually opaque infrared filter which brings its operational speed down to about 50. Under cloud conditions IR radiation is unknown and makes exposure estimation difficult.

Film processing

Monochrome processing

The best known fine grain developer is an international standard called Kodak D-76 (which is also marketed as Ilford ID-11 and Agfa-Gevaert G74c), but there are a number of others, many of which have been formulated to provide 'edge definition; as well as fine grain.

The following developers are highly recommended, and are compared when processing Agfa Pan 25 film.

- Ilford Perceptol. An ultra fine grain developer which halves the film speed but gives good contrast and almost unlimited enlargement. Typical processing is 8 minutes at 22°C (undiluted).
- Ilford: Microphen. Maintains the nominal film speed with very fine grain. Contrast is kept low and shadow detail is excellent. Typical processing is 10 minutes at 21°C (undiluted).
- Agfa: Rodinal. A liquid concentrate with excellent keeping properties. Fine grain with good edge definition and contrast. Great care must be taken in measuring out the working solution (1:25 dilution). Typical processing is 6 minutes at 20°C (dilution 1:25).

Table 7.4 *Colour films suitable for SFAP*

Film	Type	ISO speed
KodakEktar 25	Colour negative (fine grain)[a]	25
Kodak Kodachrome 25	Colour diapositive[b]	25
Kodak Ektachrome 50	Colour diapositive (Elite) E6[c]	50
Kodak Ektachrome 64	Colour diapositive[b]	64
Kodak Ektachrome 100	Colour diapositive (Elite) E6[c]	100
Kodak Ektar 100	Colour negative (C-41 process)[a]	100
Fujicolor Reala 100	Colour negative (C-41 process)[a]	100
Fujichrome Sensia 100	Colour diapositive[b]	100
Kodacolor GOLD 100	Colour negative (good latitude)[a]	100
Agfachrome CT 100i	Colour diapositve[c]	100
Agfacolor XRG 100	Colour negative[a]	100
Agfacolor Optima 200	Colour negative[a]	200
Kodacolor GOLD 200	Colour negative (good latitude)[a]	200
Fujichrome Sensia 200	Colour diapositive[b]	200
Kodacolor GOLD 400	Colour negative (coarse grain!)[a]	400
Kodak False-Colour IR	Ektachrome infrared (E6)[a]	400
Kodak Aerocolor H.S.	SO-358 aerial colour negative film. 70 mm and 24 mm wide; C-41 process)[a]	400

[a] User processed with C-41 (or compatible) colour neg process.
[b] Trade processed only, by the manufacturer or under licence.
[c] User processing (E6 or compatible kit process).

- Kodak: D-76 (Ilford ID-11) A very user friendly developer that will last a long time in solution and can be used from stock, or dilute (1+1) or (1+3) for greater sharpness. The best combination of dilution, temperature and time is usually determined from experiments with a given film. Typical processing is 6 minutes at 21°C (undiluted).
- Paterson:Aculux. A liquid concentrate fine grain developer providing low contrast. Good with fast films (400 ISO) and can be used with varying degrees of dilution. Typical processing is 5.5 minutes at 21°C (diluted 1+9).

Film processing procedure

Small plastic (or stainless steel) daylight processing tanks are available for 35 mm and 120/220 roll films. They are simple to use and can be loaded with film within a daylight loading bag. For monochrome processing all that is required is a developer, stop bath, fixer, a good thermometer and filtered water supply for washing. Film drying should be done after the film has been rinsed in a wetting agent then hung up in a dust free cupboard.

Long lengths of 70 mm film should be processed in rewind spool processing machines or, if these are not available, they can be processed by hand in long plastic trays. Hand processing is quite safe providing the film is pre-wetted before development, but it takes a bit of practice and great care to avoid development marks. Nevertheless, for 70 exposure loads it is perfectly possible to get excellent results.

Print developers

There are numerous print developers available; all can be recommended, since the choice is not critical. Typical examples include: Kodak D-19 (1+3), Paterson Acugrade (1+9), etc. The main thing to remember is that these developers should never be used for films as they are too energetic and would ruin the fine grain structure of a negative.

Colour processing

Whereas monochrome film processing is very simple, colour processing requires more care, particularly with the developer temperature. All colour films have three emulsion layers, red, green and blue sensitive, with each layer devoted to producing its own colour dye (cyan, magenta and yellow respectively) in proportion to the silver produced by the developer. The final combination is a full colour image, either negative (which has to be printed) or diapositive (transparency).

Colour diapositive processing is more complex than for negatives since it involves a 'reversal' process employing a first (negative) developer and a second (colour) developer, as well as the usual bleach bath to remove the first (monochrome) image.

The definitive negative colour process is Kodak C-41, but there are compatible processes made by other manufacturers. For colour diapositives (reversal pro.ess) there is the Kodak E6 process and a number of compatibles. Colour processing kits are readily available and procedure is as simple as following the instructions.

A stainless steel processing tank is recommended since the bleach solution can affect plastic containers.

Although C-41 negative colour requires more care than any monochrome process, this is mainly a question of keeping within the more narrowly specified temperature ranges of this four bath process. In addition, colour films are more vulnerable to scratches and drying problems than monochrome materials. But apart from these extra considerations colour processing is quite simple, even by the rewind spool process (see Chapter 12) which can easily produce processing artefacts in careless hands!

A recent and welcome addition to the Kodak range of aerial films is the 'masked' negative colour film SO-358 (Table 7.4), supplied in both 24 cm and 70 mm wide rolls. When one of the authors (RWG) was invited to conduct both flying and laboratory tests of this film (70 mm) it was a good opportunity to see how well the film performed for both vertical (1500 m, 1:30 000 scale) and obliques (1200 m down to 25 m) at various solar positions and exposures. It was also an ideal opportunity

to see how the film stood up to being processed in the relatively harsh environment of a Morse rewind spool machine (flanged for 70 mm wide rolls of film). A typical rewind spool system is shown in Figs 12.11–13. Four tanks were filled with 10 l of: pre-soak (wash), C-41 developer, bleach, and fixer, respectively.

Two films were processed, one of verticals (Vinten camera, 50 mm lens), and one of obliques (Vinten camera, 300 m lens). The obliques were given a standard C-41 development of 4 minutes 15 s (37.8°C), and the verticals were 'push-processed' for 6 minutes. On inspection the standard development produced negatives of excellent quality, and although the 6 minute development time gave rise to excessive densities the resultant extra contrast was ideal for verticals (although 5 minutes and 15 s would have been better).

There can be no doubt this is a most excellent air film, particularly since it can accommodate three stops of over-exposure and one stop of under-exposure without loss of quality in printing. Indeed, some high obliques showed excellent results along the horizon (without the usual lack of definition common to most negatives in this critical area) and the low oblique shown in Fig. 7.12 (*see* colour section) is a fine testimony of SO-358's ability to cope with shadow detail when exposures are made 'up sun'. Indeed, in the original print of Fig. 7.12, someone can be seen inside a bedroom (extreme left foreground house) waving at the aircraft (Cessna 337) as it flashed past!

Apparent image motion (AIM)

Apparent image motion (it's the aircraft that is really moving of course!) can be calculated from a simple expression:

$$\text{AIM} = (V_g \times f \times t)/H_g \qquad (7.8)$$

where V_g is the velocity of the aircraft over the ground (m/s), f is the focal length of the lens, H_g is the height of aircraft over ground (in metres), and t is the camera shutter speed.

If for example, an aircraft is travelling 108 km/h at a height of 400 m, and the camera has a 50 mm lens operating with a shutter speed of 1/500 s, then:

$$\text{AIM} = (30 \text{ m/s} \times 0.05 \text{ m} \times 0.002 \text{ s})/400 \text{ m} = 7.5 \times 10^{-6} \text{ m} = 7.5 \text{ } \mu\text{m}$$

Since the image will move through 7.5 m during its exposure, this puts a limit on the overall resolution which can be expressed as

$$R_{IM} = 1000/\text{AIM} \qquad (7.9)$$

In the above example, $R_{IM} \approx 133$ line pairs/mm.

Total system resolution (R_T)

Although not strictly accurate, the following formula will give a reasonable evalua-

tion for the total resolution of a lens, film and image-motion combination:

$$\frac{1}{R_T} = \frac{1}{R_L} + \frac{1}{R_F} + \frac{1}{R_{IM}}$$

(7.10)

A typical SFAP system could be employed with R_L = 100 line pairs/mm, R_F = 200 line pairs/mm and R_{IM} = 250 line pairs/mm. The total system resolution would then be about 52 line pairs/mm.

Print quality

The final quality of an image is that observed in a photographic print, either on paper or on film (as a diapositive) and this 'quality' can be expressed in either subjective or objective terms. Subjectively we may describe a print as being 'sharp' or of 'good definition'. On the other hand we might say an image is 'soft', 'unsharp' or of 'poor definition'. All these terms are in common use, but they explain very little!

Objective methods (quoting resolution figures for example) do at least allow us to make direct comparisons and apply improvements based on known values, whereas subjective terms often lead to argument with respect to acceptance or rejection of the final product.

There is often much confusion between what is 'sharp' and what is simply very contrasty. When asked to select the 'best' or 'sharpest' photo from a selection of different prints made from the same negative, the average amateur will almost always opt for the most contrasty print. Yet a print made on a soft grade of paper, and containing all the subtle tones between black and white, could be just as sharp, as well as being a better print!

However, there is some justification for contrast to be mistaken for good definition. One of the things which the human visual system looks for is good edge definition and since this defines the cut-off between adjacent tones, contrast plays a strong part by eliminating mid-tones that would otherwise tend to join different features together.

Edge definition requires an expensive microdensitometer for its measurement, so generally we are left with only an experienced eye to evaluate this important image property. It helps if a store of 'best quality prints' is kept as reference, to be used against future work, particularly where inexperienced printers are concerned.

With large format negatives, prints are usually contact printed, and their resolution can be spoilt by insufficient contact between the negative and positive material. With SFAP the small negative has to be enlarged, and it is here that most problems usually occur!

Just as a lot of effort and expense has gone into providing high quality negatives, so must a similar degree of importance be placed on the purchase of a best quality enlarger/lens system. This is particularly so with roll film enlargers since they need to have an expensive condenser system (one that covers the negative with uniform illumination) and be fitted with a top quality lens. That is to say, a lens that is not only free from distortion, but is capable of projecting all the fine negative detail without a significant loss of resolution and contrast in the print.

Lens filters

The purpose of a lens filter is to isolate a certain spectral band of light (radiation) and allow only this band of light to expose the film. Filters are either dyed glass or dyed gelatin, and either can be used for SFAP. The advantage of using gelatin filters (between optical glass) is that they are much cheaper than glass types and can be interchanged as required. Another advantage is the very large range available. There are over 100 Kodak Wratten filters, for example.

The only filters used with colour films are those designed to block out ultraviolet radiation. They are often called 'skylight' or 'UV' filters (Kodak 1A) and are visually colourless. The exception are false colour films which are normally exposed with a yellow (Kodak 12) filter.

In general, all monochrome aerial photography is exposed via a yellow filter to reduce the effects of haze. From the ground (looking up) a clear sky is blue: from the sky (looking down) this same sky is called atmospheric haze, and is a prime cause of poor aerial photography.

Our atmosphere is formed of microscopic particles of gas and dust, industrial pollution, smokes, etc. Solar radiation is scattered by the atmosphere, with blue wavelengths being scattered most, thus forming the blue sky. By using a yellow filter (complementary to blue) the blue light is blocked from entering the lens and the haze light reduced. In exceptionally bad cases of haze, a red filter is sometimes used.

One of the major uses for filters is in multispectral photography (MSP) which is dealt with in greater detail in Chapter 14.

It is important to realise that filters do not work alone. The spectral sensitivity of a film also takes part in isolating bands of radiation. For example, a Kodak Red (29) filter used in conjunction with Kodak Plus-X film has a bandwidth of 100 nm (filter cuts in at 610 nm and the film cuts off at 710 nm), but the same filter used with Agfa-Gevaert Aviphot Pan 200 film will have a bandwidth of 150, because of the film's spectral cut off at 760 nm (where the visible spectrum ends and infrared begins).

Summary

Although typical 35 mm SLR's seem to have little to fault them (other than their very small format) there is yet another problem when comparing them to a standard mapping camera, and that is the nature of their shutter systems with respect to the moving image.

All large format mapping cameras have inter-lens shutters, and these complex shutters only manage to provide 1/1000 s exposures by an expensive rotary blade system for reducing mechanical inertia. Although 35 mm camera shutters can reach 1/12000 s, this is because they operate focal plane shutters which do not have inertia problems. But a focal plane shutter exposes the film in increments, and is likely to create linear image distortions since geodetic relationships are not imaged all at the same time!

Regardless of the type of camera employed it is always good practice to use the fastest shutter speed possible – to reduce apparent image motion on the one hand, and isolate camera vibration on the other. But if photogrammetry is anticipated then it is even more important, in order to reduce spatial distortions. However, this is not a significant problem with modern 35 mm cameras since high shutter speeds are usually gained with fast (vertically moving) titanium shutter blades, and the effect is almost instantaneous. But with medium format cameras a focal plane shutter has to move through a larger area, and distortion is likely to be significant unless the shutter blind is travelling fast.

Chapter 8

Electronic (digital) Imagery

Although the imaging industry has been relatively slow to move from analogue (film) to digital (electronic) systems, the writing has been on the wall for at least 20 years, ever since satellite imagery became a tool for earth scientists. Despite the very poor ground resolution involved in early LANDSAT imagery (70 m), there has been a steady growth in software and applications to the point where today, SPOT images (with 10 m resolution capability) provide very acceptable pictures and are a source of important information.

Although digital imagery may never compete with film in terms of resolution, it does have other advantages, not least the ease with which data can be processed, enhanced, analysed and presented through the agency of computers. Digital (satellite) imagery has become acceptable and useful for remote sensing applications, and is now increasingly attractive to a wider range of users. In desktop publishing for example, resolution and colour requirements are easily satisfied by digital imagery, leading to speedier and more economic publishing via fully computerised technology.

The advantage of having image points in digital form did not escape the notice of mapping communities for long, and for some years photogrammetrists have been converting conventional large format air films into digital data by the process of scanning. Since photogrammetry is a highly mathematical process it makes sense to have the raw data in digital form, and as soon as suitable scanning technology became available the industry started analogue–to–digital (A/D) conversion of their air films. From here, the A/D input can be processed analytically to provide a D/A output. There are two approaches to obtaining digital aerial photographs

- scanning of existing aerial films
- direct digital acquisition.

Digital scanning

As we know, photogrammetrists employ aerial photographs (diapositives) to form a three-dimensional model that can be processed to provide mapping data. Since this processing is undertaken by a computer, it makes sense to store the raw data in digital form by scanning the image so that each image point (pixel) is recorded in terms of its position and brightness. The size of each pixel is a function of the scanning aperture.

In digital form, image storage and retrieval is simple, economic and easily accessed. Apart from general image processing, there are also other advantages such as image compression, error correction and image enhancement to be taken into consideration.

Scanner technology

Scanning photographs is not new! Indeed, the early 'wired photo' employed by press agencies was 'scanned' by the simple process of wrapping a photographic print around a drum which, when rotated under a light-sensitive device, turned luminances into electrical signals that could be transmitted down a telephone wire. In more sophisticated form we have the modern drum and roller-fed scanners employing a photodiode sensor. A similar construction principle to the latter is used with telefax machines.

Today, the majority of professional scanners are of the flatbed type. The Canon IX-4015 for example, is capable of scanning images in 24-bit colour at 400 dots per inch (dpi). Nevertheless, a simple hand scanner can provide valuable copies from an original, as shown in Fig. 8.1 (*a* & *b*).

Figure 8.1 *(a) Original (enlarged) print from a 70 mm air film.*

Figure 8.1 *(b) Scanned copy at 2× magnification. Hand-held scanner: GENISCAN GS-B10 5GX. The 3.54 MByte file was printed by Canon BubbleJet BJ-10ex printer at 360 dpi. Image processing via Aldus Photostyler (V.1.1) with two applications of 'Sharpen Heavily'.*

Flatbed scanners.

Looking very much like a compact copying machine, the flatbed scanner is just a little larger than the size of the film (transparency) or print for which it is designed. The illuminated original is scanned by either moving the charge coupled device

(CCD) sensor head over the photo or moving the photo carriage over a static sensor. In the case of the Zeiss PS1 PhotoScan instrument (designed for 23 cm × 23 cm air film scanning) the exact position and orientation of the photo are determined by an interior orientation procedure which, during the scanning process, permits precise motion of the photo carriage in swathes in the photo coordinate system. Various A4 scanners (suitable for SFAP images) include the Kodak RFS 2035 colour scanner, capable of reproducing digital images with photographic quality.

Pixel resolution

Whereas the traditional concept of resolution is given in units of line pairs/mm (equation 7.10), in digital systems the basic picture element is called a pixel. Translating pixels into line pairs/mm would appear to be simple (in that two pixels can relate to one black line and one white line of a line pair) but research (Konecny *et al.*, 1982; Makarovic and Templfli, 1979) suggests this relationship to be more complex and, to a first approximation a better solution is:

$$1 \text{ line pair} = 3 \text{ pixels} \tag{8.1}$$

or

$$\text{line pairs/mm} = 1000/3.Px \ (\mu m) \tag{8.2}$$

For flatbed scanners it is usual to find that their quoted resolution is given in terms of dpi related to the size of the (CCD) sensor. To date we can expect the best quality colour scanners to offer a resolution in excess of 3000 dpi, typically with 35 mm scanners such as Kodak RFS2035 (2000 dpi) and Nikon LS-3510AF (3125 dpi). Although the Nikon scanner is not cheap (about $9750 US), it is well worth the price since it can correct for over- or under-exposure and expand vital shadow area contrast as required. In common with most scanners it has an 8 bit (256 tone steps per colour) A/D board, but this can be upgraded to a 12 bit (4096 steps) if required. A cheaper 8 bit 35 mm slide scanner is the Microtek (1850 dpi) which costs a third of the price, but is not in the same league.

One reason why 35 mm colour (diapositive) film is important to SFAP is that its images can readily be imported into high quality scanners, where software such as Aldus PhotoStyler or Adobe PhotoShop can be used to manipulate data for GIS or remote sensing. A significant advantage in using colour slide films is the large range of materials available – certainly sufficient to meet all possible SFAP requirements. As a consequence, they may well prove to be a major source of primary data, particularly since most scanners have a range of apertures that can be selected to suit the type of film being scanned.

Radiometric quality: brightness levels, ΔB

An important parameter in digital imaging is 'bit number' (mentioned above). Whereas the pixel defines spatial image dimensions, variations in grey scale (brightness) or colour are defined in bits.

Brightness and colour are subjective terms, however, and since we are concerned with colour (wavelengths) the subject should rightly be discussed in terms of radiometry. But since brightness and colour are generally understood concepts, we shall continue to refer to them in terms of *brightness levels* (ΔB), in either monochrome or colour.

Since our scanner looks at densities, its ability to differentiate grey/colour levels is really a question of separating out different density levels, but for convenience we can equate one with the other regardless of terms used. Nevertheless, it is important to emphasis that differentiating brightness is just as important as differentiating spatial detail – whatever the imaging process.

The bit (binary digit) is the basic unit of digital information (I) expressed in logarithms to the base 2, i.e.

$$\text{bit} = \log_2 I \tag{8.3}$$

If an image has only black and white points (like an ordinary newspaper photograph) then $I = 2$ and there is only 1 bit of data. But if there were, say, 4 levels of brightness (black, dark grey, light grey and white) then $I = 4$ and we have $\log_2 4 = 2$ bits. By convention 8 bits = 1 byte, and an 8 bit store of brightness corresponds to $2^8 = 256$ levels of grey, or colour.

But what is a brightness level? This question can only be answered in terms of signal to noise level (S/N), and in photography 'noise' is granularity (equation 7.7). Important research concerning this question (Hempenius and Xuan, 1986) indicates that granularity (G) and density range (ΔD) are key factors in digitising aerial photographs. Whereas it is entirely impractical and expensive to measure granularity, the need hardly arises since there are sufficient published values of G available for reference. The only remaining value needed to quantify ΔB is the density range (ΔD), which can be found from a conventional densitometer.

The number of brightness levels per pixel (bit number) is given by

$$\Delta B = \log_2\left(\frac{\Delta D \times 10^3}{2 \times G}\right) \tag{8.4}$$

where G has been measured using a microdensitometer with a scanning aperture of 48 μm diameter (Kodak granularity).

A typical SFAP negative may have a Kodak granularity of 15 and a significant density range = 0.9. Then

$$\Delta B = \log_2\left(\frac{0.9 \times 1000}{2 \times 15}\right) = \log_2\left(\frac{900}{30}\right) \approx 5 \text{ bits/pixel}$$

The total storage capacity, or image file (C), of a SFAP negative is the product of the bit number (ΔB) and the number of pixels within the image area. If the areas of the camera format and the scanning aperture are A and a respectively, then

$$C = \left(\frac{A}{a}\right) \times \Delta B = \left(\frac{A}{a}\right) \times \log_2\left(\frac{\Delta D \times 10^3}{2 \times G}\right) \text{ bits} \tag{8.5}$$

Using the above example for bit number, the total storage capacity of a 35 mm frame (36 mm × 24 mm) scanned with a 12 μm diameter aperture, is

$$C = \left(\frac{864\,\text{mm}^2}{144\,\mu\text{m}^2} \right) \times 5 \text{ bits } = 30\,\text{Mbits}$$

The same example, but with a 56 mm square format, will accept a total storage capacity of 109 Mbits.

The Kodak Photo CD system scans 35 mm colour images at three different scan aperture diameters: 12, 25, 50, 100 and 200 μm, the very coarse scan of 200 μm being used as a contact sheet overview. Photo CD images can be read by CD-ROM drives linked to PCs or Macintosh computers.

With a foot in each camp, Kodak have coupled their conventional photographic products to digital imagery and spent $34 million to promote the Photo CD system in 1993 alone! Essentially, a 35 mm colour film is sent to a high street photo lab where 36 images are transferred to a CD-ROM disc for about $28 US. Each disc can store up to 100 colour images (compressed from about 18 Mbytes to around 5 Mbytes) and is played back on the Photo CD player for a capital outlay of around $500 – $650 US.

At present only 35 mm originals can be used in Photo CD, but a Professional Photo CD system, capable of digitising film sizes up to 10 cm × 12.5 cm (with higher scanning resolution) is already available.

It is likely that scanned SFAP images will provide a useful data source for GIS applications, and one contractor in the USA (Landcare Aviation) has already proposed distribution of SFAP Photo CD imagery to county planners.

Pixel size and photogrammetric accuracy

Research into the statistics of positional errors suggests that when measuring features such as fiducial marks, a positional error of 0.18 times the pixel size can be expected from manually centring on a point (Trinder, 1987). The conclusions from this research also suggest that (ideally) pixel sizes in the region of 10 μm should be considered as necessary for photogrammetric operations. Automated centring does not suffer from this limitation, however.

Direct digital acquisition: (digital cameras)

At the time of writing, digital cameras suitable for SFAP are only in their infancy, and since experiments with 'frame-grabbed' video cameras have not proved useful (mainly due to inferior resolution) it would seem that future developments rest with CCD digital still cameras.

The advantages of CCD cameras, compared to conventional photography, include size, weight, dynamic range, optical sensitivity, stability, linearity and durability, all of which indicate that CCDs are excellent photogrammetric sensors. Nevertheless, they are limited by format, cosmetic quality (defects due to thermal effects, noise, etc.), and framing rate.

Currently, all CCD cameras are rather expensive and only a few are suitable for SFAP, particularly since their market is aimed at desktop publishing and studio photography. Although the majority have adequate spatial resolution, for aerial photography the major problem rests with the limited size of the CCD sensor array, which is rarely as large as the standard 35 mm format. Typical systems, such as the Kodak DCS 200 or DCS 420 cameras, use the M5 CCD chip (14 mm × 9.3 mm format) which, with its 9.2 μm pixels and good colour quality is an excellent sensor for many small format applications, but the small chip size is still a major limitation.

A truly expensive system could have a CCD array covering a standard 35 mm frame, with perhaps 10 μm pixels. But from equation (8.5) we see that this represents a total capacity of 69 Mbits (8.64 Mbytes) of data for an 8 bit/pixel (i.e. 2^8 = 256:1 brightness range), and file size now becomes a problem!

Colour imagery is produced by filtration of the individual CCD cells and subsequent interpolation of adjacent colours – each cell is filtered either red, green or blue, the software driver comparing the signals from adjacent pixels in order to interpolate and reproduce the correct colours. Colour groups are created within the CCD array (some systems use groups of four cells, one red, one blue and two green in a 2 × 2 matrix, with the two green cells helping to establish better colour response) so that colour cells are never further than 1 pixel away from each other. In this fashion 'colour aliasing' is reduced and resolution increased. In the Kodak DCS 200 and 420 cameras the driver also incorporates pre-set colour balancing correction to compensate for different lighting environments (always set for daylight with SFAP of course), the best results being achieved by choosing the 'click' option which neutralises the colour balance by the user 'clicking' on a grey element of the scene such as a road or runway.

Creating CCD colour imagery in this way suffers from two penalties:
- Since at least three pixels are required to form a colour group, the image resolution is reduced by $\sqrt{3}$ (1.732) from that of the monochrome resolution.
- The interpolation of three colour bands increases the image file size by a factor of three.

Strictly speaking a CCD digital camera only becomes 'digital' when the exposed array of CCD pixels is scanned by the camera's electronic system. Each pixel output is then given a digital (binary) code according to its strength (brightness) and its x,y position within the array.

The charge coupled device (CCD)

The charge coupled device is a shift register formed by a string of closely spaced metal oxide semiconductor (MOS) capacitors. It can store and transfer analogue charge signals introduced electrically or optically. When light is incident on a CCD array, photons cause a release of electrons from each MOS capacitor and a signal proportional to the radiation is collected in its potential well. Connecting up these capacitors and applying three step voltages to them (clocked in sequence) moves the charge-signal from well to well, each charge signal is thus 'coupled' through a line of MOS capacitors to the output diode, as shown in Fig. 8.2.

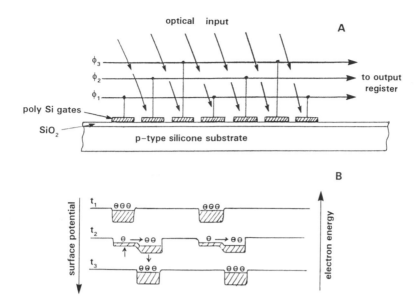

Figure 8.2 *Cross section of a CCD line. An image incident upon a CCD array (A) is transmitted to each MOS element (pixel) via its semi-transparent polysilicon gate. As a self scanned photo-sensor array, the CCD can store and transfer (under clocked pulses) analogue charge signals introduced optically at each MOS capacitor, by applying a step-voltage as the surface potential. A potential 'well' is created at each Si-SiO₂ interface (B), which is a negatively charged depletion region that can accept photons of light which release electrons, so that a charge signal is collected in the potential well. By connecting up MOS capacitors in groups of three, and applying three step-voltages to them (ϕ_1, ϕ_2, ϕ_3) clocked in sequence (t_1, t_2, t_3) each charge signal can be moved from 'well-1' to 'well-2' to well-3' to the output register. In this way the charge signal is 'coupled' through each line of an array of MOS capacitors.*

The CCD periodic clocks obviously introduce a time element to the system, creating possible framing-rate problems in aerial photography. Experiments with a digital air camera at IGN (France) showed that their 4096 × 4096 Pixel CCD array (7.5 μm pixels on a 3 cm × 3 cm chip) took 18 s to read and store a single image (16 × 10⁶ pixels) on a hard disc. In turn this could also effect the ground resolution in terms of ground pixel size (P_g) which is related to the image pixel size (P_i) and scale number (m) as follows:

$$m = \frac{P_g}{P_i} = \frac{S}{S'}$$
(8.6)

where S and S' are the sides of the ground cover and negative format respectively.

In order to investigate the unique problems associated with digital framing rates we must introduce a few survey mission parameters (detailed elsewhere in this book, pp. 173–5) at this point.

The time period (ΔT) between overlapping photographs is given by

$$\Delta T = B/V_{g} \tag{8.7}$$

where the aircraft ground speed (V_g) is given in m/s, and the base (B) is the ground distance between successive photo centres for a specific percentage of forward overlap (p) between photographs:

$$B = S(1 - p/100) \tag{8.8}$$

With $\Delta T = 18$ s, and V_g at say 50 m/s, the ground base (B) is 900 m. By taking p at the standard 60% we can then calculate for S, which comes to 2250 m. From our knowledge of S/S' we can use equation (8.6) to calculate scale (m_b), which comes to 75 000. This value can then be re-inserted into equation (8.6) to find the size of the ground pixel (P_g) from $P_g = m \times P_i = 75\,000 \times 7.5\ \mu m = 0.56$ m.

In short, CCD framing rates are an important (if unexpected) limiting factor for ground pixel resolution, and should not be overlooked when checking CCD camera specifications.

Information theory for digital imagery

In the photographic (film/print) domain, information is gained from both objective and subjective analysis.

- Objective data comes from such things as granularity (G), density (D), density range (ΔD), bar-G (\overline{G}), exposure scale ($\Delta \log H$), density gradient ($dD/d\log H$), wavelength (λ) and resolution (R).
- Subjective data is based on human visual perception, and includes terms such as contrast, definition, sharpness, colour, graininess (the subjective appearance caused by 'clumps' of granularity) and JNDs (just noticeable differences of tone or colour).

We feel more comfortable with objective values mainly because they can be quantified and compared. But since all photographic images are, in the end, viewed by the human eye – the subjective elements are never far away.

The main strength and purpose of digital imagery is its capacity for machine (computer) processing, where subjectivity is conveniently precluded from the final analysis. But if the digital image is to be printed (D/A conversion) then it will be viewed and, in turn, become subject to the same criteria as conventional photographs.

With the support of information theory it is possible to describe a digital image in terms of information (I) where

$$I = N \times \log_2 L \quad \text{(bits)} \tag{8.9}$$

and N is the number of individual pixels, and L the number of different luminances

(subjectively called a brightness) in the picture. In effect, equation (8.9) is the same as equation (8.5) where N is the equivalent of (A/a), and L the equivalent of ΔB. But here we can simplify theory by just accounting for N (pixels) and L (JNDs) regardless of how they are created.

Looking at equation (8.9) we realise that a digital image can possess the same amount of information (I) with different inputs. For example, an image may consist of an array of 32 × 64 pixels, each with 4 different grey levels (N = 2048 pixels, and $\log_2 4$ = 2) so that I = 4096 bits. But the same picture could be represented at half the resolution (N = 1024 pixels) with four times as many grey levels (L = 16) and again I = 1024 × $\log_2 16$ = 1024 × 4 = 4096 bits.

The two pictures may carry the same information, but when viewed, side by side will show the usual (subjective) differences, such as contrast and resolution.

Digital cameras

Up to a few years ago the largest available CCD imaging array was the 3 cm × 3 cm array employed in Loral Fairchild Imaging System (4096 × 4096 pixel sensor) with 7.5 μm square pixels. But with too many defective columns and a relatively low saturation level (about 6000 electrons per potential well) the system did not meet the specifications appropriate for SFAP (Thom and Jurvillier, 1993). However, it has been announced by the Canadian Company Dalsa, that a 5120 × 5120 pixel CCD array has been designed for aerial photography (Chamberlain, 1993). This new array, called 'Megasensor', is better than the Loral 4k system and has more appropriate parameters, such as 130 000 electrons for saturation level (full well capacity) and a framing rate of 1.8/s. Although the pixel size is now 12 μm this is perfectly adequate, the increased CCD saturation level being more important since this improves the dynamic range (S/N ratio) to 300, whereas that of the Loral was only 70.

Quite apart from future developments and possibilities, the only designed digital *metric* camera now available is the Zeiss UMK-Scan. But since it requires a total time of 7 minutes for a full (200 MByte) image format capture (on a highly stable platform) it is not useful for aerial photography.

At this time a number of digital cameras are being produced by, Kodak, Nikon and Canon, not all of which are useful for SFAP. However, the Kodak Professional DCS 200 and its successor, the DCS 420 (Fig. 8.3), are not only capable of providing useful SFAP imagery, but have been tried and tested in this field (DCS 200) and despite some limitations can be recommended for a number of applications.

The authors' main experience with digital SFAP has been with the Kodak DCS 200, and although this camera has now been replaced by the DCS 420 there is little basic difference between the two, in operational terms. Although the DCS 420 uses the same M5 chip as the earlier version, the main differences are an improved dynamic range (36 bit colour), a different host camera (Nikon N-90), a larger frame capacity (64 frames) and removable image storage with PCMCIA-ATA hard-disk cards.

Figure 8.3 *The Kodak DCS 420 camera. Based on the Nikon N90, the DCS 420 has a CCD pack and removable PCMCIA Hard Disk cards. Frame capacity is 75 photos per card.*

Kodak Professional DCS 200 and DCS 420 digital cameras

Although the DCS 200 and 420 cameras have a relatively small CCD array (9.3 mm × 14 mm) the M5 chip resolution is very good, with 1524 pixels (horizontal) and 1012 pixels (vertical) providing a total pixel capacity of 1.54×10^6 pixels. Each pixel is 9.2 μm square, giving a (film equivalent) resolution of 36 line pairs in monochrome and 21 line pairs/mm in colour. The image file sizes are 1.54 Mbytes monochrome and 4.5 Mbytes colour (Graham, 1995).

An interesting feature of the DCS 420 camera is that each colour has 12 bits, rather than the 8 bit colour allocated to the DCS 200. But the file size remains the same for both units since only the 'best' 8 out of 12 available bits, are taken from each pixel in the 420 system. In this way the DCS 420 has a much improved dynamic range with far better shadow detail than the DCS 200 model.

SFAP projects with the DCS 200 camera

As the authors have direct research experience with the DCS 200 system we shall concentrate on this (no longer manufactured) camera, knowing that the DCS 420 camera is little different, except where specific important differences are mentioned.

The DCS 200 allows an image to be directly imported into the host computer (Mac or PC) enabling the operator to view, store, analyse, manipulate and print with ease. Two versions are available, monochrome or colour, with the former providing an exposure index range of 100–800 and the latter of 50–400. Unlike still video systems, the DCS 200 digital camera does not require a frame grabber or other special equipment.

The DCS 200 uses an unmodified Nikon 801S (35 mm SLR) camera body which retains all the usual features of this popular camera and, like the 420 camera, has a published framing rate of one picture every 3 s (4 s is a more realistic figure).

The minimum recommended computer memory is 8 MByte of RAM, and if used with IBM-compatible hardware a Kodak SCSI host adapter kit is required. A maximum of 50 images can be stored internally, and when downloaded into the Macintosh Quadra 900 a full resolution, 24 bit image file (one photo) takes about 40 s.

The full range of Nikkor lenses can be used but since the CCD M5 image sensor is only 9.3 mm × 14 mm it effectively multiplies the focal length by a factor of 2.5. For this reason the camera is supplied with a 28 mm f2.8 Nikkor lens as standard.

The current price of the DCS 200 is between $7500 US (monochrome) and $10 000 US (colour). Four models are available: top of the range is the DCS 200ci, a colour version with a 50 image internal storage. The DCS 200c is a single image colour model. The monochrome versions are DCS 200mi and DCS 200m.

The DCS 420 comes in three types, the colour version 420C (priced at something over $12 000 US), the 420M (monochrome) and the 420IR which is an infrared version highly suitable for remote sensing operations (see Fig. 8.4).

Recent airborne experiments have convinced the authors that the Kodak DCS 200ci camera shows considerable promise for future digital SFAP applications.

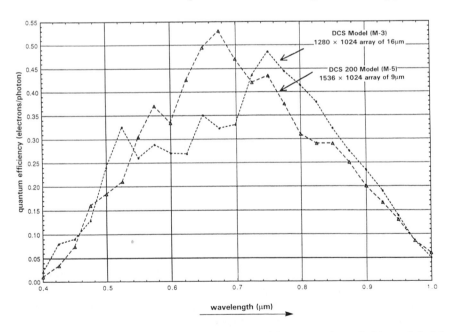

Figure 8.4 *CCD Spectral Response curves for two Kodak Imager Chips: the M-3 and the M-5. The M-5 chip is incorporated in the DCS 200 (no longer produced) and its successor the DCS 420. The DCS 420 pixels are of 9.2 μm size, and in an array of 1536 x 1024 pixels. Note the useful daylight response and its extension into the near infrared (very similar to that of Kodak's 2424 infrared film) which makes it useful for MSP work.*

However, the current framing rate of this camera is far too slow (one photo every 3–4 s) to allow it to be used at its full potential.

In the realm of aerial photography 36 line-pairs/mm is not bad! It implies that image detail separated by 3 pixels (27.6 μm) will be well resolved. At a scale of, say, 1:10 000 we could expect to resolve 276 mm of ground detail – sufficient for most urban survey requirements! But the problem is that it takes a full 4 s to download the CCD image into the camera's hard disk, and this is too long if we require stereoscopic cover (60% overlap) at large photo scales.

Flight planning for the DCS 200 has to take the framing rate into first consideration (T = 3 s) and for a nominal ground speed (V_g) it is then possible to determine the base (B) between consecutive photos.

In our experiments a Cessna 337 was to be flown at 100 knots (about 50 m/s) and the base ($B = V_g \times \Delta T$) came to 150 m. Having found B the associated ground coverage of side (S) was determined from the formula $B = S (1 - p)$ where p is the percentage of forward overlap (60%). Re-arranging, we have $S = B/(1 - 0.6) = 150/0.4$ and $S = 375$ m. Since the scale number $m_b = S/S'$, and since S' is the side of the (advancing) image frame (here taken as 9.3 mm) the scale was found to be 375 000 mm/9.3 mm = 40 322.

The DCS 200 was fitted with a standard 28 mm Nikkor lens, so the flying height was calculated as $H_g = m_b \times f = 40\ 322 \times 0.028$ m = 1129 m (3700 feet). Although in theory we could have flown at 10 000 scale and resolved ground detail as small as 27.6 cm, in practice we had to fly at 40 322 scale (for 60% forward overlap) with a corresponding ground resolution in excess of 1 m (*see* Chapter 19).

Fortunately, a great deal of SFAP does not require stereoscopic cover, and so the foregoing conclusions can be ignored. In this case, since we needed to check digital stereo quality we were constrained to the small photo scale of 1:40 000.

Digital image processing

Just as conventional (analogue) photography requires various processing stages, so do digital images. But the parallel stops there! The fact that no darkroom is required and that the entire process can be carried out by computer makes it a whole new ball game.

While displayed upon the monitor, an image (or images) can be manipulated in many ways, more rapidly than with photography and with greater ease and less space. Images (monochrome or colour) can be rotated, merged, enlarged, enhanced and processed to an extent as varied as that with photographic processing. With pointing accuracy a specific image detail can be enlarged and its pixels counted to measure the size of the object under scrutiny.

Although print quality (monochrome or colour) is a function of the price and quality of the printer, very reasonable images can be produced from relatively inexpensive printers. In Fig. 8.5 for example, we have a DCS 200 photo of St Neots (Cambridgeshire) printed on a HP 560c Deskjet printer. The photo scale was about 1:40 000 but at the printer the scale was enlarged 20 times (1:2000) on to HP glossy paper. In many ways digital image printing can be compared to photographic tech-

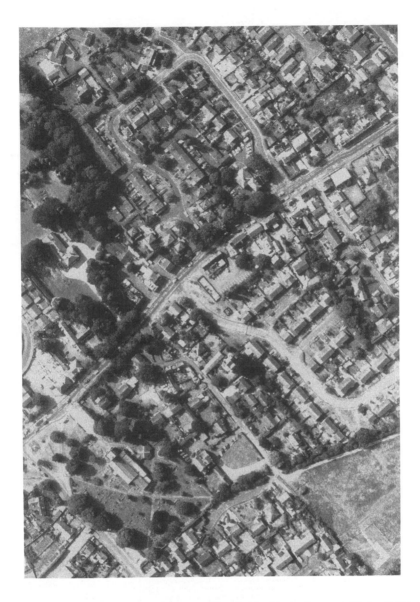

Figure 8.5 *Kodak DCS 200 image of St Neots (Cambridgeshire), taken at 3600 feet (1100 m) amgl with a 28 mm lens. Camera scale approx 1:40 000 printed to a photo-scale of 1:2000 at 300 dpi. Image processing (Aldus Photostyler 2) provided extra sharpening and contrast. (Photoair: Jon Mills and Ron Graham, 1994).*

niques, where print quality depends upon iterative testing before the final result is acceptable.

The photo shown in Fig. 8.5 is an 8 bit greyscale image enhanced with a *sharpening filter* (level 2) and processed to give *increased contrast*. The image processing

software was Aldus Photostyler (Version 2.0), and just like its photographic counterpart, has to be worked at to gain good quality – which required practice!

Figure 8.5 is one of a number of digital images flown with a DCS 200 owned by the Department of Surveying, University of Newcastle upon Tyne, where, under

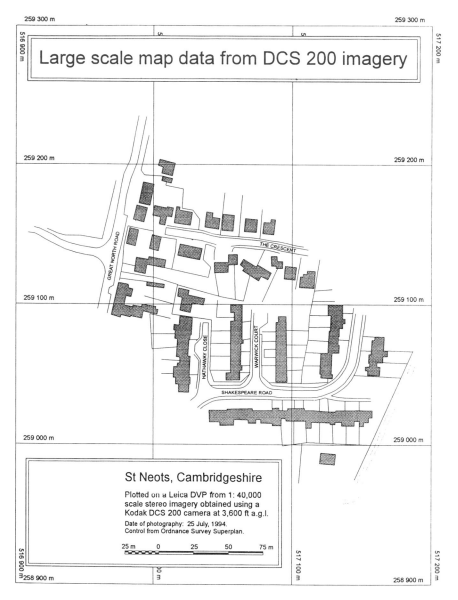

Figure 8.6 *Large scale map data of St Neots (Cambridgeshire). Original DCS 200 camera image recorded at a scale of approx 1:40000 and processed by soft-photogrammetry to a scale of 1:1650. Plotted on a Leica DVP plotter. (Image processing by Jon Mills, University of Newcastle-upon-Tyne).*

the supervision of Ian Newton, research projects are being conducted with this camera. The St Neots photography was undertaken by Jon Mills, University of Newcastle upon Tyne and Ron Graham, mainly to establish the possibility of using the DCS 200 for large scale mapping (Graham and Mills, 1995).

From the line overlap containing Fig. 8.5, Jon Mills also plotted an adjacent image to produce the large scale map (1:1650) shown in Fig. 8.6. The image was edited first in AutoCad, then in CorelDraw, before plotting on a Leica DVP to provide an excellent revision for the Ordnance Survey 1:1250 sheet.

The full colour (24 bit) low oblique shown in Fig 8.7 (*see* colour section), was exposed just after take-off (about 600 feet, 180 m) using the DCS 200 camera and, like the verticals of St Neots, was downloaded (with image compression) to a 486 PC and saved on a single floppy disk. Image processing was done through Aldus Photostyler (Version 2.0) with sharpening at level 2. Printing was done on an HP 560c Ink Jet Printer (300 dpi) which, like most colour printers, converts the red/green/blue (RGB) image to complementary colour inks. Four colour printing is necessary in order to get a good black. The four colours are cyan, (C), magenta (M), yellow (Y), and black, (K), so the process is known as CMYK.

There can be no doubt that direct digital imagery will progress rapidly, despite the current limits of format size. In astronomy for example, where CCD sensors have been used in telescopes for many years, mosaic arrays are now manufactured by butting individual arrays together to form larger (60 mm^2) mosaics with 100 μm gaps. Although such gaps are unacceptable in SFAP, it is only a question of time before they are reduced to acceptable proportions.

Chapter 9

Camera Platforms

A very basic statement can be made as we start to look at camera platforms: 'Every type of aircraft has at some time or another been used as a camera platform'.

Even the Wright brothers, early aviators, were sending cameras into the air suspended under kites, balloons, (gas and hot air), rockets, and even pigeons! Probably one of the largest 'aerial cameras' was a balloon-borne contraption with a 2.4 m × 1.35 m glass photographic plate format and weighing 400 kg. This was used to photograph the great fire of San Francisco on 18 April 1906. Probably the very antithesis of SFAP!

Platforms currently available

As we approach the end of the twentieth century, the range of aircraft available is probably greater than ever, despite the fact that most American light aircraft manufacturers were forced to discontinue light aircraft production in the late 1980s, due to swingeing product liability laws and law suits paying astronomical damages. Almost as a natural compensation for this, an increase in the numbers of new homebuilt light aircraft designs came about, including composite structures flying at up to 345 knots (640 km/h), performances unheard of only a few years ago.

Most SFAP work is done from hired flying club aircraft from the major manufacturers, Piper, Cessna, and Beechcraft, although considerable work has been done to prove the effectiveness of microlight (or ultralight) aircraft. Homebuilt aircraft are becoming more popular, and already several examples have been constructed with vertical aerial photography in mind although this process requires dedication and considerable investment in time and money. In addition a good knowledge of the legalities involved in the use of 'experimental' aircraft is required.

It is impossible in a publication of this nature to list and review all available camera platforms, but we can describe general types, attributes and range of performance characteristics as a small format layman's guide. In addition we can look briefly at how aircraft operating costs are calculated so that users of small format can weigh up the options with regard to hire or eventual ownership.

Given that the accepted requirements of SFAP are as an alternative to normal large format tasks, done for improved economy and with available 'local' aircraft being used from relatively low level, this will keep our lists to a comfortable size.

Platform selection is related to basic requirements. Air law dictates that certain

minimum altitudes must be maintained, depending on the type of area being overflown. To carry out low level tasks at large scale, flight altitudes below the legal limit are sometimes necessary, especially in the archaeological and environmental fields. Alternatives to aircraft are sometimes called into play in these cases, such as telescopic masts (manual or hydraulic) for use up to ±30 m, and Simons platforms, the large elbow-shaped vehicle mounted units (cherry pickers) used by fire services and electric companies for high access to buildings and street lamps.

Balloons

Above 50 m another ground operated camera platform is the simple advertising 'barrage' balloon. These helium filled balloons come in various sizes and can be hired by the day or purchased if the requirements justify (Pitt and Glover, 1993). Depending on the camera weight, a medium sized, (3–5 m) balloon can be used to fill the gap between the larger platforms and the minimum aircraft altitudes. With a little mechanical ingenuity a good camera rig can be put together. A simple version can be made using a bicycle wheel rim, suspended by thin cables from the balloon lifting points (loop panels attached to the main balloon fabric). A motorised turning mechanism using roller bearings on a frame inside the wheel can give the operator the possibility of aligning the camera with the subject. Camera and mount rotation control can be operated by cable going up to the balloon and down the tether cable or, more commonly, by simple model aircraft radio control.

Sometimes a secondary tilt mechanism will be incorporated to enable oblique pictures to be made. With advent of miniaturised closed circuit television, it is now possible to align the camera directly with the use of a small video monitor (Morlan, 1993) whereas previously the operator spent considerable time in leg work, trying to align the camera with the use of binoculars and a lot of trial and error. There are certain limitations with regard to local byelaws and it is always advisable to notify the local police department when a balloon flight is being arranged. (Balloon and kite operations are forbidden by law in the vicinity of airports.) Wind is the major problem with balloon operations: even with stabiliser 'ears' they tend to oscillate at anything above 5–6 knots (10 km/h). With patience very good results can be obtained.

Model aircraft

Much has been written about the use of model aircraft and helicopters as camera platforms. Whilst the concept is well tried and proven in military remotely piloted vehicle (RPV) technology, at the non-military and lower budget SFAP end there are certain reservations. The main one is that of experience requirement in model aircraft flying. In order to position a model-based platform accurately with radio control, a considerable practice time must be allowed for. This means time and money spent in building and flying your own constructions – few modellers will allow beginners to practice on their precious creations, so there are few short cuts. Then a substantial platform must be built, again depending on overall system weight, and your precious photographic equipment trusted to balsa, solarfilm and radio

control. Model helicopters are a more daunting prospect and in themselves, fairly hi-tech pieces of engineering. Costs in both acquisition and modification are higher for rotary wing models and training time somewhat longer to achieve 'safe' proficiency.

All in all, the total investment in money and time in model-borne platforms, for a complete beginner, may be prohibitive. It takes considerable courage to launch hard-earned photo equipment on model wings for the first time (Walker, 1993).

Microlight aircraft

At the lower end of the aircraft spectrum the relatively recent sport flying development, the microlight or ultralight, has already found a niche in SFAP work. The first microlights appeared at the end of the 1970s and developed in various ways throughout the 1980s. The bizarre creations of the early designers, tail-less biplanes, extended canards and weight-shift Rogallos, have gradually given way to more conventional (and controllable) aircraft.

There are two main categories of microlight, the weight-shift controlled 'trike' and the more conventional three-axis (rudder, elevator and aileron) fixed wing aircraft. In the former, the occupants sit in a cockpit unit suspended under a large triangular aerofoil wing. Attached to the wing is a rigid control-bar. The pilot moves the pivoted cockpit unit forward, backward, and side to side against the bar, using the changes in weight and centre of gravity to control the flight. Powered usually by small two-stroke engines, the trike is probably the most popular vehicle in the light sport flying world, but as a camera platform for vertical photography it cannot be recommended (and we *have* tried) since the cockpit is rarely kept vertical while controlling flight. Vertical survey photography might be possible with a fully stabilised camera mount attached directly to the wing frame, but the correction range would need to be very wide. Nevertheless, trikes make excellent platforms for oblique photography, observation and patrol tasks.

The three-axis microlights are virtually scaled down fixed wing aircraft and lend themselves well to SFAP tasks. A common machine which has found favour in SFAP circles is the Thruster (Fig 9.1, *see* colour section) which, with its wide fibreglass floor and frame structure, is easily adaptable for vertical camera installations. Since 1982 the authors have flown a considerable number of research programs with the Thruster, and many other types, mainly in establishing mounts, sights, camera combinations and flying techniques (Graham and Read, 1984; 1986). The Thruster has good 'rough field' capabilities (Graham, 1987) and with a maximum take off weight (MTOW) of 360 kg takes only 110 m to clear 15 m, in still air. Like most microlights it can be transported by trailer to many regions of the world where aerial photography would be otherwise very difficult, if not impossible! Indeed, some microlights can even be transported by car (Fig 9.2), or even by small boat.

Although microlights have their limitations, they should not be dismissed too readily. The Thruster is a relatively old design, but has proved itself to be a highly reliable platform for SFAP. Powered by a 60 hp Rotax engine it has a useful 3 h

Figure 9.2 *The Eagle microlight (like many) can be transported by car from site to site.*

duration and, with a crew of two, can be flown accurately for small (2–3 km²) blocks, providing that winds are not in excess of 12–15 mph (15–25 km/h). A small metric survey experiment, conducted in cooperation with the UK Ordnance Survey, used a calibrated MK70 Hasselblad and Thruster (Graham, 1988) to prove the value of SFAP operated from microlight platforms (see chapter 16). The same aircraft continues to be employed for similar experiments, using the Kodak DCS 200 digital camera mounted aft of the cockpit (Graham and Mills, 1996).

Three-axis type microlights have developed to such an extent that some have to be classed as light aircraft, depending on their maximum all up weight (MAUW). Currently, the European definition of a microlight is 450 kg MAUW plus a minimum speed requirement.

Of the numerous three-axis types (either in production or in kit form) the CFM-Shadow deserves special mention. This aircraft can be purchased either as a microlight or as a light aircraft (Streak Shadow), depending mainly upon its MAUW. The Shadow microlight (Fig 9.3) has a remarkable record – it can cruise for over 500 miles (800 km) without refuelling, reach an altitude in excess of 25 000 feet (7600 m), has a speed range from 30 to 80 mph (50 to 125 km/h), can be trailer transported (in dismantled form) and re-assembled in 10 minutes, and is a delight to fly. The Shadow is spin-proof, virtually stall-proof, highly stable and with dual controls – an ideal training aircraft (Graham, 1988). It has been used many times for air to air movie work, aerial surveys, remote sensing (thermal imaging) and crop dusting (depending on the civil aviation laws of the country concerned). At a price of around $30 000 the Shadow is excellent value for SFAP.

A third type of microlight has recently come into being, the single (or twin) seat powered parachute variation. As its name suggests, this is merely an aerofoil wing parachute which, using a small two-stroke engine, can climb and fly at about 30 knots maximum (in still air). The flying phase of the Vinten shutter experiments (*see* Appendix 7) were undertaken with the Kestral Powerchute shown in Fig. 9.4. The Kestral forms a useful (if limited) platform, and is currently in service with a

Figure 9.3 *The CFM Shadow is a microlight aircraft, but when powered by a slightly larger engine it must be registered (in the UK at least) as a light aircraft.*

Figure 9.4 *The Kestral Powerchute. This microlight (shown with its chute deployed ready for take-off) is fitted with a Vinten 70 mm air camera (situated below the pilot's left arm), two-way radio and GPS unit.*

number of military forces in more than 20 countries worldwide, including the British Royal Air Force. In Fig. 9.4, we see the parachute ready for take-off and the pilot loaded with radio and GPS. The Vinten camera (under test) is vertically mounted in the frame, just below the pilot's left arm.

Again there are legal limitations on the use of microlight aircraft in that, at present, it is not possible to qualify for a commercial pilot's licence on the type. This means that if any commercial photographic application is considered it should not be flown with a microlight (in the UK at least). Microlight pilots are not allowed to fly for 'hire and reward', which means that no money must change hands in payment for the flight or resulting photography. There are also other airspace restrictions applied to this form of flying, with rules and regulations regarding pilot licencing and airworthiness requirement varying from country to country.

Single-engined light aircraft

The next step up is to single-engined conventional light aircraft, i.e. those operated under full civil aviation rules and capable of being used in all normal civil airspace. In most cases these are used for commercial purposes. Once more, there are several categories and basic configurations which dictate their degree of usefulness as SFAP platforms, *see* Appendix 8.

The position of the wing relative to the fuselage is the prime aspect governing suitability for SFAP.

High-wing aircraft such as the Cessna 150 and the larger 172 (Fig. 9.5), the 180/185, 206, 207, 210; the Piper Cub, Aeronca Champ, Auster/Beagle and the much larger Pilatus Porter are ideal platforms for oblique aerial photography, and can be easily adapted to vertical SFAP either with built-in camera holes or internal/external mounting platforms. Yet another highly useful aircraft is the Polish 'Wilga'. Robust and easily modified, this aircraft has also been built under licence in Indonesia where, with a Lycoming engine it is known as the 'Gelatik': see Fig. 9.6, and Fig.

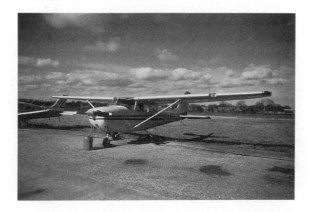

Figure 9.5 *Cessna 172 (four seater).*

Figure 9.6 *The Polish Wilga or Gelatik aircraft.*

12.12. Aircraft such as the C180, 185, 206 and Pilatus Porter are also frequently modified for large format camera operations.

The very popular Cessna 172 can be camera configured in many different ways, and one of the more obvious options for locating a vertical camera is inside the luggage compartment, as shown in Fig. 9.7. With a single-engined machine there is always the problem of engine fumes (or oil) streaking under the fuselage during flight, and since the camera hole is in direct line it is necessary to protect the camera lens. A typical protective flange associated with a 172 baggage location of a Vinten 70 mm camera is shown in Fig. 9.8.

The good visibility of high-wing monoplanes makes positioning over the target reasonably simple, and the higher the aircraft's weight the better its stability as a

Figure 9.7 *An obvious location for a vertical camera fit is in the Cessna 172 luggage compartment.*

146

Figure 9.8 *Protective flange positioned in front of a Cessna 172 camera hole in order to deflect engine oil streaming on to the camera lens.*

camera platform. For oblique photography the Piper Cub and Cessna types can be flown with side windows opened upwards to give an unobscured view. Even flying with a side door removed presents no problem, except of course in winter!

There are several aircraft in the 'home-built' category that are also very usable for SFAP although restrictions as to commercial use apply in the same way as with the microlight. The high-wing Canadian (Murphy Aviation) 'Rebel' aircraft (Fig. 9.9) has already been modified for scientific research (the Local Earth Observation, LEO project) and has excellent short take off and landing (STOL) characteristics. The Rebel has been modified with a large open hole behind the pilots' seats capable of taking all manner of mountings (including the Bochum mount shown in Fig. 10.3 and can be fitted with a number of different types of engine providing speeds up to 170 km/h.

Other types of homebuilt, such as the Avid Flyer, Zenith 701 and Kitfox are in production in large numbers and will provide economic and effective camera platforms.

Figure 9.9 *Canadian Murphy Aviation Rebel aircraft.*

Low-wing aircraft, such as the Piper Cherokee, Archer, Tomahawk, Saratoga and Comanche, Beech Musketeer and Bonanza, Aerospatial Tampico and Tobago, and Grumman AA series are not ruled out for aerial photography, but they do present more problems. Obliques can be done but the presence of the wing means that the pilot must bank more steeply into the target than he would with a high-winged aircraft, so that the camera has a clear view. This type of work takes considerable practice and team work on behalf of pilot and photographer if accuracy is to be sustained.

As slow flying is a necessity, making tight turns at what is usually low level can be a hazardous occupation, the stalling speed rising as the angle of bank increases. If a turn is entered too slowly and the bank increases, a spin can accidentally be induced with disastrous consequences. With the attention of the crew being concentrated largely outside the aircraft, extra attention is needed to monitor airspeed at all times!

An additional problem occurs in low-wing aircraft when we wish to make modifications for vertical SFAP. Usually the control and trim cables for rudder and elevator pass along below the floor of the aircraft with a series of bell cranks and rollers, and mostly on the centre line. The main spar of the wing and other wing bracing structures will pass through the cabin: just depending on the size of the engine and the number of passenger seats, the centre of gravity defining its position. This means that any available space for possible camera hold modifications will be much reduced, especially if the outside skin of the fuselage is part of a rigid bracing structure. Unless the cabin extends back beyond the trailing edge of the wing, and internal/external type of camera fitting cannot be considered, so the low-wing aircraft may not necessarily be our first choice for vertical aerial photography.

As with high-wing aircraft types, many single-engined low-wing homebuilt aircraft kits are available, including various 'canard' versions of the original Rutan designs. The difference in this category with the high-wing homebuilts is that most of the present generation of composite low-wing aircraft are built for speed and two/four seat touring purposes, as well as being considerably more expensive. Although designing in a camera modification at an early stage would be structurally straightforward in engineering terms, the 'experimental' nature of the licencing procedures might bring its own problems. Unless the user/builder was fairly experienced and was moving into fairly sophisticated GPS controlled SFAP operations, taking on the problems of additional airworthiness checks might be rather risky. Once again, remembering that commercial operations would not be permitted unless full certification had been obtained, this can be an expensive and time-consuming process.

The low-wing aircraft has the advantage of better handling capabilities in windy conditions, and many pilots prefer the better upward visibility for general flying, especially in the vicinity of airfields. Once modified for a vertical installation, especially if a GPS system is being used, there is very little to chose between high-wing or low-wing aircraft once over the target area.

In order to carry out aerial photography over any terrain and in any airspace, the step up is a twin-engined aircraft.

Twin-engined light aircraft

Once again we have the high-wing or low-wing choice, although there are fewer available high-wing twins than low-wing types, (*see* Appendix 8).

The most economic high-wing, light twin is the six-seat Italian Partenavia. This has been a very common big camera survey platform since very early in its development, the ninth production aircraft being the first modified. Easily modified for SFAP, the Partenavia also has a high visibility variant with a complete perspex nose section called the Observer making it very suitable for low level visual navigation tasks. Cessna only produced one high-wing twin, the twin-tailboomed 336 Skymaster (and its retractable offspring the 337 Super Skymaster), also commonly modified for large format aerial photo. With many examples still flying and in private and club ownership, they are readily available for SFAP users (Fig. 9.10). The British Britten-Norman (now Pilatus) Islander is a more rugged utility aircraft which can be modified for two full-size aerial cameras. With a very simple floor structure, small format camera ports are no problem to install. The Rockwell/Aero Commander 500 Shrike also found a place in large format work and is often available for small format tasks.

Light low-wing twins were produced in great abundance by the major manufacturers including the Piper Aztec, Seneca, and Twin Comanche, Cessna 310 and 320, and Beech Duchess, Baron, Twin Bonanza and Duke. All are similar in general performance, and each modifiable to some extent for SFAP, and for many years also the basic workhorses of many large format mapping companies. All of these manufacturers produce larger 'cabin class' twins, piston and turbo-prop, which tend to be the major big, single- and double-camera platforms of most of today's survey companies. See Appendix 8 for listing, specifications and performance figures.

Figure 9.10 *Cessna 337G (Skymaster) twin engined (push-pull) survey aircraft.*

Economics

In looking at such a wide range of aircraft, it should be borne in mind that most SFAP operations are 'opportunist' in that we start by using a suitable, readily available aircraft to carry out a specific, required task. Subsequent tasks then continue, based on the experiences gained. Thus the luxury of choice in aircraft is rare. The costs play an important part in many cases, and the amount of work being done and expected to be done will relate to whether casual hiring, aircraft purchase or some group operational arrangement be chosen. With used microlights being available for $6000 US or so, the simplest used light single-engined aircraft from $15 000 US and light twins from $25 000 US, it may seem an attractive proposition to invest in some sort of 'own' aircraft. (It should be mentioned at this point that to buy an aircraft to use solely for SFAP, without possible alternative uses, should only be done on the basis of proven experience and not as a speculative investment).

The purchase price of an aircraft, even a microlight, is only the starting point and some background information on how costs of aircraft operation are arrived at may be useful.

Aircraft costings are divided into two categories, *fixed annual costs*, and *direct operating costs*. If we take these in order and analyse how they are arrived at we can eventually come to a cost per flying hour based on annual utilisation.

Fixed annual costs

- *Amortisation* is the depreciation cost broken down to an annual figure. For SFAP we are generally dealing with older second- or third-hand aircraft that have virtually levelled off in price, so it is not easy to set a realistic figure. A new aircraft we can assume that over 10 years we could expect something like 60–70% depreciation from new price. For example, a $100 000 aircraft could be expected to fetch only $30 000 to $40 000 after 10 years, an annual depreciation of $6000 to $7000 per year.
- *Insurance* is also a major annual costing. Aircraft insurance is fairly complex and varies across a wide spectrum of aircraft types, uses and operators. In the light aircraft field a basic 'hull and primaries' premium of somewhere in the region of 7–10% of the aircraft value can be expected, although this will vary depending on base airfield (from farmer's field to major airport), number and experience level of potential (named) pilots, and expected types of operations. If training is being carried out then higher premiums will apply. If a single pilot is named, with high experience, operating from a medium size, runwayed airport, with full year-round hangarage, then the premium can be expected to be far lower than an operation involved in *ab initio* training and private pilot hire.
- *Hangarage*, if applicable, is also charged annually. This charge also covers parking if the aircraft is kept outside, which, although cheaper at the outset, will result in higher maintenance bills for airframe and avionics than a fully hangared aircraft in the long term. This figure will also take into account any handling charges over and above the basic hangar fees, as well as any pro-

jected 'away from base' parking, hangarage and handling at estimated higher charges. This may be just a percentage mark-up as a contingency measure.

- *Annual maintenance* costs to cover any annual inspection and preparations for the award of the certificate of airworthiness, as well as the inspector's costs are taken as a single figure (based on previous year's figures). (If the aircraft is operated on a three-year Certificate of Airworthiness or on a Permit to Fly then these costs will be averaged over the licence period.). An additional premium is often added to this item to cover the administration costs in the overall aircraft operation.

- *Crew salaries/expenses.* In a professional operation a commercially licenced pilot would be available and can either be charged for on a full time basis, if that is his or her only function, or on a percentage basis, if working on more than one aircraft, or having other in-company duties. If the aircraft is being operated privately and owner-flown then this figure would not apply. If an occasional flight requiring a commercial pilot is carried out then the fee would be set down against the direct operating costs.

- *Miscellaneous* costs cover any number of additional charges. Aircraft operation, like many other machine-related occupations, can be very expensive and costs can come from many directions. It is useful to make a comparison with car owning and operating to bring the subject into perspective. Although each of us knows what our motor vehicle costs and how much we pay in insurance and for road fuel, very rarely do we sit down and total up all of the incidental charges, depreciation, parking fees (fines?), road fund licence, accessories, repairs, and other consumables. If we did make such calculations and then arrive at a cost per kilometre, we would probably find it hard to justify continued use of our precious toy for any but the most unavoidable of journeys.

Direct operating costs

The second segment of aircraft charges, *direct operating costs*, is a little easier to define and more understandable. Each hour we fly will cost a certain amount in fuel, oil, landing fees, and maintenance of airframe, engine and avionics (aviation electronics) and these must be calculated carefully.

- *Fuel* is the first item and we must arrive at an accurate figure which represents as near as possible the actual consumption of the engine(s) over a normal period. As with a motor vehicle, fuel consumptions vary. In cars we gauge town driving, long distance high speed driving and normal economy driving as three categories. If we do prolonged town driving then our consumption will be higher than in the other two categories, and so on. With aircraft, if we are doing short circuit training flights with continuously changing power settings then our fuel consumption per hour will be higher than if we are flying cross country for several hours. Similarly, lower percentage power settings for survey flights will be a different figure again. So, we have to come to an average, across the year, consumption to use as a basis, although a slightly generous rounding up is recommended.

151

- *Oil* consumption will vary, as in road vehicles, depending on age and state of health. (This figure only includes the additional oil added between checks: the 50 and 100 hour checks already include the initial filling of oil.) Once again an average will be arrived at, spread across each different type of expected operation.
- *Scheduled maintenance* covers 50 hour and 100 hour inspections done by a licenced engineer or aircraft maintenance company. The basic 50 hour check covers oil change, plug inspections, airframe inspection, wheels, brakes, and other safety items, and will take half to a full day on most light aircraft. This will normally have a fixed cost to include oil and other lubricants, any filters, seals, etc., listed on the inspection schedule with other replacement items found necessary added as extras. This fixed figure will be divided by 50 to give the hourly rate.

 A 100 hour check is more complex and will involve all of the items in the 50 hour test plus full inspection of all controls, cables, sand-blasting or replacement of plugs, gear retraction tests (if applicable), and removal of all inspection panels, electrical inspection, avionics and full engine running and systems test. This will normally take twice as long as a 50 hour check and will be priced accordingly. The check rotation runs 50, 100, 50 100 and so on. The same charging system applies, and the average check cost divided by 100 becomes the hourly figure.

 Aircraft accessories are 'lifed', meaning that they must be replaced or fully overhauled at certain intervals, depending on the item. The overall life of a component and its replacement cost must be broken down to give an hourly figure.
- *Engine* replacement is the major item in aircraft operation. All aircraft engines have a pre-determined figure arrived at by licencing authorities in consultation with engine manufacturers and maintenance organisations, based on long-term records of actual installations of each specific engine type. Most light aircraft engines used in SFAP are lifed at anything from 1200 to 2000 hours, providing of course that all maintenance inspections are carried out and that any airworthinesss directives are complied with. When the life figure is reached the engine(s) can either be replaced by a new unit, by a remanufactured, or reconditioned unit, or the existing unit can be rebuilt to zero life specification for a further 'life'.

 Depending on which option is taken up, (a considerable price range applies), the replacement cost will be divided into the number of hours of the life applicable and the figure added to each aircraft flying hour. (A wise operator will keep a 'replacement fund' going as flight hours are made so that funds are available when the big expenditure comes around.)
- *Avionics* normally have no life requirement, and present day radios and navigation aids are extremely reliable. There will of course come a point when repair or replacement will be necessary and in order to anticipate that day, we must charge an hourly amount which will cover costs. This will of course depend on the amount of equipment fitted, the age and value, and the type

Table 9.1 *Aircraft operating costs, including pilot's salary*

Fixed annual costs		$
Amortisation:	$100 000 reducing to 35% over 10 years: $65 000/10	6500
Insurance:	Hull and primaries, 10% of value (variable)	5000
Annual maintenance:	Preparation and issue for C of A	2000
Salary (minimum crew):	Pilot at $22 500	22500
Hangarage/parking:	$150 per month	1800
Miscellaneous:	Cleaning materials, transportation, labour, etc.	1000
	Total	38 800

Direct operating costs

Fuel:	8 gallons per hour at $4 per gallon	32
Oil:	1 pint per hour	5
Scheduled maintenance:	50 h at $600, 100 h at $110: $1700/100	17
Engine replacement:	$30 000 after 2000 h: $30 000/2000	15
Propeller:	Overhaul $600 at 3 yr/1500 h	0.40
Avionics:	$15 000 equipment over 1500 h	10
Landing fees:	One per hour at $12	12
	Total	91.40

Annual utilisation (hours):	*100*	*200*	*300*	*400*	*500*	*600*	*700*
Fixed annual cost/hour:	388	194	129.30	97	77.60	64.60	55.40
Direct operating cost:	82.40	82.40	82.40	82.40	82.40	82.40	91.40
Total ($)	470.40	276.40	211.70	179.40	160.00	147.00	146.80

(and area) of operation. Sometimes this figure is kept purposely high and is then used to cover any general aircraft instrument repair/replacement, again a difficult cost to accurately predict.

- *Landing fees* are a necessary evil of aviation. Airports cost money, and aircraft must pay for their use. Once again we have a vague figure to estimate. How many landings will we do each year? Unless we are in an operation requiring short flights (training, pleasure flights, etc.) then we normally standardise on one landing fee per hour at an average amount charged by the airports most frequently used. (There is a major difference between the local grass strip and Gatwick in magnitude of cost, so a little thought should be given to reaching an average charge).

These items are fairly general and purely the basics. Each individual aircraft type will have some particular variation which will either add to, or be deducted from the overall cost.

153

Table 9.2 *Operating costs, excluding pilot's salary*

Annual hours flown	100	200	300	400	500	600	700
Fixed annual costs	163	81.50	54.30	40.75	32.60	27.20	23.30
Direct operating cost	82.40	82.40	82.40	82.40	82.40	82.40	82.40
Cost per flying hour ($)	245.50	163.90	136.70	123.15	115.00	109.60	105.70

Hourly costs

Once we have arrived at both fixed annual costs and direct operating costs, these can be used to calculate an *hourly aircraft cost* which will depend on the number of hours flown per year. Table 9.1 gives a breakdown of how the complete calculation is made. (The figures are purely for demonstration and do not refer to any specific single-engined aircraft.)

High utilisation is obviously the key to reduced costs and the above calculation is reasonably accurate if applied to a flying club scenario where the employed pilot would not be flying each flying hour. A second look at the overall equation, excluding the pilot (more akin to a private owner operation) gives the figures shown in Table 9.2.

The general method shown is based on a new aircraft with standard engine replacement prices, but can be adapted to any other example. For twin-engined aircraft, just double the engine and propeller entries. If similar calculations are made based on older second-hand aircraft with limited avionics, the maintenance cost may be reduceable but it should be remembered that the older the equipment, the more replacement parts will be needed and the more frequent non-scheduled maintenance becomes. Aircraft ownership and operations is not a cheap occupation. There is an old saying: 'If you want to make a small fortune in aviation – start with a big one'.

Chapter 10

Camera Mounts

Introduction

As with the camera, lens and film, the camera mount is a critical part of the system: it can make all the difference between sharp, drift-free photographs and blurred, *crabbed* exposures. In particular, when stereo photographs are used for precise measurements, the mount itself can make all the difference between usable and useless images.

During the past 30 years, dozens of small format camera mounts have been designed – mostly by amateur photographers. As you'd expect, they range in complexity from simple door mounted systems for a single camera to sophisticated twin-camera booms that are mounted under a helicopter.

The diversity of mount designs reflects the variety of small format applications, from simple photo interpretation to complex photo measuring. No matter how you use the photography, camera mount design is influenced by the following considerations:

- the number of cameras required
- the format and make of the camera(s)
- camera accessibility during flight
- drift sight and setting requirements
- make and size of the aircraft (and whether it can be modified)
- and, of course, budget.

Internal mounts offer a number of advantages (*see* Table 10.1) over external mounting systems: access to the camera, levelling and drift adjustments, and protection from the slipstream. There are many advantages to using an aircraft already fitted with a camera mount for a large format camera. These mounts usually have some vibration isolators in their construction, and modification often requires little more than fabricating an adapter plate to hold one or more cameras, which is supported by the mounting rings of the large-camera mount. Often the port is large enough to carry three or four small cameras. However, modifying an aircraft for an internal mount – i.e. cutting a hole in the fuselage – is no simple matter. It requires careful design considerations and approval from aviation authorities. If the internal mount is not airtight, the operator faces the discomfort, and danger of inhaling exhaust from the slipstream.

Table 10.1 *Positive and negative aspects of small format camera mounts*

SEQUENTIAL EXPOSURE
 External mount
 Advantages
 possible camera retrieval
 some mounts adjust for levelling
 minor or no modification to aircraft
 designed to fit more than one aircraft
 Disadvantages
 drift compensation difficult
 some require opening window
 difficult to sight over target
 Types cited in literature
 WINDOW AND DOOR: CSIRO (1981); Fisher and Stever (1973); Mason and Walsh (1979); Benson *et al.* (1984); Long *et al.* (1986); Warner (1989*a*)
 SEAT RAILS: Mennis (1978)
 BAGGAGE DOOR: Ekin (1984); Ekin and Deans (1986); Ekin (1988)
 WING STRUT: Neustein and Waddell (1972); Roberts and Griswold (1986)
 MICROLIGHTS: Graham *et al.* (1985); Graham and Read (1986); Graham (1988)

 Internal mount
 Advantages
 access to camera
 levelling and drift adjustment
 protected from slipstream
 Disadvantages
 requires modification of aircraft
 Types cited in literature
 ADAPTED LARGE FORMAT CAMERA MOUNTS: Marlar and Rinker (1967); Zsilinksky (1972*a*); Woodcock (1976); Kirby (1980); CSIRO (1981); Hiby *et al.* (1988)

External mounts are more popular because they can be fitted on to a variety of platforms: high-wing aircraft, helicopters, mircrolights, remote controlled model aircraft, balloons and even kites. Although external mounts do not change the structural body of the camera's platform they do affect flight; therefore, if a piloted aircraft is going to be fitted with an external mount it requires approval from aviation authorities.

Types of camera mounts and controls

At this stage one very important point must be emphasised. As soon as we start to design and build any system that has to be attached to an aircraft, we must be aware of a whole horde of rules and regulations concerned with air safety that have to be strictly adhered to. For obvious reasons, any camera system that we intend to use on an airborne platform must be safe electrically, to remove any possibility of short circuits or components burning out. The risk of fire in an aircraft must be mini-

Table 10.1 *continued*

Fixed base wing mount
 Advantages
 drift setting not necessary
 intervalometer not needed
 eliminates relative orientation
 absence of differential tilt
 Disadvantages
 camera not accessible in flight
 very short air base
 control amount of overlap
 suitable only for very large photo scales
 Types cited in literature
 Williams (1978); Panzer and Rhody (1980); Benson *et al.* (1984)

Helicopter boom mount
 Advantages
 drift setting not necessary
 intervalometer not needed
 eliminates relative orientation
 absence of differential tilt
 Disadvantages
 camera not accessible in flight
 very short air base
 control amount of overlap
 suitable only for very large photo scales
 need synchronised exposure to millisecond when base is parallel to flight
 requires heavy boom to keep base rigid when base is perpendicular to flight
 Types cited in literature
 BOOM PARALLEL TO FLIGHT: Lyons (1966, 1967); Spencer and Hall (1988)
 BOOM PERPENDICULAR TO FLIGHT: Rhody (1977); Spencer (1979)

mised at every stage. Unlike a car an aircraft cannot just pull over to the side of the road and the occupants jump out in case of such an emergency.

Aircraft are subject to regular maintenance checks (as discussed in Chapter 9), and these are the responsibility of fully licenced aircraft engineers. Before embarking on a small format camera system installation, it is advisable to consult the engineer who normally carries out the work on the aircraft you intend to use. In most cases aircraft engineers are enthusiasts and will enjoy getting involved in some new activity to make use of their charges. However, it is important for the would-be SFAP practitioner to have a rough idea what can and can't be done before making demands on an engineer. If you are too ambitious it may seem that the engineer will appear somewhat negative, rather than only be interpreting fairly stringent rules for your benefit.

Firstly, any major work (cutting holes, bolting on brackets, etc.) may require Civil (or Federal) Aviation Authority (CAA or FAA) approval. This will entail

getting drawings made and strength and stress calculations drawn up before official applications can be made. This procedure is required when changes are made to the original structure of the aircraft, for example any camera hole passing through the floor of the fuselage which requires removing rib sections. A reinforced frame around the camera aperture will be needed to carry the strength of the structure in place of the removed rib sections. This form of modification will almost certainly require full engineering approval and may be expensive.

Even minor modifications such as bolt-on systems should always be discussed with the aircraft engineer before installation and certainly before being flown for the first time. It should be remembered that, in the event of an accident, any modification made to an aircraft without the approval of the engineer responsible, and without notification to the insurance company, may nullify any insurance claims with drastic legal consequences for the pilot and/or dependants. Also, to a considerable extent, the engineer can be held responsible as he or she will have signed the last maintenance approval that the aircraft was airworthy. Aircraft are fairly fragile creatures and, with the combination of high speed and increased G forces, a poor camera modification can become detached and cause potentially fatal damage.

Camera mounting systems come in three types:

- *internal* systems, in which the floor of the aircraft has a camera hole or window through which the camera is used
- *external* systems, in which the camera system is attached to an external surface, such as an equipment rack, or strut, or even the main fuselage itself
- *extending* systems, where the actual structure is attached within the fuselage but the camera itself is outside

It is difficult to specify one overall design for a camera mount as the range of potential light aircraft camera platforms, especially if we include microlight (ultralight) aircraft, is vast. The authors have found that over the years we have designed and built many mounts and usually end up making a new type (or modifying the old ones) for each new aircraft type available. If we itemise the basic requirements that must be designed in, this may help in coming to a functional offering for your particular platform.

- *Levelling.* For vertical photography it is imperative that the camera mount can be levelled in flight. Aircraft do not fly at the same attitude (nose up/nose down) throughout the whole flight envelope of speed and altitude. For instance, at slow speed the aircraft will tend to fly nose up, and at faster speeds slightly nose down. Similarly, as altitude is gained, and the air density gets thinner, the nose will tend to rise. The camera will be in a fixed mount, with its datum that of the fuselage it should be adjustable, at least fore and aft, across the potential range of angle, to enable the camera to assume a vertical axis. A spirit level should be mounted either on the mount itself, or on the control mechanism activating tip and tilt. A very simple fore-and-aft level control is to use a piece of transparent plastic pipe bent into a curve mounted on to the side wall of the aircraft. This has liquid (preferably spirit or water with added anti freeze) and a bubble which gives the level. A lever, with

Figure 10.1 *Simple (small format camera mount) levelling system.*

indicator point at the same radius as the curve of the pipe, is fitted with a cable attachment running back to the camera mount. When the point of the lever is against the bubble, this means that the camera is level fore and aft, if the two are calibrated before flight. (Fig 10.1)

- *Drift setting.* In the same way as the aircraft attitude changes relative to its horizontal plane, it will also fly at an angle relative to its ground track line due to the effect of wind from one side or the other. This is called *drift* (see Chapter 13). A simple mechanism should be designed in to enable the camera to turn through at least 30° (i.e. ±15°). One possibility is to incorporate a large roller bearing (wide enough to accept the diameter of the camera lens) and attach the outer ring of the bearing to the camera mount itself and the inner ring to the camera. This will enable the camera to revolve within the mount until it can be locked at the appropriate measured drift setting. (Fig. 10.2).

- *Damping.* A major problem in any aircraft is vibration, and an effective camera mount should be isolated from the main aircraft structure in order to damp out any movement. This can be done simply with the use of specially designed insulating mounts as designed for the installation of radio racks and other vibration-sensitive systems. Most aircraft radio repair shops on airfields will be able to supply either new or used mounts which can be selected depending on the amount of weight of the total camera system. Most SFAP damping systems are developed through trial and error. The use of different layers of non-rigid materials, foam rubber, hard rubber, or neoprene, and wood will disperse engine, propeller, and airframe resonance effectively. If very high shutter speeds are being used this will tend to reduce the problem somewhat, although good damping is essential.

- *Controls.* Shutter firing, levelling and drift settings should be controllable from the operator's position. If the operator is positioned at the camera then the problem is relatively simple, requiring only an ability to lock the controls

159

Figure 10.2 *Roller-bearing mount to facilitate 'drift' compensation.*

when settings are made. In most cases, however, the control systems have to be designed for remote operation, often for operation where the camera is not visible to the operator. Wherever possible, controls for levelling and drift setting should be mechanical, largely for the reasons of reliability. Small format installations are mostly fitted and removed from aircraft for each flight and the more robust and damage-proof a system is, then the more the chance of in-flight failure is reduced. Bicycle brake cables and motorcycle throttle cables are very often used to make simple rotation levers for turning and raising camera mount components. Shutter control is dealt with under Intervalometers, below. A surprising place to find control components is in your local toyshop! The Danish company Lego offer several 'technical' kits for making control systems for their various model kits, and many of these items can be incorporated successfully into levelling, drift setting and firing units.

•*Attachment.* The camera mount must be attached firmly to the basic aircraft structure. In the case of an internal or extending system, then a suitable, already existing attachment point is that of the set rails. The rails are designed for the safe containment of the pilot and passenger seats and so are very robust. Using a similar fitting to the seat base attachments themselves, a frame can be located across the rails with a camera hole either between the rails or with the camera extended outboard of the rail position. Alternatively, hard points can be located and captive nuts installed through the aircraft floor for locating and fitting the mount. (*This must be done by a licensed aircraft engineer.*)

One simpler method, but not so highly recommended, is that of attaching the camera mount system to a large, space-filling, 2 cm ply board. This can be laid in the camera compartment, preferably with some retaining system. If this is not readily available, the additional weight of the board will give the system some stability.

If the system is being attached outboard, then the attachment system *must be approved by the aircraft engineer.*

One point that should be borne in mind when designing add-on systems for aircraft is that of security. Any SFAP equipment should be securely attached so that in the event of an accident or in-flight turbulence, heavy cameras or batteries do not come loose and cause injury to pilot or operator. Loose objects can kill.

Although most SFAP camera systems are designed, built and assembled by the teams using them, the time will come when more sophisticated, professionally designed and built systems will become available. One of these is the Advanced Computer Controlled Aerial Survey System with Stabilised Mount currently being developed for production by the Fachhochschule Bochum, Germany. This system incorporates a digitally-controlled, fully stabilised camera mount designed around the Rolleri 6006 and the Contax RTS III photogrammetrically calibrated cameras. In addition to normal levelling, the mount incorporates its own forward-motion compensation (FMC) by pitching the camera at the instant of exposure according to the base:height ratio. The mount also takes drift into account by calculating the correction angle from a digital directional gyro against the true track given by a GPS system, giving perfect straight lines of pictures each time.

Already in its second phase of design, (the prototype already currently in production work in Canada), the second version is moving toward using miniaturised gyro sensors and thus drastically reducing the overall system size. The Bochum team regularly fly projects with the system on an extended mount out through the rear baggage door of a standard Cessna 172. (Fig. 10.3).

The overall demand for specialised SFAP systems is relatively small, and hardly worth companies or organisations going into series production on commercial levels. Most practitioners will give information on their own systems and usually offer assistance and advice if approached properly. However, you should not expect unlimited photocopies of drawings, photographs and the loan of gadgets without at least offering to pay expenses such as postage. (The authors have long experience of heavy telephone, postal and reprint bills, but hopefully all in a good cause.)

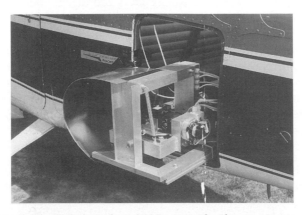

Figure 10.3 *The Fachhochschule Bochum SFAP mount, fitted as an extension from a Cessna 172 luggage compartment.*

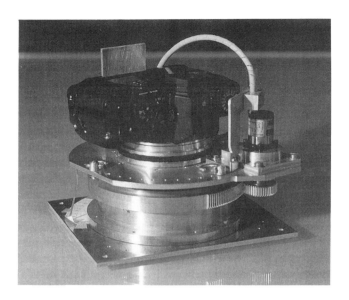

Figure 10.4 *The Bochum mount fitted with a Contax RTS III camera.*

Whereas most professional air survey operators will employ a 23 cm air camera fitted inside a specially modified (hole-in-the-floor) aircraft, SFAP operators will usually employ an *available* machine which they can then modify with a temporary fitting and at least expense.

Professional survey aircraft can easily adapt their own large format mounts to accommodate small format cameras. Such fittings can be either fully designed, complete with motorised drift compensation, such as the Bochum-designed mount shown in Fig. 10.4, or a temporised affair fitted into a wooden mount with foam damping, as shown in Fig. 10.5, where the Kodak DCS 200 digital camera is temporarily fitted into an existing 'hole-in-the-floor' of a twin-engined survey aircraft.

Although the Bochum-designed mount shown in Fig. 10.4 (complete with stabilisation, drift control and FMC) represents the ideal system for all small format cameras, the majority of operators will undoubtedly design and build their own less sophisticated systems, according to their needs and budget! A number of these mounts have been mentioned in Table 10.1, but we shall concentrate on external and extended types, starting with the simplest form of mount fitted to a 'first generation' microlight aircraft.

Heavy-duty ball-and-socket camera mount

The ball-and-socket camera platform is common in photographic studios and when fitted to a simple cantilever arm, can provide an easily adjustable SFAP mount particularly useful for 35 mm cameras in microlight aircraft. As shown in Fig. 10.6 such a mounting (fitted to an Eagle Microlight) can easily be adjusted from oblique

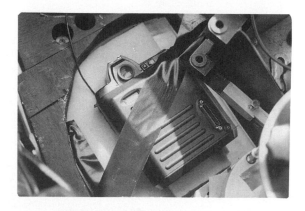

Figure 10.5 *The Kodak DCS 200 Digital Camera fitted into a temporary wooden mount and enclosed with foam-packing to prevent engine fumes from entering the cabin (Cessna 337).*

to vertical and also provide for drift compensation by the pilot (Graham, 1987). The proximity of the camera also allows for exposure adjustment and film change.

Unfortunately, simplicity does not always make for practicality. During some early research in 1983 this type of mount was found to suffer from a number of problems, not least of which was the high incident vibration (particularly from a two-stroke 5000 revs/min engine) and wind-buffeting, which required at least 1/2000 s exposure to avoid image blur (Graham and Read, 1986). Whereas this was no problem with a modern 35 mm camera, it was a disaster with the nominal 1/500 s top shutter speed of the Hasselbald MK70 shown in Fig. 10.6.

During these and other trials a further problem appeared. The authors found that Hasselblads had a very weak interface between camera and 70 mm magazine. Although this was no a problem when the camera was firmly mounted inside an aircraft, an undamped external mounting would usually result in torn film perforations brought about by movement between camera and magazine.

Changing film cassettes or magazines while in (microlight) flight may sound easy, but in practice it should be avoided unless the pilot has adequate protection from the wind. The configuration shown in Fig. 10.6 is particularly vulnerable in this respect, where items dropped were either lost to the pusher prop (if light) or doomed to the Earth below.

Non-rigid suspension mount

As the name suggests, non-rigid suspension mounts are limited by the nature of their design. Usually suspended from external struts by bunjee cords they are prone to 'swing' and cannot be oriented against drift. Their principal attraction is their simplicity, freedom from requiring major aircraft modifications, economy and (and if carefully strung and positioned to avoid wind buffeting) good damping characteristics.

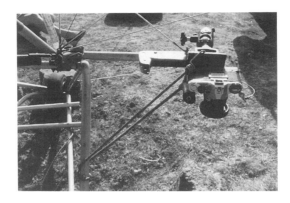

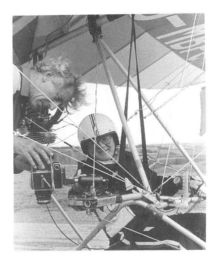

Figure 10.6 *(a-upper) Cantilever with ball and socket camera mount. Eagle microlight aircraft and 35 mm Pentax camera. (b-lower) The same mount, with Hasselblad MK-70 and 70 mm magazine.*

For line overlaps, the only way to avoid crabbing effects (due to wind drift) is to fly into wind. Whereas this is not difficult to do, it may mean altering the survey flight plan somewhat, since the predicted wind vector (speed and direction) may be quite different at altitude. If the plan is to use reciprocal survey headings, beware of the significant change in ground speed.

Rigid external mount

Whereas the primitive Eagle microlight mounting shown in Fig. 10.6 was inadequate for serious 70 mm camera work, a more sophisticated version housing two 70 mm Hasselblads in a quadrant mount was quite successful (Fig. 10.7). Designed

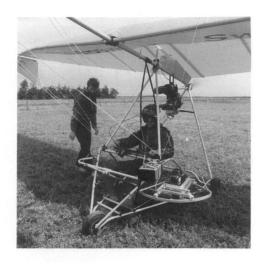

Figure 10.7 *(a-upper) Eagle microlight with two Hasselblads in quadrant mount with 'drift' correction. (b-lower) Eagle microlight used for (MSP) crop monitoring.*

by a Dutch team at Wageningen Agricultural University, the Hasselblad-equipped Eagle specialised in monitoring crops at their experimental farm and proved to be very useful with a multispectral facility, drift compensating mount and electronic intervalometer. Unfortunately, sophistication means weight, and care must be exercised when considering the payload of microlights – in this case requiring the more powerful 'double Eagle' rather than a normally engined 250 or 350 cc version.

The popular (second generation) Quicksilver Microlight proved to be a much better platform for SFAP and, with its side-by-side two-seater configuration, allowed for a semi-rigid mount, as shown in Fig. 10.8.

This light alloy mount (designed by Roger Read) incorporated a wire-controlled drift platform supported on two dashpots with a front-end suspension of bungee cords. In operation this mount was well protected from wind buffet, because of its position behind the crew, and gave good service.

Figure 10.8 *Quicksilver microlight with semi-rigid camera mount located behind pilot. Note the cable-controlled drift compensating facility.*

Just as mounts have to be specially configured for microlights, so must they be suited for light aircraft. Since high-wing monoplanes are the best suited for surveys, we consider only this type of aircraft.

Figure 10.9 *A professional survey navigation sight (Zeiss NT1) located in a small format camera mounting with drift control (Cessna 172).*

Internal mounting

As explained before, internal mountings require a 'hole-in-the-floor' and such modifications are costly! Nevertheless, a number of professional operators use internal fittings either as a small format alternative to a 23 cm air camera, or simply because their aircraft came (second hand) with such a facility. Internal camera mounts offer the best situation of course, and can be utilised in the available camera hole alongside a professional drift sight. In Fig. 10.9, a Zeiss NT1 drift sight is located next to a small format camera mounted in the copilot's position of a Cessna 172.

Extended (door canopy) mounting

A somewhat cheaper modification (not requiring a 'hole-in-the-floor') is the bulging right-hand door, shown for the Cessna 172 in Fig. 10.10. By such means it is possible to fix a camera drift mount to the right hand seat rails and allow the camera to be extended over the side of the doorway under a faired door-canopy. In this configuration the best solution for navigating the flightline is to couple the small format camera with a small video camera linked to a video monitor, as shown in Fig. 10.11.

One of the main advantages of this system is the possibility of sending the modified door to another (distant) location, where it can be fitted to an identical aircraft.

External door frame mounting

Norway's Institute for Georesources and Pollution Research (GEFO) are very advanced in SFAP applications, and their solution for mounting a pair of 35 mm

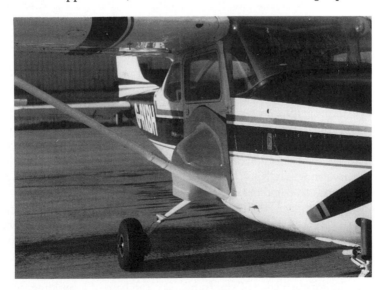

Figure 10.10 *Cessna 172 starboard door modification to house a small format camera. Camera mount is extended over the door-sill of the aircraft.*

Figure 10.11 *SF mount with video navigation system.*

cameras to the door of a Cessna 172 involved the unique system shown in Fig. 10.12. In this construction the camera rig is portable and can be fitted to any Cessna 172. The carriage lowers the camera(s) from window level (with an interior ratchet wrench) to a position at the bottom of the door, in order to avoid photographing the aircraft's wheel or strut (Warner, 1989*b*). By this construction it is possible to wind up the camera(s) to window level, allowing the observer to make any required in-flight changes to the system.

The pair of motorised Pentax 35 mm cameras shown in Fig. 10.12 can be fitted with a large range of lenses, allowing for different scales (with a different lens on each camera), as well as different types of film and filter (MSP). Alternatively, a matched pair of lenses can provide a fixed base stereo pair for large scale stereoscopy. Also shown in Fig. 10.12 is a GEFO designed intervalometer and battery pack for operating the 200 exposure (motor-driven) magazines.

Intervalometers

Most aerial photographs are exposed sequentially in a flightline to obtain stereoscopic coverage. If a fixed base system is used (i.e. two cameras mounted a set distance apart) the cameras are triggered simultaneously to obtain stereoscopic coverage; however, the twin cameras must also be triggered sequentially as a unit in order to assure proper endlap. Techniques to achieve sequential control vary from manual operations to computerised systems.

On the simplest level, the operator simply looks through the camera's viewfinder and triggers the exposure when the proper amount of overlap (generally 60% overlap) occurs. This can be determined by inserting a clear plastic template into the viewfinder. The template has a line perpendicular to the line of flight marking 60% coverage (Fig 10.13). As one views the landscape passing across the viewfinder, a feature at the forward edge of the frame, say the base of a building, is observed when the camera is triggered (*a* shown in Fig 10.13). When the same feature passes the 60% mark, the camera is triggered again, and the operator identifies the next

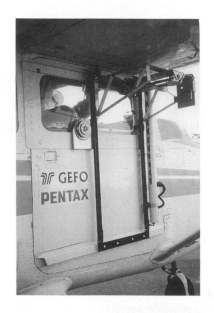

Figure 10.12 *(a-upper) the GEFO (Norway) small format mounting carriage fitted to a Cessna 172. (b-lower) A pair of motorized Pentax 35 mm cameras, intervalometer and battery pack for fitting onto the external mounting carriage shown in (a).*

feature at the forward edge (*b* shown in Fig. 10.13) and follows it till it passes the 60% mark and the camera is triggered once again; and so on.

Side sight

Often the camera operator cannot look through the viewfinder during flight. Under these circumstances there are simple alternatives. Graham (1988*a*) describes a rather primitive, but reliable, method for gaining forward overlap of frames by using a side sight mounted on the aircraft's door. Initially employed in the First

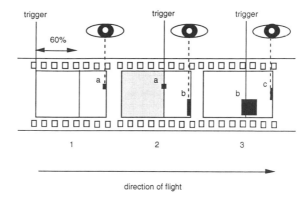

Figure 10.13 *Template with 60% coverage marked on it.*

World War, the techniques simply involves observation of ground features as they move under an array of crude bar sights. Specifically, as a given feature appears to move from, say *b*2 to 3, shown in Fig 10.14 (from the pilot's operation of the sight), the camera is triggered to provide, say 60% forward overlap for a given focal length of lens and scale. Most side sights are locally produced but, as always in aviation, need to be approved by aviation authorities before being flown on a given machine.

One significant advantage of the side sight is the complete absence of a need for a timing device. In this respect perhaps it would be more suitable to call it a subjective intervalometer since its temporal requirements rely only on waiting for a ground target to appear at another position on the side sight. But the fact remains that any form of clocked intervals disregards the uneven ground speed likely to be encountered by light aircraft, due to gusting winds. A full account of side sight construction, calculations and operation is given in Appendix 3.

Figure 10.14 *External side sight for controlling forward overlap.*

Stop watch

Another simple technique for controlling the exposure interval between camera stations is to use a stopwatch. Determining the time between exposures to assure proper overlap (ΔT) is a function of: lens focal length (f), film format of side (S'), its mean height above ground (H_g), its ground speed (V_g) and the required percentage of forward overlap (p).

The necessary calculations, shown in equation (10.1), can be found in greater detail in Chapter 11, and although equation (10.1) can be used to create suitable tables for different heights, lenses or ground speeds, it is far better to utilise such formulae in either calculators or simple computer software (*see* Appendix 1).

$$\Delta T = B/V_g \tag{10.1}$$

where

$$B = S\left(1 - \frac{p}{100}\right) \tag{10.2}$$

The stopwatch technique is effective but, like the side sight method, is also very tiring and prone to error, particularly when applied to an extensive aerial survey, because the camera operator is dedicated to concentrating on the stopwatch and nothing else.

With the increased use of small format photography, often in the hands of amateur aerial photographers, there has been an increased demand for simple, reliable control systems that control sequential exposures automatically. Such systems, called *intervalometers*, supply tripping pulses to the camera at selected intervals to assure the desired photographic coverage for a given overlap. Intervalometers are basically electrically driven timers with a dial for setting the number of seconds between trip pulses. Intervalometers vary from simple home-made devices to sophisticated systems supplied by manufacturers of conventional aerial survey cameras, which allow for constant monitoring and adjustment of overlap along the flight line.

Commercial intervalometers designed for particular cameras are few: for example Nikon markets an intervalometer for its 35 mm SLR and the Hasselblad Command Unit and the Intervalometer III is available for its 70 mm SLR. Custom-made computer-based video intervalometers are available from Syscomp Electronic Design Ltd, Toronto, Canada. So generally speaking, small format and medium format photographers build their own intervalometers, because their requirements differ as much as their applications, cameras, and budgets. For instance, van Eck and Bihuniak (1978) used an intervalometer to trigger two cameras: one taking overlapping small scale photography, the other periodically taking large scale photography. Roberts and Hiscocks (1981) used a sophisticated computer-based system, combined with a video camera and a drift sight, for controlling three different types of cameras (Vinten, Hasselblad and Nikon). Benson et al. (1984) detail the design and costs of an intervalometer for controlling four cameras simultaneously or independently in increments of 0.1 s. The system is easy to operate, flexible, and thus ideal for research programs that involve multiband or multiscale photography.

An inherent problem with some of the simpler intervalometers is matching ground speed with airspeed. Although a headwind decreases ground speed and a tailwind increases it, neither is indicated on the aircraft's airspeed indicator (ASI). Warner (1989) outlines the design and the application of a simple, hand-held intervalometer developed at ITC that assures constant overlap regardless of changing airspeed (Fig. 10.15). The intervalometer is operated by tracking the landscape (from the closed window of a high-wing aircraft) with a row of sequentially pulsating lights. Its principle is based upon the length of light-array replicating the photo base in photo scale (i.e. 60% of the negative). The operator controls the flow of lights (to match the moving landscape) by adjusting the lights' speed dial.

When working with a fixed base system, where two cameras are triggered simultaneously one should realise the importance of timing. If the camera boom is mounted such that the two cameras are parallel to the line of flight, the air base is unknown if the two cameras are not exposed at precisely the same instant – and we're talking milliseconds. Delay between shutter trips either stretches or shrinks the fixed base on which the design is set (Spencer, 1979). This is truly critical because the air base is so small.

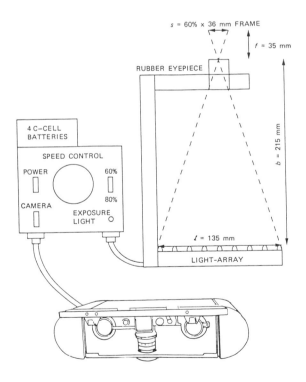

Figure 10.15 *Hand-held intervalometer viewed from the side. The adjustable frame compensates for variations in b (based on the camera's focal length and film orientation (longitudinal or transverse). Note: b = (ℓ × f) / S'.*

Chapter 11

Mission Planning

Air survey calculations

It could be said that mission planning is no more than the following calculations – but that would be a gross oversimplification. Only with an appreciation of *all* the parameters and mission constraints can an effective plan be made. Usually the procedure is an iterative process such that the best compromise can be reached – in terms of the best film for the task, film speed, flying height, air speed, scale, overlaps, base:height ratio, ground coverage per photo, photo interval period, number of photos required and the degree of image blur allowed. All this and the weather too!

The importance of mission planning is to be able to plan a successful survey so that most problems can be anticipated before take-off, and also provide for alternative measures if one, or a number, of parameters are changed. The weather is always a problem for example, and camera exposure has to be anticipated in terms of this, and the type of film employed.

Mapping calculations

Although you may find different symbols in other texts, the survey calculations given here employ symbols which are generally accepted in the field of topographic mapping.

At the end of these mapping and exposure calculations an example mission is presented in order to demonstrate how a typical mission is planned.

- Scale (M_b)

$$M_b = \frac{f}{H_g} = \frac{S'}{S} \tag{11.1}$$

where f is the focal length of camera lens (i.e. the *calibrated* focal length), H_g is the flying height above 'mean ground level' (mgl), S' is the dimension of one side of the negative format and S is the ground distance covered.

Note: For 35 mm negatives S' can be either 36 mm or 24 mm depending upon which side the format is advancing. This is important when considering the forward and side overlap.

- Scale number (m_b)

$$m_b = \frac{H_g}{f} = \frac{S}{S'} = \frac{1}{M_b} \qquad (11.2)$$

- Ground distance (S)

$$S = S' \times m_b = \frac{S' \times H_g}{f} \qquad (11.3)$$

- Area covered by a single frame (S^2)

$$S^2 = (S' \times m_b)^2 \qquad (11.4)$$

- Length of base (B) with $p\%$ forward overlap

$$B = S\left(1 - \frac{p}{100}\right) \qquad (11.5)$$

- Distance between flight lines (a) with $q\%$ side lap

$$a = S\left(1 - \frac{q}{100}\right) \qquad (11.6)$$

- Required number of photos per flight line (Np)

$$N_p = \left(\frac{L_p}{B}\right) + 1 \qquad (11.7)$$

where L_p is the length of flight line to be covered.

Note: It is usual to *start* each line two frames before the planned 'start' and *end* each line with two extra frames before shutting the camera off, i.e. add four extra frames to each line.

- Required number of flight lines (N_q)

$$N_q = \left[\frac{(L_q - S)}{a}\right] + 1 \qquad (11.8)$$

where L_q is the width of area (block) to be covered.

- Model area (stereo cover) (F_m)

$$F_m = S(S - B) = S^2 - SB \qquad (11.9)$$

- Exposure interval (ΔT)

$$\Delta T \text{ (seconds)} = \left(\frac{B}{V_g}\right) \qquad (11.10)$$

where V_g is the velocity of the aircraft over the ground.

- Apparent image motion (AIM) in shutter time (t)

$$\text{AIM} = \frac{V_g \times f \times t}{H_g} \qquad (11.11)$$

Note: Values of ground velocity (V_g) are rarely accurate, and are often planned for as indicated air speed (IAS). It is best to convert all values of V_g to m/s in order to facilitate using values of AIM in microns (μm). Conversion factors are given in Appendix 2.

PC software programs

A number of QBasic mission planning programs are listed in Appendix 1. Those which cover all the calculations above are Appendix 1(a). Additional programs, Appendix 1(h) and (i) help in gaining accurate values for true air speed (TAS) and true altitude (TALT).

Exposure calculations

For those accustomed to using a 35 mm camera the concept of actually *calculating* an exposure must seem strange, particularly since all modern cameras have incorporated automatic exposure systems for many years now. But since a mission has to be planned, it suggests that the exposure must be planned also. It cannot be left until we are in the air – so how do we know what the correct exposure should be?

To start with, we must have a fair idea of the weather. We cannot do survey photography with cloud below us, so we must assume clear air below our planned flying height and look at the estimated exposure for (hopefully) clear air above us.

The downwelling solar illumination is remarkably constant for a given latitude, calendar month, and time of day in that month. From tables (or the Kodak R10 Aerial Exposure Calculator) it is possible to predict a highly accurate exposure for planning purposes. In the event that there are cloud formations above the aircraft at time of flight, then one or two 'stops' extra exposure will usually suffice.

To determine the appropriate exposure for a given time of day, at any time in the year, see Appendix 1(j). From this program it is possible to get an accurate exposure for a scene anywhere in the world. Almost as important as exposure is the position of the sun at any time of day, particularly when the length and direction of shadows play an important role in the quality and interpretation of the image.

It is possible to determine the solar altitude (how many degrees the sun is above the horizon) and the solar azimuth (the sun's position from east, through south, to west) by applying the programs listed in Appendix 1(c) and (d).

Specimen SFAP mission plan

As our example we shall assume a small block of land some 2 km in length by 1 km wide. We shall also assume that our aircraft is fitted with a reasonable camera mount such as one of those described in Chapter 10, and that the aircraft is capable of a cruise speed of 90 knots (170 km/h).

Table 11.1 *Flight plan calculations*

Scale number (equation 11.2)
$$m_b = H_g/f \qquad\qquad = 457.3 \text{ m}/0.05 \text{ m} \qquad\qquad = 9146$$
(1500 feet is 457.3 m, but if we put the scale number at a round figure of 9000,
then $H_g = m_b \times f \qquad = 9000 \times 0.05 \text{ m} = 450 \text{ m} \qquad = 1476 \text{ feet}$
Ground covered (equation 11.3)
$$S = S' \times m_b \qquad\qquad = 55 \text{ mm} \times 9000 \qquad\qquad = 495 \text{ m}$$
Length of base (equation 11.5)
$$B = S(1-p/100) \qquad = 495(1-0.6) \qquad\qquad = 198 \text{ m}$$
Line separation (equation 11.6)
$$a = S(1-q/100) \qquad = 495(1-0.25) \qquad\qquad = 371 \text{ m}$$
Line photos (equation 11.7)
$$N_p = (L_p/B) + 1 \qquad = (2000/198) + 1 \qquad\qquad = 11^a$$
Flight lines (equation 11.8)
$$N_q = [(L_q - S)/a] + 1 \qquad = [(1000-495)/371] + 1 \qquad = 3^b$$
Exposure interval (equation 11.10)
$$\Delta T = B/V_g \qquad\qquad = 198/44 \text{ (m/s)} \qquad\qquad = 4^c$$
Image motion (equation 11.11)
$$(V_g \times f \times t)/H_g \qquad = (44 \times 0.05 \times 0.002)/450 \qquad = 10 \text{ } \mu\text{m}^d$$

[a] The number of photos per line is given as 11 (rounded down slightly) but the actual number would be 15 per line, by adding an extra two frames at each end to ensure complete cover.

[b] The number of flight lines works out to 2.36, but fractions of a flight line make no sense, so the value is rounded up to 3.

[c] The value of 85 knots has been converted (Appendix 2) to 44 m/s and here we round down from the calculated value of 4.5 s to a safer number of 4 s exposure interval. Remember the formula involves B which was found from 60% forward overlap and it is better to have more than 60% overlap rather than less.

d Since the Rollei camera's top shutter speed is 1/500 s (0.002 s) we are quite safe in suggesting this shutter speed which, at 85 knots (44 m/s), 1476 feet (450 m) and a 50 mm focal length lens, gives only 10 mm of image motion (image blur). When AIM is this small (0.01 mm) the image can be enlarged at least 2.5 times to meet the industry standard of 25 mm of acceptable image blur.

The nature of our proposed survey is a village, and we shall take our flying height to be in the region of 1500 feet (450 m) (a.m.g.l.). The camera is a Rolleimetric 6006 fitted with a f4, 50 mm wide angle lens and 70 exposure 70 mm magazine, with a negative side (S') of 55 mm.

The film load is Kodak Plus-X (EAFS 80; D-76 processed to $\gamma = 0.8$). As the flying height is below 2000 feet (600 m) it is reasonable not to use a yellow (anti haze) filter since no haze problems are likely to occur. Flightlines will be run east–west and reciprocal, with 60% forward overlap and 25% side-lap. The estimated ground-speed of the aircraft is 85 knots (157 km/h).

Using the equations for mapping calculations we find the figures shown in Table 11.1.

Figure 7.12 *Low level (about 25 m) low oblique taken with hand-held Vinten camera (300 mm lens). Kodak SO-358 (masked) colour negative film. Exposure: 'against the sun' 1/1000 at f 5.6, S.A. = 27°. Processed in C-41 chemistry, Morse Rewind Spool, development: 4 min 15 secs at 37.8° C. (Photoair: Ron Graham).*

I

Figure 17.1 *Cannabis plots are easily detected by the Kodak DCS-420 Digital Colour Infrared Camera. The bright red cluster of plants near the centre of the frame is a cannabis plot. Photograph courtesy of the US Forest Service. (See Chapters 8 and 17.)*

Figure 9.1 *The Thruster microlight has a proven record with SFAP.*

Figure 8.7 *A full colour (24 bit) low oblique taken with the Kodak DCS 200 camera. Image processing undertaken with Aldus Photostyler V.2. Printed by HP 550 Inkjet Printer at 300 dpi. (Photoair: Jon Mills and Ron Graham, 1994).*

III

a

b

Figure 14.4 *(a) Kodak Aerochrome film (2448). (b) Kodak Aerochrome Infrared film (2443). Multispectral photography of winter wheat (48 plots of Arminda and Clement). Cibachrome prints of MSP mission flown on 28 July at 1600 ft. Compare with monochrome records of Fig. 14.3 taken 17 days earlier (ITC: Ron Graham).*

IV

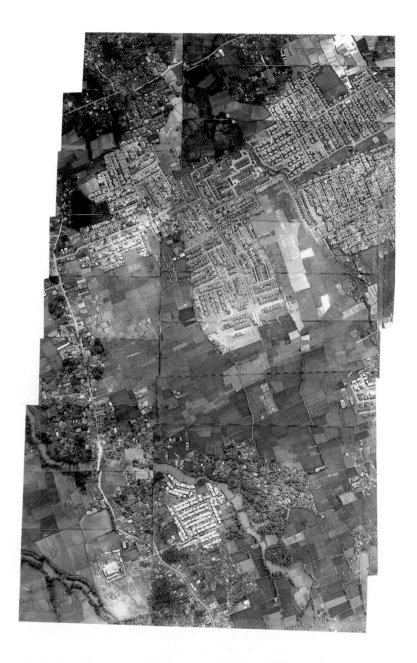

Figure 15.1 *Two lines from a SFAP survey of Bandung, Indonesia. Foward overlap 60%, side-lap 30%. Rollei 6006 camera, Gelatik aircraft and side sight (Roger Read).*

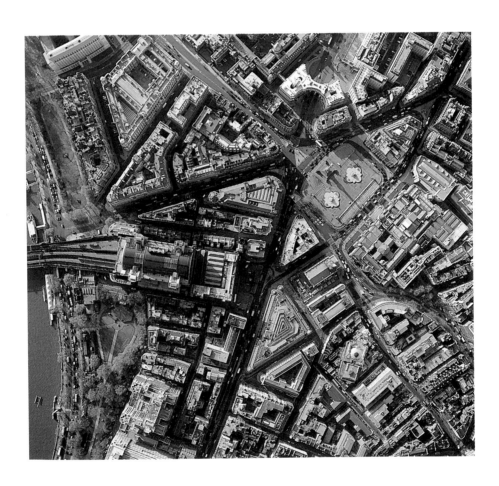

Figure 15.2 *A typical example of pinpoint photography, a speciality requiring careful selection of solar altitude and azimuth as well as the usual problems of target indentification which, although not a problem with this well-known landmark, requires good crew cooperation. Minimum height regulations must be observed at all times. Vertical colour shot of Trafalgar Square, London. Rollei camera and 50 mm lens. (Reproduced by permission of Photoair, Yaxley, Cambs, UK.)*

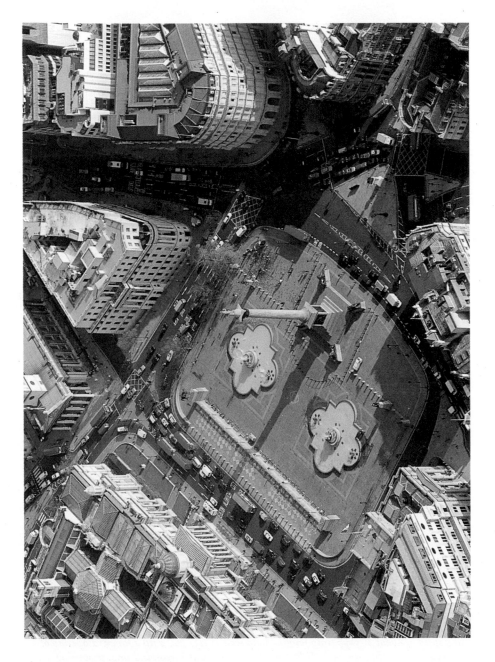

Figure 15.3 *Low oblique of Trafalgar Square, Mamiya 35 mm camera and 150 mm lens. (Reproduced by permission of Photoair, Yaxley, Cambs, UK.)*

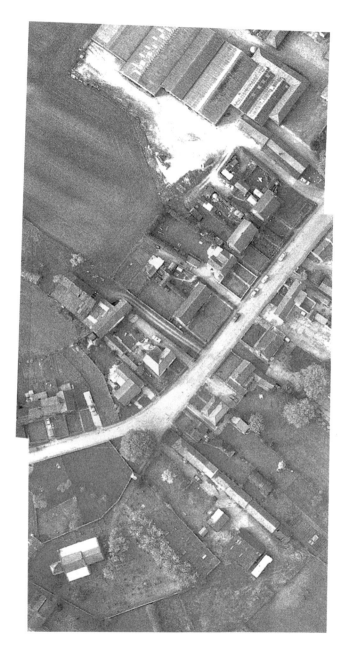

Figure 19.3 *Two DCS-200 digital images forming part of a mosaic of the village of Raskelf (North Yorkshire). Flown with Thruster aircraft at a height of 1560 feet (amgl) at an estimated ground speed of about 30 mph (into wind). Photo-scale is 1:17 000 with a forward overlap of 50% and a base/height ratio = 0.25. Photo interval (ΔT) was 5 seconds. Image processing (sharpening, contrast and brightness adjustment, colour balance and matching) conducted under Aldus Photostyler V.2. Printed on A4 HP Glossy paper at 1:850 scale. (Ron Graham).*

Using mission planning PC software

All the above calculations can be entered into the Surplan program of Appendix 1(a). Once the program listings have been entered into your QBASIC software it is only a matter of a minute to gain the answers calculated above.

The surplan program listing for this specimen mission is given in Listing 11.1 where it can be seen that there is much more information available, including the mission's base:height ratio (0.44 for this project) which is a useful parameter that photogrammetrists need (and often specify) as an index for heighting accuracy.

The next PC program necessary to complete any mission profile is the exposure program SS, listed in Appendix 1(j). Using this program it is possible to estimate the correct exposure from a specific time and date and other parameters.

Listing 11.1

<div style="border:1px solid">

SURPLAN
Air Survey Mission Planning

Mission Number 1

Scale number (m)	$=9000$
Focal length (mm)	$=50$
Required height above ground (feet)	$=1476$ feet
Average terrain evaluation (or Datum)	$=120$ feet
Required true altitude (TALT)	$=1596$ feet
Negative side	$=55$ m
Ground covered (S)	$=495$ m
Forward overlap (p)	$=60$
Side lap (q)	$=25$
Single frame area (FA)	$=0.245025$ km^2
Length of base (B)	$=198$ m
Base over height ratio (R)	$=0.4398873$
Distance between flight lines (**a**)	$=371.25$ m
Length of flight line (L_p)	$=2$ km
Width of block (L_q)	$=1$ km
Area of block (G_a)	$=2$ km^2
Number of photos per flight line (N_p)	$=15$ (includes 4 extra)
Number of flight lines (N_q)	$=3$
Model area (stereo cover) (F_m)	$=14.7015$ Ha
New stereo area (S_a)	$=7.35075$ Ha
Required number of photos per block (N_t)	$=27$
Aircraft ground speed code	$=2$
Aircraft ground speed, m/s (V_g)	$=44$
Exposure interval, $T\,(=B/V_g)$	$=4$ seconds
Applied shutter speed (SS)	$=0.002$
AIM (Apparent Image Motion)	$=10$ microns

</div>

If our specimen mission is to take place on 10 May, at a location in Germany, with latitude 52° 30' longitude 011° 15', at 10 00 hours (local time) and a flying height of 2000 feet (610 m) then, with an EAFS of 80, no filter and a lens aperture of f5.6 we can enter these values into SS as:

Latitude	= 52.5
May (fifth month)	= 5
Day	= 10
Longitude	= 11.25
EAFS	= 80
Flying height	= 2000
Filter factor (none)	= 1
Lens aperture	= 5.6

The resulting printout not only gives the shutter speed for these conditions (1/628 s), but also the solar altitude (48°), and with the data provided by Surplan completes all the essential data for this specimen mission plan.

The printout from SS is given in Listing 11.2.

Listing 11.2

SHUTTER SPEED CALCULATION (SS)	
Latitude (LA)	= 52.5
Total days (from 1st Jan.) to month M	= 120
Day number (DAY)	= 10
Longitude (LO)	= 11.25
Solar altitude (SA)	= 48 degrees
EAFS	= 80
Flying height (H) above ground (feet)	= 2000
Filter factor (FF)	= 1
Lens aperture (N)	= 5.6
Shutter speed (SS)	= 1/628 seconds

In the event that the SS program is not available then the same information can be gained from the Kodak R-10 Aerial Exposure Computer (a cardboard calculator). If this is not available either, then an estimate can be made from the camera exposure meter – taking ground readings of a landscape to gain some measure of the required shutter speed.

Block photography

When a target area has to be covered at a a specific scale, more often than not a series of flightlines will have to be flown to achieve full coverage, in the same way as in

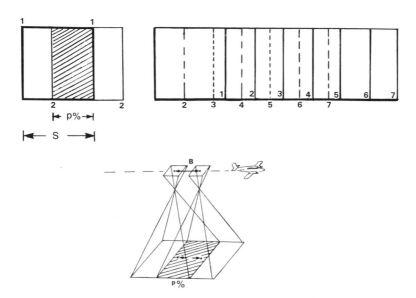

Figure 11.1 *A single flightline with 60% forward overlap.*

mowing a lawn we must cover the surface with a series of swathes until coverage is complete. However, unlike the oblong flat grass area of the front garden, a survey block will invariably have anomalies which make the process more complex.

The overall structure of a survey flight block is fairly straightforward, but certain variations will need to be introduced to take care of any specific requirements dictated by the *purpose*. If we first establish a few basic rules, variables can be introduced later to address specific requirements.

We have seen that a normal flightline comprises a series of single photographs flown at a specific flying height with a specific focal length, to give coverage of a pre-calculated ground area at the correct photo scale at the focal plane (for original negative or transparency). Each photograph will overlap the previous one by a certain, also pre-planned amount, again depending on the purpose. If stereoscopic cover is needed (for photogrammetric mapping machine use) then the forward overlap will be a minimum of 60%, ±5% (Fig. 11.1). This may be increased if an urban study or high detail subject is being covered. If the final product is just to be simple pictorial photo laydown then the forward overlap can be reduced, although additional cover is desirable to make final print laydown easier. If a photo mosaic is to be laid and some form of measurement control introduced then the forward overlap will need to be increased to somewhere in the region of 80%.

Small format methods lend themselves to simpler forms of aerial photography which would not be considered by large format practitioners. For instance, small format techniques often used in area inspection for environmental and resource sampling and measurement. In this kind of work low density photo cover, or even video material, will suffice. A forward overlap of photography at 20% would be

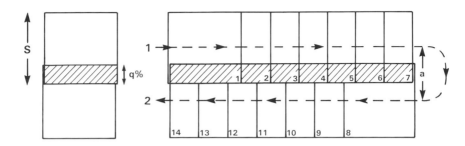

Figure 11.2 *A second flightline will overlap the previous line by a pre-calculated amount, in this case 25%.*

quite adequate to provide a simple print laydown for statistical measurement at an early stage in a project.

Just a single photograph must overlap its partners along the flightline, then each run must also overlap the previous one, and similarly with a specific percentage of common cover or overlap. This amount will also depend on the final requirement of the user, but may additionally be influenced by the terrain and even the experience of the flight crew and of the equipment being used. A common standard both in large format and small format operations is a side overlap of 25% with a tolerance in most cases of $\pm 10\%$. This may be increased to 30% or 35% if the scale being flown is very large (or at low level, giving limited forward view), over an urban target area, or with a less experienced crew. The percentage of side overlap deducted from the photocover (S) will give the flightline spacing a (Fig. 11.2).

If a more sophisticated navigation control system such as GPS is being used then it may be possible to reduce the side overlap accordingly. (In large format GPS survey flight management system controlled operations, 20% side overlap over flat terrain is now quite common. It may also be possible to pulse individual photographs to give a uniform grid network of photocentres so that 'lines' of photographs are aligned both along, and across flightlines.)

In small format work, survey blocks are usually small, economy not being achievable against large format methods in bigger blocks. This means that surface height variations across the block, affecting photoscale, are usually not so large and in most cases the same flying height can be maintained over all flightlines. However, at very large scales the problem can arise and missions may have to be planned following terrain features: for example, flying *along* a valley with different flying heights (Fig. 11.3) to compensate for valley bottom and rising ground on either side, rather than flying a series of strips *across* the valley at a uniform height. Similarly, if a target area has ground rising from one side to the other then the flightlines would be flown *parallel* to contour lines with increasing altitude (Fig. 11.4), rather than *across* contours at uniform altitude.

For each flightline a *reference elevation* must be decided in order that an average photo scale can be achieved along the line as near as possible to the required, specified photo scale. In small format work, with usually shorter flightlines, this is merely

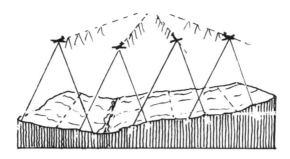

Figure 11.3 *Run lines flown along a valley at varying flying heights (for optimal scale), rather than across the same area at uniform $Z_{(ref)}$*

Figure 11.4 *Flightlines planned with ascending $Z_{(ref)}$ across rising ground, for uniform scale.*

a matter of taking an average of spot heights or contour crossings along each flightline, and making that the reference elevation, (Z_{ref}). The flying height will then be *added* to the reference elevation and that used for the final flight plan (Fig. 11.5). (Remember that this required true altitude must also be subjected to correction for temperature and pressure variations during the actual flight.)

When deciding upon the Z_{ref} once again the *purpose* of the project must be taken into consideration. For instance, if the task in hand is to revise an existing map to include a new industrial estate or shopping complex, then the elevation of the new site will be of paramount importance as a datum, rather than surrounding terrain which is not being revised. Thus an average height across the new feature would then become the reference elevation.

The overall alignment of flightlines relative to block shape can be critical in small format work, in cases other than those defined by terrain, as discussed earlier. Mapping projects covered in large format work can be governed by many rules for run alignment, usually dictated by existing map sheet presentation. Small format projects, however, will invariably be dictated by economy, and the need to keep flightlines and flying time to a minimum. Lines should be planned as parallels to the

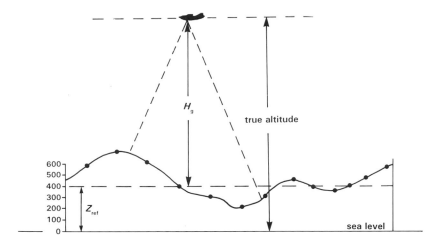

Figure 11.5 *Reference elevation ($Z_{(ref)}$) can be calculated as an average of spot-heights along the flightline. Flying height above $Z_{(ref)} = H_g$.*

longest possible single flightline when the block shape is irregular, or to give the maximum number of long flightlines (Fig. 11.6).

Map preparation and flight pack

Starting small format operations for most people is a 'learn-as-you-go' process. A single project with all of the information fresh in the memory, and details all in the head, is the norm. As we progress, however, some semblance of organisation must be introduced. One of the vagaries of aerial photography is the uncertainty of when the actual task will be flown. It is not uncommon for a job to be planned in February and not flown until May. Obviously the normal human memory cannot be relied on to assemble all of the relevant detail of even a single project at that distance.

As we start to expand our operations and to have two, three or four projects in hand at any one time, it is advisable to design a standard procedure for mission material being assembled, and for some method of making that information user-friendly to the flight crew 'on-the-day'. Although it is not necessary to go to the same lengths as for a full scale, large format mission, many of the standard items and examples used by large format planners can be borrowed. (Throughout this book the authors have stressed the point that it is not necessary to 'reinvent the wheel' for every procedure when effective and well proven examples can be 'borrowed'.)

One of the well-accepted approaches to photo flying is to use a *flight-pack* as a basis for the pre-flight and in-flight organisation. This is an assembly of all of the relevant items that will be needed to manage the mission from pre-takeoff to post-flight debrief. We will now examine each contributory item and discuss the rel-

Figure 11.6 *Flightlines should be aligned to produce the minimum number of lines and turns from line to line, thus reducing overall flying time.*

evance with regard to small format work. It should be borne in mind that if you are likely to expand your operation and take on more projects, the earlier you can arrive at a good, workable system the better. To reorganise at too late a stage can cause many problems, in the same way as we will see in downstream film handling and archiving. It is never too early to organise.

Flight maps

Although in Europe and most western countries we have the luxury of choice of large scale maps to use in this form of aerial photography, in many countries anything other than Michelin small scale road maps is hard to come by. Depending on the scale of photography and altitude of the mission being flown, we can lay down some simple guidelines for map selection.

For single, small area projects such as revision of industrial estates, or new housing estates, short road lines, or other line features, the largest map scale available should be obtained, 1:10 000 maps, although often limited in colouring and shading, are adequate for such detailed, close range survey when the flightline is flown using individual buildings for visual guidance. The next step up from small block photography is to move to 1:25 000 scale maps. The representation of 4 cm/km gives plenty of room for information to be visible between drawn flightlines. Most small format projects are flown using 1:25 000 maps.

When using a survey flight map in the air it is important that the marking up of the information is done in a way than can be easily understood, and most important, cannot be misread. The important aspect is to mark the portion of the flightline where the camera is on and to also mark 'run-in, run-out' segments. A common rule is to make the 'camera-on' section a solid line and the 'run-in, run-out' a broken line. One of the reasons for this is that, if the flightline extends across a fold, or across another mapsheet, it is not necessary to hunt for the 'camera-on' arrow to

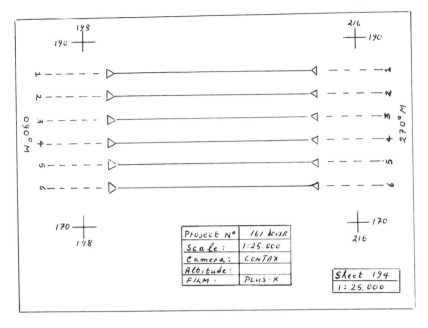

Figure 11.7 *Standard flightline layout for the 'in flight' navigation map.*

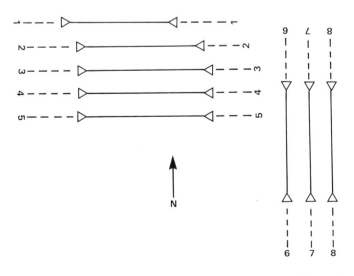

Figure 11.8 *Standard procedure for numbering flightlines (W – E) and (N – S).*

check whether the camera should be running. It should be remembered that the flight environment is fairly stressful, and concentration can be much reduced with the effects of noise, cold and vibration. Thus, all maps and other tools have to be simple to take these factors into account.

The flightlines should be numbered on the run-in, but not in a position where any relevant detail is obscured. In addition the *magnetic course* is also added at the same position (Fig. 11.7). This is not necessary on each single run, if several parallel runs are to be flown, and one magnetic course value for each four or five runs is enough. (The reason for using the magnetic course is that the navigator can then measure the drift and add/subtract from it to provide the pilot with *magnetic heading*.) This can be varied if GPS is being used, as some systems will present the course data in *true track* form which can be used instead.

Another standard procedure is to number flightlines from west to east and from north to south (Fig. 11.8). This can be useful when multiple flightlines are spread across a map, and it reduces the chances of runs being overlooked. Small format users are often involved in line feature flying – roads, rivers, power lines, etc. (Fig. 11.9) – and the numbering of lines in an organised way is essential in this type of work.

A small label should be attached to each map sheet giving brief information of the mission. This will identify the

- project
- number/name
- scale
- camera
- focal length
- altitude
- film type
- map sheet number

This information will depend on the type of work being done and any information being included should be there *only* if absolutely necessary. Do not add need-

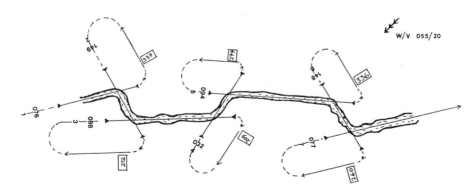

Figure 11.9 *Feature-line flight planning.*

less items of information that are not really relevant to your task. Even the best designed work materials should be subjected to serious review every year or so, to make sure that items haven't been included for the wrong reasons.

Before the flight map is consigned to the aircraft file, it must be attacked with scissors. Whittle it down to a usable lap-size item with enough terrain detail around the sides of the block to take in the 'aircraft manoeuvring area'. At first you might like to discuss this requirement with the pilot until you get some actual experience. A slow aircraft can operate in a fairly limited space and often some 10–12 km beyond the start and end points of the block will be sufficient. Similarly, some 5 km off to either side will also make for a comfortable size of map.

If a flight index has to be prepared from the photography (a map overlap indicating the PP of each photo) it is sometimes useful to include four coordinate positions inside the remaining map area, before cutting down to size (see Fig. 11.7). This will enable a simple flight index to be made from the flight map sheet without having to consult another, uncut sheet.

If the map is relatively small it may be useful to glue it to a piece of stiff card. This makes it easier to handle in flight, and with one hand. Also it is good practice to mark any deviations from the flightline on to the actual drawn lines. Having a stiff backing to the map sheet makes this easier. If the block covers a large number of longer lines then the map should be folded, concertina-like, along line direction, once again making it easy to turn over as the lines progress.

In addition to the basic flight map, a second chart or even a photocopy of an aeronautical chart at 1:250 000 or 1:500 000, should also be included in the flight pack. This will have the photo block drawn, with the run alignment, and in addition the manoeuvring area included. The reason for this is that the pilot will need to coordinate the flight with air traffic controllers and will need to know if there are any restricted flying areas or danger areas of relevance to the proposed flight. At the pre-flight stage the pilot will use this chart, and its attached information, to negotiate with ATC and to make the initial flight plan. During flight he or she will probably prefer to have it to hand as a local area chart. This can also be tacked to a stiffer backing (Fig. 11.10).

Additional information will include
- altitude required
- flight time estimate (over the block)
- any danger/restricted area
- supervisor telephone numbers/operating times
- writing space for the pilot to add:
- radio frequencies (tower/approach/FIR, etc.)
- transponder code
- any limitation marks

A covering folder will contain all of this material and cover page will be a full resume of the project with all checklist items in the heading area and a listing of individual runs. This will give run numbers, magnetic course (each direction) and the number of pictures per run. This is a very useful checklist item in that if too many, or too few pictures are obtained, then the operator will immediately be

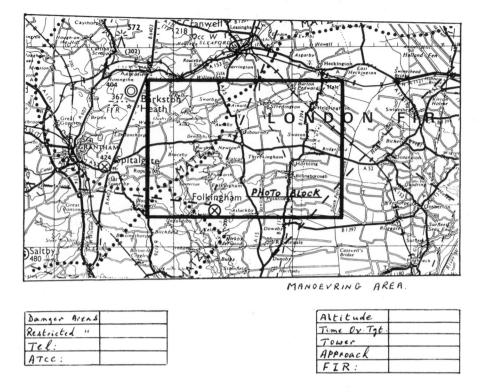

MANOEVRING AREA.

Danger Areas	
Restricted "	
Tel:	
ATCC:	

Altitude	
Time Ov Tgt:	
Tower	
Approach	
FIR:	

Figure 11.10 *Pilot's area chart (taken from 1:250 000 Aeronautical Chart).*

aware. All of the relevant pre-flight information is also on the outside page so that the pilot or photographer does not have to go on a page search when asked a project-related question by air traffic control in the pre-flight stage.

Other items in the flight pack might also include a blank flight photo report (or several), pre-prepared flight plan forms, and where necessary a full film/exposure breakdown. This is a formsheet which analyses the eventual processing and gives exposure guidance for different altitudes and terrain/subject types. This may not be necessary when a fully automated camera system is being used, although when a user intends to mix film types – colour (negative and diapositive) black and white, infrared, and false colour infrared – then some form of photo control sheet can be useful in avoiding potential mistakes.

Well-planned preparation can save considerable time before a flight and a professional approach to how the job is handled can impress air traffic control and other contributors to the project, making future requests for services that much easier.

Lighting conditions

Whereas optimum lighting conditions are always to be hoped for (and flight planning usually assumes this), in practice matters are quite different. Although a clear

187

sky is usually best, in its absence we can still take aerial photographs – its just a question of limits!

For example, if we intend to fly SFAP with a wide angle lens at say, 450 m (1500 feet), and the cloud base is just above this level, photography *could* be possible! But will the available light be sufficient, particularly as a short shutter is necessary to arrest the apparent image motion? And it's not *only* the question of exposure we must consider, but the nature of the terrain as well.

If our mission is an urban area with high-rise buildings then the absence of direct sunlight could prove useful. Perhaps an overcast sun prevails, giving soft shadows? In the event, lighting conditions are ideal for the shadow areas. Scene contrast will remain, and if the mission profile requires colour, then a material such as Kodak Aerocolor H.S. Negative film (SO-358) would be ideal for a 70 mm camera. The SO-358 film offers very good shadow detail and can be conveniently processed in C–41 chemistry (see Table 7.4). Indeed, for colour work a softly veiled sun is to be preferred to direct sunlight, mainly because harsh shadows tend to obscure fine detail. It must also be remembered that in direct sunlight, shadow areas are illuminated only by (blue) skylight. The authors recall one instance where a large scale urban survey (looking at parked cars) failed to adequately record blue cars parked in the shadow of buildings!

Daylight is the sum of 'sunlight' and 'skylight' as shown in Fig. 11.11 where, on a clear summer's day we can expect the contribution of blue skylight to be about

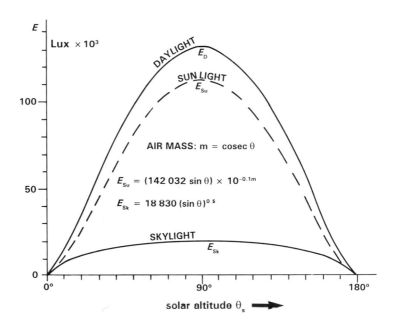

Figure 11.11 *Daylight is the sum of sunlight and skylight, both are a function of solar altitude (SA).*

16% of 'daylight'. It is obvious from Fig. 11.11 that for a given air mass, solar illumination (E_{su}) steadily rises from dawn to noon (which can only approach 90° at tropical latitudes) then declines to sunset. Similarly, skylight also rises and falls with solar altitude (θ_s), but not in so pronounced a fashion.

It is from a knowledge of geographic position (longitude and latitude) that we can calculate the solar altitude for any place in the world, at any local time (see Appendix 1(c), and from this determine the correct aerial exposure at that location. In some circumstances it is important to know the azimuth position of the sun, as well as solar altitude, in order to predict the direction of cast shadows. This information can be gained from Appendix 1(d).

As we fly higher, atmospheric haze starts to intrude into our aerial image quality. For SFAP the haze problem is not too great, mainly because we fly much lower (for a given scale) than is necessary for large format surveys. Nevertheless, at about 4000 feet (1200 m) haze can be a problem and is made manifest by a strong reduction in image contrast. Haze forms a uniform veil of (non-image) light over every part of the terrain and is due to back scattered light coming from small particles of the atmosphere. We see from Fig. 11.12 that the vectors of back scatter are greater than forward scatter, and it is mainly this back scatter that is to blame. It is the short (blue) wavelengths of light that are preferentially scattered (which is why the sky is blue) and so to cut through the haze we generally employ a yellow filter over the lens, since a yellow filter will not pass blue. Naturally we cannot use a yellow

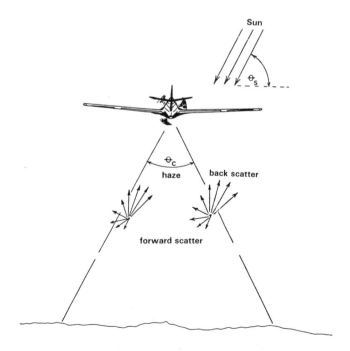

Figure 11.12 *Haze, due to light scattered from atmospheric particles.*

189

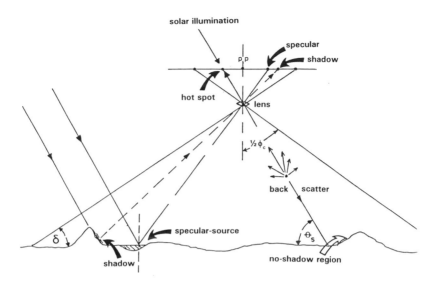

Figure 11.13 *Solar altitude, scatter, reflections and 'hot spots'.*

filter with colour film (except Kodak false color infrared film which has to be used with a No 12 yellow filter).

If we look again at Fig. 11.12, we see that the camera would receive more back scatter from the left side of the aircraft than the right, which in this case depends only on the fact that the sun is on the right of the machine (a phenomenon easily observed the next time you travel in an airliner). A consequence of this is that if the sun reaches a solar altitude (θ_s) higher than a certain value the haze can completely remove all detail from part of the negative – the well-known 'hot spot'.

The solar altitude diagram of Fig. 11.13 illustrates a general terrain illumination, with reflections, shadow areas and a no-shadow region created by back-scatter. The hot spot condition can be avoided, however, and in most survey specifications it s presence is totally unacceptable, mainly because of the lack of image detail which, in open terrain, depends on small shadows.

To avoid hot spots the solar altitude must never be greater than the angle,, which is complementary to the lens semi-angle ($\theta_c/2$), so we can put

$$\theta_s < \delta \qquad (11.12)$$

Mission logistics

A surprising fact applicable to small format aerial photography is that the simpler the equipment and method, the more extensive and meticulous must be the initial

pre-flight planning. The reason for this is that automated camera systems and more sophisticated navigation and camera control systems reduce all aspects of the work-load, giving the small format survey crew more time to concentrate on other aspects of the mission.

If the flight is using a very basic camera, no camera firing system, and visual navigation, then not only is the in-flight workload high but also the detailed planning and crew briefing are liable to be more extensive. Ironically, as this is liable to be the starting point for most would-be small format practitioners, it can often result in frustration and in terminated projects.

In order to make sure that our early missions will have a fighting chance, then we must take a longer look at other parts of the project that we can pre-plan rather than rely on action and reaction to in-flight happenings.

Let us look first at the simple camera/simple navigation scenario. The task is to provide a standard block of photography of a small area some 3 km × 4 km at a negative scale of 1:20 000 for enlargement 4 to a print product at 1:5000. We have available a Rollei 6 cm × 6 cm camera with 50 mm lens and 220 roll film capability. With no electronic intervalometer available we are faced with the problem of ensuring a forward overlap along each flightline to within an acceptable margin of 60%. Secondly we must also be able to maintain an accurate flightline pattern to give ourselves a tolerable 30% side overlap which will provide a full area coverage for our purpose.

Standard calculations are made and, before the flightlines are drawn on the map, a look at the available navigational method must be taken. The simple 'bicycle spoke' T-bar can be readily adopted for this simple task (*see* Fig. 13.12), with minimal modification to the aircraft, and discussion with the pilot and strategy planned. (With this gadget the pilot aligns a mark on the side window with the bicycle spoke extended out parallel to the fuselage. The corresponding line on the ground that the spoke tracks is the centre line of the next flightline to the left of the aircraft.) The pilot will then align the aircraft with the first of the drawn lines on the map and track the flightline from start to end. The photographer meanwhile switches on the camera at the appropriate point and photographs the line that is directly below the aircraft. So, to prepare the map for this task we must delineate not just the four flightlines required but also two additional ones on the outer edges of the block.

In the calculations 4 runs will be required at a line spacing of 770 m and each run will comprise 11 pictures. This will enable the task to be completed with two rolls of 220 film. We must now plan in some method of forward overlap control. A very crude method which will add a few minutes' extra flying time to the overall task can be offered. Basically we approach the flightline in a 'dry run' at the same speed and altitude as will be flown on the photo run, and at the 'camera on' point the photographer starts a stopwatch and logs the time it takes to fly to the end of the line and the 'camera off' point. This elapsed time is then divided by the number of pictures required, minus 1, in this case 11 − 1 = 10. So, if our aircraft has a ground speed of 176 km/h (95 knots) then we will run the 4 km flightline in approximately 81 s. If we divide by 10 it will give us an interval time of 8.1 s. Heavier overlap is preferable so we can round down to 8 s safely.

During this first run the pilot will angle the aircraft to compensate for wind effect, (drift) and can inform the photographer so that the camera also be angled by the same amount (see Chapter 13, Basic flightline navigation).

The aircraft will then return to beyond the start point and fly the run again, this time using the camera and starting photography at the planned point with the photographer firing the shutter manually using the stopwatch to measure each 8 s interval. The photographer will also keep an eye on how accurately the last picture falls phased with the passing of the delineated endpoint. This will give a check on the accuracy of the intervals and of the consistency of the airspeed. The process is repeated with the aircraft returning to the other end yet again and repeating the process one line along. At the end of the second line the film must be changed and the next two lines will be flown to complete the block in exactly the same way.

This scenario describes the simplest of approaches, flying all of the runs in the same direction, ensuring constant interval, heading and drift setting. With familiarity and practice the interval and drift can also be measured for the opposite heading and runs flown from both ends with the necessary adjustments being made. This can be somewhat demanding for inexperienced crews so the 'one direction' method is recommended, at least for starters.

An essential part of this planning is to estimate a mission profile so that the crew know how the photo task fits into the flight time available, fuel, endurance, etc. Although it may not be so relevant to our single, relatively simple example above, should we add further blocks or flightlines to a flight, then the efficiency, economy and even safety of the enterprise can be compromised. Small format is an economy-based air photo method and if a mission is broken off and has to be resumed later because of fuel shortage, then any savings are jeopardised. Also, when a crew is fully absorbed in a complex photo mission it can happen that the desire to complete the mission can distract the pilot from managing the fuel situation correctly. 'Stretched' approaches, coming back to the airport at lower power settings and higher than usual 'safe' altitudes, are not uncommon in professional large format operations, and more than one heavyweight survey aircraft has finished up a few kilometres short of the intended runway.

To this end, each survey mission should have additional calculations to account for transit time to and from the target area, and the total 'on-line' flying time required (at the power setting for photo flying at that altitude and scale). Allowance must be made for each turn from line to line, and also for any additional measuring lines (for interval control as we saw earlier) or to fly all lines from one direction, as well as any extra time for film changes and other time consuming activities.

Most light aircraft have endurances of from 2–4 hours on average, and if each mission is planned with its own full profile, when a flying day comes a series of targets can be put together to fit comfortably into the time available. Before take-off the all-round programme should be put together and the mission profiles of each target area compared so that a tentative 'survey route' can be planned. The pilot and photographer will then decide the order in which each target will be approached. There are certain 'rules' that must also be applied to decide upon which target will be given priority over another.

Although the altitude ranges encountered in small format operations are much more limited than with large format work, under certain conditions some of the same problems can apply. In conditions of high humidity, or in early/late season cold weather periods, condensation on the camera lens can ruin a mission. As first year physics taught us, condensation occurs when a cold object is exposed to warm, humid air. Camera lenses in the types of cameras used in aerial photography are usually quite large masses of glass, slow to react to temperature change, and prone to condensation. In survey flight this can happen when the aircraft descends from cold air at a certain altitude into warmer, more humid air at a lower level. Dry adiabatic lapse rate (the rate at which temperature decreases with altitude) is of the order of 2°C per 300 m, so that when descending from 1800 m to 600 m, the temperature can increase by around 8°C, enough to cause condensation under certain conditions. Thus, when we are planning two or three separate targets in a single flight, each at different altitudes, it is safer to start at the lowest altitude block first, climbing to the higher levels as the mission progresses, rather than start high and descend into warmer air.

(An additional word of warning on the topic of condensation. If the air camera is installed with the lens protruding into the outside air, care should be taken when changing magazines if the aircraft cabin heating is on. When the inner lens surface is exposed to the warmer cabin air mass, conduction from the outside lens surfaces and lens mount itself can cause moisture to form. It can happen that the new magazine is dropped on without the steam-up being noticed and the consequences noticed only later.)

Every flight and every single survey task must be planned down to the last detail, more so in the early stages of small format experience. Although it is possible to receive training in small format photography operations this is normally expensive. Most users start from small beginnings, using their own instincts and ideas. The better their overall planning is, the more likely they will be to achieve success and go on to more polished, productive operations.

Chapter 12

Operational Procedures

Pre-flight procedures

Camera

Under ideal conditions a good camera fit is done at a comfortable pace with enough time to check all items thoroughly. In practice, however, time is usually at a premium and there are various pressures (such as weather, airfield imperatives and client priorities) that urge haste. This is where the main pre-flight checklist becomes necessary (see Table 12.1).

A critical item on the installation check is the sealing of any adjustable items. Most small format cameras are built with smoothly operating controls for focus, film speed, etc., but in aerial photography we are not concerned with focus – infinity is the standard setting – and film speed will usually be standard for the whole flight. The focusing ring should be taped against the lens body, set in the infinity position, and the film speed setting taped against accidental movement. Similar precautions should also be made for any other exposure adjustments, particularly since small format cameras are designed for hands-on use rather than remote operation.

Most of the expensive small format cameras come with an option for either aperture priority or shutter priority while working in the auto-exposure mode. In general it is best to operate with shutter priority since by selecting the preferred shutter speed (against an estimate for correct exposure, found by the calculations given in Appendix 1(j) the degree of apparent image motion (Appendix 1(b)) can be controlled throughout the entire mission. Regardless of any automatic change in exposure (due to cloud shadow or terrain reflectance) it is then the aperture that alters and not the all-important shutter speed setting.

Camera mounting

With many internal camera mountings there is the possibility that a change in camera fit could leave gaps around the camera hole, allowing engine fumes (from a single-engined aircraft) to be sucked into the cabin (Fig. 9.8). This is a potentially dangerous situation, of course, but one that could be easily overlooked if not included in the camera checklist! It is a simple matter to block up any gaps with foam rubber or other material, as shown in Fig. 10.5.

The camera mount should be checked for stability and camera security, and if it is fitted with drift compensation this facility needs to be checked for ease of movement and locking (Figs 10.8 and 10.11). If the mount assembly is external to the aircraft (Figs 10.3 and 10.12) then the pre-flight checks must be very stringent.

Navigation sight

Perhaps the most vulnerable type of sight is the externally fitted side sight (Figs 10.14 and 13.12) mainly because of its flimsy structure and position with regard to accidental damage. Even if the sight is damaged it can easily be thrown out of true, and should be carefully checked to ensure that its arrangement is correct for the lens and format in use.

If a professional navigation sight is installed (such as the Zeiss NT1 shown in Fig. 10.9) then it should be checked for cleanliness and freedom from moisture. Under the atmospheric changes of flight, moisture can fill the optical cavity with mist, making it completely useless. The sight should also be checked for drift movement, and a complete reversal of the sight so that the external optics can face rearward during take-off and landing (to avoid damage). The pre-flight check should also look at sight alignment. Although this cannot be thoroughly checked before the flight, if there is any hint of doubt the mission should be aborted and a thorough check made on the sight and its alignment with the camera.

If a video system is employed, the camera and monitor must be checked for electrical continuity, optical cleanliness and alignment.

Mission planning and air traffic control

An important aspect to be considered during initial flight planning, and again in discussion with the pilot before flight, is the nature of the airspace in which the survey flight will be done. All airspace is categorised as to its accessibility for various groups of aircraft and users. Small format flights are most often carried out under visual flight rules (VFR) and as such must keep clear of controlled airspace, unless some prior permission has been obtained. A telephone call to the air traffic control centre (ATCC) and a brief request to the supervisor can often get the aircraft permission for a specific task, but rejections can also be expected.

If you have a task that entails invading a control zone or other busy airspace, it is often useful to prepare a detailed flight plan map to send in advance (by post or fax) to the ATCC. A photocopy of the 1:250 000 (or Jeppesen, or Aerad) area chart, with your actual photo area marked and information as to required time overhead, altitude, aircraft type and (if possible) the time frame of your project will always be appreciated. A second outline, delineating your probable manoeuvring area, will also help since the actual photo area does not give the controller any idea of how much room you will actually need to turn on to, and to reposition, for second and third runs and so on (see Fig. 11.10). Some information as to why you are flying, and for whom, will also help, especially if the task has a public service or environmental background. Similarly, a company logo or authorisation helps, even that of your flying club or aircraft operating company.

Table 12.1 *Checklists*

1. Mission planning requirements (block)

 a. Area delineation (map/diagram, coordinates)
 b. Scale of photography (at negative) (m)
 c. Required side overlap (q)
 d. Required forward overlap (p)
 e. Size of negative (S')
 f. Focal length of lens (f)
to produce:

 g. Side of ground (S)
 h. Line spacing (a)
 i. Forward gain (B)
 j. Number of runs
 k. Number of pictures
 l. Altitude (Z)

2. Flight preparation

 a. Install camera mount, check levelling and rotation
 b. Install camera, tape/secure focusing ring and check shutter/aperture priority
 c. Install navigation sight/system. (If GPS, run for initial almanac/position)
 d. Install intervalometer/overlap regulator
 e. Connect camera/mount/intervalometer
 f. Install battery unit or connect to aircraft supply, and check operation
 g. Load film magazines or direct camera load
 h. Set any camera/magazine data parameters
 i. Stow additional films and data recording materials
 j. Check flight path
 k. Brief pilot/crew
 l. Check outside of aircraft for possible/potential lens-obscuring objects/liquids
 m. If meteorological conditions are good – fly

What usually happens is that the ATCC will reply giving an offer to assist with a special flight number and giving telephone numbers and instructions regarding how to get things under way on the mission day. Alternatively, they could put the damper on it by giving a list of reasons why not!

The main thing is to be professional, using good radio procedures, staying within given clearances and under no circumstances taking chances to steal that uncleared picture. A 'bogey' in controlled airspace can cause all sorts of safety problems and will make life difficult for other, less cavalier, aerial photographers on future occasions.

A rather more significant problem is that of military airspace. This comes in various forms, from actual *danger areas* where army and navy artillery firing takes place on a regular basis or where air-to-ground live ammunition activities are involved, through *restricted areas* which are similar but usually involve small arms

Table 12.1 *continued*

3. Approach check

a. visual check for clear target
b. Ask pilot to set power and airspeed for flight over target
c. Turn on camera system, intervalometer, mount, etc.
d. When straight and level, set camera/sight levels (with pilot's agreement)
e. From flight pack select relevant maps for pilot and flight report

4. Over target

a. Identify specific target features from map
b. Ask pilot to turn to run heading (plus any estimated offset for known wind)
c. Measure drift and give correction to pilot
d. Turn on to first line, check system levels and set drift
e. At first checkpoint, turn on camera, record run number and start time
f. At end of first run, check correct number of pictures from flight pack information
g. When film ends ask pilot to orbit specific ground object, change magazine/film
h. Continue to next lines, recording data on film report
i. On completion, check correct number of runs completed and number of exposures
j. Cursory check that camera system is still working correctly
k. If satisfied of full coverage, set heading to next target
l. Go back to 3a

5. Post-flight checks

a. Remove all exposed films from aircraft, labelled, with reports, to transit box
b. Collect and reassemble flight packs, maps; remove from aircraft
c. Disconnect cables from camera, mount and intervalometer; remove from aircraft
d. Remove camera from mount, check focus is secure and there is no damage or dirt
e. Remove intervalometer, check for damage or wear
f. Remove mount, checking integrity, movement range and for damage, wear, dirt
g. Reinstall any aircraft panels removed for mission
h. Tidy aircraft and camera area
i. Thank pilot and any ancillary crew
j. Pay the bill

and tank operations on less regular schedules, to *military low flying areas* and *low level routes*. In the planning and pre-flight stage of a flight you must check out all of these aspects from the aeronautical chart, in close consultation with the pilot. The fact that areas are marked as 'no-go' for general operations does not mean that all is lost. A quick look at the relevant aeronautical information publications (AIP) in the local airfield briefing office or air traffic control tower will give more information and usually a telephone number to call. It is often possible to get a time slot to get in and out to fly your mission (unless it will present a security risk to the ground installation). Even mortar gunners have lunch breaks!

A more dangerous aspect of military operations for SFAP is the network of *low level flying routes*. In recent years a few light aircraft and helicopters conducting

SFAP and observation activities have been involved in fatal collisions with airforce fighter-bombers and low level strike aircraft. These low level routes are well marked on flight maps, and their altitudes clearly stated. It's up to the SFAP pilot and crew either to avoid these routes or to make sure that they are above the stated altitudes, as well as keeping a good look out.

Preparing to fly

Having completed photographic and flight preparations, we can now enter the aircraft. Hopefully we shall have prepared ourselves for what might easily be a very cold and rather noisy experience. Since cold and noise contribute to destroying concentration more than any other airborne factors, they should be reduced as much as possible.

In photo flights we usually fly with camera holes open: windows, panels or even doors are either open or completely removed. This may seem acceptable on the ground, but in the air, with an airflow of 200 km/h or more pulling warm air out and forcing supercooled air in, the working environment can soon reduce the operator's abilities to perform adequately. A good flight overall with woollen pullover and thick trousers are essential, as are thick woollen socks and gloves. If the small format photographer or navigator has any doubts in this quarter, he or she should visit a microlight airfield – where participating pilots dress like First World War aviators, even in summer. An open cockpit environment is cold, even at 1000 m, and after 30 minutes crew performance deteriorates fast.

Noise has the same debilitating effect as cold, but over a longer period. However, a headset is needed for communication with the pilot and there is the added benefit that it not only keeps noise at bay, but keeps your ears warm as well. Communication with the pilot is important, of course, but it is interesting to note that the more experienced you and the pilot become in working together the less you need to give commands.

Pre-take-off checks

Once the engine is running and any power connections to the camera switched on, the system should be tested. The importance of these tests cannot be over-emphasised, particularly where installations preclude in-flight removal of the camera, and consist of a film flow test (take care not to use too many frames) which will also check the shutter mechanism. Once the camera system is checked OK the pilot is then given the signal to taxi for take-off.

During the taxi run the photographer should ensure that everything is stowed away. With open windows, maps and paperwork are particularly at risk – and so is the aircraft.

In-flight procedures

During the mission the flight/film report (Fig. 12.1) must be maintained diligently. It is impossible to remember every in-flight condition, and the flight report has great importance to future photo-library records. A disciplined approach to keep-

Aircraft	Pilot	Camera	F/L	Date	Task Name/Number
Film Number	Run Number	Direction	Time on	Time off	No of pix/Remarks

Figure 12.1 *Specimen flight/film report.*

ing a record of the photographs taken on each mission is essential, particularly since identifying the location of an aerial photograph is difficult – unless the image is like that shown in Fig. 15.2.

En route to the target area the crew will be keeping an eye on the weather, and as the aircraft climbs to its operational altitude the pilot will be busy with radio transmissions, dealing with any clearances that may be necessary. It is important to clear every possible task before block photography starts, thus reducing the workload over the target area.

As the mission area gets close, the photographer will go through the approach checks (Section 3 of Table 12.1). Once the target has been identified and the map is to hand, the system should be switched on and made ready. The altitude will be checked again (a pilot can make a mistake just as easy as anyone else) and the pilot asked to level the aircraft. At this stage the pilot will adjust the engine power settings and trim the aircraft for the survey flightlines. Once the aircraft attitude has been settled, the camera and navigation sight (if appropriate) must be levelled by the photographer.

If overlapping photographs are being flown then 'drift' must be measured. The photographer will give the pilot a heading to fly and, when straight and level, the actual track over the ground will be measured to find the drift angle (DA) as shown in Fig. 12.2*a*. Once this is known the heading can be corrected by applying the 'wind corrected angle' (WCA) to put the aircraft on its 'crab-like' track (Fig. 12.2*b*).

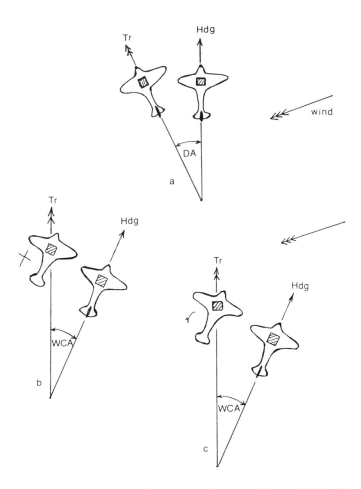

Figure 12.2 *(a) Under the influence of a cross-wind, an aircraft's track (Tr) will move through a drift angle (DA) from its original heading (Hdg). Note, the aircraft's nose always points in the direction of its heading. (b) In order to put the aircraft's track on its original heading, it must be flown into the wind, through the wind-corrected angle (WCA). It will be noted that WCA = DA, but is of opposite direction. (c) The camera must be turned square to the track, by rotating the camera mount to the drift angle (DA).*

It should be noted that the wind corrected angle is equal (but opposite in sign) to the drift angle.

The correct camera drift setting for the run direction being flown can then be applied to the camera mount and the aircraft aligned for the first run. It can be seen from Fig. 12.2c that unless the camera is set at the correct drift angle, the line overlaps will appear as shown in Fig. 12.3, which is a significant waste of film.

The line-overlap shown in Fig. 12.3 illustrates how easy it is to get everything right – except one single error which is enough to ruin an otherwise excellent mis-

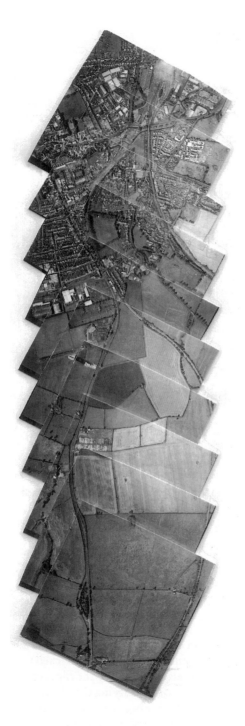

Figure 12.3 *The effects of flying a correct track, but with uncompensated camera drift angle.*

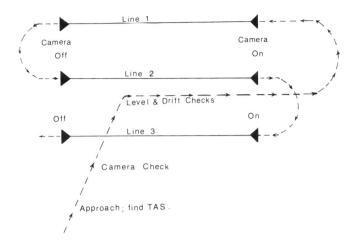

Figure 12.4 *The approach, camera check, level and drift checks and turn on to the first line of a three-line block.*

sion, flown by an experienced pilot and navigated by a flight student. The error is a typical example of inexperience. Flown with a 70 mm Vinten camera and NT1 navigation sight, a drift angle of –22° was correctly measured as the aircraft was flown along the pre-planned mission heading. The pilot then turned on to the first line and applied the wind corrected angle (+22°) to the line heading, providing the correct tracks shown in Fig. 12.2c. The track is accurate, as may be seen in Fig. 12.3, and the forward overlap (60%) is also good, but unfortunately the photo/navigator forgot to apply the drift angle to the camera mount!

When visual methods of survey navigation are being used it is usual to fly parallel to the first run to measure drift, then turn back to fly this run in the opposite direction, as shown in Fig. 12.4. This gives the pilot and photo/navigator a chance to identify useful check points on the flightline. In this case the opposite drift angle to that measured will be set. It is usual to write down headings and drift angles for each run on the flight report as an aide memoire.

When GPS is being used it is quite common to line up on the flightline from some distance out and do the levelling and drift checks on the long run in.

Photo management

SFAP often entails much film changing during a mission; it is important to have a system to ensure that exposed films can be simply marked to avoid them being used twice. Any film marking must also be allied to the film report. It should be remembered that the downstream tasks of identifying the photo against the flightline may not necessarily be done by the photographer who actually flew the mission. A positive method of identification and registration throughout the operation is therefore highly desirable.

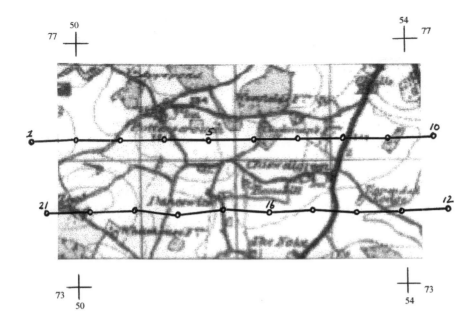

Figure 12.5 *A typical SFAP index, showing the photo centre of each exposure overlaid on to a 1:50 000 scale map. Photography (1:40 000) from a 70 mm camera and 28 mm lens, base is 880 m for 60% forward overlap and line spacing is 1540 m for 30% side-lap.*

During the photo flight the photo/navigator should carefully mark the progress of the aircraft on the map (against the planned flightlines) to verify coverage, and if possible, any potential gaps in cover should be reflown before leaving the target area. Aspects of photo quality also have to be monitored, such as cloud shadow, turbulence, correct number of photos per run (compared with the photo flight plan), large on-line corrections (3° heading change is usually regarded as the maximum between photos), aircraft attitude changes and any electronic or mechanical anomalies that may occur.

Depending on the type and amount of film used in the project, it is sometimes useful to have one film at the end of the mission with some 'throw-away' pictures that can be used for test processing.

Indexing

Before any survey photography can be released to the client it is necessary to check the centre of each negative on to an appropriate map. Index details will usually be covered by the clients specifications, and will usually include data such as the mission area, date, scale, amount overlap, etc.

A typical index for a SFAP mission (flown at 1:40 000 over a small village area) is shown in Fig. 12.5, where each photo centre is indicated by a small circle. In this

example only two lines were required, and despite slight kink in the lower run, the index shows a good standard of visual navigation. As an aid to locating each photo on the 1:50 000 map, the mission area has been plotted with relevant map coordinates and every fifth photo indicated on each run.

Monochrome film processing techniques

A brief introduction to film processing and sensitometric terms has already been given in Chapter 7. We must now consider these issues in greater depth, for they can make all the difference between success and failure in SFAP practice.

Small cameras may make for easier handling, but their convenience stops right there! It is a truism of photography that the larger the format, the greater the latitude for processing mistakes. With 35 mm films there is virtually none at all. Dirt, dust, scratches, overexposure, overdevelopment, excessive granularity, too much contrast or processing temperature, all contribute to poor if not disastrous image quality.

All small format imagery *must* be correctly exposed and correctly processed to get a negative, or series of negatives, that can be enlarged to yield a positive image with full detail, differentiation between tones (or colour) and contrast. We have to start by getting a good negative, and this entails knowing how the film is to be developed since the type of film and its development must satisfy terrain conditions, flying height, film speed, lighting, exposure requirements and the degree of enlargement necessary.

In the best of all possible worlds, the film will have a speed of about 200 ISO, and an ability to be enlarged about 10 times without showing its granular structure (graininess). At the same time, it will have good contrast and an ability to discriminate detail over a wide exposure latitude (i.e. show detail in dark shadows as well as in the bright highlights). With 35 mm stock this is not easy, and although there are many claims to the contrary (by manufacturers and others) at least one of the above criteria has to be sacrificed to favour the others.

If we want an ultra fine-grain Panchromatic film then we should select Kodak 2415 Technical Pan film (Table 7.3), but this implies that we must develop this film in Kodak's LC (low contrast) developer and accept a working film speed of only 32 ISO. It is true that we will be able to enlarge up to 50 times without showing undue graininess (providing we don't overexpose or overdevelop), but even if we have a very slow aircraft – which might allow us to use only 1/50 s at f2 on a very dull day – the film speed could prove restrictive if a lens filter has to be employed.

It is always necessary to compromise. The best will usually be a fine-grain film with processing that allows a film speed in the region of 50–100 ISO. Such films usually provide acceptable granularity with sufficient exposure latitude to allow for good terrain detail, and, most of all, sufficient processing latitude to allow for a range of developer that can be used to gain the required negative.

Processing control

If, say, we flew a particular SFAP (35 mm) mission with Kodak Panatomic-X (rated

at 50 ISO) and a yellow filter on the lens, and we developed for 10 min in D-76 developer (1 + 1) at 20°C, we might perhaps congratulate ourselves on achieving first-class negatives!

Perhaps our mission was of mixed rural and urban terrain at large scale, flying height about 750 m and a clear atmosphere with small white cumulus clouds (about 2/8) above us. When enlarged we found the shadows were well exposed and the fine detail in light areas also printed well. So perhaps we could be excused for repeating the same processing, for the same type of film, at our next mission.

But if our next mission is a large forest area covered at small scale, with a flying height of 6000 feet (1800 m), and a hot and humid day with overcast sun, then we may not be so pleased with our results – even if we used the same film and process as before! We could expect the images to lack the contrast of our former mission for two reasons: first a lack of clear shadows (which provide contrast) and second we can expect a greater amount of haze (hot and humid) which would be significant at 6000 feet. As a consequence we could expect the negatives not only to lack contrast (which we cannot afford to lose if we are to differentiate tree crowns) but also be overexposed, due to the extra hazelight, with a corresponding loss of resolution.

Process control allows some degree of compensation for the above loss of quality, simply by rating the film at a higher speed (say 80 – 100 ISO) and compensating for the underexposure by developing for perhaps 15 min rather than 10, or by using the D-76 developer at normal strength, rather than diluting with water at (1 + 1). By such means the negatives can be made to yield a higher contrast without an associated higher density level.

A contrary practice is to overexpose and underdevelop the film. This technique is very useful when one needs to lower the contrast and extend the exposure scale of the D–log H curve such that the curve, as shown in Fig. 7.10, would slope less steeply and extend further to the right before reaching the same maximum density. In this way a scene with a very large exposure scale (say a dark pine forest under hill shadow, contrasting with a sunlit snow-covered ground) could be exposed to provide detail in the dark shadows of the trees, yet not be too dense in the snow-covered areas.

In both of these cases where there are problems of terrain and/or atmosphere and lighting, the answer is 'process control'.

Although sensitometric procedure is ideal, it is not necessary for SFAP once sufficient experience, awareness and practice have given the operator a good working knowledge of the parameters involved. In order to establish this education it is prudent to use film – lots of it – every time you fly! Experiment with exposure, different scenes, altitude, developers, processing parameters – make notes and learn. Very often, too often, the camera operator will send his or her film to a film lab for processing – this is a mistake. The aerial scene, camera exposure and film processing are linked, and an understanding of this linkage is essential to those who operate the camera – particularly with SFAP. Once this association of scene, exposure and processing is understood, then, and only then, can the operator delegate processing to another party, for then he or she will be able to instruct the laboratory correctly.

It is not so easy to find a laboratory or photographic studio that will do your

monochrome processing these days, so user processing is the only way as well as the best way.

The daylight film processing tank

The most convenient and economical method for developing 35 mm films (of conventional 36 or 24 exposure lengths) is by way of the daylight film processing tank. These plastic (or stainless steel) tank units are made up of a spiral reel into which the film is threaded, a funnel top into which the processing solutions are poured, a stirring rod, a tank cover and a spiral reel cylinder. A similar tank unit is available for 120 roll films, and many can be adapted for either 35 mm or 120 size films. It is also possible to purchase larger units which can mount up to three spiral reels – but obviously each film must have the same processing solutions and processing cycle!

But, you may ask, how do you get the light-sensitive film into the 'daylight' processing tank? The answer is to buy a daylight film changing bag! An entire system is shown in Fig. 12.6.

In Fig. 12.6 we can see all the components of a typical 35 mm daylight processing tank, with a lightproof daylight film changing bag alongside. The changing bag is rather like a shirt, with a zip fastener through which the film(s), cassettes and tanks can be inserted. The operator then zips up the bag and puts his or her arms through the 'sleeves' to perform the tasks in hand, e.g. changing films from a bulk roll to cassette, or loading film into the spiral reel before closing the tank.

Once the film is inserted correctly into the spiral reel (this takes some practice), it is very important to ensure that the flanged spiral reel cylinder has its flange at the bottom of the tank. Failure to do this will allow light to creep down the funnel top and bounce back up into the film spiral, with a consequent fogging of the film.

Figure 12.6 *A complete daylight processing kit for 35 mm photography. This is suitable for both monochrome and colour film processing, but if infrared film is to be processed first check the 'changing bag' and the plastic tank for opacity to infrared.*

Film processing

The only precise temperature requirement is for the developer, which is usually a standard 20°C. But wherever possible, all other solutions should be close to this value within 2–3°C.

It is important to agitate the film during every step of the processing. Agitation can be done by use of the stirring rod or by inverting the tank (when closed with the tank cover) two or three times at intervals of 30 s. The latter method is best since the action can be repeated in a uniform manner – and remember, agitation is also a development parameter. The tank cover serves only for this function and is not required to keep out the light – that task is served by the spiral reel cylinder.

There are six basic steps to film processing, and all except one can be conducted within the tank.

- Pre-soak. It is always wise to pre-soak the film with water, for about 30 s, before pouring developer into the tank. All films have a supercoat (to guard against abrasions) on top of a gelatine emulsion which holds the light-sensitive salts (Fig. 12.7a). Pre-soaking softens the film in advance of development and helps to give a uniform result.
- Development. The developer should be at the correct dilution and temperature so that it can be entered into the tanks as soon as the pre-soak is poured away. The film should be agitated every 30 s and development carried out for the period dictated by the type of film and developer concerned.

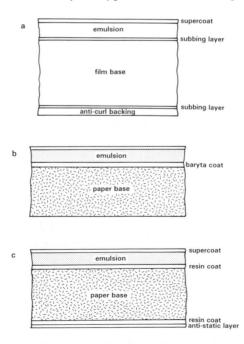

Figure 12.7 *(a) Cross section of a monochrome (black and white) film. (b) Conventional monochrome printing paper. (c) Resin coated monochrome printing paper.*

- Stop bath. Since developer is alkaline and fixer is acid, it is not a good thing to have developer carried over (in the gelatine) into the fixer! To avoid this we use a stop bath of 2% acetic acid (or just plain tap water) as an intermediate step.
- Fixer. The fixer (see Appendix 4) is a solution that dissolves away all the unexposed light-sensitive salts, and so fixes the image in a permanent state. Until the film is fixed it is vulnerable to the action of light – the funnel top must not be removed until at least 5 min of fixation has elapsed.
- Washing. The function of the washing process is to reduce the amount of soluble salts to such a level that they will allow the negative image to last 30 years or more. The easiest way to wash a film is to place the tank under a running (cold) tap for about 30 min, but this is rather expensive on water and not all that efficient. A more economical method is to give the film about 10 changes of water.

 It is important to note that washing is efficient only if the fixation is complete! It is wrong to think that less fixation can shorten the washing time – on the contrary, it is impossible to wash out the complex soluble salts unless they have been made soluble in the first place.
- Drying. Small films require very careful drying. If water droplets are allowed to form on the film – they can result in permanent drying marks that are easily confused with terrain detail. It is essential to dry films in a dust-free atmosphere at a normal rate of evaporation.

 Ideally, films should be suspended (vertically) with a small weight at the end, and small droplets removed with a chamois cloth (on both sides of the film). In very humid climates the drying room should be heated with an electrical heater to allow for better evaporation. If long rolls of film are involved (70 mm rolls or 200 exposure lengths of 35 mm film), suspend the film (via sprocket holes) with paper clips along the length of a string.

 Take care with sprocketed film – each sprocket hole is a source of water droplets, and should be removed as soon as possible.

Film developers: types, techniques, temperatures and times

There are numerous proprietary developers available, and all of them will serve you well. The few mentioned here, and those formulated in Appendix 4, only serve as useful examples.

The standard small format developer is the well-known Kodak D-76, (or Ilford ID-11) which can be used at full (stock) strength or, better still, diluted $(1+1)$ with water. If the working solution is at some temperature other than 20°C then the development time (for a given film) can be found from a table or graph such as that shown in Table 12.2.

In Chapter 7, we referred to contrast (equation 7.4) and modulation (equation 7.5) and how these terms could be related to either target or image. A more practical control of image contrast is given by the term gamma (γ) which value is the tangent of the (almost) linear region of the D–log H curve, i.e.

Table 12.2 *Film development times for D76/ID11 at 20°C/68°F*

Film type	Undiluted (min)	Diluted 1+1 (min)
HP5	7½	12
HP4	8	12
FP4	6½	9
PAN F	6	8½
TRI X	8	10
PLUS X	6	8
PAN X	7	9

(see chart for other temperatues)

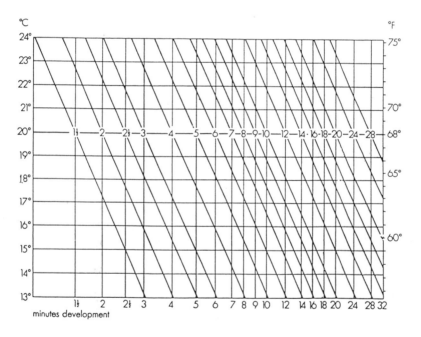

$$\gamma = \frac{\Delta D}{\Delta \log H}$$

(12.1)

For the five D-76 curves shown in Fig. 12.8, a plot of each against γ its respective development time produces a time–gamma curve, which is the primary processing control for image contrast.

Whereas the curves of Fig. 12.8 were produced with a non-calibrated sensitometer, the DK-50 curve of Fig. 12.9, is the product of a calibrated (H = 1000 lx s) light source. In this instance the light source was covered with a neutral density of 2.35,

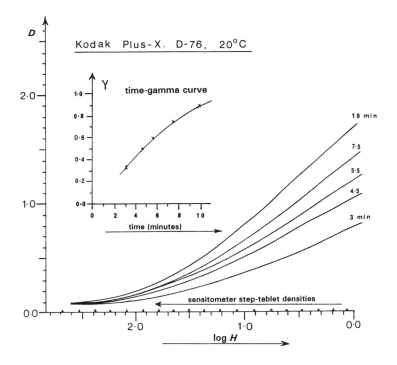

Figure 12.8 *D-logH curves for Kodak Plus-X film developed in D-76 for various times at 20°C. The time-gamma curve is an indication of the film contrast, as controlled by the development time. Note: gamma (ã) is the tangent of the linear portion of each curve.*

and a Kodak No.29 red filter. To find the effective aerial film speed (EAFS) of the Plus-X film (when processed in this fashion) we take a point of density at 0.3 above fog level and drop a vertical to the logH axis, where we find the master step tablet density value D_m = 2.0 (a light transmission of 1/100). But the actual transmitted light that reaches the film is the sum of two densities (2.0 + 2.35) and so the total amount of light reaching the film is given by H_m where:

$$H_m = \frac{H}{\text{anti}\log(D_m + ND)} \qquad (12.2)$$

from which we compute:

$$H_m = 0.0447 \text{ lx s}$$

The EAFS is specifically suited for air films and is a combined function of the film and its processing:

$$\text{EAFS} = \frac{1.5}{H_m} \qquad (12.3)$$

In this example the EAFS for this film and process is 1.5/0.0447 = 33. But if we

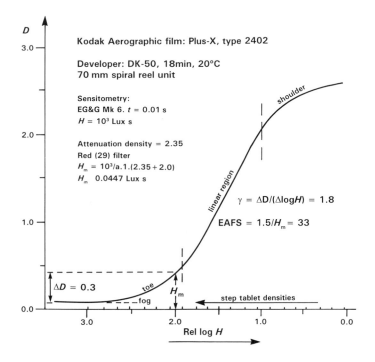

Figure 12.9 *A complete sensitometric analysis of a film intended to be used at high altitude (red filter over lens) with high contrast (γ = 1.8). The 'toe' of the D-logH curve is steep, which is good for shadow detail and contrast at low densities, but over exposure must be avoided since high densities obliterate fine detail. Although the nominal film speed is 125 ISO, the EAFS is calculated as 33, and takes the 4× (red filter factor) into account.*

refer to Table 7.3, we see that Plus-X has an ISO rating of 125. Although there is little difference between EAFS and ISO ratings, this discrepancy (a factor of 4) has to be explained. The difference is due to the red filter of course, and is a useful method for finding a filter factor for any film/filter combination.

The process illustrated in Fig. 12.9 is very contrasty. A γ of 1.8 is generally excessive for SFAP, but there are times when a high processing contrast is required – where there is no sun, where terrain contrast is very low, and so on. We may also note that the process was carried out using a 70 mm spiral reel unit. A typical unit is the Hansen (Delft, Holland) spiral reel assembly (see Fig. 12.10). These units can load up to 30 m of 70 mm film and come with plastic reels and dishes. The Hansen outfit comes complete with an air-blower drying unit and is very efficient, but requires careful handling. In particular, when processing perforated 70 mm film, it is important not to over-agitate since this can lead to uneven development; on the other hand, too little agitation can lead to sprocket-hole modulation where highly localised developer concentrations can lead to streaks of uneven development.

211

Figure 12.10 *The Hansen 70 mm spiral film processing outfit.*

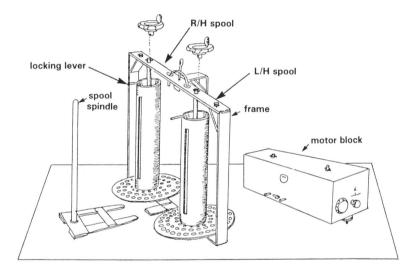

Figure 12.11 *The Zeiss FE-120 rewind spool film processing unit.*

Yet another method for developing 70 mm films is to employ the rewind spool units common in large format film processing. These units are very expensive, but they are often available for SFAP since they seem to be out of favour in many survey companies – mainly because the companies employ large continuous processing machines these days. The spool unit is shown in Fig. 12.11, where it can be seen that once film has been wound on to one spool it can be hand-wound on to the other (Fig. 12.12). The entire operation is conducted in the safety of a darkroom. Although a motor wind is available, this is only used for washing – it is too fierce for development.

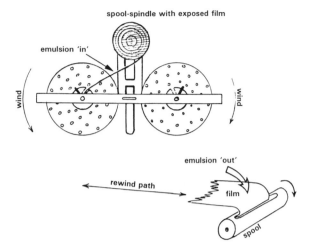

Figure 12.12 *Loading film into a rewind spool before processing.*

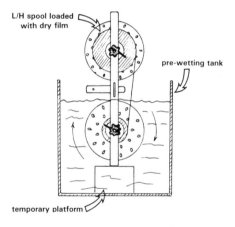

Figure 12.13 *Winding dry film into the pre-wetting tank prior to development (rewind spool).*

Although made for 23 cm format films, the American Morse rewind unit can be adapted for 70 mm film, where as the Zeiss FE-120 unit is for 23 cm format only. A total of four tanks are supplied. A pre-soak tank which allows the film to be evenly wetted by winding the dry film (vertically) into the wash water (Fig. 12.13), then three processing tanks where the film is (horizontally) wound from one spool to the other and back again to complete a full cycle. The three tanks are for developer, stop-bath, and fixer. When the film has been fixed (perhaps four cycles) the light can be put on and the stop-bath tank used for washing.

213

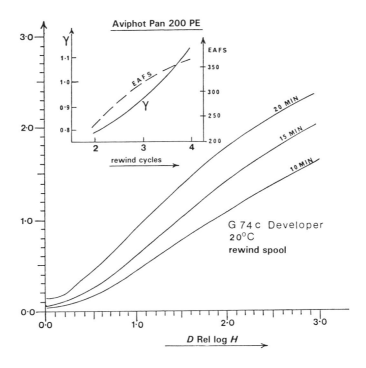

Figure 12.14 *Sensitometric data for Agfa-Gevaert 70 mm Aviphot Pan 200 film, developed in G-74c with the Morse rewind spool unit.*

The rewind spool system is good, but has to be used with care. The number of processing turns must be counted, and when the total number is close the handles must be turned very slowly so as not to synch the film tight against the spool. Failure to do this will always result in about six frames (close to the spool) having 'bar-marks' where they were compressed against the film spool lock (see Fig. 12.12).

After washing, the 70 mm film should be carefully hung to dry on a line, as mentioned previously.

For the rewind process it is usual to monitor the processing in terms of the number of rewind cycles necessary to gain a certain γ, as shown in Fig. 12.14, where 70 mm Agfa-Gevaert Aviphot Pan 200 film has been processed in a Morse rewind spool unit in Agfa G-74c developer. In this figure (Graham and Dasmal, 1992) both EAFS and γ have been plotted from three identical lengths of film, developed for different numbers of cycles (each cycle being of 5 min length).

If no special processing equipment is available you can always hand-process a roll of 70 mm film. The method is very simple and rather tedious, but it gives results as good as any other method. All you need are some long plastic trays, about 60 cm long by 14 cm wide and 16 cm deep – the kind that are sold as gardening trays. The roll of film is then hand-wound (vertically) from one end to the other and back.

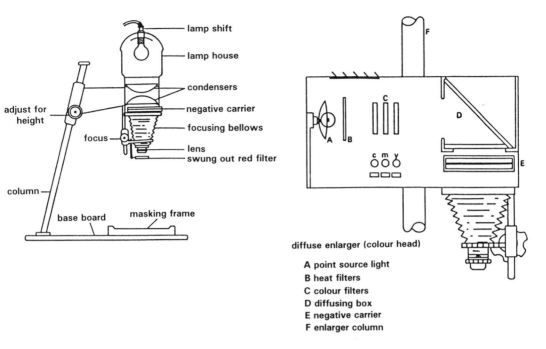

lamp shift
lamp house
condensers
adjust for height
negative carrier
focusing bellows
focus
lens
swung out red filter
column
base board
masking frame

F

c
D

A B

c m y
○ ○ ○
▭ ▭ ▭

E

diffuse enlarger (colour head)

A point source light
B heat filters
C colour filters
D diffusing box
E negative carrier
F enlarger column

Figure 12.15 *Typical design features of (A) monochrome (condenser) enlarger and (B) colour diffuse enlarger.*

Monochrome printing

Since all SFAP negatives have to be enlarged, in order to reveal the maximum amount of detail, it makes sense to ensure that the enlarger is of the best possible quality. Contact printing (using the same type of contact printing frame shown in Fig 7.9) is possible of course, but only the larger 120 or 70 mm negatives are going to yield images that will be useful – for checking flight cover, for example.

A good, if basic, monochrome enlarger should be fitted with glass condensers, as shown in Fig. 12.15*a*, in order to get the best quality prints. If colour printing is contemplated then a colour enlarger (which incorporates a special light source and filters) can always be used for black and white quality printing (see Fig. 12.15*b*).

Monochrome printing is not only easy, it is a delight. True, it must be done under a yellow safelight, but its basic simplicity and satisfying technology allows one to truly enjoy this task. Many amateur photographers just black out the bathroom and place their processing line across the bath. The arrangement shown in Fig. 12.16 illustrates the processing line and a simple contact printing frame.

The processing line (in trays) is developer; stop-bath/rinse; fixer. Washing is easily accommodated in the bath, and drying is simply a matter of hanging the prints on a line.

Monochrome printing papers are made in two types: those with a conventional papers base (Fig. 12.7*b*) and the resin-coated type, as shown in Fig. 12.7*c*. The latter

Figure 12.16 *An improvised bathroom print processing line and simple contact printing frame.*

has the advantage of not absorbing solutions into the paper base thanks to its resin coating, and consequently requires less washing and drying time. But the conventional type has a considerable advantage when it comes to making mosaics – it can be feathered (by trimming the paper from adjoining edges) to make less conspicuous joins.

Most manufacturers of printing papers make them in four or five different grades. The numbering of the grades may differ, but the principle is always the same – to provide a range of papers that will suit the contrast of any given negative. The set of grades of paper shown in Fig. 12.17 illustrates the sensitometric properties involved. The grade O paper is the softest grade, as shown by its extended slope over the log exposure axis. This paper would be employed to print a highly contrasty negative. Grades 2 and 3 would suit a normal negative, and grade 5 would be employed for a low-contrast negative.

Although this system works well, it has the economic disadvantage of requiring every grade, in every size of paper. A more popular alternative is to buy multigrade paper, which can provide even more grades through a system of filters placed above the negative. Multigrade papers are very popular, but their resolution is not as good as the conventional graded paper.

Further control of the printed image is accomplished by 'shading', as shown in Fig. 12.18. In Fig. 12.18*a* we see the use of a cardboard mask for 'printing-in', i.e. giving more exposure to a specific region of the print (perhaps a detailed highlight in the scene), whereas in Fig. 12.18*b* we may use a shaped piece of cardboard to protect a region from excessive exposure (perhaps a wooded area under cloud

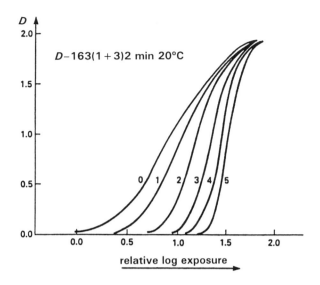

Figure 12.17 *Printing paper sensitometry. Notice the increasing slope of the D-logH curves as the paper 'grades' increase from 'soft' (0) to 'extra contrasty' (5).*

shadow). At all times during the shading process the mask or shape should be gently agitated to avoid obvious signs of shading.

Figure 12.18 *'Dodging' techniques. (a) 'printing-in' with a mask; (b) 'shading' with a dodging shape.*

217

Colour processing

As mentioned earlier, colour processing is well established throughout the entire world, and consequently it makes sense to send all films to a processing laboratory. It is always possible to process the films yourself, particularly 35 mm rolls, but this is far from economical unless you have a large and consistent throughput. The main problem with user processing is that even if there are only two or three films they still have to be printed, and this requires much more expensive equipment, chemistry and expertise than is necessary for monochrome processes.

For SFAP it is desirable to establish a sound working relationship with the local colour laboratory so that they understand your specific needs. Aerial photography will be confusing for the laboratory staff, and so your instructions as to the type of image you require will be essential. Wherever possible it is best to use a commercial laboratory rather than a convenient high street facility, where their conventional colour processing is designed for rapid throughput rather than individual requirements.

Colour negatives are developed in the C-41 process (or its equivalent). Like all colour chemistry, this is expensive and has a short working life. Nevertheless, it is often necessary to process films on site – if there is any uncertainty of the cover for example. This is not difficult for 35 mm and 120 roll films, since the daylight processing tank shown in Fig. 12.6 can be used. Processing is simple: only the addition of a bleach bath makes it different from monochrome, plus a more critical developing temperature. All one has to do is follow the processing instructions in the package. But for 70 mm lengths of film, a larger spiral unit (such as the Hansen) is needed. For diapositive films the only difference is the chemistry and processing baths. The main advantage here is that you don't need to print!

Chapter 13

Air Survey Navigation

Many users of SFAP have become involved in the subject due to necessity, usually budget related, and often in their chase for an economic solution have sometimes gone a little too far in re-inventing the aerial photography wheel. A common mistake is to assume that in scaling down the format and size of material and ground cover achieved, the level of expertise required is also scaled down. In the area of navigation, unfortunately, the opposite is true.

Positioning an aerial platform with consistent accuracy requires considerable practice and the acquired skills of both pilot and navigator/photographer. As we saw in Chapter 11, when a mission is planned certain *tolerances* are designed in. If we are flying a large format project even at low level for 1:5000 scale with standard side overlap, the aircraft has a flight bandwidth of 115 m either side of the planned line in which to operate. (Fig. 13.1). Although this may seem to be quite a reasonable tolerance, it should be remembered that any excursion from the planned flightline, even though we may stay in tolerance with our first line, will also have an effect on the next, and other subsequent lines (Fig. 13.2). At the speed of a normal survey aircraft even seemingly large tolerances require skill and concentration from the navigator.

If we look at small format dimensions, film sizes and ground cover, then we will see that for a similar 1:5000 cover using a 6 cm × 6 cm format, the 10% off-line

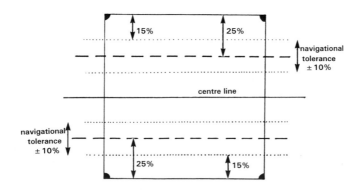

Figure 13.1 *Standard overlap planning. The dimensions of the aerial photograph and the allowable tolerance in side-overlap (q), in this case 25% ±10%.*

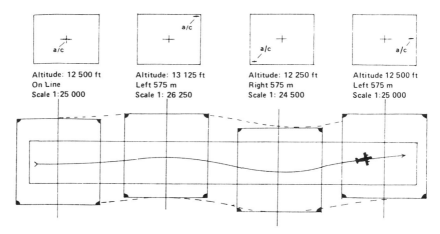

Figure 13.2 *Off-line excursions. Even staying within tolerances can reduce subsequent line accuracy.*

possibility will only be ±30 m. Obviously this would be restrictive even for the most skilled of survey navigators and most small format cover is planned with an enlargement factor of 2× or 4× planned in. This means that cover is flown at 1:10 000 or 1:20 000 to achieve 1:5000 cover (with 2× and 4× enlargement respectively), bringing the level of difficulty back to the same as that of large format at 1:5000.

As most small format projects are required for large scale end product tasks, the small format practitioner may rarely have the luxury of working with tolerances of more than 100–150 m. The large format navigator/photographer, however, will only spend a very small proportion of his or her time at scales larger than 1:10 000. When you are standing in the centre of a football field 100 m each side of a line may seem enormous, but from the viewpoint of a small aircraft at more than 1000 m it can seem like walking a tightrope. Add to this the fact that the aircraft is susceptible to roll and we have reduced our options even further. (Fig. 13.3).

It has to be emphasised that our planned-in tolerances are only there to allow for situations beyond the navigator's or pilot's control. Slight variations in wind effect, difficulties in interpretation of ground detail, turbulence, yaw, and so on, can all contribute to move the aircraft off line. Regrettably, inexperience is not taken into account when most flight plans are made.

Happily, the advent of GPS navigation systems has opened the door to more accurate survey navigation, although the skill levels required for acceptable small format results are still higher than their large format equivalents. What this does mean is that the potential for small format users to achieve acceptable results has risen considerably. Whereas in the past many SFAP experimenters fell by the way-side when unable to fly usable blocks of photography, even simple GPS systems can be pressed into survey use effectively.

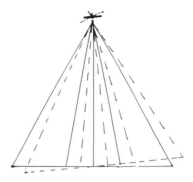

Figure 13.3 *Tolerances are reduced even further with aircraft roll, or long focal length lenses.*

Irrespective of which navigation method or system is eventually used, the aerial photographer must have a working knowledge of the basics of aircraft flight and navigation for a better understanding of the tasks ahead. In the remaining parts of this chapter the essential elements will be covered and suggestions for further study offered.

Basic flightline navigation

In order to achieve successful aerial photography over planned areas and specific flightlines, the would-be aerial photographer has to work very closely with his or her pilot. It is useful if they are able to communicate with each other and are using (and understanding) the same terminology. The photographer should therefore spend a little time in learning the rudiments of air navigation and aircraft procedures before committing time and precious resources to photo missions.

The aircraft environment can sometimes be rather hostile and uncomfortable, and to expect success on one's first flight without adequate conditioning, training or preparation might be somewhat optimistic. Familiarity with aircraft and low-level small aircraft operations is recommended and a few non-photo 'joyrides' initially to become accustomed to aircraft noise, motion and view should be planned in. The simplest way is to have one or two 'trial lessons' at a local flying club where an instructor, or even the nominated photo pilot, will take you through the full sequence of flight from take-off to landing, giving hands-on experience right from the first.

Although a serious study of aeronautics is not wholly necessary, the photographer is advised to commit to memory a few fundamentals of simple navigation to help in the planning and execution of his or her early photo flights.

Aircraft move in a somewhat different way to most earthbound vehicles and in order to get pictures that are of areas and flightlines that we require, and uniformly aligned, we should have some knowledge of how the elements affect our camera platform.

First we must look at *airspeed*, the simplest of concepts but made a little complicated by basic physics. Airspeed is the speed that the aircraft is moving *in relation to*

the surrounding air. When driving a car or riding a bicycle, the concept of relative speed does not vary: it is the rate at which the vehicle is moving *in relation to the ground.* An aircraft, however, has no physical connection with the ground, and is moving only relative to what could be called a 'parcel of air'.

Moving through particles of gas (air), the rate of the aircraft's progress can be measured by the force of air flowing into the *airspeed indicator* (ASI). This measurement gives us what is known as *indicated airspeed* (IAS). Physics tells us that the density of a gas will vary according to several factors; the two factors that concern us as aerial photographers are *altitude* and *temperature.* The airspeed indicator will give a higher reading if the gas is relatively dense (at low altitude or low temperature). Thus as the aircraft climbs higher into areas of reduced air pressure and temperature some adjustment must be made to arrive at a corrected airspeed called the *true airspeed* (TAS).

- Standard air temperature at sea level is taken to be 15°C. At sea level the airspeed indicator of the aircraft is seen to be indicating 100 knots (100 nautical miles per hour, approximately 185 km/h). This will also be 100 knots TAS, as no correction is needed. However, if the temperature at sea level rises to 25°C then the actual TAS will be 102 knots, with the ASI still showing 100 knots (the airspeed indicator under-reading by 2 knots).
- If we climb the aircraft to 10 000 feet (3048 m) above sea level and we still have the standard temperature for that height, –5°C, then the IAS reading of 100 knots will equate to a TAS of 118 knots. This time the ASI has under-read by 18 knots.

True airspeed then is an important datum from which we are able to calculate a series of other relevant measurements which affect the movement of the aircraft. (There are other airspeeds which do not concern us as aerial photographers, such as rectified airspeed (RAS) and calibrated airspeed (CAS), which are used for calculation in more advanced areas of the flight envelope. At the accuracies required in SFAP, basic TAS will suffice).

As the aircraft moves through the air, the air mass itself, our parcel of air, can also move relative to the ground. These air movements are caused by the rotation of the earth and pressure variations upon the earth's surface which themselves cause global and local winds. Put simply, if a wind is blowing, our parcel of air, including aircraft, will be moved accordingly. The effects of these variations we can draw using a simple scale vector diagram (Fig. 13.4).

Figure 13.4 *The distance flown in one hour on a given heading (with no wind) and drawn to scale.*

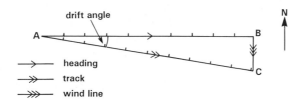

Figure 13.5 *The complete vector diagram with the addition of a 37 km/h (20 knot) wind from the North.*

A line is drawn to scale to represent the true airspeed, in this case 100 knots, and in an easterly direction (090). In a still air (no wind) condition, the aircraft will fly for 100 nautical miles in one hour on its given heading 090. If we have planned our flight from point A to point B then we would reach B in exactly 1 hour with no correction necessary to our heading. Alas, such weather conditions rarely occur and usually nature will make mischief with our flight plan. Our aircraft, originally pointing from A to B, is now subjected to a wind of 20 knots blowing from the north (Fig. 13.5).

We can now draw a *triangle of velocities*, which is a representation of what will happen to our aircraft in 1 hour at a given airspeed. This will enable us to represent (and thus calculate) the angle away from our planned line the aircraft will fly as a result of the wind blowing. In this example we will arrive at a point C, some 20 nautical miles south of B, having been blown off track by some 13°. However, as we have also been subject to a slight *tailwind*, our true airspeed can now be equated to a *groundspeed* of 102 knots. (In order to identify the various lines on the vector diagram each is drawn with the addition of one, two, or three directional arrows in a standard form). Obviously this is no real help to us in actually staying on our A–B flightline in this form, so we must move a stage further and make some modification to the construction of the vector diagram (Fig. 13.6).

By rearranging the construction of our triangle of velocities in the following way we can make it more usable. First we draw in our original, desired track, a free line at 90° from point A. This time we drop the wind line *from A* at the point C_1. We now have two sides of our triangle. If we complete the construction by drawing a line at scale (TAS), the point where the two lines converge will become B.

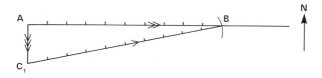

Figure 13.6 *By reversing the construction of Fig. 13.5, we can now derive corrected heading and ground speed.*

Thus, the angle made by ABC_1 will be the drift angle, angle AC_1B will be the required heading to fly and the measured length of line AB will give the new groundspeed; in this case a slight headwind has reduced the groundspeed slightly.

In making a flight plan, the pilot will usually have to hand the forecast wind, given as a vector (degree/knots) and will also know the TAS at which the aircraft will fly. If a cross-country flight is planned a calculation will be made using the previously explained triangle of velocities, although the pilot will usually use a navigational computer. This may be in the form of a metal or plastic gadget having a circular slide rule on one side and a transparent, rotating, degree-etched face and sliding graticule on the other. By setting first wind vector and then desired track, the same triangle of velocities construction is made although in a simpler, more readable form. Also various specialised electronic navigational computers are available, as well as many programmable pocket calculators which can handle air navigation calculations.

Once we become involved in the finer points of moving ourselves from A to B, other than with a ground vehicle or the use of signposts and roadmaps, other complications seem to creep in. The next topic that we have to briefly consider is *direction* and how we must express it in order to make ourselves understood by our pilot.

So far we have carefully mentioned only *degrees* as units without any qualification, assuming that most would-be aerial photographers, large or small format variety, have at least studied simple geometry at school. However, there are different sorts of degrees to be made with in the world of aviation.

When geographers first tried to represent the Earth on paper they decided upon various map projections, based on north being at a specific and locatable point. Drawing a map then consisted of delineating the area concerned with a network of lines, all related to points north and south and at angles to those lines giving east and west. For SMAP that is really all we need to know about map projections. (Our colleagues mapping the world in larger segments and formats have to concern themselves more deeply with Lambert and Mercator and Gauss-Kruger, but for the purpose of this book we will leave them to it.)

When we draw our projected flightline on our map or chart, the finishing touch will usually be to measure the angle of the line in relation to north. When we do this on a standard map the result will be given as a three-figure number (001, 057, 132, 360, etc.) and the figure referred to as *degrees true* (T) as being a measurement in relation to *true north*, the geographical north pole on the north pole–south pole axis.

To enable us to locate north in a practical sense, however, we use magnetic compasses which point to a northerly position that is slightly removed from the actual geographical north. So we now have two versions of the same position to deal with: the second is known as *magnetic north* (M).

Although the position of magnetic north is fairly stable – the small annual movements are known and predictable – it is not possible to create a second network of uniform latitude and longitude lines related to a magnetic north–south axis. This is due to other variables, firstly the fact that the magnetic poles are not *antipodal* (they

are not opposite one another), and secondly the mineral content of the Earth's outer layers creates many local magnetic fields which also have an adverse effect on accurate magnetic north measurements.

The various anomalies in this form of measurement are well known, and very accurate magnetic/true measurement can be made, given time. In the aircraft environment we rely on several types of magnetic compass from the simple 'floating ball' type seen in most twin-engined aircraft and for large format survey operations.

So, having now measured our flightline and assigned it a true north value, we must now convert this to a magnetic north value. In order to do this we now must find the *local magnetic variation* in the area of our flightline. The simplest way of approaching this is to look at the pilot's *aeronautical chart* (usually in scale 1:500 000 or 1:250 000 depending on the country). On this chart will be overprinted a series of dotted lines, usually coloured purple or brown, with an annotation in either degrees west or degrees east. Added to this at the start and end of each line will be a date and an annual change to the variation, usually given in minutes west or east. These lines are called *isogonals*, and provide us with the correction that has to be added or subtracted from our original true north measurement.

The variation can be either east of true north or west of true north, and an easy method of committing this to memory is *west best, east least*. This means that if the variation is westerly then we add the value to our true measurement to give its magnetic equivalent, and if east then we take off the variation (Fig. 13.7). (Purists will decry this old and tried aide memoire as it may lead to confusion when using electronic calculator programs and when taking on more advanced mathematical tasks in navigation. For the purposes of flying small format survey blocks, however, it works very well and the authors are fully confident that any readers taking the trouble to take on this topic will be eminently capable of subsequent transitions.)

When a flight plan diagram is made (see Chapter 11) it is probably a good idea to follow standard methods as used in the line format industry. It may be assumed that you will come across pilots and other colleagues who may already have air photo experience, and following simple and well-developed and tried rules can make life easier. The general form of flight chart marking has usually been to give all map measurements in °M. The reason for this is simple. The navigator/photographer

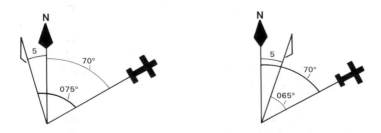

Figure 13.7 *Westerly and easterly magnetic variation added to true measurement.*

225

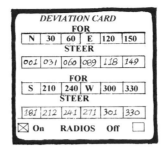

Figure 13.8 *Example of an aircraft deviation chart (kept close to compass for reference).*

will measure the drift angle and add/subtract directly from the value on the chart, the *magnetic course* (MC), and pass the result as a *heading* (MH) to the pilot.

However this is not quite the end of the line. There is yet another variable, although one that does not directly affect the photo/navigator. Aircraft are usually made of metal, and even composite or wooden versions have substantial amounts of ferrous material, giving additional possibilities for changes in local magnetic fields. Electrical circuits, aircraft radios, navigation systems, even small format camera systems can all give off interference that can affect the magnetic compass. Before an aircraft is certified as airworthy, usually on an annual basis for commercially operated or public transport machines, it must undergo what is called a *compass swing*. The aircraft is parked on an interference-free, sterile area and positioned progressively, pointing from north through every 45° and back to north, against an independent, calibrated stand compass. The compass inside the aircraft is calibrated against the master compass and a *deviation chart* is derived (Fig. 13.8).

When the navigator passes the pilot a magnetic heading to fly – the drift applied to the magnetic course – the pilot then checks against the deviation chart and applies any correction necessary. This new heading now becomes the *compass course* (C). True to form there is still one more variation which we, as simple aerial photographers, definitely do not need to worry about, and that is the angle of dip. This is the angle in the vertical plane between the horizontal and the Earth's magnetic field at a given point – and it doesn't matter.

We now have on hand all of the right terms and words to get our pilot on to line, and at least an overview of the method. One more aspect has to be addressed which is of especial importance in aerial photography, and that is *altitude*. Of course, this being aviation, it is another topic jam-packed with variables and 'other names'.

When we set out to plan an aerial photography mission, the first item we have to consider is the *photo scale* required by our end user. With small format products we often take pictures at a smaller scale than eventually required and then enlarge to the final, required scale. Whichever method we use, however, we must decide on the scale required at the original negative (or transparency). This scale determines the altitude above the terrain that will be needed to achieve that scale. This altitude

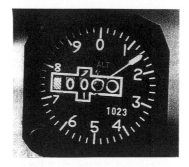

Figure 13.9 *Standard light aircraft altimeter.*

is derived by calculation from the desired scale and the size of the negative format (Chapter 11).

The aircraft uses a barometric instrument to measure altitude called an *altimeter*. This analogue instrument reads out the altitude with the use of two clock-type hands (Fig. 13.9). The datum for the instrument is set by a barometric scale reading either in *hectopascals* (hPa) (or earlier, and still used *millibars*, mb) or in *inches of mercury* (inHg). The altimeter setting is usually given by air traffic control and this is where the anomalies creep in.

For reasons of aircraft safety, aircraft separation and communication, it was necessary at a very early stage in aviation history to define various forms of address for altimeter settings and altitudes. We discussed earlier the variations in airspeed due to changes in temperature and pressure; the same physical laws apply in altimetry. Aircraft altimeters are of two types; barometric altimeters and radio altimeters. The latter are more commonly found in larger commercial aircraft and operate using a simple radar system, usually from ground level to 2500 feet (750 m) as an aid when approaching to land. They are rarely used in survey operations.

Barometric altimeters are found in all aircraft and are certified to be accurate to within ±50 feet (15 m). As most survey projects have tolerances built in, this will normally present no problem to the aerial photographer.

First we must define the normal altimeter settings as used in standard aviation procedures (Fig. 13.10). The basic setting is that of the instrument barometric pressure to enable the pilot to read his or her *altitude above mean sea level* (QNH). This means that, before take-off, the tower will pass a barometric reading (i.e. QNH is 1023hPa) and when set on the altimeter, the reading will be that of the airport above mean sea level. (This setting is taken from a calibrated barometer in the airport meteorological office and updated regularly throughout the day where necessary.) This setting is then the *airfield QNH*. (The 'Q' prefix is derived from a series of radio code abbreviations used when communications were less efficient. They are largely being dropped, but the altimeter setting codes are still retained.)

For local flying in and around an airfield, for training flights, and for simplified circuit flying, a second pressure setting QFE is used. When the aircraft is sitting on

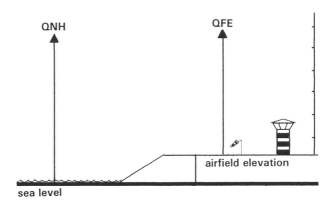

Figure 13.10 *Altimeter settings vary according to the type of flight, or to local ATC requirements.*

the runway the altimeter will read '0', and all readings in the air will show the altitude above the airfield, rather than mean sea level.

As barometric pressure varies across a region due to areas of high and low pressure, the airfield QNH may only be accurate over a short distance. For safer air traffic operations a third pressure setting will then be given to the pilot for flights within the local flight information region (FIR) and this will be the *regional QNH* which may vary by a unit or so from the airfield QNH. For safe aircraft separation within the FIR, all aircraft will use this setting. This setting, however, applies only when the aircraft is flying in clear weather, or under *visual flight rules* (VFR). (Even the term for 'clear weather' has an official nomenclature – visual meteorological conditions, VMC).

As most aircraft movements these days are of a commercial nature – passenger, freight, business – and flown in all weathers, VFR flying is left largely to low-level general aviation activities. Above certain pre-determined levels, aircraft are expected to fly under *instrument flight rules* (IFR) and this can be in VMC or in instrument meteorological conditions (IMC) (the opposite to clear, visual weather). In this case the altimeter is set to a common setting of 1013.2 hPa (QNE), irrespective of any local pressure variations. This means that all aircraft under IFR are flying on the same setting and thus aircraft level separation is simplified.

Accurately scaled aerial photography requires as exact a flying height as is possible and it is therefore obvious that for a local flight the original airfield QNH would tend to give the most reliable datum on which to base our measurement. Once again we now have to indulge in the variations game. In order to make some sense from this handful of variables, maybe we should label them to make the picture clearer.

When the altimeter is set to a given pressure setting (QNH, QFE, or QNE) the altitude shown is the *indicated altitude* (IAlt) and is only a relative value. This is not

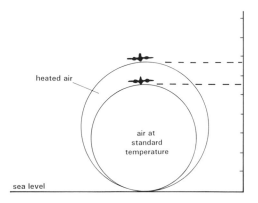

Figure 13.11 *True altitude will be higher, but indicated altitude the same, in warm air.*

to be taken as an accurate measurement once again because of temperature and pressure effects on our instrument of measurement.

In order to fly accurately enough for scaled aerial photography we must therefore correct the indicated altitude to arrive at the *true altitude* (TALT). If we take the local QNH, which we have already mentioned as potentially the most accurate for small format photo operation, the only correction needed is that of temperature. Atmospheric temperature reduces as we climb higher at a reasonably standard rate of ±2°C per 1000 feet (300 m). If we imagine the air below the aircraft as being contained in a balloon, at the standard (QNE) pressure setting (and on a standard day, 1013.2 hPa at a sea level temperature of 15°C), we will have the correct altitude as indicated (Fig. 13.11).

If the temperature rises above standard, the balloon will expand and although our altimeter will still read the same, we will actually be at a higher altitude. Conversely, and potentially more dangerous if we are flying in cloud and in areas of high ground, when the temperature reduces, the contents of the balloon will contract and the balloon become smaller. The altimeter will indicate the same value but we will be considerably lower. Thus, in order to convert our QNH altitude to true altitude we must find the difference between the actual temperature at the indicated altitude and standard.

The usual method of making this correction is using a 'whizz wheel', as carried by most pilots. The grandly named navigation computer mentioned earlier has its origins in the circular slide rule, and got its name long before 'computer' came to mean something with screen and keyboard; it is still one of the most reliable items found in any aircraft. It is manufactured worldwide by firms such as Jeppesen-Sanderson (US), Airsto (FRG) and Airtour (UK), and is available at flying clubs, schools and aviation suppliers everywhere, and must be part of the aerial photographer's kit. (You can ask the pilot to make the calculation for you but this will only work well until the first mistake hands you a set of wrongly scaled aerial photographs. There is no better way than doing it yourself, and with your own tools.)

There are electronic alternatives, pocket calculator-sized navigational computers, of all shapes and prices. After a few flights and some actual experience of what is required, the new aerial photographer will have some idea of which particular gadget will suit on technical, or budget grounds. A useful point to remember is that a whizz wheel never lets you down with a dead battery, at low temperature, or if it's been soaked in coffee. A third alternative is to use a programmable pocket calculator and write in specific aerial photography programs for flight planning, altitude correction, sun angles and so on. (Details of such programs for standard PCs can be found in Appendix 1.)

Most small format work is usually done in what is called uncontrolled airspace. This means that aircraft are able to fly under visual flight rules (VFR), and as long as they stay within certain minimum and maximum altitudes are able to operate without restriction. Thus with either a local QNH (obtained over the radio from the nearest airfield) or an area QNH and an altitude/temperature correction, the camera platform can be flown at a reasonably accurate true altitude for optimum photo scale.

Unfortunately, owing to the demands of instrument flying, the amounts of uncontrolled airspace are gradually being reduced with networks of airways. These are controlled airspace corridors acting as highways carrying air traffic at different levels and different time separations and linking terminal controls area (TCAs), controlled airspace around major airports. The situation often arises in large format aerial photography where the camera platform must operate inside controlled airspace and at a specific, accurate altitude. This can present problems when all other aircraft using the airspace are flying at flight levels on the standard altimeter setting (1013.2 hPa). Thus our original QNH to TALT conversion now has to be modified in order to request the equivalent QNE altitude (or flight level). On a bright UK summer day, for instance, the pressure can be up around 1032 hPa giving more than 500 feet (150 m) altitude difference to a QNE setting of 1013 hPa, and some serious scale discrepancies for the photographer.

These problems are usually solved by the pilot with a little deft knob-twiddling on the altimeter (or the use of the second altimeter found in most instrument flight equipped aircraft), but an awareness on the part of the photographer can make life easier in the crew situation. The total ReqTALT/QNH/TALT/QNE/FL calculation can be programmed into a calculator, which will simplify the whole operation, especially as there are many other tasks demanding the team's attention on the approach to a survey block. Potential errors which can be programmed out with the correct tools should always be carefully considered.

It is not the intention here to turn the reader into an instant aviation expert, but to map out some of the terrain to enable the would-be aerial photographer to get a toe in the door with the pilot. Many aerial photographers go on to take flying lessons and to become licenced pilots themselves (the authors of this book are examples), but this requires extensive study. By listening and learning, and most of all, asking questions, the SFAP student will soon be able to get the most out of aircraft and crew to produce good and accurate results.

SFAP navigation methods: visual

The majority of us embarking on some new project will usually start with a simple exercise and when that is successfully completed, widen our parameters. The motto 'start small, and start quietly' should be embroidered onto the flying suit of anyone even hinting at taking a camera into the air for anything other than a 'me-in-an-aeroplane' picture.

In the large format air photo world, a major training course for survey navigators (now sadly, closed), gave a minimum of 80 hours of flight simulation and some 35 hours of in-flight training to supplement a 10 month intensive ground school course. Upon graduation the participants were then adjudged able to take on relatively simple flight tasks over their first year of actual survey operations, the major proficiency coming from the 'on-the-job' experience.

As we have already seen, the scaling down of the equipment does not mean any scaling down of the degree of difficulty. If we approach the task in a systematic way, however, it is possible, to achieve acceptable results, providing our goals are realistic at each stage of the learning process.

All photo survey tasks start with a single picture. We have to bring the camera platform overhead the required point, flying on a desired heading, at the correct altitude, and in a stable, wings level attitude. Most of the types of aircraft pressed into service for aerial photography are less than ideal in terms of visibility. Forward visibility over the aircraft's nose is usually hampered by engine cowlings and propeller and, although adequate for general flying and landing from the pilot's point of view, are not sufficient for accurate photo survey navigation.

Trying to maintain position along even an existing line feature, a railway line or road, with no vertical visual reference can be difficult unless the flight conditions are very stable, or an accurate measurement of drift and heading has been made. In order to achieve the sort of accuracies necessary for aerial photography, some additional equipment will be required.

By identifying the basic requirements we can then adapt our own particular situation to come up with solutions.

First it is necessary to have some form of reference line which can be used by the pilot or photographer to maintain a pre-planned track across the ground. Ideally this would be also a way of looking straight down below the aircraft directly through the aircraft floor (as with the navigation telescopes used with large and small format cameras) or from a side window with a perspex bubble. Alternatively, a side-mounted reference line at a fixed angle can be used in which a line parallel to the required line is followed, removing the necessity for a vertical viewpoint; see the 'bicycle spoke' T-bar system shown in Fig. 13.12. By following the side-sighted reference line (adjusted to a line-separation a) the camera is switched on to expose the line vertically below the aircraft. Adjacent lines are then followed in a similar manner. The mission profile outlined in 'Mission Logistics' (Chapter 11) refers to this in more detail.

A more modern solution is that of using a small closed circuit television system. Even a simple video camera can be adapted as a navigation unit with some mounting modification. There are many extremely small black and white or colour cam-

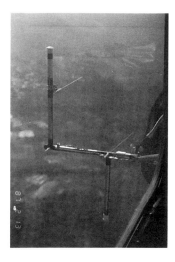

Figure 13.12 *Side mounted navigation sight.*

eras available, usually designed for security systems, which can be coupled to small monitors and operated from an aircraft's 12 V or 24 V system (usually through the cigarette lighter attachment).

The second requirement is that the reference line must be movable to offset the effects of drift and ideally able to move through ±20°. (The slower the camera platform, the larger the drift correction range required. For a microlight aircraft a ±30° range might be advisable.)

A further necessity is that it must be possible to level the reference system in all axes, so that the line accuracy can be consistent.

At some point we must decide on a method to adapt, and this decision must take into account how much aerial photo work we are expecting to do. If our utilisation is only one task per year, then the simplest and most economic method should be sought. Should we intend to embark on an SFAP career, then we should expect to put together more sophisticated equipment and techniques.

One early decision that must be made is to allocate the navigation task itself. In the large format world the lines are quite well drawn. The navigator/photographer has a major part to play and, almost without exception, is also the crew chief. For small format tasks, unless a full-time operation is anticipated, some consideration should be given to utilising the pilot's already acquired skills in handling the on-line navigation, leaving the camera control and overlap regulation to the photographer. This form of operation will be outlined briefly.

The type of navigational sight shown in Fig. 13.12 is ideal for pilot operation and requires a high-wing aircraft and only a minimum of additional training. The upper and lower lines are aligned with ground features and heading adjusted accordingly. A short period of flying on the planned heading is first required in order to measure (and set) drift so that a stable line heading can be followed. By map-reading

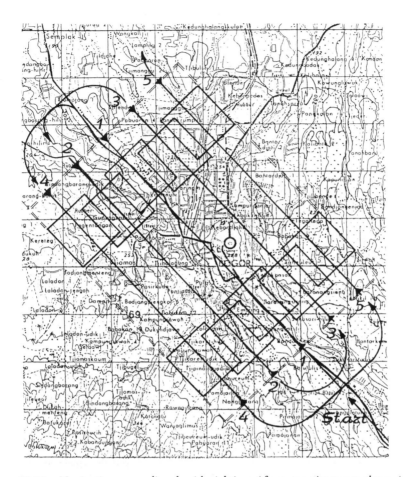

Figure 13.13 *Navigating survey lines by side sighting. After a practice pass to determine drift, this 'five-line' block is started (lower right-hand corner) by photographing line 1, with the pilot sighting a clear line-feature on line 2 using the inner flight bar. At the end of line 1, the pilot turns on to line 2 (with opposite drift setting) using the same flight bar, now lined up on line 1. Once line 2 is completed the pilot photographs line 3, by using the outer flight bar on the original line feature. These procedures are repeated (as shown in the diagram) until the entire block is photographed.*

from an existing map the pilot can follow the pre-planned flightlines and build up a block of photography. Some short practice sessions along a straight line feature, such as a railway line or highway, to familiarise the pilot with the method, are all that is usually required with most pilots.

This method has been used with great success in south east Asia to fly five-line and seven-line photo blocks for town development projects without the use of existing maps, once again with only the minimum of pilot training. The aircraft would position over the site to be photographed and the pilot would identify any available

straight-line feature. Almost every town has at least one major straight road or river which can be used as a datum.

The pilot establishes the heading to be flown from a first practice pass to evaluate drift and levelling using the chosen line feature and then returns to the starting point (Fig. 13.13). The first line is flown using the inner flight bar aligned with the line feature from 'camera on' to 'camera off' point. At the end of the line the pilot runs left through 180° and flies the return line (with the opposite drift setting), on the opposite side of the same line feature.

Once the second line is completed, the pilot now selects the outer flight bar and aligns that with the same line feature flown in the original direction (line 1) and flies the third pass with the camera on. Again at the end of this line the aircraft turns left with a slightly wider turn and aligns the outer line with the line feature (parallel to line 2) and flies line number 4. We have now completed two pairs of parallel, overlapping lines and all that remains is a last line directly over the line feature itself to complete the five-line block. The last line is the most critical but by this time the pilot will have a good idea of the actual heading needed to hold a straight line and also will have selected other parallel check points as navigational aids along the fifth line. (The method is much simpler to fly than to describe. The inexperienced crews on the south east Asian project had very few reflights on the 40 or so towns completed.)

Air survey turns

Flying survey lines over prominent ground features can be undertaken with proven techniques, employing devices such as optical navigation sights (Fig. 10.9) video systems' (Fig. 10.11) side sights (Figs. 10.14 and 10.15), and side sights designed for 'next-line' navigation (Figs 13.12 and 13.13), but all these are compromised by featureless terrain. Apart from obvious navigation difficulties in tracking over desert or jungle, there are other feature-scarce areas which inexperienced trackers will find difficult: terrain such as moorland, large tracts of agricultural land, swamps and flood plains, where positioning the aircraft on to adjacent lines becomes close to guesswork.

Under difficult circumstances it is possible for a well-practised pilot to fly from his first straight line onto the next (adjacent) line by instruments alone. Keeping the platform straight and level during each run, and with a knowledge of the aircraft's drift and required track, the pilot can turn on to the next line by instrument flying. The method may not be as assured as with visual tracking, but with practice it works well enough. Survey turns can take a number of forms, but the two best-known, and the ones we discuss here, are the direct turn and the U-turn.

Direct survey turns

The simplest and most efficient turn is a direct turn on to the reciprocal track at a given bank angle. If the mission plan indicates that a certain distance a has to be kept between flightlines then, in the absence of any navigational aids, the pilot can make a direct turn on to the next line (reciprocal track) from a knowledge of:

- true air speed (TAS) which can be calculated reasonably accurately from charts or calculators (or from Appendix 1(h))
- line separation, *a*
- drift angle, *d*
- wind direction, *k* (i.e. are the turns upwind or downwind?)

Essentially the pilot's task is to calculate the required 'rate of turn' and 'angle of bank' that he has to make in order to turn directly on to the reciprocal track (at distance *a*) then fly straight and level on this (hopefully) parallel track until (at a given groundspeed) it is time to make the next turn. This has to be done very accurately, of course, and although it looks simple (see Fig. 13.14) the trick is to turn without losing height!

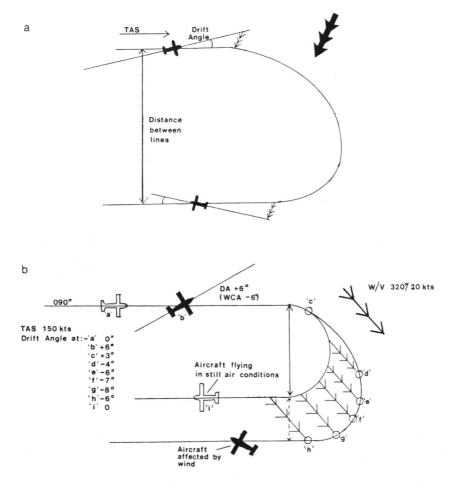

Figure 13.14 *(a) The direct turn. Flying on the correct track, with the aircraft heading into wind corrected angle (equal but opposite to the drift angle) the pilot turns at a calculated rate-of-turn, and angle-of-bank, to come onto the next line. (b) The direct turn is here quantified for a TAS (True Air Speed) of 150 knots and 320° / 20 knot wind vector.*

A so-called 'rate 1 turn' is one that turns through 3°/s (180°/min), a 'rate 2' is 180°/30 s and a 'rate 3' 180°/15 s. The rate of turn depends upon air speed and angle of bank, and if coordinated correctly the ball in the 'turn and slip' indicator should remain central (under these circumstances a full glass of water should not spill even in a steeply banked turn). The normal range of bank angles is between 15° and 50°. The correct angle of bank for a standard (rate 1) turn may easily be calculated from the following rules:

- Take 10% of the IAS (in knots) and add 7.
- Take 10% of the IAS (in miles/h) and add 5.

So a rate 1 turn at an indicated air speed of 90 knots is 16°.

The principal factors involved in a direct turn are shown in Fig. 13.14a, and are quantified for a TAS of 150 knots in Fig. 13.14b where, for a 320°/20 knot wind vector, the drift angle (DA) has been calculated as 6°. The aircraft's turn is shown both for still air conditions and with a cross-wind where it flies with a wind corrected angle (WCA) of −6°. As can be seen, the aircraft's turn is significantly affected by wind.

A direct turn computer program (suitable for in-flight applications) is listed in Appendix 1(e), and a typical example is given as follows. For TAS = 120 knots, line separation (a) = 1500 m and drift angle = 12°, we have the following answers:

- For an upwind turn: Required rate of turn is 3°/s and required angle of bank is 20°.
- For a downwind turn: Required rate of turn is 6°/s and required angle of bank is 35°.

Survey U-turns

For large distances between lines it is usually better to employ a U-turn, which is a direct turn with a linear portion in the middle, as shown by Fig. 13.15.

To apply a U-turn the pilot needs exactly the same data as for a direct turn, but in this instance the turn will always be at rate 1. The answers the pilot wants from the calculations are

- the time required to fly the linear component of the turn (which starts as soon as he/she is at 90° to the flightlines and ends after time t when the pilot returns to the reciprocal track, with appropriate WCA applied to the reciprocal heading)
- the required angle of bank.

The QBASIC listings for a U-turn computer program can be found in Appendix 1(f), and the following example is for a flightline separation (a) of 3000 m, a TAS of 110 knots and a drift angle of 5°:

- For an upwind turn: Upwind linear time (tu) = 22 s.
- For a downwind turn: Downwind linear time (td) = 9 s.
- Required angle of bank (rate 1 turn) = 17° (in each case).

In some areas of mission planning it is sometimes useful to calculate the line separation a for known inputs of TAS, drift angle and the linear component time.

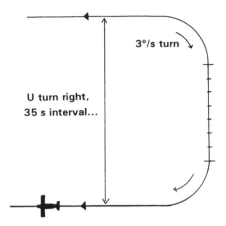

Figure 13.15 *The U turn is a direct turn with a linear portion flown for a calculated period and a standard, rate 1 turn (180°/minute).*

For these calculations it is convenient to employ the program listed in Appendix 1(g).

Global positioning systems (GPS)

One of the major problems encountered by early practitioners of SFAP was that of accurate flightline navigation. Even in large format operations, the skill level required to produce accurate survey blocks at medium scales (1:8000 to 1:15 000) was quite high. Most professional survey navigators went through a thorough apprenticeship from photo lab work and in-flight camera operating to eventual one-to-one training on simple flightlines before being 'sent solo'.

The advent of satellite navigation systems has simplified this training process and it is now possible to train a 'survey systems manager' for today's mapping aircraft, using GPS flight management systems with a check-list based approach, in as short a time as 6–7 weeks. At this level the pupil can plan and handle medium and large scale in-flight operations within 3 months of being introduced to camera and system. With further study and 'on-the-job' training and experience, he or she can become fully qualified within 1–2 years.

Many small format users were reluctant to try their hands at anything other than single line surveys because of similar difficulties in producing parallel flightlines to within acceptable specification. However, the same system that has made large format training simpler can also be applied to SFAP – the global positioning system (GPS) based on the US Department of Defense Navstar military satellite network.

Two satellite navigation systems are at present in existence, the US Navstar and the Russian Glonass, which are very similar in operation. The US version is currently being used in the civilian sector worldwide, with work being done in developing dual Navstar/Glonass units. Many SFAP users have already taken advantage

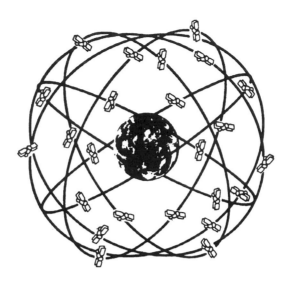

Figure 13.16 *The Navstar GPS satellite network.*

of various cheap, hand-held GPS systems to assist flightline flying and the potential for future development for light aircraft survey operations is excellent. As GPS will become an important factor in SFAP work, we will spend some time in describing the principles, equipment available and operational possibilities.

The principal advantages of GPS are that it is available worldwide, usable 24 hours per day, is completely independent of weather conditions, and can determine position, velocity and time continuously with a high degree of accuracy. It comprises three separate parts, the *space segment*, the *control segment* and the *user segment*.

The *space segment* consists of 24 space vehicles positioned some 20 000 km above the Earth, each orbiting the Earth in just under 12 hours in six 55° orbital planes with four satellites in each plane (Fig. 13.16). With this configuration, at least four satellites are 'in sight' at any point on the earth at all times, giving the possibility for three-dimensional positioning. In the northern hemisphere, six to eight satellites are above the horizon for most of the time. Each satellite continuously transmits a string of data containing information on its orbit, repeating every 30 s, the *ephemeris data*. Every 12.5 min the orbital information of all other Navstar satellites is transmitted with a lower accuracy. This is known as the *almanac data*. This information is transmitted at frequencies of 1575.42 MHz and 1227.6 MHz at a data transmission rate of 50 bits/s, the L1 and L2 bands.

The *control segment* monitors the orbits of the satellites from a worldwide network of receiving stations. These stations transmit the received data back to the main control centre at Falcon Air Force Base in Colorado where they are used to calculate the accurate orbit of each space vehicle. This information is then proc-

essed by combining it with a complex mathematical model of the Earth's gravitational field, and the future position of the satellites can be predicted for many hours ahead. These predictions are then transmitted back to each satellite and stored on the vehicle's computer. This is then re-transmitted by satellite for use by the navigator.

The *user segment* is the GPS receiver carried in the aircraft and, depending on type, can track a number of satellites, most standardising on five or six, although for ground survey measurements many systems will track up to twelve. Two separate signals are transmitted by each satellite, the *C/A code* (Coarse Acquisition) signal for worldwide civilian use, and a *P code* (Precise) signal for US and allied military use which determine the accuracy of the final calculate position.

Being a military based system, the Navstar is subject to various shortcomings. In its basic form the GPS is capable of a general positional accuracy of some 15 m but this accuracy is degraded (as a military requirement) by the use of *selective availability* (S/A) which reduces the general accuracy to something in the region of 100 m (for 95% of the time). Random errors are injected into the ephemeris data broadcast by the satellites when S/A is switched in. (During the Gulf War, the first time GPS was used in 'real' military operations, the S/A restriction was removed and civilian GPS users were treated to unprecedented accuracies for a short period. The reason for this was because the US Army had purchased many thousands of hand-held receivers and they were all C/A coded, which rather defeated the object.)

Naturally, as soon as a restriction is applied, a method will be found to overcome the problem, and so it is with GPS. This is by using a second ground station receiver to make a correction from the transmitted GPS positional data to the exact, surveyed receiver position. This *differential GPS* (DGPS) positional correction can then be applied to the recorded x, y and z position at the time of exposure of the picture, and the exact photo centre calculated. This is called *post-processed* DGPS. A variation on this is to transmit the correction from the second receiver immediately to the aircraft so that the *real time* DGPS position can be resolved.

Currently, at the time these pages are being written, S/A is fully applied and the predicted 100 m accuracies are in force. However, survey users are realising much better accuracies than those stated, with ± 50 m being fairly common. Much discussion is going on as to the future of the S/A restrictions, and at present civil airport landing procedures are being published for most American airfields which may lead the US Department of Defense to rethink their Navstar policies.

If we look first at the types of GPS survey flight management systems that have been developed for large format aerial photography operations, it will give some idea of what is achievable with such systems. Although such systems are usually well out of the price range of most SFAP users, it is only a matter of time before pocket organisers and programmable calculators, already being coupled to GPS cards, will have the potential to incorporate simple SFAP block flying software.

The major large format camera manufacturers market GPS survey systems (hardware and software) with their latest cameras which incorporate flight planning, inflight and post-flight programs. In addition various other manufacturers produce systems that can be coupled to any camera systems to give similar results. Prices for

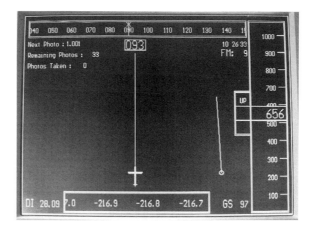

Figure 13.17 *On-line screen display of the FHB-SFM system (Fachhochschule Bochum Germany, Survey Flight Management).*

these fairly sophisticated units can range from $20 000 US to $120 000 US depending on specification.

The simplest of the manufactured systems is software-based and uses any standard 386/486 laptop computer with a minimum of 2 Mb RAM and clock speed of not less than 25 MHz. Flight planning information is entered on a menu-drive question/answer screen asking for scale, negative size, ground elevation, forward overlap required, and start and end latitude and longitude for each flightline. The lines are entered and are then presented in drawn form for checking. Blocks can be created left or right of a single flightline to cover a given area if required as well as single picture pinpoints.

With the laptop coupled to a GPS and antenna, the flight plan can be converted to an aircraft-type VOR screen in which the pilot flies the indicator line toward the displayed flightline (Fig. 13.17). When the aircraft approaches to within 200 m of the required flightline the screen image automatically zooms in and the pilot has a wide band to keep the small aircraft 'on-line', with even a 5 m off-line indication being visible. The screen gives distance-to-next-exposure and distance-off-line throughout, with photo centres appearing to march down the screen from top to bottom to (hopefully) pass under the small aircraft (Fig. 13.17).

A cable from the laptop computer to the air camera carries a pulse to fire the camera as the pre-planned photo position is reached. The pulse can be advanced or retarded depending on the type of shutter being used to achieve better accuracies. (Most large format cameras use rotating shutters and the shutter firing may not necessarily be instantaneous, depending on the position of capping blade and main blades.) Data is recorded during the flight, and each exposure photo centre is stored and can be downloaded either as a full listing or as a flight index after flight.

The most advanced of the commercially available systems is hardware based and independent of the major camera manufacturers. It is also the most widely used

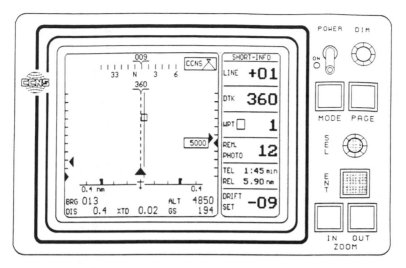

Figure 13.18 *IGI-CCNS-IV Electronic Flight Information Systems (EFIS), panel mounted control unit. (IGI - Hilchenbach Ltd, W-5912 Hilchenbach, Germany).*

GPS survey flight management system. The flight planning program is extremely user friendly and uses a digitising tablet. The area outline is entered from the original map on the digitiser, and flightline spacing and photo centres are calculated for optimum coverage with a minimum number of photogrammetric models. Individual photo centres and other waypoints can be entered form the digitiser or from the keyboard.

In-flight the pilot or systems manager has a single small screen and control box which, being menu driven, controls the whole operation with a VOR or EFIS type presentation. Runs are selected by scrolling the screen data display and all functions available at the push of small buttons. A very comprehensive display of auxiliary data is available on alternative 'pages', and data is stored of shutter opening, aircraft track, and GPS receiver information (Fig. 13.18).

The aerial photographer has to be confident of a considerable amount of work before committing his or her budget to a fully fledged survey flight management system, although if serious mapping projects are in the pipeline the investment will be worthwhile.

At the lower end of the market many simple GPS systems are now becoming available, several giving graphical presentation of the flightpath being flown, or 'moving map displays' in general aviation parlance. Depending on make and model, others are also modified to be programmed by personal computers and simple flight plans pre-entered. Although visual presentation is possible, the screen images are small and usually rather coarse which can be limiting if high accuracy is required. However, results will still be an improvement on 'eyeball' methods. Using a hand-held GPS without the benefit of pre-loaded flight plans is also possible, but several keystrokes are necessary for each new pair of checkpoints to be entered, which can be somewhat time-consuming in the photo-flight environment.

The main advantage of the hand-held units, Garmin 95A VD, Magellan Map 7000 and Skyblazer, Morrow Apollo 920, NavTech Sierra 4.0(based on the Psion 3a Organizer), and Skyforce Locator II, is that their antenna systems require no modification to the aircraft or airframe and will operate satisfactorily when taped to the inside of the windscreen. Most also have the facility to operate from the usual cigarette lighter socket which is a standard accessory on many light aircraft.

With a little experimentation and hands-on practice the user will soon be able to devise simple methods to assist their SFAP operations. The most effective use of GPS units is that the track being maintained by the aircraft across the ground will be displayed (either in degrees true, or degrees magnetic, depending on the system). This means that if the aircraft is brought over an initial checkpoint, the planned track/heading can be maintained accurately along the flightline, usually a major problem for low-experience SFAP crews when an indeterminate drift is present.

Once again the axiom 'preparation reduces perspiration' crops up, and pre-flight planning using GPS systems is time consuming. A major problem in using GPS is that of map projections or datums being used. Because the Earth has an irregular shape, rather than the perfect sphere that we tend to imagine, it is difficult to make accurate measurements on the actual surface. The earth is slightly flattened at the poles and bulges at the equator, making an ellipsoid (an ellipse that has been rotated around its short axis to form a three-dimensional shape). Unfortunately various geodesists the world over have created several ellipsoids, with different dimensions and different centres, and these have been adopted by various countries and their mapmakers as local standards. By creating a datum based on the ellipsoid whose shape most closely approximates an area or country being mapped, mapmakers have each gone their separate ways, paying little attention to global parameters.

As a worldwide system, GPS uses the WGS 84 ellipsoid (World Geodetic System) and latitude/longitude coordinates of a particular position in WGS 84 will differ from those in Clarke 1866 ellipsoid (Bermuda, Kenya, Tanzania, South Africa, Tunisia and Cape Canaveral) or Bessel 1841 ellipsoid (Ethiopia and Namibia), or the most common International (New Zealand, St Helena, Bahrain, Austria, Finland, Netherlands, Norway, Spain, Sweden, and Switzerland to name but a few). Most hand-held GPS units have datum conversion programs preloaded into their software to change the local datum into WGS 84 which can be run from tables contained in the handbooks.

A good exercise when acquiring a new GPS system is to plot the position of your home base (published airport charts always have accurate geographical coordinates in the local system for reference), and then check the GPS indicated position over a long period to find the mean WGS 84 position. By comparing the GPS position to the surveyed (chart) position your own local correction can be entered, which will suffice for most local operations. Each early flight should be analysed and photo centre positions plotted against the planned/flown flightline as a check on the system calibration. Similarly the unit can be used in a car and local checkpoints, such as Ordnance Survey trigonometric pillars or benchmarks in the district, visited with the GPS running. This type of preparation can save a lot of more expensive mistakes later in the mission.

Each start and endpoint of individual flightlines must be plotted in latitude and longitude (degrees, minutes, seconds) from the flight map and then loaded into the GPS and this will then be automatically corrected as the program runs. The start and endpoints will not necessarily be the camera on and camera off points, and most survey crews prefer a good approach run-in on-line so that the line can be checked, aircraft attitude and level checked, drift angle confirmed and set, and camera readiness confirmed. This can be 1–2 km out for a small, slow aircraft and 5–8 km for faster aircraft or if the terrain or maps present problems with sparse details.

If photography is being done at small scale (at higher altitude and with large ground cover and tolerance, e.g. 1:25 000 with Rollei 6 cm × 6 cm and 50 mm lens at 4100 feet, 1250 m, or higher), then the project may be flown entirely on information from the GPS, although close monitoring of the flightline against the map is recommended.

At lower levels and with larger scales then tolerances may not be sufficient to ensure accurate overlap and the assistance of the indicated track (degrees time or degrees magnetic) may be the more usable information. It should be mentioned that any SFAP operation, no matter what equipment is being used, can only be perfected by good preparation, hands-on practice with the actual equipment, and a build up of in-flight experience. A checklist approach really works, but a mistake many advocates of SFAP make is to try to lay down fixed procedures, airliner-type procedure turns between lines, counting the seconds on each heading, setting up the GPS with the autopilot, etc., tending to overcomplicate what is, in reality a fairly simple process. If the aerial photographer progresses through the basic fundamentals and then learns to use more advanced systems as tools to streamline the particular aircraft/camera/intervalometer/crew configuration then this may be more effective than copying an alternative, published system however professional it may seem.

As this book is being written, the choice of GPS systems is already large. The next generation of ground transportation navigation systems in which CD-ROM software of large scale road maps is operated in PCs already equipped with GPS boards are already being brought on to the market. The progression from this to the same type of system in a laptop which could be used as an airborne SFAP navigation unit can be expected before very long.

GPS is here to stay. As with personal computers, the systems available will become more and more sophisticated and lower in price, and new uses will be found to widen their operating base. A mistake made by people in buying PCs was to 'wait until prices come down' or to 'wait until the next chip comes along'. The soundest advice for SFAP users hesitating before making the leap into satellite navigation, is to do a little market research through the general aviation magazines at your local flying club, looking for avionics advertisements and reviews. *Pilot*, *Flying*, *Flyer*, and *Flight International* as well as many other magazines are well endowed with articles and comparative listings over the year as new systems appear. A little window shopping and a look at the specifications and handbooks will give a good idea as to how a particular GPS will fit in with your operation. With luck you

may even be able to organise the loan of a unit for a trial flight or drive around the airfield, which will give a good idea of potential uses. Even the purchase of a second-hand one, which are slowly coming on to the flying club notice boards, will enable you to build up expertise in this now unavoidable facet of SFAP technology.

Part 3

APPLICATIONS

Review the literature and you'll discover more than 300 publications related to SFAP. From a practical standpoint it is impossible for us to discuss all of the techniques and applications in depth, and simply listing them would not tell you much more than what you already know, or might guess. As a compromise, we've outlined a few topics that we believe will be of particular interest to natural resource managers: solving specific problems associated with various types of mission, their planning, navigation, ground control, camera fit, types of film, and so on.

Readers will have realised by now that SFAP is a very diverse subject. In an attempt to provide an overview we are using the closing chapters to provide specific examples (case studies taken from actual operations) from a variety of successful SFAP applications.

Chapter 14

Multispectral Photography (MSP)

Multispectral photography (MSP) is an important technique in remote sensing, and simply means using more than one camera/film combination to record a given scene with a number of different spectral channels. Typically, a four-camera configuration (each with identical focal length lens) may be loaded with, for example:
- panchromatic film and a green filter
- panchromatic film and a red filter
- monochrome infrared film and an infrared filter
- colour negative or colour diapositive film (no filter)

The MSP array will then record a given area in the normal manner so that the resulting images can be evaluated for spectral differences.

It is usual to employ 6 cm × 6 cm format cameras for MSP, Hasselblads and Vinten cameras particularly, but 35 mm cameras can also be used effectively. In fact MSP was one of the earliest SFAP applications, mainly because a number of small cameras can easily fit into a conventional (23 cm size) camera mounting, and the required ground cover is usually small.

Some typical examples include:
- forest inventories (where monochrome infrared, or false colour infrared images, are compared to panchromatic records to define tree types
- rural surveys (to define crops)
- crop surveys (to inspect for crop health)
- oil spillage
- coastline and swamp surveys (water is a strong absorber of infrared radiation, as can be seen in Fig. 14.1)
- many other areas in the field of earth sciences.

The following example is one conducted at the International Institute for Aerospace Surveys (Enschede, The Netherlands) in a series of experiments to detect disease infection in two varieties of winter wheat (Graham and Kannegieter, 1980).

Crop damage assessment

In cooperation with an experimental farm, 48 equally sized plots of land were set aside for growing 24 plots of Arminda and 24 plots of Clement winter wheat, all of which had been sprayed with known levels of nitrogen fertiliser. Each variety was

Figure 14.1 *Low-oblique infrared coastal survey. Kodak 2424 monochrome infrared (70 mm) film and Kodak No. 87 filter (transmission band 760 –900 nm). Note: High infrared reflectivity at power station outfall is due to plankton (attracted by warm water) and not a thermal response.*

neatly planted in groups of six plots, half of which were treated with fungicide. The MSP profile had also to be multi-dated, thus ensuring good temporal control of the results. A subsequent image analysis could then be checked against crop yield at harvest.

Three 70 mm (Vinten) cameras, with 100 m lenses, were mounted inside a Navajo Chieftain aircraft and fitted with films and appropriate gelatine filters according to the following criteria:

- Since healthy crops are known to reflect infrared radiation according to their chlorophyll content, an infrared (IR) band is essential.
- As the chlorophyll content of plants is proportional to green reflectance, a panchromatic green band seemed appropriate.
- It is known that any disease or pest attack results in a thinning of crop canopy, revealing more surface soil and an increased red reflectance, suggesting the inclusion of a panchromatic red band.

From the useful Kodak M-29 film data and B-3 filter data booklets, it is possible to gain a reasonable filter factor (FF) by dividing the 10% transmission bandwidth of the filter into the total spectral sensitivity curve of the film, as shown for the Green Kodak No. 61 filter and Plus-X film in Fig. 14.2. The initial MSP camera configuration is summarised in Table 14.1.

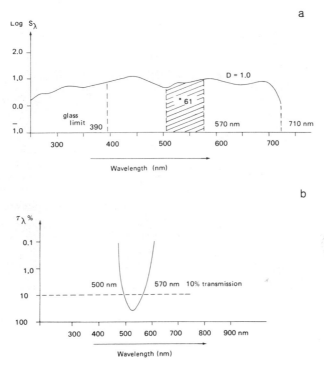

Figure 14.2 *(a) Spectral sensitivity curve for 70 mm Kodak Plus-X (2402) air-film. The hatched area represents the spectrum cut-out by the Kodak No. 61 green filter. (b) Transmission bandwidth of the No. 61 green filter.*

The first two missions, flown in May and June, gave no evidence of disease, but on the third flight (11 July) the red and infrared records provided positive identification of an 'infection focus' (yellow rust) at plots 41 and 42 in the non-fungicide Clement, clearly shown in Fig. 14.3. From this point onwards missions were increased, but the fourth flight (26 July) gave weaker tonal differences, mainly because the canopy was outgrowing the underlying disease at this stage of crop growth.

A final mission was flown on 28 July to see if colour imagery could detect crop health at this late stage of growth. On this flight the MSP profile consisted of:

Table 14.1 *MSP camera configuration*

Camera	Film	Kodak filter	FF	Bandwidth (nm)
1	Kodak Plus-X (2402)	Green No.61	×12	500–570
2	Kodak Plus-X (2402)	Red No.29	×4	610–710
3	Kodak Infrared (2424)	Infrared No.87c	×7	815–915

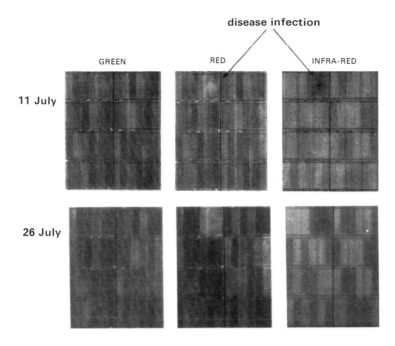

Figure 14.3 *Multispectral photography (MSP) of 48 experimental plots of winter wheat. Three Vinten camera (70 mm) records were taken on 11 July when the red and infrared records showed an obvious focus of infection in plots 41 and 42. The same records taken on 26 July are not so obvious, because the infection is covered by the faster growing canopy.*

- Kodak Ektachrome (2448)
- Kodak false colour infrared (2443) with Kodak (No. 12) yellow filter
- Kodak Plus-X with red (No.29) filter to compare with previous missions, see Fig. 14.4 (*a* & *b*) in the colour section.

The full colour photograph (2448) showed much the same pattern in colour tones as the panchromatic red image did in grey tones (Fig. 14.4*a, see* colour section). The only significant observations noted were the greens of non-sprayed Arminda, which were a shade lighter than the sprayed plots, and the badly diseased (non-sprayed) Clement plots which showed yellow hues. In the false colour infrared (2443) a clear separation showed between the sprayed and non-sprayed groups (Fig. 14.4*b, see* colour section). This film also indicated increasing redness (high infrared reflection) proportional to nitrogen levels in the plots, which was in line with yield figures. However , due to the late stage of investigation the disease noted in earlier missions was not apparent.

In support of the subjective analysis shown in Fig. 14.3, the negatives of the red

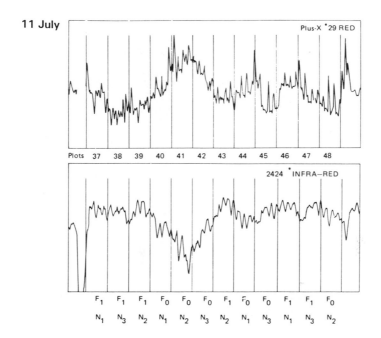

Figure 14.5 *Microdensitometer traces of the red and infrared negatives taken on 11 July. Note the density peaks of the red record at infected plots 41 and 42 (light spot in the print) compared to the density trough over the same plots in the infrared record. F_1 and F_0 refer respectively to plots treated and not treated with fungicide. N_1, N_2 and N_3 refer to nitrogen levels.*

and infrared records were scanned under a microdensitometer to provide spectral signatures of the MSP flown on the 11 July. Identical scans over plots 37 to 48 are shown in Fig. 14.5 where the opposite amplitudes of red and infrared records are clearly evident. The terms F_1 and F_0 denote respectively, plots treated and not treated with fungicide protection, and N_1, N_2 and N_3 refer to increasing levels of nitrogen.

Conclusions

There is a tendency in MSP applications to employ more camera/filter channels than is necessary. Usually three channels will suffice, the main ones being
 • colour (diapositive)
 • monochrome infrared (with No. 87b filter)
 • panchromatic with a red No. 29 filter

A number of analysts may ask for false colour infrared (2334), and perhaps colour negative for making prints, depending on the task in hand. However, it is worth mentioning that from colour negative frames one can always select a useful spectral channel by printing on to monochrome paper via a particular filter (or via an inter-

251

A B

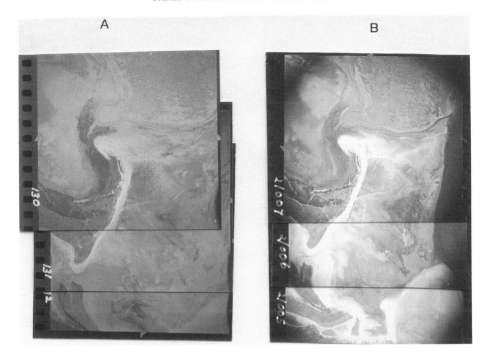

Figure 14.6 *Monochrome (MSP) prints made from an original 70 mm Fujicolor 400 ISO negative film. In A we have three frames printed via a No. 44 (cyan) filter, in B the colour negative has been printed through a No. 29 (red) filter. Vinten 70 mm camera, scale 1 : 6000, Cessna 172, 8 octa of cloud cover.*

negative if the original is a colour diapositive). This has been found very useful where there is a limited number of cameras available for a mission, and in one particular coastal MSP project (looking at different types of sand and shingle on a North Sea island), the authors employed only two cameras: monochrome infrared Kodak (2424) with a No. 87b filter, and Fujicolor 400 ISO negative colour film. Important frames from the Fujicolor negatives were subsequently enlarged on to black/white paper using a Kodak No. 44 (cyan) filter and the complementary No. 25 (red) filter, providing two extra spectral bands for analysis, as shown in Fig. 14.6 (*a* and *b*).

Chapter 15

Urban Survey

Introduction

Perhaps the most successful SFAP application known to the authors is one developed for urban surveys when they were involved (ITC, 1979) in an already established project that used 35 mm colour photography to record kampong developments in Indonesia. The many thousands of islands that make up the Indonesian archipelago present a formidable problem for urban planners, particularly when it comes to providing economic aerial surveys, and a localised system employing a door-mounted camera in a light aircraft proved to be a good solution.

The system, first instigated by Professor Hasan Poerbo of the Bandung Institute of Technology, used a 35 mm Nikon camera (loaded with colour negative film) and a light (crop spraying) aircraft to provide 1:2500 scale mosaics of overcrowded kampongs. This simple approach allowed for a fast and economic provision of colour prints that was easily gained from local photo shops.

According to Juppenlatz (1994) most town planners require up-to-date maps that vary from 1:2500 to 1:10 000 scale, and for action area planning maps in the range 1:500 to 1:2500. These maps need to be up-dated each year!

Starting with several kampong developments in the urban Bandung area, individual runs of 6 cm Rollei negative colour photos were made and loose mosaics produced to 1:5000 scale. Photocopies were made of the mosaics and small armies of students were dispatched into the kampongs to gather details of population, building size and use, available facilities (water, electricity, sewage, transport, etc.). This information was then analysed and in a matter of weeks large scale urban study maps were produced – which were immediately useful in kampong development and further planning.

Lessons learned from the initial surveys confirmed that SFAP had a relevant place in Indonesia. Alternative large format material and general town maps were taking 3–5 years to produce, and then only when funding was available. Outside help was sought from ITC (Enschede, The Netherlands) where many of the BIT technicians had done their photogrammetry and cartography training. A programme was outlined to take in similar studies of a further 40 or so townships with similar problems. For this much larger project it was necessary to plan a more systematic method using equipment with a greater degree of sophistication.

An Indonesian-built light aircraft, a Lycoming-powered Gelatik (the licence-

253

built Polish Wilga), already modified with a survey hole, was available to the project and a motorised Rollei 6006 using 220 (24 photo) roll film obtained. A fully levelling and drift-capable mount was designed and built, and an electronic forward overlap regulator, already being used by the ITC team brought into use. A simple navigation system was devised whereby the pilot identified a straight line feature on the ground and, by using a navigation sight mounted on the side of the aircraft, was able to construct a block of five runs (giving specified side-overlap) without using a large scale map (see Fig. 13.12). Pilots were briefed in detail as to how the method worked and were able to achieve successful results within the first hour of training flights.

The programme was started with ten local towns, a pilot, camera operator and ITC advisor. Within three or four flights the two-crew operation continued. Overall the project was extremely successful with few re-flights, the only common problem being an occasional lapse in setting drift on the camera. The next stage – to progress to forty towns in the central Java area – went on, and by 1991 the programme was completed. The national mapping agency in Indonesia is now firmly committed to using SFAP methods as an adjunct to its normal large format capability.

With GPS, such methods are even more efficient and cost effective. One of the benefits of small format urban photography is that large scale, small area cover can be done by pinpointing individual photos over a given town in an initial full cover. The photo cover can be repeated exactly using the same GPS flight plan data at regular intervals of 3, 5 or 10 years as required, and information more accurately (and easily) updated by overlaying the later photographs. However, individual photos can be replaced at any time in the intervening years, against using the same flight plan, making map upgrading for newly altered ground detail much more efficient and economic.

For the first time, with high resolution calibrated small format cameras, GPS survey flight management systems and stabilised camera mounts, SFAP can present a real challenge to large format surveys in keeping municipalities up to date in large scale map revision.

Two runs typical of a Bandung SFAP survey are shown in Fig. 15.1 (*see* colour section). The nominal forward and side-laps are 70% and 30% respectively, using the Rollei 6006, side sight and Gelatik aircraft.

SFAP Survey for Bangkok Metropolitan Region

A SFAP photo-mosaic coverage of metropolitan Bangkok was made in 1984/85, where 5000 km^2 of the city were photographed with a Rollei SLX camera fitted with a 50 mm lens using Kodak Plus-X film. The cover was needed for measuring changes in the housing situation and was designed to produce a finished (print) scale of 1:10 000 (Chanond and Leekbhai, 1986).

The Royal Thai Air force produced 1:52 000 photo scale cover (60% forward and 20% side overlap) with an AU 23-A Peace Maker aircraft (fuel cost $111 US per hour) that was navigated with the aid of a conventional Zeiss NT1 navigation sight.

Flown at 8500 feet (2500 m) and 120 knots (220 km\h) ground speed, the flight plan was designed to give a useable ground cover of 2 km² for each frame. The camera shutter was pre-set at 1/500 under shutter priority and operated at intervals of 17 s. The entire block was divided into four zones, and each flightline limited to a length of 30 km (film load capacity) taking 10 min – the entire mission took some 10 hours of flight time.

Apart from its technical success, this SFAP mission was very cost effective, the total area of 5000 km² being covered, processed, enlarged and printed to a scale of 1:10 000 for a total of $6154 US. By comparison, the estimated cost of conventional (23 cm format) aerial photography at the same scale amounted to $23 700 US.

SFAP for large scale digital town mapping (Caloundra, Australia)

Recent experiments conducted by the Australian Key Centre for Land Information Studies (AKCLIS) were concerned with SFAP digital town mapping, and were designed to look at its cost effectiveness for cover of medium sized towns aimed at large scale map updating. The Caloundra project (reported by Juppenlatz *et al*, 1994) was undertaken in July 1991 and covered a built-up area of approximately 70 km².

In this very complete project an entire system was designed, based upon the use of a Rollei 6006 (metric) camera, with 50 mm lens, and a pilot monitored GPS (Pronav – GPS 100) for air navigation. The aircraft was a twin-engined Piper Seneca, flying at 1000 m to provide a little more than 1 km² of ground cover/frame at 1:20 000, with the camera operator monitoring the flight runs via a video camera and monitor to control seven runs with 60% forward and 20% side-lap coverage.

Kodak PXP (monochrome) and EPP colour diapositive films were employed, and assembled contact prints of the seven runs showed the entire mission to be a complete success.

Digital mapping tests were conducted using the Adam MPS-2 analytical stereo plotter, and the Zeiss Planicomp. Setting up the model in the Planicomp proved to be both swift and convenient for mapping purposes, with each model of 600 000 m² being mapped in a single day. First results with the MPS-2 indicate that modifications to the operation of the system could be made to make it more user friendly, but the potential use of the MPS-2 for low cost digital town mapping from SFAP and GPS navigation is obvious, according to Juppenlatz's report.

SFAP for producing a three-dimensional database

In an Adam Technology publication (MPS-2 Application No.4) a small format photogrammetry project is described which compares the time and accuracy of the system with existing means of obtaining three-dimensional measurements of a typical city area (Perth, Australia) for incorporation into a CAD or LIS system suitable for use by town planners and engineers.

The quoted project details a Cessna 172 aircraft fitted with a Rollei 6006 camera (80 mm lens) flying at 1400 m to provide a scale of 1:17 500. Data collection was

provided by the MPS-2 interfaced to Intergraph Microstation software, some 2000 points being observed (in 3.5 h) to produce a plan, elevation and perspective view of the city. Photogrammetric accuracy is given as x = 0.25 m (RMS), y = 0.27 m (RMS) and z = 0.84 m (RMS). The total production time (including photography, observations and editing) is claimed to be no more than 8 h.

Small format pinpoint photography

One of the most difficult types of aerial photography is pinpoint recording of specific targets within a large urban sprawl. Locating the required target is not the easiest part, of course, and there are the usual difficulties of flying over areas where air traffic is strictly controlled (over London a twin-engined aircraft is mandatory). But apart from all that, there are the added problems of lighting!

Two examples of a well-known London landmark help to illustrate the problem, as shown in Figs 15.2 and 15.3 (*see* colour section). The vertical was taken with a 50 mm lens on a 55 mm square format and enlarged four times, the low oblique was taken with a 35 mm camera fitted with a 150 mm lens and enlarged 5.5 times.

Although both the vertical and oblique shots of Trafalgar Square are aided by the low sun and long shadows – particularly those cast by Nelson's Column – the same could not be said of the deep shadows cast over the Strand and Northumberland Avenue, which are considerably underexposed!

In consideration of normal air law (which requires a minimum height of 1500 feet (450 m) over populated areas) the flying height was 1800 feet (550 m), but the automatic exposure systems employed could hardly be expected to 'expose for the shadows' unless an 'overexposure factor' was provided.

If full exposure was a requirement for these photographs then a mid-day mission would be appropriate, where the solar altitude would at least provide for better illumination of the streets. Even better, a thin and high cloud cover (providing only the softest of shadows) would be more appropriate – but only at the expense of losing the three-dimensional modelling shown here!

Chapter 16

Small Format Photogrammetric Surveys

For map intensification purposes, or for new topographic surveys of small blocks, it is increasingly evident that photogrammetric methods can be applied to SFAP missions – provided that suitable controls are employed. Nevertheless, it is useless to save money on the acquisition of primary data only to spend more on increased requirements for ground control (more photos means more models) and more working hours spent on the photogrammetry! Obviously SFAP metric surveys must be considered with regard to financial limitations, type of cover (planimetric only, or with heightings?), location of terrain, total area of cover, degree of accuracy required and various other factors.

There are some locations where conventional aircraft cannot be operated. The authors were once asked to plan for a microlight survey (calibrated 70 mm camera) of the island of St Helena simply because there is no airfield at this remote mid-Atlantic isle. As far as SFAP was concerned there was no problem, and the Thruster microlight could fly from a small site on the island – but for 60% forward overlap, and 30% side-lap, over 600 photos would be needed, necessitating an expensive number of ground control points. In the event the project was not advised, and a long-range (large format) mission was provided from Ascension Island.

The following examples of small format metric surveys are instructive since they span a whole decade of developments and indicate typical fields of application.

A small format microlight survey (0.5 km^2): Redruth, Cornwall, 1985

This experimental project was designed as a feasibility study, to test a system which comprised a Thruster microlight; Hasselblad MK-70 calibrated 70 mm camera; simple external camera mount with drift adjustment; Plus-X film; hand-wound film processing in plastic trays; optical (0.45S) frame to indicate overlap regulation, and three different types of photogrammetric machine.

The (0.45S) optical frame mentioned above deserves further explanation. The Hasselblad camera was fitted with an optical finder, into which a small transparent frame was fitted to indicate a nominal 55% forward overlap, as described for a side sight (see Appendix 3). Since the ground speed of a microlight will tend to vary with gusts of wind, the 55% value was considered as a minimum and the shutter was always tripped in advance of the prescribed mark.

Mission planning was based on a camera scale of 1:8000 using a 100 mm lens (f = 100.64) and a flying height (above mean ground level of 145 feet (44 m)) of 3100 feet (945 m). With a format of 52 mm square, and a nominal overlap of 55%, the base B was equal to 187 m.

Navigation was planned for a total of three (east–west) runs with visual control. The pilot was responsible for keeping the aircraft straight and level, and 'on track' by the simple expedient of looking over the side and flying over the flightlines marked on his 1:10 000 scale map (provided by Ordnance Survey). The plan called for seven photos per flightline but two prior and two post photos made this a total of eleven. Run 1 was planned for the centre of the block, followed by runs 2 and 3 distant 250 m on each side of the central flightline. The total number of photos came to only 33, allowing for two attempts, since the magazine has a capacity of 70 exposures.

The site of this block was a new domestic estate on the side of a hill (Mount Ambrose) and at a nominal flying height of 3100 feet (945)m, and with the aid of a 1:10 000 map, it was considered possible to fly each run at 3050 feet (930 m), 3100 feet (945 m) and 3150 feet (960 m), in order to keep a common scale for each run. The planned ground speed of the aircraft was 45 miles/h (72.4 km/h) and the camera interval period (ΔT) calculated to be 9 s (equation 11.10 or Appendix 1(a). Although a knowledge of the interval period was not essential (because side sighting was employed) it is always useful to keep a check on ΔT since microlight ground speed is never known with any great accuracy.

Although the mission started in good weather, by the time the target area was reached fair-weather cumulus had concentrated to about four octa (4/8) in the NE corner of the block. However, by changing the direction of the flightlines from 90° to 120° it was still possible to cover the essential parts of the area, as shown in Fig. 16.1. During the initial runs a note was made wherever small cumulus obscured parts of the block, and additional frames exposed to cover these parts on a second run.

Film processing was conducted by hand-reeling the 70 mm Plus-X through long plastic trays (as detailed in chapter 12) using Kodak 'Dektol' diluted 1:25. The negatives were then contact printed on to Kodak Gravure film, to produce diapositives for photogrammetric analysis. *Note:* The correct quality of a diapositive is such that when placed on a sheet of white paper, it reveals full image details.

Photogrammetry was an important part of these trials and was conducted by three different operators, using three different types of machine.

Ross SFS-3 stereocomparator

The Ross SFS-3 incorporates a digitising interface link to a computer providing stereo observation, measurement and analysis on images up to 10 cm × 10 cm format. It was therefore very appropriate for SFAP when associated with British Oceanics 3DMAPS software. With the aid of 10 ground control points supplied by the O.S. (relevant to their 1:1250 map sheet: SW 7043 SE) a plot was made of an area where new buildings and roads had been recently constructed. A fair copy overlay of the plotted model, and its reference to the O.S. 1:1250 sheet, is shown in Fig.

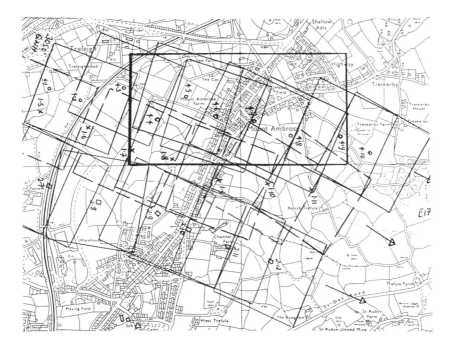

Figure 16.1 *Although the original flight plan called for three (1:8000) west - east lines (each with a specific height to provide an almost uniform scale over rising ground) they had to be flown on a 120° track, due to low cloud cover in the NE corner of the block. Survey flown with the aid of an 1:10000 map sheet SW 74 SW. Ordnance Survey, ©Crown Copyright. Published with permission of the Editor, Photogrammetric Record, 12 (71), 561–73.*

16.2, where new constructions (shown hatched) illustrate the degree of fit achieved by this small format system.

From a road area in this plot (with four control points) the RMS errors (relative to control) were $X = 5.7$ cm; $Y = 9.1$ cm and $Z = 15.3$ cm. Excellent though these figures are, it should be noted that they only refer to a small area, and if control was spread over a larger area they would not be as good.

Carto Instruments: AP-190 analytical plotter

The AP-190 is marketed as an add-on to any IBM-compatible PC, and is designed to handle complex photogrammetric calculations in a modular fashion. The menu-driven software enables virtually anyone to operate the system from small format stereo images up to large format (25 cm square). If further proof of the concept is required, one need look no further than the AP-190 analysis of the Redruth mission.

Although Bill Warner is a forester by training, he has taught himself to master the AP-190 through his work at Jordforsk, Norway. The mission plan (Ron Graham) was to evaluate the system through three different machines, and with operators of

Figure 16.2 *From the SFAP shown in Fig. 16.1, photogrammetric analysis (conducted with the Ross SFS-3 Stereocomparator and ten ground control points) was highly successful. New constructions (shown hatched) are accurately plotted over a 1:1250 sheet (Ordnance Survey SW 7043 SE). Mission flown with Thruster Microlight, Hasselblad MK-70 camera (100 mm lens) and Plus-X film. Ordnance Survey, © Crown Copyright. Published with permission of the Editor, Photogrammetric Record, 12 (71), 561–73.*

different backgrounds and experience so a self-taught photogrammetrist was ideal.

Bill Warner's analysis was supported by eight X,Y,Z control points, and seven X,Y points, to provide the plot shown in Fig. 16.3. From this report we get absolute orientation values of $X = 28$ cm, $Y = 46$ cm and $Z = 24$ cm, at a scale of 1:7642.

Adam Technology: MPS-2 microphotogrammetric system

Whereas the previous two machines could be applied to medium and large formats, the MPS-2 is a dedicated small format analytical photogrammetric measuring system. Designed for 35 mm and 70 mm photos the MPS-2 requires a host computer (being analytical) and has menu-driven software which is designed to be 'user friendly', so that anyone can operate the system.

In recent years Adam have supported a number of SFAP projects (as described later in this chapter), but the Redruth project was perhaps their first taste of a microlight mission. Indeed, one of the authors (Ron Graham) remembers a call

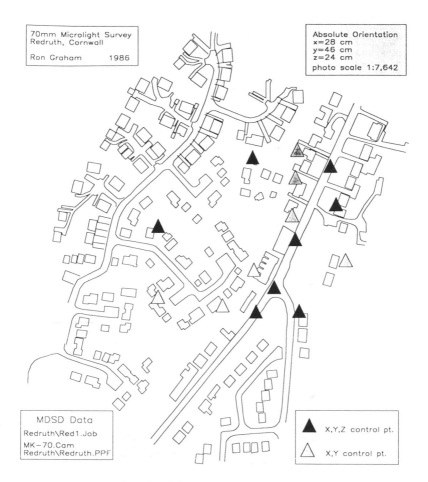

Figure 16.3 *A more complete plot of the cover shown in Fig. 16.1, plotted with the Carto Instruments AP-190 Analytical Plotter.*

from Australia, with a query regarding the type of platform he used for gaining the images they had in the machine. Evidently their operator had calculated a difference of about 15 m (50 feet) in flying height, between adjacent photos! The lesson was salutary. There was more involved to microlight surveys than just staying on track, and flying straight and level, and keeping a specified overlap. We were also expected to keep altitude, which is not so easy with such a light platform! Nevertheless, the calculations from the MPS-2 were excellent, giving values close to those of the other two systems, with average errors of $X = 6.6$ cm, $Y = 7.1$ cm and $Z = 5.8$ cm.

Adam's SFAP system

Adam Technology are an Australian company with a European office based in Salisbury, UK (see Appendix 6), and are known to the authors because of a shared

261

interest in SFAP, and the fact that their MPS-2 is an important feature for promoting worldwide interest in small format photogrammetry.

The Adam SFAP system consists of:
- Rollei 6006 camera, with 50 mm f4 Distagon lens, two NiCad batteries and two 120/6006 film magazines
- aircraft camera mount with video intervalometer
- Jobo ATL 1000 automatic film processor
- Adam MPS-2 three-dimensional digitiser (including software) and computer
- CMAP simultaneous independent model block adjustment program for aero triangulation
- 3DD PC-based software designed specifically for photogrammetric mapping projects
- GEOCOMP surface modelling software
- output device for interfacing with a variety of plotters

All of these components can be configured to suit individual requirements, and backed up with training, installation, support and maintenance. As may be seen, no platform is mentioned! No doubt this would be left for the client to provide; a sensible precaution, since there are a great number of different aircraft that can be utilised for SFAP.

Two examples of Adam system applications are quoted in their Application sheets 4 and 7, which are briefly reviewed here to indicate the scope of an 'off-the-shelf' system.

Small format aerial photogrammetry for topographic surveys (Application sheet 7)

The objective was to produce a digital terrain model (DTM) and topographic plans for the 250 ha Hotel Nikko site in Bali, Indonesia. A Jakarta-based survey company approached Adam and gave them complete control for this SFAP project.

A Piper Navajo aircraft was hired for the work and four lines were flown at a flying height of about 2300 feet (700 m) a.m.g.l. using a 50 mm lens. The Adam video intervalometer was used to keep the camera on line and control overlap. A total of 26 control points was placed on the site using a WILD GPS System 200. Subsequent adjustment using GEOLAB software provided a tightly controlled set of control points to be used later in aerial triangulation calculations.

A total of 56 stereo models was observed on the MPS-2 and triangulated using C-MAP aerial triangulation software. A DTM was generated by GEOCOMP software and a total of 22 000 points observed to produce topographic plans at 1:2000 scale (with 1 m contours) and an overall plan at 1:5000. The accuracy obtained was 0.2 m in plan and 0.3 m in elevation. This application report concludes with the following economic analysis:
- total project time 24 days
- A profit margin of 35% from project costs and fees collected.

Using conventional methods (rather than SFAP) for the same level of accuracy would have meant 20% more time, three times as many people and more than twice the cost to the client.

Small format production of a three-dimensional database (Application sheet 4)

Using the Adam SFAP system and a Cessna 172 (with the right-hand door removed) an area of 950 m × 750 m of central Perth was photographed at a height of 4600 feet (1400 m). The objective was to obtain three-dimensional measurement data of a 'typical' city area for incorporation into a CAD or LIS (land information system) in order to compare the time and accuracy of SFAP with existing means of obtaining such data.

The vertical photography was at a scale of 1:17 500 and existing ground control was available from the Department of Lands. The total exercise took only 45 minutes (ground to ground), and subsequent MPS-2 observations were interfaced with Intergraph's Microstation PC. Some 2000 points were observed in the 3.5 hour period to produce a plan elevation and perspective views of the city.

The total production time came to less than 8 hours:
- 1 hour for photography
- 1 hour for film processing
- 3.5 hours for observation
- 2.5 hours for editing.

When comparing the accuracy of observed control targets against surveyed positions the accuracy (RMS metres) was X = 0.25, Y = 0.27, Z = 0.84.

Bundle adjustment for 35 mm oblique aerial photography

Using Kodak 5052 TMX film (200 ISO), three strips were photographed at about 2500 feet (760 m) a.m.g.l. (*see* Fig. 16.4). The photographer estimated 60% forward overlap through the camera viewfinder, while maintaining 45°ω. Nineteen negatives were custom enlarged to 20 cm × 30 cm prints. Tie points and control points were captured with a standard digitising tablet interfaced with Carto MDSD software. For each photography 15 to 20 points were registered (digitised and ID recorded). The bundle adjustment used 12 points for ground control.

Based on the deviations of 80 check points (points with known coordinates), the accuracy of the coordinates estimated in the adjustment for the 1:32000 scale imagery was around 1.5 m in X, 3 m in Y, and 2 m in Z (Warner and Blankenberg, 1995).

The LEO project

After some 15 years of extensive research into every aspect of SFAP for photogrammetric and thematic surveys, a significant system has been developed by two well-known figures in the exciting field. As we have seen, air survey must always be considered from the client's point of view, and if a SFAP system is to be justified it has to be more economic than the large format alternative.

The LEO (local Earth observation) project was devised by Prof. Dr. Ing. F.J. Heimes (Head of the Department of Photogrammetry, University of Bochum,

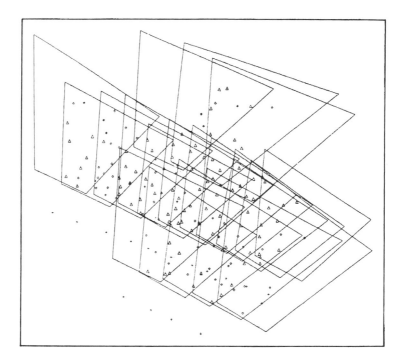

Figure 16.4 *Three oblique lines taken with a 35 mm camera. Negatives were subsequently enlarged to 20 cm x 30 cm, and control points captured with a digitising tablet interfaced with Carto MDSD software.*

Germany) and Dr Peter Poole, a Canadian ecologist. Both are very experienced in mapping and earth sciences, and both are qualified pilots. They are well known to the authors of this book, and we have worked with them on a number of research projects prior to the development of LEO.

The idea for LEO grew out of conversations with NASA officials on the Earth Observation System (EOS), the first satellites of which will be launched in 1995/96. It was felt that EOS could be both complimented and reinforced by a dispersed network of local stations capable of gathering matching data sets. By georeferencing all environmental data with GPS the infrastructure is in place for a reciprocal local-global data exchange.

The system under development and to be used for LEO is named MASER (Multispectral Airborne System for Environmental Research). It is centred upon the design of a multipurpose remote sensing system installed in the Murphy Rebel aircraft (see Fig. 9.9).

In many ways LEO defines most of the aims we wish to achieve in SFAP: economy, simplicity and metric accuracy. And although LEO represents the sum of the parts, it is the parts themselves which are of main interest to us here. In Fig. 16.5, LEO is defined from the schematic outline (top left) with its GPS controlled Survey Flight Management (SFM) system (Fig. 16.6) to the various platforms where

Figure 16.5 *The LEO project.*

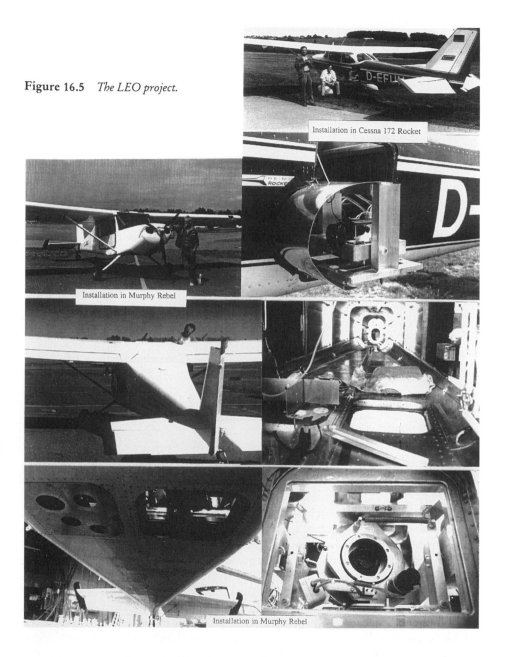

Installation in Cessna 172 Rocket

Installation in Murphy Rebel

Installation in Murphy Rebel

(clockwise) we have the Cessna 172 and its stabilised camera mount (extended from luggage compartment) followed by the Murphy Revel with its two camera hole modifications cut into the cabin floor. The Rebel can be built with a number of different types of power plant and can even satisfy microlight specifications when the Rotax 582 engine is used, but its main advantage is the possibility of modifying

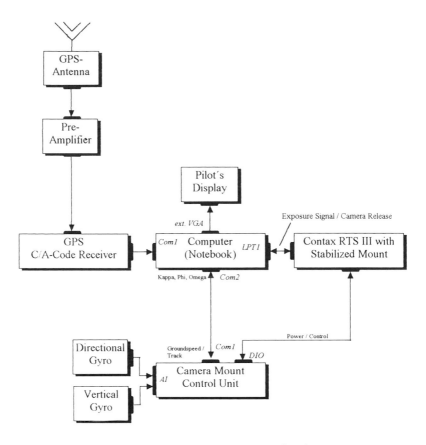

Figure 16.6 *The GPS controlled survey flight management (SFM) system.*

the aircraft during its assembly, allowing camera holes, GPS fittings and mountings to be introduced with relative ease and economy.

The general specifications for the Rebel are shown in Fig. 16.7, where it can be seen that a float version is also possible. The kit (without engine) costs something in the region of $14 000 (US), and the engines are priced at around $14 500 for the Lycoming 0-235 (four-cylinder horizontally opposed 116 HP); $8300 for the Rotax 912 (four-cylinder, four-stroke, 80 HP); and $4000 for the Rotax 582 (two-stroke, 65 HP water cooled).

The Murphy Rebel has considerable space for mounting a comprehensive MA-SER system behind the pilots. In Fig. 16.8a, two different camera systems are shown. In the starboard camera bay we have an MSP array of one Hasselblad, one Rollei 6006 and one Contax RTS III. In the port bay there is a calibrated Contax RTS III fitted into a stabilised mount for metric surveys. The underside view of these mountings is shown in Fig. 16.8b.

Figure 16.7 *The Murphy Rebel specifications.*

Another kit-built aircraft (now being modified for SFAP by Professor Heimes) is the Rotax powered 'Pulsar XP' made by Aero Designs (11910 Radium Street, San Antonio, Texas, USA). This elegant two-seater (see Fig. 16.9) can be fitted with either the Rotax 582 or the 912 and has a cruise speed in the region of 130 miles/h (200 km/h).

Small format mapping with GPS Survey Flight Management (SFM)

The Survey Flight Management system was designed and developed by the Bochum Technical University group under the supervision of Professor F.J. Heimes. One of the principal features of this small format mapping research programme was to establish a complete system where a portable 'do it yourself' survey could be conducted with the minimum of expensive ground control.

In brief, the basic functions of computer-supported missions starts with the flight plan. The survey navigator (or pilot) makes the usual calculations and decisions, then carefully installs the mission plan into a lap-top computer. When fitted to the aircraft interface the computer then controls navigation and camera operation (shown

Figure 16.8 *(a) MASER system incorporated inside the Murphy Rebel aircraft. (b) Murphy Rebel camera ports.*

in the schematic drawing of Fig. 16.6) where the precision guidance of the pilot and computer-controlled shutter release are also associated with a camera-stabilised mount. Survey Flight Management systems also allow for post-flight analysis of a mission, with plots of each line showing the accuracy of each exposure within the flight plan.

At Bochum, photogrammetric SFAP has been designed around two cameras, the metric 6006 and the Contax RTS III suitably modified for metric purposes. The RTS III has the advantage of being considerably cheaper than the 6006 and, in addition, is very robust. With the standard 28 mm lens a large number of tests indicated that a resolution of 180 line pairs/mm could be obtained, and, when calibrated, a standard deviation of only 3.3 μm was calculated. These excellent results are mainly due to the film flattening of the RTS III and the fitting of eight fiducial marks

Figure 16.9 *Aero Designs 'Pulsar XP' aircraft.*

within the frame, one at each corner and one at the centre of each edge, as shown in Fig. 16.10. The aerial photo of Bochum Fachhochschule (Fig. 16.10) was taken with a 28 mm lens at a height of 1740 feet (530 m) (1:19 000 scale), two lines being flown with 60% forward and 30% side-lap. In the mission area about 40 control points were signalised and determined with an accuracy of 2 cm surveyed by one frequency C/A code GPS receivers.

Small format mapping with SFM: Ohrdruf, Germany

Ohrdruf, a small city in east Germany, was the subject of a small format survey using a 70 mm Rollei 6006 fitted with a 50 mm lens. Flown by Franjo Heimes, using a club Cessna 172 fitted with the Bochum small format mount (Fig. 10.3), the survey area (350 ha) was controlled by SFM software and four parallel runs were flown under GPS guidance. About 60 photos were exposed at a photo scale of 1:8000. The calculated flying height of 1669 feet (508.7 m) and other details are shown for each run in the SFM print-out shown in Fig. 16.11.

Digital mapping with Planicomp/Phocus provided final map sheets at 1:1000, with an accuracy (standard deviation for well-defined points) of 8 cm in planimetry and 15 cm in height, as shown in Fig. 16.12.

Aerial survey without ground control

Depending on accuracy requirements it is possible to complete an air survey without ground control. The six elements of exterior orientation (X,Y,Z and κ, ϕ, ω) have to be determined with high precision for each exposure station and can be accomplished with the aid of differential GPS (DGPS) for X,Y,Z and inertial measurements for κ, ϕ, ω.

The Bochum tests have been conducted with a six-channel C/A code GPS receiver in the aircraft (Cessna 172) and a 12-channel C/A code GPS receiver used as a ground reference station. GPS data is then synchronised with AHRS (attitude and heading reference system) data. The standard AHRS (LCR 88 from LITEF) consists

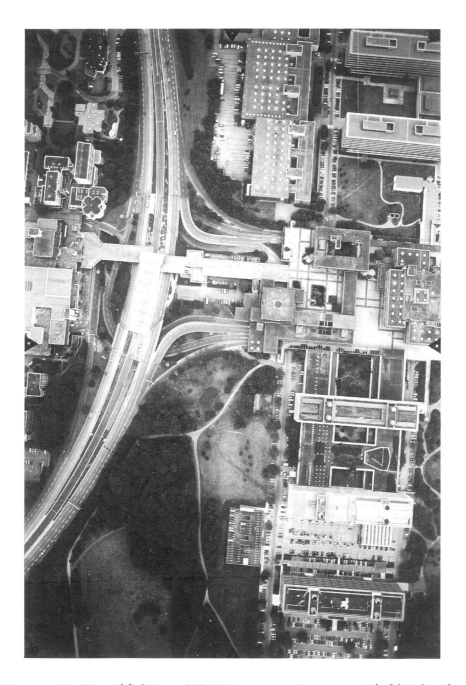

Figure 16.10 *The modified Contax RTS III 35 mm camera incorporates eight fiducial marks within its image frame, one at each corner and one in the centre of each side. (Prof. Dr. Ing. F.J. Heimes, Fachhochschule Bochum, Germany).*

```
Project : OHRDRUF.FD0                           Line nr. :      1

                     Geographic latitude      Geographic longitude

Starting point........:   50 ° 49 ' 22.0 "  N    10 ° 43 ' 32.0 "  O

End point.............:   50 ° 49 ' 47.0 "  N    10 ° 43 ' 34.0 "  O

Negative length [mm]..:    55    Negative width [mm]........:      55

Forward overlap [%]...:   64.8   Photo scale................:    8000

Focal length [mm].....:    51    Flight altitude [feet].....:    1669

Length of line [km]...:  0.774   Air base [km]..............:   0.155

Number of photos......:     6    Base / height ratio....: 1 :  0.378
```

```
Project : OHRDRUF.FD0                           Line nr. :      2

                     Geographic latitude      Geographic longitude

Starting point........:   50 ° 49 ' 21.0 "  N    10 ° 43 ' 50.0 "  O

End point.............:   50 ° 49 ' 49.0 "  N    10 ° 43 ' 52.0 "  O

Negative length [mm]..:    55    Negative width [mm]........:      55

Forward overlap [%]...:   60.6   Photo scale................:    8000

Focal length [mm].....:    51    Flight altitude [feet].....:    1669

Length of line [km]...:  0.866   Air base [km]..............:   0.173

Number of photos......:     6    Base / height ratio....: 1 :  0.424
```

```
Project : OHRDRUF.FD0                           Line nr. :      3

                     Geographic latitude      Geographic longitude

Starting point........:   50 ° 47 ' 50.0 "  N    10 ° 43 ' 51.0 "  O

End point.............:   50 ° 50 ' 23.0 "  N    10 ° 44 ' 14.0 "  O

Negative length [mm]..:    55    Negative width [mm]........:      55

Forward overlap [%]...:   60.0   Photo scale................:    8000

Focal length [mm].....:    51    Flight altitude [feet].....:    1669

Length of line [km]...:  4.750   Air base [km]..............:   0.176

Number of photos......:    28    Base / height ratio....: 1 :  0.430
```

```
Project : OHRDRUF.FD0                           Line nr. :      4

                     Geographic latitude      Geographic longitude

Starting point........:   50 ° 48 ' 43.0 "  N    10 ° 44 ' 18.0 "  O

End point.............:   50 ° 49 ' 50.0 "  N    10 ° 44 ' 27.0 "  O

Negative length [mm]..:    55    Negative width [mm]........:      55

Forward overlap [%]...:   68.5   Photo scale................:    8000

Focal length [mm].....:    51    Flight altitude [feet].....:    1669

Length of line [km]...:  2.078   Air base [km]..............:   0.139

Number of photos......:    16    Base / height ratio....: 1 :  0.339
```

Figure 16.11 *A typical SFM print-out for a SFAP mission (Ohrdruf) navigated with GPS. (Prof. Dr. F.J. Heimes, Fachhochschule Bochum, Germany).*

of two gyros with two measurement axes and three pendulum accelerometers, and the basic idea is to combine inertial measurements (with short time stability) with the DGPS measurements with long time stability.

At time of writing the system has already been flight tested, but not yet in combination with SFAP.

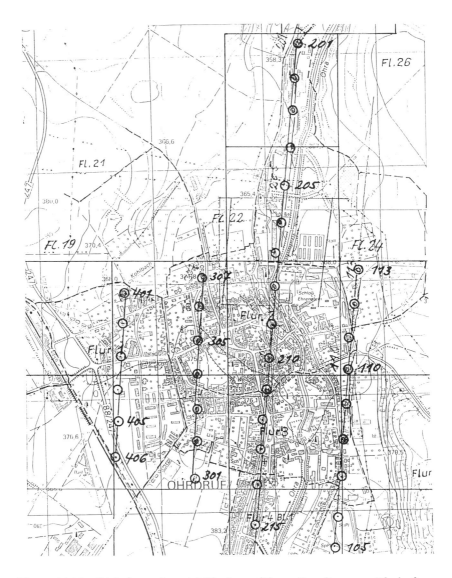

Figure 16.12 *Digital mapping with Planicomp/Phocus. Four lines over Ohrdruf area, Rollei 6006, f=50 mm. (Prof. Dr. Ing. F.J. Heimes, Fachhochschule Bochum, Germany).*

Chapter 17

Small Format Aerial Photography for Natural Resources

Many believe small format is synonymous with small projects. Based upon the abundant literature documenting its use, one can understand why SFAP is considered a tool for *ad hoc* research rather than a system for continuous operations. These myths have been dispelled in Canada. Since the late 1960s Ontario's Ministry of Natural Resources (MNR) has been documenting the impact of logging practices on millions of hectares with supplementary aerial photography (SAP). Developed by Victor Zsilinszky, a pioneer in using small cameras for natural resource work, SAP has grown to include many applications in forestry, geology, agriculture, fisheries, wildlife and environmental monitoring. Today, a large well-organised staff, largely forest technicians actively use SAP for continuous forest inventory in 52 district offices (Goba and Senese, 1992). Because the MNR is a world leader in SFAP, their refinements in technology and professional approach towards organisation will be of particular interest to resource managers.

For additional information about the SAP program, contact Ontario Centre for Remote Sensing, Ministry of Natural Resources, 90 Sheppard Ave East, 4th Floor, North York, Ontario, M2N 3A1, Canada.

Forestry

SFAP has been applied to forestry more than to any other discipline. The reason is that foresters are attracted to simple, low-cost techniques for capturing reliable data. Although small format systems cannot compete with the efficiency and accuracy of traditional aerial surveys, they remain popular in forestry for two basic reasons:
- small format mapping generally meets the foresters' accuracy requirements at a reasonable cost
- aerial photography and mapping are conducted by those who best understand the project objectives, i.e. the resource specialists.

For these reasons, several forestry organisations have integrated SFAP into their basic operations. For example, the Ontario MNR has trained more than 200 forest technicians in SFAP, primarily to measure the impact of logging practices on the forest inventory.

Swedforest of Falun, Sweden, employs a team of small format aerial photographers for annually mapping about 1200 clearcuts, and there are a number of private

273

small format aerial survey firms supporting the forest products industry in North America and Europe.

The application of SFAP within forestry is well documented, with more than 100 articles in the past three decades. Most research has been devoted to data capture, which includes testing platforms, camera mounts, intervalometers, films, filters, etc. During the past decade however, attention appears to have been focused on data analysis, which included photogrammetric techniques and equipment. In this section emphasis is placed upon applications.

The primary application of small format work is forest inventory (see for example Paine and McCadden, 1988). Generally speaking, small format aerial surveys are meant to supplement rather than supplant fieldwork. Nevertheless, small format forest inventories have been integrated into state-wide field tests in the USA (see for example Batson, 1974) as well as continuous forest inventories on a provincial level in Canada. The cost benefit of small format forest inventory is testified by its application within the private sector of the forest industry.

An inherent dimension of forest inventory is sampling, and the economical benefits of small format surveys have been exploited for this particular task for more than three decades (Aldrich et al, 1959). A common technique for sampling is the fixed base system which uses a boom supporting two cameras suspended beneath a helicopter, or two cameras mounted in wingtips of a light aircraft. Again, the fixed base system is not new; since the mid 1960s foresters have used this technique to capture accurate measurements without the worrisome task of supplying ground control (Lyons, 1966, 1967). Today, fixed base systems are commercially available.

Since the fixed base system is generally restricted to very large scale photography (e.g. 1:500) it is one of the many small format techniques used for monitoring regeneration. For additional details on the application of small format surveys for regeneration appraisal see Goba et al. (1982), Kirby (1980), Hall and Aldred (1992), Smith et al. (1986) and Weigh et al. (1984).

Another popular use of small format surveys is for detecting pests (Harris, 1971, 1978; Willett and Ward, 1978) and monitoring diseases, such as oak wilt (Ulliman and French, 1977) and Dutch Elm disease (Nash et al., 1977; Stevens, 1972). The forester's continuous concern with fire also has been assisted by small cameras, with inventory slash fuel (Muraro, 1970) and measuring fire behaviour (Clements et al., 1983).

Although most small format work is essentially for interpretative purposes, it is also a useful technique for forest measurements (see for example Kippen and Sayn-Wittgenstein, 1964): crown diameters (Hagan and Smith, 1986), tree size (Sayn-Wittgenstein and Aldred, 1972), stand density (Heer and Smith, 1986), and volume estimates (Aldred and Kippen, 1967; Pitt, 1984).

An interesting development in small format oblique photogrammetry is explained by Warner and Carson (1992), where monoscopic measurement is based upon space resection by collinearity. Briefly, the method consists of enlarging 35 mm slides with a colour laser scanned copier, then digitising surveyed targets with a standard digitising tablet. This particular paper also illustrates how SFAP can support natural-resource managers in their research. Indeed, Bill Warner (one of the authors of

this book) is a forester by profession, and through SFAP he has also become a highly competent photogrammetrist and aerial photographer. Like many others who use SFAP, Bill can control his own research with an economic budget that is just not possible with large format systems.

Yet another example of small format ingenuity is exhibited in a paper by Pitt and Glover (1993), where two 35 mm cameras were mounted on a boom and suspended from a tethered helium-filled blimp to obtain nominally vertical aerial photographs (1:828 and 1:414 photo scale) of vegetation management research plots. Conducted by Canada's Forest Pest Management Institute, these trials were aimed at the generation of treatment efficacy, crop tolerance, and crop growth response data for silvicultural purposes.

One of the most recent advancements in forestry surveillance is the application of Colour-Infrared Digital Photography. The primary reason for applying the Kodak DCS-420 Colour Infrared camera (see Chapter 8) was to support US Forest Service law enforcement in detecting cannabis plots (Fig. 17.1 in colour section). Other applications include the survey of fire damage to vegetation, timber mortality, bark-beetle infestation and monitoring riparian channel changes.

Forestry is more than merely growing trees; consequently, small format cameras have been applied to just about every task associated with this multidimensional discipline, including riparian studies (Meyer et al., 1982), soils, recreation, cultural resources and, of course, wildlife. The latter application relies on SFAP for a broad spectrum of activities worldwide.

Wildlife

Wildlife specialists are attracted to small format surveys for the same basic reasons that foresters are: surveillance is
- cost effective
- conducted by those who best understand the problems at hand.

If one were to categorise the use of small cameras for wildlife work, essentially two fields of studies come to mind: monitoring populations and evaluating habitat.

In the first category, census studies rely upon well-established aerial point sampling techniques (Norton-Griffiths, 1988). From Arctic regions (Poole, 1989) to the African plains (Norton-Griffiths, 1978), population studies have included a wide variety of species including wildebeest (Norton-Griffiths, 1973), seals (Hiby et al., 1988), waterfowl (Ferguson and Gilmer, 1980; Ferguson et al., 1981) to name just a few.

In the second category, small airborne cameras are used for evaluating and mapping wildlife habitat. Although much of the work is basic photo-interpretation for habitat analysis (Meyer et al., 1975, Scheierl and Meyer, 1976, Steffensen and McGregor, 1976), SFAP is also used for measurement purposes, such as measuring food consumption of swans (Lee and McKelvey, 1984), quantifying annual changes in floating-leafed plants (Nohara, 1991), and mapping wetlands (Mead and Gammon, 1981).

The application of SFAP to marine biology is a speciality in itself. Whitehead and Payne (1981) began early work with 35 mm cameras for assessing whale populations. Later, Cubbage and Calambokidis (1987) measured whales for size-class segregation with wingtip mounted 35 mm cameras. Recently 70 mm photogrammetry has been used to measure whale length frequency (Withrow and Angliss, 1992) and growth rates (Best and Ruther, 1992; Koski *et al.*, 1992; Hain *et al.*, 1992), determine calving intervals (Miller *et al.*, 1992), and estimate calf production and allometry (Ratanswamy and Winn, 1993). Smaller marine mammals also have been studied. For example, Perryman and Lynn (1980*a*) photogrammetrically evaluated dolphin school structure with an array of camera equipment.

Rangeland

Like forestry, rangeland management uses SFAP for a variety of purposes. From basic identification of rangeland sites (Everitt *et al.*, 1980) and interpreting vegetation (Francis, 1969) to classifying rangeland use (Meyer and Gerbig, 1974). Small cameras have found a particular niche for monitoring and mapping rangeland (Meyer, 1977; Meyer *et al.*, 1980, 1982), sampling vegetation (Waller *et al.*, 1978; Warren and Dunford, 1986) and measuring vegetation change (Tueller *et al.*, 1988). Of particular interest to rangeland managers is a video graphic system that enhances and digitises 35 mm photography to measure the area of wind erosion on converted rangeland (Lyon *et al.*, 1986). The implications of video-to-digital analysis are far reaching, because such a system exploits 35 mm photography to quantitatively evaluate damage and provide data for rangeland management activities.

Finally, we should note that although most of these references are related to activities in North America, the application of small format aerial surveys is worldwide, with current activities operational in Europe, South America, Africa, Asia, Australia, and the Arctic regions.

Chapter 18

Small Format Aerial Photography for the Environment

Geology and Mining

Small format aerial photography is also used for *photogeology*, the qualitative and quantitative application of photography for geological information. Geologists commonly use photographs for structural mapping, energy and mineral exploration, and general engineering surveys. Although detailed analysis of geomorphology requires professional training in geology, skilled small format interpreters have developed proficiency in recognising distinctive land forms or surface features.

Small camera stereo photography has proven useful for rapid geological reconnaissance (Hall and Walsh, 1977), hydrological research (Sherstone, 1978), energy planning (Bradley *et al.*, 1985), and assisting mining operations (Evans *et al.*, 1983; Wracher, 1973). Notable photogrammetric applications have been complex geological mapping with the Adam Technology MPS-2 SF analytical plotter (Sarossy n.d). The inherent attraction of small format surveys is that they can provide frequent volume measurements at reasonable cost. Generating a digital elevation model (DEM), and determining volume from it, is straightforward (Warner and Carson, 1989). The technique can be performed even with oblique imagery and a standard digitising tablet (Warner, 1994*b*). Alternative photogrammetric methods have been used to determine iceberg volumes (Farmer and Robe, 1977) and glacier movements.

Pollution control

Since mines are often the point source for pollution, small format surveys have been used for economically monitoring pollution. Canada, for example, initiated Operation Skywatch in 1978, an experimental program involving women pilots for airborne environmental patrols. The women pilots volunteer time and cost of aircraft operation on a limited basis. Each region of the Ontario Ministry of Environment provides a 35 mm camera, film and processing costs. On regular Skywatch flights, the pilots and crew are given large scale topographic maps with targets clearly market. A special flight log is attached, indicating relevant information for each flight. When an environmental problem is spotted, the scene is photographed, located on the map and reported immediately to a local control tower who, in turn, forwards the information to a local Ministry of Environment district office. Once the aircraft has landed the film is processed and submitted, with flight log data, to a

regional coordinator. Applications of the program include detecting oil spills, air pollution, and illegal use of land fills (Johnson, 1980).

In addition to identifying point source pollution, small cameras have been used for mapping waste sites (Warner *et al.*, 1993). For example, Warner (1994*b*) describes three waste site investigations, and evaluates a small format aerial mapping system used by Norway's Centre for Soil and Environmental Research (Jordforsk), for environmental monitoring. Photographs are taken with a hand-held 35 mm camera and enlarged using a commercial colour copier. Stereoscopic and monoscopic measurements are captured with a digitising tablet using Carto Instruments MDSD software.

Another environmental monitoring system is MASER (multispectral airborne system for environmental research), which combines video and photo technology with GPS (Heimes *et al.*, 1993). MASER is part of LEO (Local Earth Observation) which is a collaboration between indigenous resource groups and remote sensing institutions with the purpose to equip communities and environmental research management groups in remote and developing areas. LEO/MASER is a low cost approach to provide data from aerial photography to GIS, using both digital and analytical methods. The digital method uses image processing to manipulate high resolution scanned images. The analytical method relies upon an Adam Technology MPS-2 analytical plotter. Applications include geo-referencing aquatic contamination, protected area patrolling, animal census, habitat inventory, coastal zone management, water pollution and quality, and open cast mine and waste site surveys.

These are just a few examples of how small cameras are used for geological and environmental surveillance. There are many public and private organisations conducting similar surveys worldwide. Although each varies with technique, scope and objective, they all seem to have a common goal – to provide local environmental data in an efficient and economical way. As the metric quality of small cameras improves, and images are geo-referenced with GPS technology, it is certain that small format systems will play a larger role in environmental monitoring.

Chapter 19

Large Scale Map Revision from Digital Cameras

The rapid expansion in the use of Geographic Information Systems (GIS) has led to the requirement for up-to-date, large scale, accurate mapping on a nationwide scale, and the need for such data was recognized at least a decade ago. Today, the continuing movement from paper to computer-based GIS records in many sectors, ranging from transport to local council, means the demand for such data is greater than ever (Mills. & Newton, 1995). In some circumstances updating and verifying large scale maps may be necessary, but even if SFAP is employed this can still be an expensive business due to the high cost of restitution instrumentation. However, if the primary data can be acquired in digital format, then installed into a digital workstation based on a personal computer (PC), a cost saving system is conceivable – providing the data can be acquired without loss of resolution.

As part of his Ph.D research into various digital mapping systems, Jon Mills (Department of Surveying, University of Newcastle-upon-Tyne) is looking at SF digital cameras for aerial survey. As mentioned in Chapter 8, past and current research projects (with Ron Graham) are aimed at establishing the accuracy, limitations and possible economy from the use of Kodak DCS-200/420 cameras for large-scale map revision and civil engineering applications.

In the initial trials a number of problems and errors associated with flight-planning became obvious, and although they provided adequate images for the production of a very reasonable map at a scale of 1:1650 (*see* Fig. 8.7) it was obvious that further trials were required in order to resolve some remaining problems.

As mentioned previously, a significant problem with digital cameras is the time taken to download an image into the camera's hard-disk. With Kodak DCS-200/420 cameras this is a nominal 3 s which has to be taken into account at the earliest stage of estimating various mission parameters. The important parameters to be optimized are: scale (m); forward overlap (p); flying height above ground (H_g); aircraft ground speed (V_g); base (B) and base/height ratio (B/H_g).

In preliminary trials, the DCS-200 was planned to be orientated so that the shorter dimension of the M5 chip ($S' = 9.3$ mm) would be leading with respect to the aircraft's heading, and all calculations were based on that premise. Unfortunately the camera could only be placed in the existing mount with the larger ($S' = 14$ mm) dimension leading – no problem really – except we forgot that the format was not square and we failed to re-calculate! The result, as shown in Fig. 19.1, was a line overlap of only 41% rather than the planned 60%.

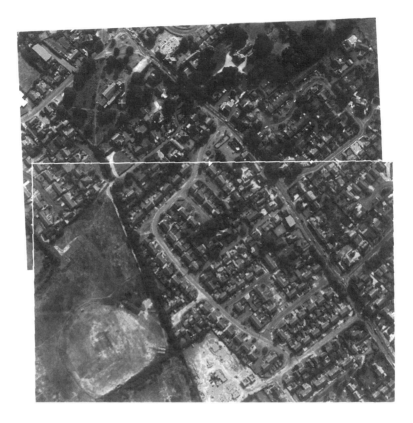

Figure 19.1 *Two line-overlap digital images of St Neots, taken with the Kodak DCS-200 camera on board a Cessna 337. Forward overlap is 41%. Aircraft ground speed 100 mph, AIM = 6μm, exposure 1/250 f/4. Flying height (amgl) 3650 ft, scale 1:40 000.*

Although the normal camera mount (Cessna 337) allowed for $\pm 15°$ of drift compensation, the primitive adaptor used to house the DCS-200 denied its proper use. Nevertheless, by flying 'into wind' it was possible to gain a good line overlap without unacceptable 'crabbing'. However, with only 41% of forward overlap the results could only be used for planimetry, and although this would be sufficient for many surveys, the original requirements needed at least 50% overlap for heighting measurements.

It is useful to look further into this planning error since it can be quite common when employing non-square formats. The pre-planned parameters were: H_g = 3650 feet (1112 metres); S' = 9.3 mm; ΔT = 3 s; p = 60% (or 0.6) and f = 28 mm. From these values the calculations shown in Chapter 8 are good (flying height = 3650 feet, scale number = 40 000) and the aircraft was flown accordingly. But if S' is now put at its correct value of 14 mm (as mounted in the aircraft) then the ground coverage (S) is given by $S = m \times S'$ (40 000 × 14 mm) = 560 m (rather than 375 m

when $S' = 9.3$ mm). The base (for a value of $p = 60\%$) is now $560 \times 0.4 = 224$ m. But in the original calculations $B = 150$ m (for 60%p), and so we find the resulting overlap to be only $60\% \times (150/224)$ or 40%, as shown in Fig. 19.1.

Camera Exposure and Image Quality

The DCS-200 was set at a film speed of 50 ISO and programmed to operate in 'aperture priority' mode set at f4. Although shutter priority is the preferred mode (as a guarantee against excessive image motion) it was decided to employ aperture priority since, at this time, the M5 chip performance was unknown at high shutter speeds.

From the camera's on board 80 Mb hard disk, over forty uncompressed raw images (which go through A/D conversion directly on frame capture) were then downloaded to the PC through the use of a SCSI (Small Computer System Interface) port operated by a 'Future Domain' controller. Image files are stored in a proprietary Kodak format (KC2 extension) for archiving but after downloading are saved into any file format supported by the software running the Kodak driver (in this case Aldus Photostyler V.2.0). In addition, data – such as time and date of exposure, f no. and shutter speed are automatically tagged to each image. The camera data recorded with the images shown in Fig. 19.1 show the exposure as 1/250 second at f4, which at 100 mph suggests an AIM = 6µm.

Although well exposed in the shadow areas, a few small highlights lack detail suggesting a small measure of cell saturation that could have been avoided with slightly less exposure. However, flying conditions were excellent and with 32° of solar altitude the images were supported by strong form and contrast.

The images of Fig. 19.1 then underwent pre-processing within Aldus PhotoStyler (converted to grey scale, gamma controlled to give a reasonable match and then sharpened) and saved into 8 bit TIF format.

Soft Copy Photogrammetry from the Kodak DCS-200 camera

Since Newcastle University's Survey Department purchased their DCS-200 for metric purposes, the camera (and its 28 mm lens) were calibrated and RMS errors of 1 µm in the x, y image co-ordinate residuals of the bundle adjustment were determined, i.e., approximately 1/9th pixel. The calibrated focal length came to 29.3045 mm.

Despite having only 41% overlap in the imagery (Fig. 19.1) it was decided to attempt to plot detail from one of the 1:40 000 scale overlaps using a Leica Digital Video Plotter (DVP), which is a low cost photogrammetric workstation based on a standard PC. Ground control for the model area was available from an Ordnance Survey 1:1250 Superplan map sheet.

The 8 bit TIF images were then loaded into the DVP along with a camera file giving details of the camera's inner orientation and fiducial mark co-ordinates (corners of the image frame), and a ground control point file (consisting of 6 well dis-

tributed plan points scaled from the map sheet, and 3 height points derived from spot heights).

As Jon Mills reports, 'the traditional process of inner, relative and absolute orientations employed by the DVP was followed in order to set up the stereomodel, with the latter two stages aided by automatic stereo correlation. The standard errors of 0.23 m, 0.55 m and 0.02 m for the x, y, z co-ordinates of the control points used in the absolute orientation were satisfactory given the resolution of the imagery (0.34 m ground/pixel size) and the accuracy to which one can scale co-ordinates from a 1:1250 map sheet. Detail was then plotted for the area covered by the overlap and the drawing exported in DFX format and dropped into AutoCAD for editing. It was then cartographically enhanced in CorelDraw to produce the final plot shown in Fig. 8.7.'

Digital imagery at 1:17,000 photo-scale

Although results from initial trials were very encouraging in terms of quality, their main value rested in the questions they raised and the appropriate answers. As mentioned previously, the chief limitation for gaining larger scales rested with the 4 s framing period (ΔT), and unless this problem could be answered there was little chance of gaining larger photo-scales with a minimum of 50% forward overlap. Along with this requirement for scale were a number of questions relating to ground resolution, accuracy, heighting and the associated base/height ratio.

In Fig. 19.1, the overlap is insufficient for heighting and so the question of B/H_g ratio remains academic, but had the camera been orientated as planned then (for p = 0.5) the B/H_g ratio would have been only 0.17 – a figure that would be critically low for many types of terrain!

Since there was no way to reduce the value ΔT (in order to fly at a larger scale) the remaining solution was to fly at a lower ground speed. Whereas the Cessna 337 could be flown at 100 mph (48 m/s), a suitable microlight could easily be flown into wind at 30 mph (13 m/s). From previous experience (Graham, 1987; Graham, & Read, 1987; Graham, 1988a) it was known that a highly suitable research platform existed in the 'Thruster' microlight (Fig. 9.1, see colour section). Although these machines are excellent for research such as this, it must be recognized that under CAA laws they cannot be used for commercial operations in the UK (and a number of other countries too).

Through the courtesy of David Smith (Baxby Airsports, Husthwaite, North Yorkshire) arrangements were made to fit a suitable aluminium camera mount to a Thruster (see Fig. 19.2a). In this case the shorter side of the DCS-200 format is leading, and once again no provision was made to provide for drift compensation, since the aircraft was to be flown into wind. This mount proved to be very rigid, and was aligned with the main boom to ensure the image plane would be parallel to the ground (when the aircraft was suitably trimmed) as shown in Fig. 19.2b.

Taking the wind direction into consideration, two suitable villages (with adequate landmarks and structures) were selected for photography. The first mission (Graham) was flown at 1430 hours and *appeared* to have no problems. But within

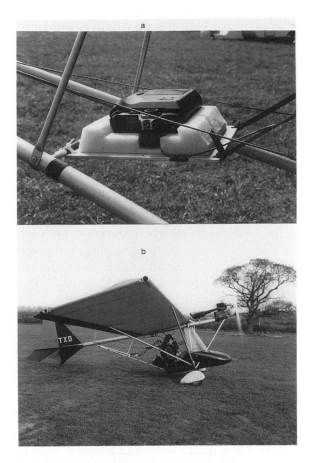

Figure 19.2 *(a) DCS-200 digital camera situated in a simple aluminium mount fitted to a Thruster microlight aircraft. Note: the 9.3 mm edge of the photo-frame is leading in line-of-flight. The electrical shutter release cable can be seen in front of the mount, leading to the co-pilot's position. (b) Thruster aircraft (Baxby Airsports) showing location of crew (David Smith and Jon Mills), and camera (provided by Department of Surveying, University of Newcastle-upon-Tyne).*

half an hour of landing it was evident that the mission was a complete failure – with some of the images (from two lines over a 1 km × 0.5 km block) having no overlap at all due to an exhausted battery.

Nevertheless, with the ability to inspect images in such a short time after landing, it was possible to change batteries and start again.

The second mission (Mills) was quickly put into effect, but due to the later time of day (1700 hours) an area closer to the airfield was selected. The village of Raskelf was photographed with 50% forward overlap at 1550 feet (a.m.g.l.), with a resulting scale of 1:17 000 and a base/height ratio of 0.25. The exposure interval (ΔT) being an estimated 5 seconds for 30 mph ground speed.

Photographed in early May at 1715 hours, the solar altitude was only 19°, but fortunately the sun was slightly veiled and harsh shadows avoided – ideal lighting for urban surveys recorded in colour. With the lens aperture set at f2.8 the shutter speed was 1/650 s, and with a ground speed in the region of 30 mph the apparent image motion (AIM) was calculated to be only two microns.

After a quick check on the imagery, a group of frames was archived into a Zip file of photos, specially selected for their interest and information content. One file was retained by the University for future photogrammetric analysis, and another was made available for immediate quality analysis, mosaicing and presentation for this book. The latter file was installed into a PC (32 Mb RAM) and after inflating each image, a number were processed in Aldus Photostyler to improve sharpness, brightness, contrast and colour balance. Two such images, matched (as part of a mosaic) are shown in Fig. 19.3 (see colour section). The top image (31 TIF) was adjusted to match that of the lower (32 TIF) photograph printed at a scale of 1:850 in a HP Deskjet 560c printer. Even with a moderately priced printer such as this the results are very acceptable but when printed on a top quality dye-sublimation printer (such as the Codonics NP-1600) the results equal those of conventional photography (Mills, Graham and Newton, 1996).

As may be seen from Fig. 19.3, the matching of detail, hue and brightness is good in mosaic terms, and image resolution equal to that normally required of any large scale aerial photograph. See Fig. 19.4 for the corresponding map.

A useful and practical unit for quantifying spatial resolution in satellite and remote sensing imagery is the Ground Sampled Distance (GSD). Although lacking in scientific rigour, GSD provides a convenient figure of merit and one that is likely to prove useful for aerial photography with digital cameras. Rather than quantifying resolved *image* detail, GSD is a measure of the resolved *ground* detail and is calculated from:

$$GSD = m_b \times (ISF) \tag{19.1}$$

In its most simple terms ISF (Image Spread Function) is the diameter of a basic image point in an optical system and, with some reservations (Thomson, 1994), can be equated to the size of a pixel to give:

$$GSD \approx m_b \times Px \tag{19.2}$$

Applying equation (19.2) to the DCS-200 imagery under discussion (where each pixel is about 10 µm and $m_b = 17\,000$) results in a GSD of about 17 cm.

In looking for the smallest resolved ground detail printed in the images of Fig. 19.3, we can clearly identify two wooden rafters (revealed by missing tiles) in the roof of a large barn. And as these rafters are known to be about six inches wide (15 cm) it would appear that equation (19.2) can be considered a reasonably accurate measure of ground resolution.

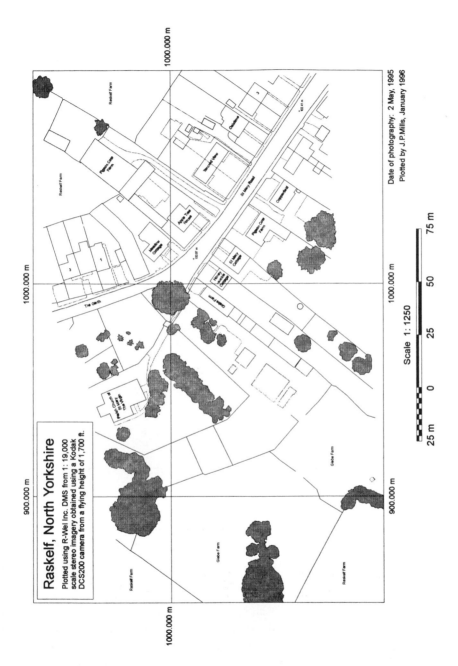

Figure 19.4 *Photogrammetric plot from images shown in Fig. 19.3. Thruster Microlight (c. 30 mph), Kodak Digital Camera DCS200, flying height 1700 feet. Mapping accuracy (against ground control) gives RMS errors as: 0.1m in x and y (0.7Px) and 0.24m in z (1.5Px). Plotted by Jon Mills, Department of Surveying, University of Newcastle.*

285

Appendix 1

Computer programs (QBasic) for aerial survey

The nine programs in this appendix are written in Quick Basic. This programming language is available with versions 5 and upwards of the MS-DOS operating system for IBM compatible PCs. Once installed in desktop, laptop or notebook PC, these programs allow for rapid, iterative calculations of missions.

(a) **SURPLAN** (survey flight planning)
(b) **AIM** (apparant image motion)
(c) **SA1** (solar altitude)
(d) **SZ1** (solar azimuth)
(e) **DITURNS** (air survey line turns: direct turns)
(f) **UTURNS** (air survey line turns: U turn – linear region time)
(g) **UTURN-A** (air survey line turns: U turn – line separation)
(h) **TAS** (true air speed)
(i) **TALT** (true altitude)
(j) **SS** (shutter speed calculation for given f/No, EAFS, FF, date and time)

(a) SURPLAN

```
1   PRINT "                        APPENDIX. 1a"
5   CLS
10  PRINT "                        SURPLAN. BAS."
15  PRINT "                        Press F5 to RUN."
20  PRINT
25  PRINT "                    AIR SURVEY MISSION PLANNING."
30  PRINT
35  INPUT "          ENTER MISSION NUMBER:          ", MT
40  PRINT
45  PRINT "          Scale = M  = 1/m              (where m = Scale Number).";
50  PRINT "          H = Height above ground.      F  = Focal length of lens.";
55  PRINT "          S = Ground distance covered.  Ne = Negative side.";
60  PRINT "          Scale No (m) = H/F = S/Ne "; ""
65  PRINT
70  INPUT "          Enter Scale No (m) required:          ", m
75  INPUT "          Enter Focal length of Lens (F) in mm: ", F
80  PRINT "                                                  ANSWER.";
85  H = m * (F / 304.8)
90  PRINT
95  PRINT "          Required Height above Ground(feet)       = ";
100 PRINT INT(H + .5); "Feet.";
105 PRINT
106 INPUT "          Enter average elevation or datum (feet)  =    ", EL
107 TALT = (H + EL)
108 PRINT "          Required True Altitude (TALT) in feet:   = ";
109 PRINT INT(TALT + .5); "Feet."; ""
110 INPUT "          Enter Negative Side (Ne) in mm:          =    ", Ne
115 PRINT
120 S = (Ne * m) / 1000
125 PRINT "          Ground Covered (S) (Single Frame)       = ";
130 PRINT INT(S + .5); "Meters.";
135 PRINT
140 REM       Area Covered by a single frame: FA = S^2.
145 FA = (S / 1000) ^ 2
150 PRINT "          Single Frame Area (FA)                  = "; FA; "Sq.KM"
155 PRINT
160 INPUT "          Enter Forward Overlap p(%):             = ", P
165 REM       Base (b) = S(1 - p/100)
170 b = S * (1 - (P / 100))
175 PRINT "          Length of base (b)                      = ";
180 PRINT INT(b + .5); "Meters.";
181 R = (b / (H / 3.28))
182 PRINT "          Base over height Ratio:                 = "; R;
184 PRINT
185 INPUT "          Enter Side Lap       q(%):             = ", q
190 REM       a = Distance between Flight-Lines, with q Side-Lap.
195 a = S * (1 - (q / 100))
200 PRINT "          Distance between Flight-Lines (a)       = ";
205 PRINT INT(a + .5); "Meters.";
210 PRINT "          Ga = Area of Block (Length (Lp) * Width (Lq)) "
215 PRINT
220 INPUT "          Enter Length of Flight-Line Lp (km)     = ", Lp
225 INPUT "          Enter Width of Block Lq (km)            = ", Lq
230 PRINT
232 Ga = Lp * Lq
235 PRINT "          Area of Block                           = "; Ga; "Sq.km";
240 REM  Np = Number of Photographs/Line (plus 2 prior & 2 post frames).
245 Np = ((Lp * 1000) / b) + 5
250 PRINT "          Number of Photos/Flight-Line (plus 4):  = ";
255 PRINT INT(Np + .7); "(inclusive)."
```

(a) SURPLAN *continued*

```
260 REM        Nq = Number of Flight-Lines.
265 Nq = (((Lq * 1000) - S) / a) + 1
270 PRINT "         Number of Flight-Lines:            = ";
275 PRINT INT(Nq + .7); ""
280 PRINT
285 REM    Fm = Model Area (Stereo-cover) = ((S-b)*S)
290 Fm = ((S - b) * S) / 10000
295 PRINT "        Fm = Model Area (Stereo Cover)       = "; Fm; "Ha";
300 PRINT
305 REM    Sa = New Stereo Area = a.b
310 Sa = (a * b) / 10000
315 PRINT "          Sa = New Stereo Area              = "; Sa; "Ha";
320 PRINT
325 Nt = Ga / (Sa / 100)
330 PRINT "        Required Number of Photos/Block (Nt)   = ";
335 PRINT INT(Nt + .5); "Photos";
340 PRINT
345 PRINT "              SELECT CODE FOR AIRCRAFT GROUND SPEED (Vg):"; ""
350 PRINT "        Code: 1 = m/sec. "; ""
355 PRINT "        Code: 2 = Knots. "; ""
360 PRINT "        Code: 3 = MPH.   "; ""
365 PRINT "        Code: 4 = Km/Hr. "; ""
370 INPUT "        Enter Aircraft Ground Speed Code:      = ", C
375 PRINT
380 IF C > 4 THEN PRINT "              ERROR! Codes are between 1 to 4!"; ""
385 IF C > 4 GOTO 370
390 INPUT "        Enter Aircraft Ground Speed (Vg):      = ", Vg
395 PRINT
400 IF C = 1 THEN Vg = Vg
405 IF C = 2 THEN Vg = Vg / 1.9417
410 IF C = 3 THEN Vg = .447 * Vg
415 IF C = 4 THEN Vg = .276 * Vg
420 REM  Exposure Interval T = b/Vg (seconds).
425 T = b / Vg
430 PRINT "        T = Exposure Interval              = ";
435 PRINT INT(T - .5); "(seconds)"; ""
440 REM  Apparent Image Motion (AIM) = 1000.(SS.Vg.F)/(H/3.28083) microns.
442 PRINT
445 PRINT "              APPARENT IMAGE MOTION (AIM)."; ""
450 PRINT
455 INPUT "        Enter Shutter Speed (decimals):        = ", SS
460 PRINT
465 AIM = 1000 * (SS * Vg * F) / (H / 3.28083)
470 PRINT "        AIM (Apparent Image Motion)        = ";
475 PRINT INT(AIM + .5); "Microns"; ""
480 PRINT
485 PRINT "              END OF MISSION PLANNING CALCULATIONS.";
490 PRINT
493 PRINT "              For HARDCOPIES connect the PRINTER."
495 PRINT
500 GOSUB HARDCOPY
502 END
505 HARDCOPY:
510 INPUT "        FOR HARDCOPY OPTION: KEY (1), RETURN TO PGM KEY (2).", HC
515 PRINT
520 IF HC = 1 THEN
530 PRINT
535 PRINT "   If the PRINTER is NOT CONNECTED wait ONE MINUTE for an automatic"
540 PRINT "   return to the Pgm then, press ENTER and EXIT Pgm."
545 PRINT
```

(a) **SURPLAN** *continued*

```
550 PRINT "                        CONNECT PRINTER AND RE-OPEN."
570 LPRINT "                            SURPLAN."
575 LPRINT
580 LPRINT "                    AIR SURVEY MISSION PLANNING."
585 LPRINT
590 LPRINT "                        MISSION NUMBER:         "; MT
595 LPRINT
600 LPRINT "        Scale Number (m)                  = "; m
605 LPRINT "        Focal Length (mm)                 = "; F
610 LPRINT "        Required Height above Ground (feet)  = ";
615 LPRINT INT(H); "Feet.";
616 LPRINT "        Average Terrain Elevation (or Datum): =    "; EL; "Feet"
617 LPRINT "        Required True Altitude (TALT)      = ";
618 LPRINT INT(TALT); "Feet.";
619 LPRINT "        Negative Side:                    =    "; Ne; "mm"
620 LPRINT "        Ground Covered (S)                = ";
625 LPRINT INT(S); "Meters.";
630 LPRINT "        Forward Overlap (p):              = "; P
635 LPRINT "        Side-Lap       (q):               = "; q
640 LPRINT "        Single Frame Area (FA)            = "; FA; "Sq.Km"
645 LPRINT "        Length of Base (b)                = "; b; "Meters."
646 LPRINT "        Base over Height Ratio (R)        = "; R;
650 LPRINT "        Distance between Flight-Lines (a) = "; a; "Meters."
655 LPRINT "        Length of Flight-Line (Lp)        = "; Lp; "Km."
660 LPRINT "        Width of Block (Lq)               = "; Lq; "Km."
665 LPRINT "        Ga = Area of Block.               = "; Ga; "Sq.Km"
670 LPRINT "        Number of Photos/Flight-Line (Np) = ";
675 LPRINT INT(Np + .7); "(includes 4 extra)";
680 LPRINT "        Number of Flight-Lines (Nq)       = ";
685 LPRINT INT(Nq + .7);
690 LPRINT
695 LPRINT
700 LPRINT "        Fm = Model Area (Stereo-Cover)    = "; Fm; "Ha."
705 LPRINT "        Sa = New Stereo Area              = "; Sa; "Ha."
710 LPRINT "        Required Number of Photos/Block (Nt) = ";
720 LPRINT INT(Nt + .7); "Photos";
722 LPRINT
724 LPRINT
725 LPRINT "        Aircraft Ground Speed Code        = "; C;
730 LPRINT "        Aircraft Ground Speed (m/sec): Vg = ";
735 LPRINT INT(Vg + .5);
740 LPRINT "        T = Exposure Interval = b/Vg      = ";
745 LPRINT INT(T - .5); "Seconds."
746 LPRINT "        Applied Shutter Speed (SS)        = "; SS
750 LPRINT "        AIM (Apparent Image Motion)       = ";
755 LPRINT INT(AIM + .5); "Microns.";
760 ELSEIF HC = 2 THEN
765 PRINT
770 ELSE
775 GOTO 530
780 END IF
800 END
```

RWG

(b) AIM

```
1     PRINT "                          APPENDIX.1b"
5     CLS
6     PRINT "                              AIM.BAS."
8     PRINT "                          Press F5 to RUN."
10    PRINT
15    PRINT "                  APPARENT IMAGE MOTION: AIM "; ""
20    PRINT
25    PRINT "             A Program to evaluate Exposed Image Motion"; ""
30    PRINT "             in Vertical Air Survey Photography."; ""
35    PRINT
40    INPUT "                Enter Shutter-Speed (decimals of a second): ", SS
45    CLS
50    REM Different units of Estimated Ground Speed can be expected!
55    PRINT
60    PRINT "             SELECT CODE FOR AIRCRAFT GROUND SPEED:"; ""
65    PRINT
70    PRINT "                 Code: 1  =  m/sec."; ""
75    PRINT "                 Code: 2  =  Knots."; ""
80    PRINT "                 Code: 3  =  MPH.  "; ""
85    PRINT "                 Code: 4  =  Km/h. "; ""
90    PRINT
95    INPUT "                Enter Aircraft Ground Speed CODE: ", N
100   PRINT
105   IF N > 4 THEN PRINT "                    ERROR! Codes are between 1 and 4!"; ""
110   PRINT
115   IF N > 4 GOTO 95
120   INPUT "             Enter Aircraft Ground Speed: ", Vg
125   CLS
130   PRINT
135   INPUT "             Enter Lens Focal Length, in mm: ", F
140   CLS
145   PRINT
150   INPUT "             Enter Height above Ground, in feet: ", H
155   CLS
160   IF N = 1 THEN Vg = Vg
165   IF N = 2 THEN Vg = Vg / 1.9417
170   IF N = 3 THEN Vg = .447 * Vg
175   IF N = 4 THEN Vg = .276 * Vg
180   AIM = 1000 * (SS * Vg * F) / (H / 3.28083)
185   PRINT
190   PRINT
195   PRINT "                    AIM =  ";
200   PRINT INT(AIM + .5); "microns"; ""
205   PRINT
210   PRINT "                END OF CALCULATION.";
215   END
```

RWG

291

(c) SA1

```
1    PRINT "                        APPENDIX.1c"
5    CLS
6    PRINT "                             SA1. BAS."
7    PRINT
8    PRINT "                        Press F5 to RUN. "
10   REM      Duplicate ŞA Pgm for further modifications, as may be required.
15   PRINT
20   PRINT "                    SOLAR ALTITUDE "; CHR$(91); "SA"; CHR$(93)
25   PRINT
30   PRINT "        Sin SA = ((SinLA.SinSD) + (CosLA.CosSD.CosHA))"; ""
35   PRINT
40   INPUT "                    Enter Latitude:  ", LA
45   CLS
50   PRINT
55   INPUT "                Enter Number of Month: ", M
60   CLS
65   IF M = 1 THEN M = 0
70   IF M = 2 THEN M = 31
75   IF M = 3 THEN M = 59
80   IF M = 4 THEN M = 90
85   IF M = 5 THEN M = 120
90   IF M = 6 THEN M = 151
95   IF M = 7 THEN M = 181
100  IF M = 8 THEN M = 212
105  IF M = 9 THEN M = 243
110  IF M = 10 THEN M = 273
115  IF M = 11 THEN M = 304
120  IF M = 12 THEN M = 334
125  PRINT
130  INPUT "                        DAY NUMBER: ", D
135  Z = M + D
140  PRINT
145  INPUT "    Enter Longitude (Degrees WEST are -ve): ", LO
150  CLS
155  PRINT
160  INPUT "            Enter Local Time (0 to 24 hours): ", LT
165  CLS
170  Pi = 3.1416
175  Angle1 = LA:                        REM in Degrees.
180  Arads1 = Angle1 * (Pi / 180):       REM in Radians.
185  A = SIN(Arads1)
190  PRINT
195  Angle2 = ((360 / 365.25) * (Z - 83)):   REM in Degrees.
200  Arads2 = Angle2 * (Pi / 180):       REM in Radians.
205  SD = 23.45 * SIN(Arads2) + .6
210  Angle3 = SD:                        REM in Degrees.
215  Arads3 = Angle3 * (Pi / 180):       REM in Radians.
220  B = SIN(Arads3)
225  F1 = A * B
230  C = COS(Arads1)
235  D = COS(Arads3)
240  HA = (LO + ((LT - (LO / 15)) - 12) * 15)
245  Angle4 = HA:                        REM HA = Hour Angle, Degrees.
250  Arads4 = Angle4 * (Pi / 180):       REM in Radians.
255  E = COS(Arads4)
260  F2 = C * D * E
265  F3 = F1 + F2
270  REM  F3 = Sin SA and must be converted to Tan SA for further calculation.
275  REM  F4 = Tan SA = (Sin SA)/(SQR(1 -(Sin SA)^2)).
280  F4 = (F3) / (SQR(1 - (F3) ^ 2))
285  Arads5 = ATN(F4)
290  Angle5 = Arads5 * (180 / Pi)
295  PRINT
300  PRINT "                    SOLAR ALTITUDE = ";
305  PRINT INT(Angle5 + .5); "Degrees";                     RWG
310  END
```

292

(d) SZ1

```
1   PRINT "                        APPENDIX.1d"
5   CLS
6   PRINT "                              SZ1. BAS."
7   PRINT
8   PRINT "                        Press F5 to RUN."; ""
10  PRINT
15  PRINT "               Q BASIC: SOLAR AZIMUTH PGM: SZ1"; ""
20  PRINT
25  PRINT "                  SZ = (Sin HA.Cos SD)/Cos SA."; ""
30  REM THE formula for SA (Solar Altitude) includes all parameters for SZ.
35  PRINT
40  INPUT "                    Enter Latitude: ", LA
45  CLS
50  PRINT
55  INPUT "  Enter Longitude (Degrees WEST are -ve): ", LO
60  CLS
65  PRINT
70  INPUT "                 Enter Number of Month: ", M
75  CLS
80  PRINT
85  INPUT "                    Enter Day Number: ", D
90  CLS
95  PRINT
100 INPUT "            Local Time (0 to 24 hours): ", LT
105 CLS
110 IF M = 1 THEN M = 0
115 IF M = 2 THEN M = 31
120 IF M = 3 THEN M = 59
125 IF M = 4 THEN M = 90
130 IF M = 5 THEN M = 120
135 IF M = 6 THEN M = 151
140 IF M = 7 THEN M = 181
145 IF M = 8 THEN M = 212
150 IF M = 9 THEN M = 243
155 IF M = 10 THEN M = 273
160 IF M = 11 THEN M = 304
165 IF M = 12 THEN M = 334
170 Z = M + D
175 Pi = 3.1416
180 Angle1 = LA:                    REM in Degrees.
185 Arads1 = Angle1 * (Pi / 180):   REM in Radians.
190 A = SIN(Arads1)
195 Angle2 = ((360 / 365.25) * (Z - 83)):   REM in Degrees.
200 Arads2 = Angle2 * (Pi / 180):   REM in Radians.
205 SD = 23.45 * SIN(Arads2) + .6
210 Angle3 = SD:                    REM in Degrees.
215 Arads3 = Angle3 * (Pi / 180):   REM in Radians.
220 B = SIN(Arads3)
225 F1 = A * B
230 C = COS(Arads1)
235 D = COS(Arads3)
240 HA = (LO + ((LT - (LO / 15)) - 12) * 15)
245 Angle4 = HA:                    REM in Degrees.
250 Arads4 = Angle4 * (Pi / 180):   REM in Radians.
255 E = COS(Arads4)
260 F2 = C * D * E
265 F3 = F1 + F2
270 REM                      F3 = Sin SA.
275 REM                      F4 = Cos SA = (SQR(1-(F3)^2))
280 F4 = (SQR(1 - (F3) ^ 2))
285 REM                      B  = Sin SD.
290 REM                      F5 = Cos SD = (SQR(1-(B)^2))
```

(d) **SZ1** *continued*

```
295 F5 = (SQR(1 - (B) ^ 2))
300 REM
305 REM
310 F6 = (SQR(1 - (E) ^ 2))
315 S = (F6 * F5) / F4
320 REM   S = Sin SZ (Sin Solar Azimuth) and must be converted to Tan S.
325 REM   F7 = Tan S = (Sin SZ)/(SQR(1-(Sin S)^2))
330 F7 = S / (SQR(1 - (S) ^ 2))
335 Arads5 = ATN(F7)
340 Angle5 = Arads5 * (180 / Pi)
345 IF LT < 12 THEN Angle5 = -Angle5
350 IF LT > 12 THEN Angle5 = Angle5
355 PRINT
360 PRINT "                       SOLAR AZIMUTH = ";
365 PRINT INT(Angle5 + .5); "Degrees."; "   "; CHR$(1); ""
370 PRINT
375 PRINT
380 PRINT "     "; CHR$(1); ""
385 END
```

```
E  = Cos HA.
F6 = Sin HA = (SQR(1-(E)^2))
```

RWG

(e) DITURNS

```
1    PRINT "                       APPENDIX 1e"
5    CLS
6    PRINT "                            DITURNS.BAS."
8    PRINT "                          Press F5 to RUN."
10   PRINT
15   PRINT "                    AIR SURVEY LINE-TURNS."; ""
20   PRINT
25   PRINT "                         DIRECT TURNS."; ""
30   PRINT
35   PRINT "      FROM:      True Air Speed (TAS), Line Separation (a),"
40   PRINT "                 Drift Angle (D), and Wind Direction (k):"; ""
45   PRINT
50   PRINT "           COMPUTE REQUIRED RATE OF TURN (R) & ANGLE OF BANK (B):"
55   PRINT
60   REM                 R = (2.TAS/a).(((180/Pi)CosD)+k((90+kD)SinD))
65   PRINT "           Select CODE (C) for Aircraft True Air Speed (TAS): ";
70   PRINT
75   PRINT "           CODE 1 = m/sec.     "; ""
80   PRINT "           CODE 2 = Knots.     "; ""
85   PRINT "           CODE 3 = MPH.       "; ""
90   PRINT "           CODE 4 = Km/h.      "; ""
95   PRINT
100  INPUT "           ENTER TAS CODE:                       ", C
105  PRINT
110  IF C > 4 THEN GOTO 70
115  PRINT
120  INPUT "           ENTER TAS:                            ", TAS
130  PRINT
135  INPUT "           ENTER LINE SEPARATION (meters):      ", a
140  PRINT
150  INPUT "           ENTER ANGLE OF DRIFT:                 ", D
160  PRINT
165  REM    Turns are either UPWIND (k=-1) or DOWNWIND (k=1) with respect to
170  REM    direction of turn and crosswind component.
175  Pi = 3.1416
180  Angle1 = D
185  Arads1 = Angle1 * (Pi / 180)
190  X = COS(Arads1)
195  Y = SIN(Arads1)
200  IF C = 1 THEN TAS = TAS:                REM e.g,      77.25 m/s.
205  IF C = 2 THEN TAS = TAS / 1.9417:       REM e.g,      150    Knots.
210  IF C = 3 THEN TAS = .447 * TAS:         REM e.g,      173    MPH.
215  IF C = 4 THEN TAS = .276 * TAS:         REM e.g,      280    Km/h.
220  REM  UPWIND RATE OF TURN = RU,     DOWNWIND RATE OF TURN = RD.
225  PRINT
230  RU = (2 * TAS / a) * (((180 / Pi) * X) - ((90 - D) * Y))
235  RD = (2 * TAS / a) * (((180 / Pi) * X) + ((90 + D) * Y))
240  REM  UPWIND ANGLE OF BANK = BU,    DOWNWIND ANGLE OF BANK = BD.
245  REM  B = Atan((TAS.Pi.R)/(g.180): where g (gravy y const) = 9.81 m/sec^.
250  REM  B = Atan(F1) = Atan(0.00178.TAS.R)
255  F1 = .00178 * TAS * RU
260  F2 = .00178 * TAS * RD
265  Arads2 = ATN(F1)
270  Angle2 = Arads2 * (180 / Pi)
275  Arads3 = ATN(F2)
280  Angle3 = Arads3 * (180 / Pi)
285  PRINT "                         UPWIND."; ""
290  PRINT
295  PRINT "           REQUIRED RATE OF UPWIND TURN    (RU)    = ";
300  PRINT INT(RU + .5); "Degrees/Second.";
```

(e) **DITURNS** *continued*

```
305 PRINT "            REQUIRED UPWIND ANGLE OF BANK   (BU)   =  ";
310 PRINT INT(Angle2 + .5); "Degrees."; ""
315 PRINT
320 PRINT "                                   DOWNWIND."; ""
325 PRINT
330 PRINT "            REQUIRED RATE OF DOWNWIND TURN  (RD)   =  ";
335 PRINT INT(RD + .5); "Degrees/Second.";
340 PRINT "            REQUIRED DOWNWIND ANGLE OF BANK (BD)   =  ";
345 PRINT INT(Angle3 + .5); "Degrees."; ""
350 PRINT
355 PRINT "                        END OF CALCULATIONS."; ""
360 PRINT
370 PRINT "  NOTE:  Normal range for Bank-Angle is from 15 to 40 degrees."; ""
380 PRINT
500 PRINT "                  For HARDCOPIES connect the PRINTER."
505 PRINT
510 GOSUB HARDCOPY
520 HARDCOPY:
524 INPUT "            FOR HARDCOPY OPTION: KEY (1), RETURN TO PGM KEY (2).", HC
526 PRINT
528 IF HC = 1 THEN
530 PRINT "   If the PRINTER is NOT CONNECTED wait ONE MINUTE for an automatic"
532 PRINT "   return to the Pgm then, press ENTER and EXIT Pgm."
534 PRINT
536 PRINT "                  CONNECT PRINTER AND RE-OPEN."
538 LPRINT "                          DITURNS."
540 LPRINT "     TAS CODE                                = "; C
541 LPRINT "     TAS (Always printed in meters/sec)      = "; TAS
542 LPRINT "     LINE SEPARATION (meters):               = "; a
543 LPRINT "     DRIFT ANGLE:                            = "; D
545 LPRINT "                        UPWIND."
550 LPRINT
555 LPRINT "            REQUIRED RATE OF UPWIND TURN   (RU)   =  ";
560 LPRINT INT(RU + .5); "Degrees/Second.";
565 LPRINT "            REQUIRED UPWIND ANGLE OF BANK  (BU)   =  ";
570 LPRINT INT(Angle2 + .5); "Degrees. ";
575 LPRINT
578 LPRINT
580 LPRINT "                        DOWNWIND. "
585 LPRINT
590 LPRINT "            REQUIRED RATE OF DOWNWIND TURN  (RD)  =  ";
695 LPRINT INT(RD + .5); "Degrees/Second.";
600 LPRINT "            REQUIRED DOWNWIND ANGLE OF BANK (BD)  =  ";
605 LPRINT INT(Angle3 + .5); "Degrees.  ";
610 ELSEIF HC = 2 THEN
615 PRINT
620 ELSE
625 GOTO 530
630 END IF
650 END
```

RWG

(f) UTURNS

```
1     PRINT "                    APPENDIX 1f"
5     CLS
6     PRINT "                              UTURNS. BAS."
8     PRINT "                           Press F5 to RUN."
10    PRINT
15    PRINT "                  AIR SURVEY LINE-TURNS."; ""
20    PRINT
25    PRINT "                        `U' TURNS."
30    PRINT
35    PRINT "     THIS PROGRAM WILL FIND THE REQUIRED TIME (t) for FLYING THE"
40    PRINT "     LINEAR PART OF A `U' TURN WITH A RATE 1 TURN (3 Deg/Sec)."; ""
45    PRINT
50    PRINT " Parameters:"; ""
55    PRINT "        True Air Speed (TAS), Line-Separation (a), Drift (D),"
60    PRINT "        Direction of turn with respect to crosswind component (k)."
65    PRINT "        Fixed Rate of Turn (R = 3 deg/Sec)."; ""
70    PRINT
75    REM   t = (a - ((2TAS/R).(((180/Pi)CosD)+k((90+kD)SinD))))/(TAS(1+kSinD)).
80    PRINT "        Select CODE (C) for Aircraft True Air Speed (TAS): ";
85    PRINT
90    PRINT "        CODE 1 = m/sec.    "; ""
95    PRINT "        CODE 2 = Knots.    "; ""
100   PRINT "        CODE 3 = MPH.      "; ""
105   PRINT "        CODE 4 = Km/h.     "; ""
110   PRINT
115   INPUT "        ENTER TAS CODE:                        ", C
120   PRINT
130   IF C > 4 THEN GOTO 85
135   INPUT "        ENTER TAS:                             ", TAS
140   PRINT
150   IF C = 1 THEN TAS = TAS:          REM e.g,    77.25  m/sec.
155   IF C = 2 THEN TAS = TAS / 1.9417: REM e.g,    150    Knots.
160   IF C = 3 THEN TAS = .447 * TAS:   REM e.g,    173    MPH.
165   IF C = 4 THEN TAS = .276 * TAS:   REM e.g,    280    Km/h.
170   INPUT "        ENTER FLIGHT-LINE SEPARATION (meters):    ", a
175   PRINT
185   INPUT "        ENTER ANGLE OF DRIFT:                     ", D
190   PRINT
200   Pi = 3.1416
205   Angle1 = D
210   Arads1 = Angle1 * (Pi / 180)
215   X = COS(Arads1)
220   Y = SIN(Arads1)
225   REM   Turns are either UPWIND (K=-1) or DOWNWIND (k=1) with respect to"
230   REM   direction of turn and crosswind component.
235   REM   tu = UPWIND time,      td = DOWNWIND time.
240   REM   tu = (a - ((2TAS/3).(((57.29)X)-((90-D)Y))))/(TAS(1-Y))
245   REM   td = (a - ((2TAS/3).(((57.29)X)+((90+D)Y))))/(TAS(1+Y))
250   F1 = (2 * TAS / 3)
255   F2 = ((57.29) * X) - ((90 - D) * Y)
260   F3 = (TAS * (1 - Y))
265   tu = (a - (F1 * F2)) / F3
270   IF tu >= 4 THEN
275   PRINT "           UPWIND LINEAR TIME    (tu)     = ";
280   PRINT INT(tu + .5); "Seconds.";
285   ELSEIF tu <= 3 THEN
290   PRINT "           UPWIND TIME IS TOO SHORT - TRY DIRECT TURN PROGRAM!"
295   ELSE
300   GOTO 275
305   END IF
310   F4 = ((57.29) * X) + ((90 + D) * Y)
315   F5 = (TAS * (1 + Y))
```

(f) **UTURNS** *continued*

```
320 td = (a - (F1 * F4)) / F5
325 IF td >= 5 THEN
330 PRINT "                    DOWNWIND LINEAR TIME (td)     = ";
335 PRINT INT(td + .5); "Seconds.";
340 ELSEIF td <= 4 THEN
345 PRINT
350 PRINT
355 PRINT "                    DOWNWIND TIME TOO SHORT!"
360 ELSE
365 GOTO 330
370 END IF
375 REM    Angle of Bank (B) = Atan((TAS.Pi.R)/g.180). g(gravity) = 9.81m/s^.
380 REM    Since R = Const = 3 deg/sec, then: B = Atan(0.00534.TAS).
385 REM    For R = Const, Upwind and Downwind Bank(s) are equal.
390 F6 = .00534 * TAS
395 Arads2 = ATN(F6)
400 Angle2 = Arads2 * (180 / Pi)
405 PRINT
410 PRINT "                    ANGLE OF BANK (RATE 1 TURN)  = ";
415 PRINT INT(Angle2 + .5); "Degrees."; ""
420 PRINT
425 PRINT "                         END OF CALCULATIONS.  ";
430 PRINT
435 PRINT " NOTE:"
440 PRINT "     If distance between lines (a) is required (for a given time)";
445 PRINT "     either tu, or td, use the Program: UTURN-a."; ""
450 PRINT
460 PRINT "                    For HARDCOPIES connect the PRINTER."
465 PRINT
470 GOSUB HARDCOPY
475 HARDCOPY:
500 INPUT "                    FOR HARDCOPY OPTION: KEY (1), RETURN TO PGM KEY (2).", HC
505 PRINT
510 IF HC = 1 THEN
512 PRINT
514 PRINT "     If the PRINTER is NOT CONNECTED wait ONE MINUTE for an automatic'
516 PRINT "     return to the Pgm then, press ENTER and EXIT Pgm."
518 PRINT
520 PRINT "                    CONNECT PRINTER AND RE-OPEN."
525 LPRINT "                         `U' TURNS."
526 LPRINT "     TAS CODE                             = "; C
527 LPRINT "     TAS (Always printed in meters/sec)   = "; TAS
528 LPRINT "     FLIGHT-LINE SEPARATION (meters)      = "; a
529 LPRINT "     DRIFT ANGLE:                         = "; D
530 LPRINT
532 LPRINT "     UPWIND LINEAR TIME (tu)              = ";
535 LPRINT INT(tu + .5); "Seconds.";
537 LPRINT
538 LPRINT
540 LPRINT "     DOWNWIND LINEAR TIME (td)            = ";
545 LPRINT INT(td + .5); "Seconds.";
547 LPRINT
548 LPRINT
550 LPRINT "     Angle of Bank (Rate 1 turn)         = ";
555 LPRINT INT(Angle2 + .5); "Degrees.";
560 ELSEIF HC = 2 THEN
565 PRINT
570 ELSE
575 GOTO 525
580 END IF
600 END
```

RWG

298

(g) UTURN-A

```
1   PRINT "                    APPENDIX 1g"
5   CLS
6   PRINT "                              UTURN-A      "
8   PRINT "                         Press F5 to RUN."
10  PRINT
15  PRINT "             AIR SURVEY LINE-TURNS."; ""
20  PRINT
25  PRINT "             `U' TURNS (Line Separation). "; ""
30  PRINT
35  PRINT "     THIS PROGRAM WILL FIND THE REQUIRED LINE SEPARATION (a) FOR";
40  PRINT "     A `U` TURN MADE AT THE STANDARD RATE OF 3 deg/sec, AND AN ";
45  PRINT "     INTERTIME (LINEAR REGION) OF (t) SECONDS."; ""
50  PRINT
55  PRINT " PARAMETERS:"; ""
60  PRINT "     True Air Speed (TAS), Drift (D), Fixed Rate of Turn (R), ";
65  PRINT "     Direction of Turn with respect to Cross-Wind Component (k),";
70  PRINT "     Time of Linear component (t)."; ""
75  PRINT
80  REM    a = ((2TAS/R).(((180/Pi).CosD)+k((90+kD)SinD))) + TAS(1+kSinD)t.
85  PRINT "     Select CODE (C) for Aircraft True Air Speed (TAS):    "; ""
90  PRINT
95  PRINT "     CODE 1 = m/sec.       "; ""
100 PRINT "     CODE 2 = Knots.       "; ""
105 PRINT "     CODE 3 = MPH.         "; ""
110 PRINT "     CODE 4 = Km/h.        "; ""
115 PRINT
120 INPUT "     ENTER TAS CODE:                              ", C
130 PRINT
135 IF C > 4 THEN GOTO 85
140 INPUT "     ENTER TAS:                                   ", TAS
150 PRINT
155 IF C = 1 THEN TAS = TAS:         REM e.g,    77.25  m/sec.
160 IF C = 2 THEN TAS = TAS / 1.9417:  REM e.g,  150    Knots.
165 IF C = 3 THEN TAS = .447 * TAS:   REM e.g,   173    MPH.
170 IF C = 4 THEN TAS = .276 * TAS:   REM e.g,   280    Km/h.
175 INPUT "     ENTER ANGLE OF DRIFT:                        ", D
185 PRINT
190 INPUT "     ENTER LINEAR COMPONENT TIME (Seconds):       ", t
200 PRINT
220 Pi = 3.1416
225 Angle1 = D
230 Arads1 = Angle1 * (Pi / 180)
235 X = COS(Arads1)
240 Y = SIN(Arads1)
245 REM  Turns are either UPWIND (k=-1) or DOWNWIND (k=1) with respect to
250 REM  direction of turn and crosswind component.
255 REM  au  =  UPWIND distance between lines, ad = DOWNWIND distance.
260 REM  au = ((2TAS/3).(((57.29)X)-((90-D)Y))) + TAS(1-Y)t.
265 REM  ad = ((2TAS/3).(((57.29)X)+((90+D)Y))) + TAS(1+Y)t.
270 F1 = (2 * TAS / 3)
275 F2 = ((57.29) * X) - ((90 - D) * Y)
280 F3 = (TAS * (1 - Y) * t)
285 F4 = (TAS * (1 - Y) * t)
290 F5 = ((57.29) * X) + ((90 + D) * Y)
295 F6 = (TAS * (1 + Y) * t)
300 au = (F1 * (F2)) + F3
305 ad = (F1 * (F5)) + F6
310 PRINT "              UPWIND DISTANCE BETWEEN LINES   (au) =  ";
315 PRINT INT(au + .5); "Meters.";
320 PRINT "              DOWNWIND DISTANCE BETWEEN LINES (ad) =  ";
```

(g) **UTURN-A** *continued*

```
325 PRINT INT(ad + .5); "Meters."; ""
330 PRINT
340 PRINT "                        END OF CALCULATIONS."; ""
345 PRINT
350 PRINT "                   For HARDCOPIES connect the PRINTER."
355 PRINT
360 GOSUB HARDCOPY
365 HARDCOPY:
370 INPUT "             FOR HARDCOPY OPTION: KEY (1), RETURN TO PGM KEY (2).", HC
375 PRINT
380 IF HC = 1 THEN
382 PRINT
384 PRINT "    If the PRINTER is NOT CONNECTED wait ONE MINUTE for automatic"
386 PRINT "    return to Pgm then, press ENTER and EXIT Pgm."
388 PRINT
390 PRINT "               CONNECT PRINTER AND RE-OPEN."
392 LPRINT "                        `UTURN-A'."
395 LPRINT "    TAS CODE                              = "; C
396 LPRINT "    TAS (Always printed in meters/sec)    = "; TAS
397 LPRINT "    DRIFT ANGLE:                          = "; D
398 LPRINT "    LINEAR COMPONENT TIME (Seconds):      = "; t
399 LPRINT
400 LPRINT "       UPWIND DISTANCE BETWEEN LINES (au)  = ";
405 LPRINT INT(au + .5); "Meters.";
410 LPRINT "       DOWNWIND DISTANCE BETWEEN LINES (ad) = ";
415 LPRINT INT(ad + .5); "Meters.";
420 ELSEIF HC = 2 THEN
425 PRINT
430 ELSE
435 GOTO 382
440 END IF
450 END
```

RWG

300

(h) TAS

```
1    PRINT "                        APPENDIX. 1h"
5    CLS
6    PRINT "                           TAS. BAS."
8    PRINT "                        Press F5 to RUN."
10   PRINT
15   PRINT "                    TRUE AIR SPEED (TAS). "; ""
20   PRINT
25   PRINT "          To determine TAS from IAS (Indicated Air Speed)."; ""
30   PRINT
35   PRINT "    PARAMETERS:"
40   PRINT "       Pressure Altitude, i.e, Altimeter set at standard 1013.2 mb"
45   PRINT "       atmospheric pressure (A); Outside Air Temperature (OAT), in"
50   PRINT "       degrees Celsius (C); Indicated Air Speed (IAS)."
55   PRINT
60   REM    TAS = IAS(SQR((273.16 + C)/(288/10^D)))
65   REM      D = A/(63691.776 - (0.2190731712.A)
70   REM    TAS increases (roughly) as 2% per 1000ft amsl.
75   INPUT "            Enter INDICATED AIR SPEED (IAS):           ", IAS
80   CLS
85   PRINT
90   INPUT "            Enter ALTIMETER PRESSURE ALTITUDE (ft):    ", A
95   CLS
100  PRINT
105  INPUT "            Enter OUTSIDE AIR TEMPERATURE (C):         ", C
110  CLS
115  PRINT
120   D = A / (63691.776# - (.2190731712# * A))
125   TAS = IAS * (SQR((273.16 + C) / (288 / 10 ^ D)))
130  PRINT
135  PRINT "                        TAS =    ";
140  PRINT INT(TAS + .5);
145  END
```

RWG

(i) TALT

```
1   PRINT "                    APPENDIX. 1i"
5   CLS
6   PRINT "                        TALT. BAS."
10  PRINT "                      Press F5 to RUN."
15  PRINT
20  PRINT "        FINDING THE NECESSARY PRESSURE ALTITUDE (PALT) TO FLY";
25  PRINT "        THE TRUE ALTITUDE (TALT) REQUIRED FOR AN AIR SURVEY. "
30  PRINT
35  REM   TALT will be different to PALT due to differences between the QNH
40  REM   (Altitude) setting for atmosphere, and the Pressure Altitude, which
45  REM   employs the International Standard Atmosphere (ISA)of 1013.25mb; and
50  REM   also the difference in Outside Air Temperature (OAT) and the ICAO
55  REM   temperature of 15 degrees Centigrade.
60  REM   Note:  1 mm Hg = 1.33322 mb.
65  PRINT
70  INPUT "        Enter REQUIRED TRUE ALTITUDE (TALT),(ft):       ", TALT
75  CLS
80  PRINT
85  INPUT "        Enter OUTSIDE AIR TEMPERATURE (OAT), (C):       ", OAT
90  CLS
100 PRINT
105 INPUT "        Enter QNH value (mb):                           ", QNH
110 CLS
115 PRINT
120 REM   PALT = Pressure Altitude to be flown with altimeter set at 1013.25mb.
125 REM   PALT = TALT(1 + ((dT/288.15) - (187.8/1000000).dP) + 27.3*dP.(feet)
130 dT = OAT - 15
135 dP = QNH - 1013.25
140 PRINT
145 PALT = TALT * (1 + ((dT / 288.15) - (187.8 / 1000000) * dP)) + dP * (27.3)
150 PRINT
155 PRINT "                   REQUIRED PALT =    ";
160 PRINT INT(PALT + .5); "feet"; ""
165 END
```

RWG

302

(j) SS

```
1    PRINT "                        APPENDIX.   1j"
5    CLS
6    PRINT "                         SS. BAS."
8    PRINT "                      Press F5 to RUN."
10   REM     Shutter Speed (SS) Calculations for Aerial Photography.
15   PRINT
20   PRINT "                    SHUTTER SPEED"; CHR$(91); "SS"; CHR$(93)
25   PRINT
30   PRINT "         SS = ((286*(EAFS)*(FS)*(FH))/(FF)*(Aperture)^2))"
35   PRINT
40   PRINT "     (FS) =  Function of Solar Altitude."
45   PRINT "     (FH) =  Function of Height above Ground."
50   PRINT "     (FF) =  Filter Factor."
55   PRINT
60   PRINT "     Variables: Lat, Month, Day, Long, Local time, EAFS,"
65   PRINT "     Height, Filter factor, Aperture."
70   PRINT
75   INPUT "            Enter Latitude:                    ", LA
80   PRINT
90   INPUT "            Enter Number of Month:             ", M
100  IF M = 1 THEN M = 0
105  IF M = 2 THEN M = 31
110  IF M = 3 THEN M = 59
115  IF M = 4 THEN M = 90
120  IF M = 5 THEN M = 120
125  IF M = 6 THEN M = 151
130  IF M = 7 THEN M = 181
135  IF M = 8 THEN M = 212
140  IF M = 9 THEN M = 243
145  IF M = 10 THEN M = 273
150  IF M = 11 THEN M = 304
155  IF M = 12 THEN M = 334
160  PRINT
165  INPUT "            Enter Day Number:                  ", DAY
170  PRINT
175  Z = M + DAY
185  INPUT "         Enter Longitude (Degrees West are -ve): ", LO
190  PRINT
195  INPUT "         Enter Local-Time (0 to 24 hours):      ", LT
205  pi = 3.1416
210  Angle1 = LA:                        REM in degrees.
215  Arads1 = Angle1 * (pi / 180):       REM in radians.
220  A = SIN(Arads1)
230  Angle2 = ((360 / 365.25) * (Z - 83)):  REM in degrees.
235  Arads2 = Angle2 * (pi / 180):       REM in radians.
240  SD = 23.45 * SIN(Arads2) + .6
245  Angle3 = SD:                        REM in degrees.
250  Arads3 = Angle3 * (pi / 180):       REM in radians.
255  B = SIN(Arads3)
260  F1 = A * B
265  C = COS(Arads1)
270  D = COS(Arads3)
275  HA = (LO + ((LT - (LO / 15)) - 12) * 15)
280  Angle4 = HA:                        REM in degrees.
285  Arads4 = Angle4 * (pi / 180):       REM in radians.
290  E = COS(Arads4)
295  F2 = C * D * E
300  FS = F1 + F2
305  REM     FS = Sin(SA) must be converted to Tan(SA) for further calculations.
310  REM     F3 = TAN(SA) = (SIN.SA)/(SQR(1-(SIN.SA)^2)).
```

(j) SS *continued*

```
315 F3 = (FS) / (SQR(1 - (FS) ^ 2))
320 Arads5 = ATN(F3)
325 Angle5 = Arads5 * (180 / pi)
330 PRINT
335 PRINT "                    Solar Altitude =                    ";
340 PRINT INT(Angle5 + .5); "Degrees"; ""
345 PRINT
350 INPUT "                    Enter EAFS:                    ", EAFS
355 PRINT
360 INPUT "                    Enter Flying Height (feet):            ", H
365 PRINT
370 FH = ((.4343 * LOG(H)) - 2.14):         REM Function of height in feet.
375 INPUT "                    Enter Filter Factor (none = 1):        ", FF
380 PRINT
385 INPUT "                    Enter Camera Aperture:            ", N
390 PRINT
395 SS = ((286 * (EAFS) * (FS) * (FH)) / ((FF) * (N) ^ 2))
400 PRINT "                    SHUTTER SPEED =                    ";
405 PRINT "1/"; INT(SS); "Seconds."; ""
410 PRINT
415 PRINT "                    END OF CALCULATIONS."
420 PRINT
500 PRINT "                For HARDCOPIES connect the PRINTER."
505 PRINT
510 GOSUB HARDCOPY
515 END
520 HARDCOPY:
525 INPUT "            FOR HARDCOPY OPTION: KEY (1), RETURN TO PGM KEY (2).", HC
530 PRINT
560 IF HC = 1 THEN
570 LPRINT "                    SHUTTER SPEED CALCULATION (SS). "
575 LPRINT
580 LPRINT "        Latitude (LA)                        = "; LA
585 LPRINT "        Total days (from 1st Jan) to Month M:    = "; M
590 LPRINT "        Day Number (DAY)                    = "; DAY
595 LPRINT "        Longitude (LO)                        = "; LO
596 LPRINT "        Local-Time (LT)                        = "; LT
600 LPRINT "        Solar Altitude (SA)                    = ";
605 LPRINT INT(Angle5 + .5); "Degrees.";
610 LPRINT "        EAFS                        = "; EAFS
615 LPRINT "        Flying Height (H) above Ground (ft)    = "; H
620 LPRINT "        Filter Factor (FF)                    = "; FF
625 LPRINT "        Lens Aperture (N)                    = "; N
630 LPRINT
635 LPRINT "        SHUTTER-SPEED (SS)                = ";
640 LPRINT "1/"; INT(SS); "Seconds.";
645 ELSEIF HC = 2 THEN
650 PRINT
655 ELSE
660 GOTO 570
665 END IF
700 END
```

RWG

Appendix 2

Unit conversions

To convert from A to B, multiply by factor C.

A	B	C
Length		
Inches	Millimetres (mm)	25.4
Feet	Metres (m)	0.3048
Metres	Feet (ft)	3.2808
Metres	Yards	1.0936
Miles (statute)	Kilometres (km)	1.6093
Miles (statute)	Nautical miles (NM)	0.8688
Nautical miles	Statute miles (SM)	1.1509
Nautical miles	Kilometres (km)	1.8523
Area		
1 square metre	Square feet	10.764
1 square kilometre	Square metres	1 000 000
1 hectare	Square metres	10 000
1 hectare	Acres	2.471
1 square metre	Square yards	1.196
1 acre	Square yards	4840
Mass		
Ounces	Grams	28.3495
Kilograms	Pounds	2.204
Tons	Kilograms (kg)	1016.05
Capacity		
UK gallons	Litres (L)	4.546
US gallons	Litres	3.785
Pints	Litres	0.568
Speeds		
Miles per hour	Kilometres per hour	1.6093
Knots (NM per hour)	Miles per hour	1.151

Appendix 3

Side sight calculations

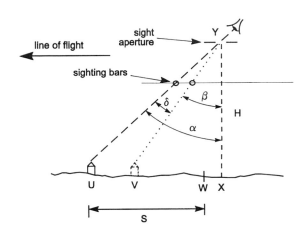

$H = XY = fm$
$S = S'm = UW = HS/f$
$B = UV = S(1 - p/100)$

For $\alpha = 45°$, $H = UX$, and $VX = UX - UV = H - UV$
$\tan \beta = VX/H = (UX - UV)/H = (H - B)/H$
The 'trail angle' (δ) is given by:
$$\delta = \alpha - \beta = 45° - \beta$$

Example
(i) A 35 mm camera (24 mm × 36 mm format) with its shorter side advancing at 90° to the flightline, for a 50 mm lens and 60% forward overlap, will have
$$S = S'.H/f = 0.48 \times H, \qquad B = 0.0192 \times H$$

(ii) A 70 mm format (56 mm × 56 mm) camera with 100 mm lens and 60% forward overlap, will have
$$S = S'.H/f = 0.56 \times H, \quad B = 0.224 \times H$$

Appendix 4

Photo laboratory processing formulae

Kodak D-76 (Ilford ID-11) fine grain film developer (suitable for 35 mm films)

Water (40–50°C)	600 mL
Metol	2 g
Sodium sulphite (anhydrous)	100 g
Hydroquinone	5 g
Borax	2 g
Water to make	1000 mL

A soft-working developer with excellent keeping qualities. Can be diluted $1+1$. Typical development for Panatomic-X film (EAFS 40) is 14 minutes (20°C), $\gamma = 0.8$, spiral reel processing.

Kodak DK-50 medium grain (normal contrast) developer (suitable for 70 mm films)

Water (40–50°C)	600 mL
Metol	2.5g
Sodium sulphite (anhydrous)	30 g
Hydroquinone	2.5 g
'Kodak' (or sodium metaborate)	10 g
Potassium bromide	0.5 g
Water to make	1000 mL

Ideal for spiral reel and rewind spool processing. Offers higher contrast and EAFS than D-76. Not suitable for 35 mm films because of larger grain size than with D-76. Typical development: Plus-X (EAFS 120), $\gamma = 1.2$ for 70 m of 70 mm film processed in rewind spool for 6 cycles at 20°C.

Kodak D-19 universal film and print developer (not suitable for 35 mm films)

Water (40–50°)	600 mL
Metol	2 g
Sodium sulphite (anhydrous)	90 g
Hydroquinone	8 g
Sodium carbonate (anhydrous)	45 g
Potassium bromide	5 g
Water to make	1000 mL

A very useful, if somewhat contrasty, developer. Suitable for 70 mm films (diluted 1 + 3) will provide an EAFS of 200 for 70 m of Plus-X film processed for 4 cycles rewind spool, with γ = 1.3. Dilute 1 + 1 for paper prints, or as required. Also highly suitable for making diapositives with Kodak gravure film.

ID-20 paper developer (dilute 1 + 3)

Water (40–50°)	600 mL
Metol	3 g
Sodium sulphite (anhydrous)	50 g
Hydroquinone	12 g
Sodium carbonate (anhydrous)	60 g
Potassium bromide	4 g
Water to make	1000 mL

Acetic acid stop bath (for films and papers)

Water (40°C)	600 mL
Acetic acid (glacial)	17 mL
Water to make	100mL

Acid fixer (for films and papers)

Water (45–50°C)	600 mL
Sodium thiosulphate (anhydrous)	125 g
Potassium metabisulphite	8 g
Water to make	1000 mL

For films use undiluted for 10–20 minutes. For papers dilute 1 + 1, fix for 5–10 minutes.

Appendix 5

Abbreviations, symbols and glossary

ADF	automatic direction finding
AIM	apparent image motion
a.m.g.l.	above mean ground level
a.m.s.l.	above mean sea level
ATC	air traffic control
CCD	charge coupled device
DEV	deviation (magnetic compass)
EAFS	effective aerial film speed
EI	exposure index
ETA	estimated time of arrival
ETD	estimated time of departure
FF	filter factor
FMC	forward motion compensation
f no.	relative aperture of a lens
G	G-Bar (average gradient)
GMT	Greenwich Mean Time (UMT)
GPS	global position system
GS	ground speed
IAS	indicated air speed
IFR	instrument flight rules
IR	infrared
ISA	International Standard Atmosphere
ISO	International Standards Organisation (film speeds)
JND	just noticeable difference
LED	light emitting diode
MH	magnetic heading
MOS	metal oxide semiconductor
MSP	multispectral photography
MTF	modulation transfer function
N	relative aperture of a lens (f no.)
ND	neutral density
NDB	non-directional beacon
OAT	outside air temperature
PALT	pressure altitude
PD	principal distance
PPS	pictures per second
PP	principal point
QFE	Airfield elevation (Q-code), altimeter reads zero on landing
QNH	Altitude above sea level, altimeter reads airfield height a.m.s.l on landing
RAM	random access memory

RF	radio frequency
RMS	root mean square (statistics)
ROM	read only memory
SLR	single lens relfex (camera)
t	camera shutter speed (fraction of a second)
TALT	true altitude
TAS	true air speed
TC	true course
TH	true heading
TTL	through the lens metering (camera exposure)
UV	ultraviolet
VAR	variation (magnetic)
VDU	visual display unit
VFR	visual flight rules
VHF	very high frequency
W/V	wind velocity
WA	wide angle (lens)

PHOTOGRAMMETRIC SYMBOLS

Symbol component	*Usage*
English	
- upper case	points, distances, coordinated, etc. in the **object** space
- lower case	points, distances, coordinates, etc. in the **image** space
Greek	
- upper case	rotation angles in absolute space
- lower case	dimensionless quantities or angular measurements

abc	Image space plane containing points $a,b,$ and c
ABC	Object space plane containing points $A,B,$ and C
b	Base length at the scale of the stereomodel
B	Base length (i.e. the physical distance between cameras)
b'	Image distance between principal point and corresponding (conjugate) principal point on the right hand photograph
b_x,b_y,b_z	Components of the base length at the scale of the stereomodel
B_x,B_y,B_z	Components of the base length in an exterior coordinate system
C_x,C_y,C_z	Cartesian (map) coordinates
d	Dispacement of a photographic image due to any cause
$d\,h$	Difference in height or elevation
$d\,p$	Difference in parallax
h	Height or elevation of a ground station or object above sea level datum (unless specified otherwise)
H	Height or elevation of a camera station above sea level datum (unless specified otherwise).
K *(kappa)*	Model rotation about the Z axis
n	Nadir point on a photograph; number of observations or measuements
N	Ground nadir point; northing in grid coordinates
p	photograph principal point
P	ground principal point
P_x	x Parallax corresponding to elevation difference
P_y	y Parallax
x,y,z	Model coordinates
X,Y,Z	Object or ground coordinates
$\mu\mathrm{m}$	Micrometer (micron), 10^{-6} m
σ (sigma)	Standard deviation or standard error
ϕ (phi)	Pitch, longitudinal tilt, tilt about the Pitch, longitudinal tilt, tilt about the y or Y axis
Φ (PHI)	Model rotation about Y axis
ω (omega)	Roll, lateral titl, tilt about the x or X axis
Ω (OMEGA)	Model rotation about the X axis

Glossary of photogrammetry

accuracy the degree of conformity with a standard; relates to the quality of a result, and is distinguished from precision which relates to the quality of the operations by which the result is obtained.

affine a geometrical condition in which the scale along one axis or reference plane is different from the scale along the other axis or plane.

affine transformation a transformation in which straight lines remain straight and parallel lines remain parallel. Angles, however, may undergo changes and differential scale changes may be introduced.

air base the length of a line joining two air camera stations; also, the distance (at the scale of the stereoscopic model) between adjacent perspective centres as reconstructed in the plotting instrument.

altitude the height of an aircraft above a specific datum point or *reference elevation* (usually mean seal level).

analogue instruments devices that represent numerical qualities by means of physical variables; e.g. by rotations, as in a mechanical gear system.

analytical photogrammetry photogrammetry in which solutions are obtained by mathematical methods.

angle of depression the complement of *tilt*. The angle in a vertical plane between horizon and a descending line. Also called *depression angle*.

angle of incidence the angle at which a ray of light strikes a surface.

angle of reflection the angle at which a ray of light leaves a surface.

apparent depression the angle between the principal axis of an oblique camera and the *apparent horizon*.

apparent horizon in an aerial photograph, the line where land and sky meet. It is slightly below the *true horizon*.

attitude the angular orientation of the camera, or of the photograph taken with the camera, with respect to some external reference system. Three angles are required to satisfy attitude: 1. ω (*x*-tilt), 2. ϕ (*y*-tilt) and 3. κ (*z*-rotation); otherwise called 1. tilt, 2. swing, and 3. azimuth; or 1. *roll*, 2. *pitch*, and 3. *yaw*.

base, photo the distance between *principal points* of two adjacent prints of a series of photographs. It is usually measured on one print after transfer of the principal point of the other print.

base-height (B/H) ratio base-to-height ratio, where B (the airbase) is the displacement of the camera between two exposures at H, the height above the object being photographed.

blunder See *error*

calibrated focal length an adjusted value of the equivalent focal length computed to distribute the effects of lens distortion over the whole angle of field of an air camera. It is equal to the principal distance. See *focal length*.

camera

 metric a camera whose interior orientation is known, stable and reproducible.

 survey (mapping) a camera specially equipped with means for maintaining and indicating interior orientation for the photographs with sufficient accuracy for mapping purposes.

 standard a non-metric camera (e.g. off-the-shelf 35 mm).

camera constant an alternative name for *calibrated focal length*.

camera station the point in space, in the air or on the ground, occupied by the camera lens at the moment of exposure. Also called *exposure station*.

conjugate principal point the *principal point* of one aerial photograph where it appears on the adjacent overlapping area of a stereo pair of photos. Also called *corresponding principal points*.

control a system of points with established positions (horizontal) or elevations (vertical), or both, which are used as fixed references in positioning photo features. See *ground control*.

coverage the ground area represented on aerial photographs, photomosaics, or maps.

convergent photography photography taken from two camera stations so as to maintain a fixed angles convergent between optical axes.

coordinate transformation a mathematical (or graphic) process of obtaining a modified set of coordinates by scaling, rotating and translating.

coordinates linear or angular quantities which designate the position that a point occupies in a given reference system. Also used as a general term to designate the particular kind of reference system, e.g. cartesian coordinates, expressed as X, Y, Z or C_x, C_y, C_z. See *photograph coordinates* and *model coordinates*.

crab (aerial photography) the condition caused by incorrect orientation of the camera with respect to the track of the airplane, indicated in vertical photography by the sides of the photographs not being parallel to the principal point base line (air navigation). Any turning of an airplane which causes its longitudinal axis to vary from the track of the plane.

datum a reference element, such as a line or plane in relation to which the positions of other elements are determined. Also called *reference plane* or *datum plane*.

degrees of freedom in statistics, the number of redundant observations (those in excess of the number actually needed to calculate the unknowns). Redundant observations reveal discrepancies in observed values and make possible the practice of least squares adjustment for obtaining most probable values.

diapositive a transparent positive print intended for viewing by transmission.

differential rectification also known as an *orthophotographic system* for correcting the scale of hilly ground in a vertical photograph be exposing successive strips, changing the image magnification to match the height of the terrain.

digital pertaining to data in the form of digits.

digitize to use numeric characters to express or represent data.

digitizer a computer input device that is specially designed to put graphic information into a computer. A digitizer is to graphics what a keyboard is to text. Also called two-dimensional) *digitizing tablet* or *digitizing board*.

dip angle the angle between true and apparent horizons.

displacement any shift in the position of an image on a photograph which does not alter the perspective characteristics of the photograph. Contrast with *distortion*. See *relief displacement* and *tilt displacement*.

distortion any shift in the position of an image on a photograph which alters the perspective characteristics of the photograph. Causes of image distortion include lens aberration, shrinkage of film or paper, and motion of the film or camera.

dot grid film positive with regularly spaced dots used in estimating areas.

elevation vertical distance from the datum (usually mean sea level) to a point or object *on* the Earth's surface. Sometimes used synonymously with altitude, which refers to distance of points *above* the Earth's surface. See *altitude*.

error (statistics) The difference between any measured quantity and the true value for that quantity Like true value, errors are indeterminate and hence they are strictly theoretical quantities. See *root mean square*.

absolute absolute deviation from corresponding *true value*.

blunder the result of carelessness or a mistake; may be detected through repetition.

random deviation caused by chance only; the relation between magnitude and frequency of the individual errors are regulated by laws of normal frequency, and therefore tend to be compensating.

systematic an error which follows some definite mathematical or physical law, for which a correction may be determined and applied.

exposure the total quantity of light received per unit area on a sensitized plate or film. Also, the act of exposing a light-sensitive material to a light source.

fiducial mark usually four in number, located at the edge of the camera film plane. Recorded on the negative to define axes, the intersection of which fixes the *principal point*

(fiducial centre) of the aerial photograph and fulfils the requirement for *interior orientation*.

film distortion the dimensional changes which occur in photographic film with changes in humidity or temperature, or from ageing, handling, or other causes.

flight index a transparent map overlay indicating the principal point of each photograph exposed in an aerial survey.

focal length the distance measured along the optical axis from the rear nodal point on the lens to the plane of critical focus of a very distant object.

focal plane the plane (perpendicular to the axis of the lens) in which images of points on the object field of the lens are focused.

forward overlap the percentage of the image which is recorded twice in successive frames in a forward direction.

ground control point a point on the ground (usually marked artificially) which is readily identifiable from an aerial photograph. Ground control points are used for checking scale and camera tilt; when used in rectification at least such points should appear in any one negative. See *control*.

high-oblique photography see *oblique photography*

horizon in general, the apparent or visible line of demarcation between land/sea and sky, as seen from a specific location, also called 'apparent horizon'. See *true horizon*.

image motion the smearing or blurring of imagery on an aerial photograph because of the relative motion of the camera with respect to the ground at the moment of exposure.

interior orientation see *orientation*

isocentre the point on a photograph intersected by the bisector of the angle between the plumbline and the photograph perpendicular. The isocentre is significant because it is the centre of radiation for *displacement* of images due to *tilt*. See *displacement*.

isoline a line representing the intersection of the plane of a vertical photograph with the plane of overlapping oblique photograph.

kappa see *yaw*

least squares a method of adjusting observations in which the sum of the squares of all residuals derived from fitting the observations to a mathematical model is made a minimum. It assumes the frequency distribution of the errors is normal, i.e. symmetrical, characteristic of the typical bell-shaped curve.

levelling in *absolute orientation*, the operation of bringing the model datum parallel to a reference plane, usually the tabletop of the stereoplotting instrument. See *orientation*.

low-oblique photography see *oblique photography*.

map, planimetric a map showing only horizontal positions of drainage and cultural features.

micrometer a unit of length equal to 1 millionth of a metre (0.001 mm), expressed as μm. Also called *micron*.

metric (planimetric) accuracy a term used to indicate that an item of optical equipment has been (or could be) calibrated to a standard which would allow it to be used for photogrammetric work.

model coordinates the space coordinates of any point image on an overlapping pair of photographs, which define its position with reference to the air base or to the instrument axes.

model scale the relationship which exists between a distance measured in a stereoscopic model and the corresponding object distance.

nadir the point at which a vertical line through the perspective centre (node of emergence) of the camera lens is incident on the film plane. Also, by implication, the point on the ground immediately below the aircraft. Also known as *plumb point*.

negative titling information (e.g. sortie number, camera, date, height, scale, etc.) recorded on the negative for identification.

nodal point a camera lens has two nodal points, the position of which can be determined geometrically. The front nodal point, or node of incidence, is the point which defines

the plane from which distances to all points in the object space are measured. The rear nodal point, or node of emergence (known in photogrammetry as the *perspective centre* of the lens), is the point defining the plane from which distances to all points in the image space (including the principal focus) are measured.

non-metric camera see *camera.*

oblique photography photography using an aerial camera that is tilted rather than (quasi-) vertical. Oblique photography is subdivided into *high oblique*, where the horizon is visible in the photograph, and *low oblique*, where it is not.

omega see *roll*

orientation

absolute scaling, levelling and orientation to ground control of a relatively-orientated model.

interior the determining of the interior perspective of the photograph as it was at the instant of exposure. Elements of interior orientation are the calibrated focal length, location of the calibrated principal point (usually by fiducials) and calibrated lens distortion.

outer the photogrammetric or analytical determination of the position of the camera station and altitude of the camera at the instant of exposure. When determined by stereoscopic instruments it is separated into two parts, *relative* and *absolute.*

relative the determination of the position and attitude of one photograph with respect to another in a stereo pair of aerial photographs.

orthogonal meeting, crossing or lying at right angles; rectangularly.

orthophotograph a photograph having the properties of orthographic projection; derived from a conventional aerial photography by *differential rectification* so that the effects of both camera tilt and terrain relief are removed.

orthophotomap an orthophotographic map with contours and color enhanced cartographic treatment, presented in a standard quadrangle format and related to standard reference system.

parallactic angle the angle between the two axes view in a stereoscopic pair of images. also called *angle of convergence.*

parallax the change in appearance of an object or scene as the viewpoint is shifted.

x parallax the difference in the absolute stereoscopic parallaxes of two points imaged on a pair of photographs. Customarily used in the determination of the difference in elevation of objects. Also called *parallax difference.*

y parallax the difference between the perpendicular distances of the two images of a point from the vertical plane containing the air base. The existence of *y parallax* is an indication of tilt in either or both photographs and/or a difference in flight height.

parallax bar a device used to obtain relief data from a stereoscopic pair of aerial photographs. Also known as *stereometer.*

pass point a point whose horizontal and/or vertical position is determined from photographs by photogrammetric methods and which is intended for use in the orientation of other photographs.

perspective centre see *nodal point.*

perspective grid a network of lines, drawn or superimposed on a photograph, to represent the perspective of a systematic network of lines on the ground or datum plane.

perspective plane any plane containing the perspective centre. The intersection of a perspective plane and the ground will always appear as a straight line on an aerial photograph.

phi see *pitch.*

photograph centre the centre of the photograph as indicated by the images of the *fiducial marks* of the camera. In a perfectly adjusted camera, the photograph centre and the *principal point* are identical.

photograph coordinates a system of coordinates to define the positions of points on a photograph, expressed as *x,y.*

photogrammetry the process of making accurate measurements from photographs, and the analysis of such measurements.

pitch the vertical attitude of an aircraft with reference to a horizontal line drawn along the flight path. Known in photogrammetry as *tip* and expressed as *phi* (ϕ).

plumb point see *nadir.*

principal axis the axis of symmetry of a camera lens.

principal point the point at which the principal axis intersects the film plane. It can be determined by the intersection of lines coming from diagonally opposing corners of the photograph.

real time generally associated with data transmission at the time of occurrence with no delay.

rectification the process of converting a tilted or oblique photograph to the plane of the vertical.

reference elevation the datum above which the flying height of the survey aircraft is measured to achieve the required photo scale.

relative accuracy an evaluation of the random errors in determining the positional orientation (e.g., distance, azimuth) of one point or feature with respect to another.

relief displacement *displacement* of images radially inward or outwards with respect to the photo *nadir,* according as the ground objects are, respectively, below or above the elevation of the ground nadir.

relief model a three-dimensional representation of a portion of the earth's surface as a reduced scale. Normally some vertical exaggeration is used to accentuate relief features.

reseau camera a survey camera fitted with a register glass engraved with a reseau of calibrated marks, usually crosses on an orthogonal grid 10 mm apart in each direction.

residual (statistics) the difference between any measured quantity and the most probable value for that quantity determined through a least squares adjustment (which is based upon the mathematical laws of probability). The term *error* is frequently used when *residual* is in fact meant.

resolution the ability of an optical system to record fine detail. In aerial photography it is usually given in the form of ground resolution in feet or metres for a bar target on the ground, from a specified height.

roll rotation of an aircraft about its longitudinal axis so as to cause a wing-up or wing-down attitude. Known in photogrammetry as *tilt,* the rotation of a camera or a photo-coordinate system about the *x* axis. Expressed as *omega* (ω).

root mean square RMS a technique for obtaining statistical information using a large number of samples. The RMS value is obtained by taking the square root of the sum of the squares of the differences of the samples from the mean value divided by one less than the total number of samples. The figure obtained is called the *standard deviation* or *standard error.* It is generally denoted by the Greek letter *sigma* (σ) and is a measure of precision (or accuracy) or a single observation. Its square is termed *variance.*

scale ratio of distance on a map or aerial photograph to ground distance. e.g. 1:20 000 means that 1 mm on the map represents 20 m of actual distance. The first figure is always 1; the second figure is known as the scale number.

spot height a point on a map whose height above a specified reference datum is noted, usually by a dot or small cross and elevation value. Also called *spot elevation.*

standard deviation see *root mean square.*

stereomodel the three-dimensional model formed by the intersecting rays of an overlapping pair of photographs.

swing a rotation of a photograph in its own plane around the photograph perpendicular from some reference direction (such as the direction of flight). May be designated by the symbol *kappa* (κ). Also, the angle at the *principal point* of a photograph which is measured clockwise from the positive *y* axis to the principal line at the *nadir* point. See *yaw.*

tilt the angle at the perspective centre between the photograph perpendicular and the plumb-line. The direction of tilt is expressed by swings (when referred to the exterior coordinate system). Tilt's *x* axis is more nearly in the direction of being lowered, displacing the nadir point in the positive *y* direction. Similarly, a positive *y* tilt results from the nose of

the aircraft being lowered, displacing the nadir in the positive x direction. See *roll* and *pitch*.

tilt displacement *displacement* of images, on a tilted photograph, radially outward or inward with respect to the *isocentre*, according as the images are respectively, on the low or high side of the isocentre parallel (the low side is the one tilted close to the earth, or object plane). See *displacement*.

tip another name for y tilt. See *pitch*.

transformation the process of projecting a photograph (mathematically, photographically or graphically) from its plane on to another plane by *translation*, rotation, and/or scale change. When a photograph is transformed to a horizontal plane, so as to remove displacement due to tilt, the process is termed *rectification*.

translation movement in a straight line without rotation.

true depression angle the angle made by the principal axis of the lens of an oblique aerial camera with the true horizon.

true horizon the horizontal plane containing the aircraft. It approximates the *apparent horizon* only when the point of vision is very close to sea level. See *horizon*.

true value (statistics) the theoretically correct value of a quantity. In measurements, however, the true value can never be determined because no matter how much care is exercised in measurement, small random error will always be present.

variance (statistics) see *root mean square*.

vertical control see *control*.

vertical photography aerial photography in which the axis of the lens is approximately vertical.

x axis see *tilt*.

x parallax see *parallax*.

y axis see *tilt*.

y parallax see *parallax*.

yaw the horizontal attitude of an aircraft with reference to a horizontal line along the aircraft flight path. Known in photogrammetry as *swing* and expressed as kappa (K,κ).

Appendix 6

Manufacturers and institutes

Aerial Imaging Systems (Small Format Consultancy), 6 Shaston Road, Stourpaine, Blandford, Dorset DT11 8TA, UK. Tel/Fax: +44 1258 452673.

Adam Technology, Enterprise House, Boathouse Meadow Business Park, Cherry Orchard Lane, Salisbury SP2 7LD, UK. Tel: +44 722 414221.

Agfa-Gevaert Ltd, 27 Great West Road, Brentford, Middx TW8 9AX, UK. Tel: +44 181 5602131.

Agfa-Gevaert N.V, Septestraat 27, B-2640, Mortsel - Belgium. Tel: +01032 4444271.

American Society of Photogrammetry, 210 Falls Street, Falls Church, VA 22026, USA.

British Microlight Aircraft Association, The Bullring, Dedington, Banbury, Oxford OX15 0TT, UK. Tel: +44 1869 338888.

Canada Map Office, 615 Booth Street, Ottawa, Ontario, Canada.

Carl Zeiss (Oberkirchen) Ltd, P.O. Box 78, Woodfield Road, Welwyn Garden City, Herts AL7 1LU, UK. Tel: +44 1707 331144, Fax: 373210.

Carto Instruments, P.O.Box 215, 1430-Ås, Norway.

Cartographic Engineering Ltd, Landford Manor, Salisbury, Wiltshire SP5 2EW, UK.

CFM-Metalfax ('Shadow Aircraft'), Unit 2D, Eastlands Industrial Estate, Leiston, Suffolk IP16 4NL, UK. Tel: +44 1728 832353. Fax: 832944.

Johannes Heidenhain GB Ltd, 200 London Road, Burgess Hill, Sussex, UK.

Eastman Kodak Co, 343 State Street, Rochester, NY, 14650, USA.

IGI-Hilchenbach Ltd, W-5912 Hilchenbach, Germany.

ITC: International Institute for Aerospace Surveys and Earth Sciences, P.O Box 6, 7500A, Boulevard 1945, Enschede, The Netherlands.

Jordforsk, Norwegian Centre for Geo-Resources and Pollution Research, P.O Box 9, As-NLH, Norway. Tel: +47 9948100 (Dr W S Warner).

Kodak Ltd (Aerial Systems), P.O Box 66, Station Road, Hemel Hempstead, Herts. HP1 1JU. UK. Tel: +44 1442 61122 (x 44280).

LEO (Local Earth Observations). Dr Peter Poole, RR 1, Alcove, Quebec, J0X 1A0, Canada. Prof Dr Ing F.J Heimes, Fachhochschule, Bochum, Germany.

Murphy Aviation (Rebel Utility Aircraft), 8880-C Young RD.S, Chilliwack, B.C, V2P 4P5, Canada. Tel: +1604 792 5855, Fax: 792 7006.

NV Optische Industrie de Oude Delft, Delft, The Netherlands. (Hansen spiral reel unit).

The Ordnance Survey, Romsey Road, Maybush, Southampton SO9 4DH, UK.

The Photogrammetric Society (Editor, *Photogrammetric Record*), Department of Photogrammetry and Surveying, University College London, Gower Street, London WC1E 6BT, UK.

Ross Instruments Ltd, Morgansvale Road, Redlynch, Salisbury, Wiltshire SP5 2HU, UK.

Royal Photographic Society, The Octagon, Milsom Street, Bath BA1 1DN, UK.

University College London (Postgraduate Certificate in Air Survey Photography). Department of Photogrammetry, Gower Street, London. WC1E 6BT. Tel: +44 171387 7050 (x2741).

W. Vinten Ltd (70 mm cameras), Vicon House, Western Way, Bury St. Edmunds, Suffolk IP33 3SP, UK. Tel: +44 1284 750599, Fax: 750598.

Appendix 7

Focal plane shutter testing

Although most modern 35 mm cameras employ three-bladed metal focal plane shutters (which are rather like inter-lens shutters in operation) there are still a number of important cameras which use the older cloth type of horizontal-blind focal plane shutter, and it is these types which we address here. As shown in Fig. 8.2, cloth type shutters move horizontally, sequentially exposing the film as its slit moves across the focal plane. Vinten 70 mm cameras employ this type of shutter, but as it takes a specific period of time for the blind to travel across the 55 mm frame, so the metric value of the camera is suspect.

Ideally metric cameras should have an inter-lens shutter, so that all ground detail is exposed at one instant in time, not sequentially as with focal plane shutters. But if it can be shown that the time taken by the slit to cross the frame is short enough to be ignored (that is to say, the time delay in exposing different ground points in one photo is negligible) then, for a given ground speed and scale, a high-speed focal plane shutter can be accepted for photogrammetry.

Research into this question was conducted at University College London (Duncan, 1992) where a calibrated Vinten camera (Table 7.2) was tested to determine its blind speed, and the camera then flown over a surveyed plot to see if scale was significantly distorted by the 1/1000 s shutter speed. Using a Kestral Parachute microlight (see Fig. 9.4), GPS, a flying height of 1080 m and a ground speed of 29 knots (54 km/h), the theoretical scale distortion was 0.07%, and supporting evidence from experimental data gave a uniform distortion (the blind was travelling in line of flight) of 0.095%, which compared very favourably. As the image blur was only 1.4 μm, well below the plotting accuracy of the machine employed, the Vinten focal plane shutter provided no difficulty for photogrammetry.

The actual shutter test is simplicity itself and involves no more than a commercial television set, the camera and a fast film. The test will find the correct shutter speed and, from a measured value of the blind slit width, the velocity of the blind.

1. Open the camera back and measure the slit width (w) of the cloth blind.
2. Focus the camera on a 625 line TV screen, with the focal plane shutter blind moving horizontally.
3. Load a roll or sheet of film (400 ISO) into the camera.
4. Expose the film to any normal television image at the shutter speed under test.
5. Process the film (D-19 developer) to gain an image such as that shown below:

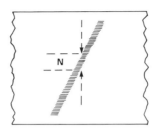

6. Carefully measure the number of television lines (N) exposed (vertically) on the negative.
7. True shutter speed: $t = N/15\ 625$ (i.e. 625 lines in 1/25 s = 15 625 lines/s).
8. Blind velocity (V_b) is then $V_b = w/t$

Example For t(nominal) = 1/1000 s,
$\qquad\qquad w = 2.5$ mm and
$\qquad\qquad N = 15,$
$\qquad t = 15/15\ 625 = 1/1042$ s;$\qquad V_b = 2.5/0.00096 = 2.6$ m/s

Appendix 8

Aircraft listing

The aircraft listed here are all conventional general aviation types, either single or twin engined, and specified in terms of their suitability for various types of small format aerial photography.

Microlight aircraft are not included since they, and kit-built aircraft, are usually out of the mainstream of available camera platforms and have too many variations for suitable listing of their characteristics. Nevertheless, a number of these and other aircraft found to be specially suitable for SFAP applications are referred to in Chapter 9.

The following aircraft listing is based on manufactured aircraft generally available for hire or purchase in the aviation world and known by the authors to have been used in SFAP operations. Information has been taken from published sources, provided largely by manufacturers. Many examples of homebuilt or kit-built aircraft have also been pressed into service, but owing to the variations in specification, engines, and performance, and build quality a listing could be unreliable. There are several publications covering homebuilt aircraft published by the Experimental Aircraft Association (US and worldwide) and the Popular Flying Association (UK).

Manufacturer	Aero Commander	Aero Commander	Aero Commander	Bellanca
Type	500S	680F	690F	Citabria
High/low wing	H	H	H	H
Nose/tailwheel	N	N	N	T
No.engines/hp	2 × 290	2 × 250	2 × T'prop	1 × 115
No. seats	6	6	6	2
Endurance (hrs:mins)	4:45	4:45	4:45	4:30
Ceiling (feet)	19 000	20 000	32 000	12 000
Cruise speed (kts)	176	150	190	109
Suitability for SF (vertical)	Excellent (mod. required)	Excellent (mod. required)	Excellent (mod. required)	Good
Suitability for SF (oblique)	Good	Good	Good	V. good
Remarks	Used in LF	Used in LF	Used in LF	

Manufacturer	Bellanca	Aerospatiale	Aerospatiale	Aerospatiale
Type	Decathlon	Rallye	Tobago	TBM 700
High/low wing	H	L	L	L
Nose/tailwheel	T	N	N	N
No.engines/hp	1 × 150	1 × 145	1 × 250	1×700shp T'prop
No. seats	2	4	4	6
Endurance (hrs:mins)	4:30	4:20	5	6
Ceiling (feet)	16 000	12 950	13 000	30 000
Cruise speed (kts)	128	119	121	237
Suitability for SF (vertical)	Good	Poor (mod. required)	Poor (mod. required)	Excellent (mod. required)
Suitability for SF (oblique)	V. good	Good	Good	Poor
Remarks				Used in LF

Manufacturer	AA Grumman	AA Grumman	AA Grumman	Auster
Type	Traveler	Tiger	Cougar	J/1N
High/low wing	L	L	L	H
Nose/tailwheel	N	N	N	T
No.engines/hp	1 × 150	1 × 180	2 × 160	1 × 130
No. seats	4	4	4	4
Endurance (hrs:mins)	4	4	6:30	2
Ceiling (feet)	12 650	13 800	17 400	11 000
Cruise speed (kts)	118	139	130	80
Suitability for SF (vertical)	Poor (mod. required)	Poor (mod. required)	Good (mod. required)	Good (mod. required)
Suitability for SF (oblique)	Good	Good	Poor	Excellent
Remarks				

Manufacturer	Auster/Beagle	Beagle	Beagle	Beagle
Type	Husky	Terrier	Airedale	206
High/low wing	H	H	H	L
Nose/tailwheel	T	T	N	N
No.engines/hp	1 × 160	1 × 160	1 × 180	2 × 310
No. seats	4	4	4	6
Endurance (hrs:mins)	2:30	2	3:30	–
Ceiling (feet)	13 000	15 000	15 000	20 000
Cruise speed (kts)	90	85	90	–
Suitability for SF (vertical)	Good (mod. required)	Good (mod. required)	Good (mod. required)	Good (mod. required)
Suitability for SF (oblique)	Excellent	Excellent	V. good	Poor
Remarks				

Manufacturer	Beechcraft	Beechcraft	Brditschka	Brditschka
Type	Sierra	Baron	HB 21	HB 23
High/low wing	L	L	H	H
Nose/tailwheel	N	N	N	N
No.engines/hp	1 × 200	2 × 285	1 × 75	1 × 75
No. seats	4	6	2	2
Endurance (hrs:mins)	5	5:30	4	4:30
Ceiling (feet)	17 000	20 688	15 000	16 400
Cruise speed (kts)	115	195	80	90
Suitability for SF (vertical)	Poor (mod. required)	Poor (mod. required)	V. good (mod. required)	V. good (mod. required)
Suitability for SF (oblique)	Poor	Poor	Good	V. good
Remarks		Used for LF		

Manufacturer	Britten-Norman	Brooklands	Cessna	Cessna
Type	BN 2 Islander	Optica	C 152	C 172
High/low wing	H	Mid	H	H
Nose/tailwheel	N	N	N	N
No.engines/hp	2 × 260	1 × 260	1 × 108	1 × 160
No. seats	10	2	2	4
Endurance (hrs:mins)	5	7	3:30	4
Ceiling (feet)	17 200	14 000	14 700	13 000
Cruise speed (kts)	132	86	106	120
Suitability for SF (vertical)	Excellent (mod. required)	Good (mod. required)	Good (mod. required)	Good (mod. required)
Suitability for SF (oblique)	Good	Good	V. good	V. good
Remarks	Used for LF			

Manufacturer	Cessna	Cessna	Cessna	Cessna
Type	C 182	C 180/185	C 206	C 210
High/low wing	H	H	H	H
Nose/tailwheel	N	T	N	N
No.engines/hp	1 × 235	1 × 300	1 × 300	1 × 310
No. seats	4	6	6	6
Endurance (hrs:mins)	6	6	7	4
Ceiling (feet)	14 900	17 900	14 800	17 300
Cruise speed (kts)	142	147	168	168
Suitability for SF (vertical)	Good (mod. required)	V. good (mod. required)	V. good (mod. required)	V. good (mod. required)
Suitability for SF (oblique)	V. good	V. good	V. good	V. good
Remarks		Used for LF	Used for LF	Used for LF

Manufacturer	Cessna	Cessna	Cessna	Dornier
Type	C 310/320	C336/337	C402/404	DO 27
High/low wing	L	H	L	H
Nose/tailwheel	N	N	N	T
No.engines/hp	2 × 285	2 × 210	2 × 325	2 × 275
No. seats	6	6	10	6
Endurance (hrs:mins)	6	4	4	–
Ceiling (feet)	19 750	16 300	25 000	–
Cruise speed (kts)	150	169	194	–
Suitability for SF (vertical)	V. good (mod. required)	V. good (mod. required)	V. good (mod. required)	V. good (mod. required)
Suitability for SF (oblique)	Poor	V. good	Poor	Good
Remarks	Used for LF	Used for LF	Used for LF	Used for LF

Manufacturer	Dornier	Ercoupe	Fournier	Fuji
Type	DO 28	F 1A	RF 5	FA 200
High/low wing	H	L	L	L
Nose/tailwheel	T	N	T	N
No.engines/hp	2 × 380	1 × 90	1 × 68	1 × 180
No. seats	10	2	2	4
Endurance (hrs:mins)	3:30	–	–	6
Ceiling (feet)	25 200	–	–	11 400
Cruise speed (kts)	165	–	–	106
Suitability for SF (vertical)	V. good (mod. required)	Poor (mod. required)	Poor (mod. required)	Poor (mod. required)
Suitability for SF (oblique)	Good	Good	Good	Good
Remarks	Used for LF			

Manufacturer	**Grob**	**Grob**	**Gyroflug**	**Helio**
Type	G 109	G 115	Speed Canard	Courier
High/low wing	L	L	Mid	H
Nose/tailwheel	T	N	N	T
No.engines/hp	1 × 80	1 × 115	1 × 116	1 × 260
No. seats	2	2	2	8
Endurance (hrs:mins)	–	5	7	–
Ceiling (feet)	–	14 500	14 500	–
Cruise speed (kts)	–	110	138	–
Suitability for SF (vertical)	Good (mod. required)	Poor (mod. required)	V. good (mod. required)	Good (mod. required)
Suitability for SF (oblique)	Good	Good	V. good	V. good
Remarks				

Manufacturer	**Maule**	**MBB**	**Partenavia**	**Partenavia**
Type	M4/M5	Bolkow Jnr	P 68	P 68 Observer
High/low wing	H	H	H	H
Nose/tailwheel	T	N	N	N
No.engines/hp	1 × 180-235	1 × 180	2 × 200	2 × 200
No. seats	4	2	6	6
Endurance (hrs:mins)	5:30	–	5	5
Ceiling (feet)	15 000	–	20 000	20 000
Cruise speed (kts)	110	–	160	160
Suitability for SF (vertical)	V. good (mod. required)	Good (mod. required)	V. good (mod. required)	V. good (mod. required)
Suitability for SF (oblique)	Excellent	Good	V. good	V. good
Remarks			Used for LF	Used for LF

Manufacturer	**Pilatus**	**Piper**	**Piper**	**Piper**
Type	PC 6	PA 18 S/Cub	PA 22 T'Pacer	PA 28 Cherokee
High/low wing	H	H	H	L
Nose/tailwheel	T	T	N	N
No.engines/hp	1 × 550 T'prop	1 × 95–180	1 × 135–160	1 × 150–235
No. seats	6	2	4	4
Endurance (hrs:mins)	4:30	4	–	4
Ceiling (feet)	30 025	19 000	–	14 000
Cruise speed (kts)	129	100	–	118
Suitability for SF (vertical)	V. good (mod. required)	V. good (mod. required)	Good (mod. required)	Poor (mod. required)
Suitability for SF (oblique)	V. good	Excellent	Good	Poor
Remarks	Used for LF			

Manufacturer	Piper	Piper	Piper	Piper
Type	PA32 Cherokee 6	PA 23 Aztec	PA 34 Seneca	PA 31 Navajo
High/low wing	L	L	L	L
Nose/tailwheel	N	N	N	N
No.engines/hp	1 × 300	2 × 250	2 × 200	2 × 350
No. seats	6	6	6	10
Endurance (hrs:mins)	5	5	5	5
Ceiling (feet)	17 100	17 600	25 000	25 000
Cruise speed (kts)	148	179	166	190
Suitability for SF (vertical)	Good (mod. required)	V. good (mod. required)	V. good (mod. required)	V. good (mod. required)
Suitability for SF (oblique)	Poor	Poor	Poor	Poor
Remarks	Used for LF	Used for LF	Used for LF	Used for LF

Manufacturer	Robin	Rollason	Ryan	Scheibe
Type	HR 100	Condor	Navion	Falke
High/low wing	L	L	L	L
Nose/tailwheel	N	T	N	T
No.engines/hp	1 × 180–320	1 × 90	1 × 260	1 × 30–65
No. seats	4	2	4	2
Endurance (hrs:mins)	4:30	–	–	–
Ceiling (feet)	16 500	–	–	–
Cruise speed (kts)	150	–	–	–
Suitability for SF (vertical)	Poor (mod. required)	Poor (mod. required)	Poor (mod. required)	Poor (mod. required)
Suitability for SF (oblique)	Good	Good	Poor	Good
Remarks				

Manufacturer	Slingsby	Stinson
Type	T 67C	108
High/low wing	L	H
Nose/tailwheel	N	T
No.engines/hp	1 × 160	1 × 150
No. seats	2	4
Endurance (hrs:mins)	2:40	–
Ceiling (feet)	12 000	–
Cruise speed (kts)	125	–
Suitability for SF (vertical)	Poor (mod. required)	Good (mod. required)
Suitability for SF (oblique)	Good	Good
Remarks		

Classified Bibliography

This bibliography is designed to direct the reader to detailed sources of information about the various dimensions of small format aerial photography. It is the most comprehensive bibliography on the subject with more than 300 references. Some references, however, are not in the open literature (e.g. conference proceedings, M.S. theses, government reports); and others are missing information (e.g. page numbers) because they were collected from incomplete bibliographies.

The bibliography is prefaced with a classification index which enables the reader to select references dealing with a particular application or technique of small format aerial photography. A citation's classification number is based upon the publication's primary point(s) of interest. The classifications are cross-referenced; therefore, a particular citation might fall into more than one category. For example, an article that describes forest mapping with a helicopter-borne twin-camera system might be listed under:

> APPLICATIONS
> **Natural resources**
> *Forestry*
>
> TECHNIQUES
> **Photography**
> *Fixed base*
> **Systems**
> *Camera mounts*
> *Platforms*
> Helicopter
> **Photogrammetry**
> *Mapping*
> *Stereo*

Reference classification

Applications

Agriculture and Aquatic
Agriculture and Soil
6, 12, 18, 29, 41, 42, 51, 80, 81, 94, 98, 109, 113, 130, 141, 153, 156, 185, 186, 187, 196, 199, 238, 300, 301, 316, 324

Hydrology and Aquatic
21, 24, 54, 60, 78, 81, 109, 114, 162, 212, 213, 214, 245, 260, 275, 277

Cultural resources (archaeology)
28, 125, 126, 127, 141, 148, 177, 182, 193, 255, 266, 292, 293, 294, 295, 298

Environment
Geology and Mining
21, 45, 62, 68, 83, 102, 109, 123, 150, 161, 247, 248, 260, 262, 280, 332

Pollution and energy
23, 149, 150, 277, 301, 309

Natural resources
Arctic and Alpine
21, 45, 67, 140, 182, 232, 259, 260, 280

Forestry
1, 2, 3, 4, 9, 15, 16, 20, 31, 37, 46, 47, 71, 90, 92, 93, 108, 115, 116, 119, 120, 121, 124, 131, 132, 133, 134, 158, 159, 160, 161, 174, 175, 179, 180, 184, 186, 188, 189, 190, 191, 196, 202, 204, 205, 206, 207, 209, 210, 218, 219, 222, 223, 227, 238, 239, 249, 250, 257, 265, 268, 270, 271, 272, 276, 281, 284, 285, 290, 305, 315, 319, 328, 334, 336, 339

Marine studies
19, 40, 117, 167, 195, 224, 225, 234, 256, 322, 329

Rangeland and arid land
12, 13, 53, 64, 79, 109, 157, 171, 187, 191, 215, 221, 283, 296, 318

Wildlife, wetlands and park
19, 38, 40, 60, 69, 70, 112, 140, 155, 167, 168, 181, 192, 195, 215, 216, 217, 224, 232, 234, 251, 256, 315, 322, 327, 329

Urban and civil engineering
29, 34, 48, 61, 88, 102, 144, 145, 149, 151, 166, 170, 197, 212, 213, 230, 231, 245, 254, 288, 301, 309, 310

Techniques

Photography
Fixed base
4, 9, 15, 20, 71, 75, 118, 122, 172, 173, 174, 175, 238, 239, 271, 272, 298, 326

Bibliography: alphabetical listing

1. Aldred, A.H. and Hall , J.K. 1975. Application of large-scale photography to a forest inventory. *The Forestry Chronicle*, 9–15.
2. Aldred, A.H., and Hall, R.J. 1992. Forest regeneration appraisal with large scale photographs. *The Forestry Chronicle*, **68**, 142–150.
3. Aldred, A.H., and Kippen, F.W. 1967. Plot volumes from large-scale 70 mm air photographs. *Forest Science,* **13**, 419–426.
4. Aldrich, R.C., Bailey, W.F. and Heller, R.C. 1959. Large-scale 70 mm colour photography techniques and equipment and their application to forest sampling problem. *Photogrammetric Engineering*, **25**, 747–754.
5. Anderson, B.A., Ireland, A.K. and Walker, J.W. 1992. Low altitude large-scale reconnaissance (LALSR) at Wupatki National Monument, a study in continuing coverage at nominal cost. In *ASCM-ASPRS 58th Annual Convention,* **1**, 149–152, Albuquerque, N.M.
6. Anderson, W.H. 1977. *Assessing Flood Damage to Agriculture Using Color Infrared Aerial Photography* No. U.S Geological Survey, EROS, Sioux Falls, S.D.
7. Anderson, W.H. and Kroeger, K.J. 1980. *Selected Readings in Agricultural Applications of Small-Format Aerial Photography* No. NASA/EROS Data Center.
8. Anderson, W.H. and Wallner, F.X. 1978. *Small Format Aerial Photography: A Selected Bibliography* No. U.S. Geological Survey, Sioux Falls, S.D.
9. Avery, G. 1959. Photographing forests from helicopters. *Journal of Forestry*, **5**, 339–342.
10. Avery, T.E. 1977. *Interpretation of Aerial Photographs* (3rd ed.). Minneapolis, Minn.: Burgress Publishing Co. 392 pp.
11. Badekas, J., Peppes, E. and Stambouloglou, E. 1980. Low altitude aerial photography. *Int. Archives of Photogrammetry and Remote Sensing*, **23**, 1–20.
12. Bartholome, E., Gregoire, J.M. and Zeyen, R. 1988. Small format air photo from ultralight aircraft as an aid for data collection of agricultural statistics in Sahelian countries. In *Proceedings: IGARSS '88 Symposium*, 269–270, Ispra, Italy.
13. Batson, F. 1974. *Report on Results of a State-Wide Field Test of 35 mm Aerial Photography System* USDI-Bureau of Land Management, Bilings, Montana.
14. Becker, R.D. and Barriere, J.P. 1992. Airborne GPS for photo navigation and photogrammetry (an integrated approach). Paper No 84, ASPRS/ACSM Convention, Washington DC, 1992, 1–8.
15. Befort, W. 1988. Controlled-scale aerial sampling photography. *Journal of Forestry,* **86**, 21–28.
16. Befort, W.A. and Degan, G. n.d. *Organizing Statewide 35 mm Photography in Support of Forest Inventory.* Forestry Dept., Minn. Dept. of Nat. Res., Grand Rapids, MN, 4pp.
17. Benson, M.L., Meyers, B.J., Craig, I.E., Gabriel, W.C. and Swan, A.G. 1984. A camera mount and intervalometer for small format aerial photography. *Photogrammetric Engineering and Remote Sensing*, **50**, 1571–1580.
18. Benton, A.R. *et al.* 1976. Low-cost aerial photography for vegetation analysis. *Journal of Applied Photographic Engineering*, **37**, 46–49.

19.Best, P.B. and Rüther, H. 1992. Aerial photogrammetry of southern right whales, *Eubalaena australis. Journal of Zoology*, London, **228**, 595–614.

20.Biggs, P.H., Pearce, C.J. and Westcott, T.J. 1989. GPS navigation for large-scale photography. *Photogrammetric Engineering and Remote Sensing*, 55, 1733–1741.

21.Blöschl, G. and Kirnbauer, R. 1992. An analysis of snow cover patterns in a small alpine catchment. *Hydrological Processes*, 6, 99–109.

22.Bolt, M.F. and Atkinson, K.B. 1984. Space resection of 35 mm model aircraft photography. *Int. Archives of Photogrammetry and Remote Sensing*, 24, 90–99.

23.Bradley, P.N., Chavang, N. and van Gelder, A. 1985. Development research and energy planning in Kenya. *AMBIO*, 14, 228–236.

24.Breedlove, B.W. and Dennis, W.M. 1983. The use of small-format aerial photography in aquatic macrophyton sampling. In *Ecological Assessment of Marcophyton: Collection, Use and Meaning of Data*, 100–111. New York: ASTM Pub.

25.Brock, G.C. 1967. *The Physical Aspects of Aerial Photography*. New York: Dover.

26.Burnside, C. 1985. The future aspects of data acquisition by photographic and other airborne systems for large scale mapping. *Photogrammetric Record*, 11, 459–506.

27.Burnside, C.B. and Marshall, M.P. 1992. Experiences in calibrating small format cameras. *Photogrammetric Record*, 80, 323–331.

28.Burnside, C.D., Walker, A.S., Hampton, J.N. and Soffe, G. 1983. A digital single photograph technique for archeological mapping and its application to map revision. *Photogrammetric Record*, 11, 59–68.

29.Canas, A.D. and Irwin, D.A. 1986. Airborne remote sensing from remotely piloted aircraft. *International Journal of Remote Sensing*, 7, 1623–1635.

30.Carneggie, D.M. and Reppert, J.N. 1969. Large scale 70 mm color photography. *Photogrammetric Engineering*, 35, 249–257.

31.Caylor, J.A. 1988. *How to Use Aerial Photographs in Natural Resource Applications*. Nationwide Forestry Applications Program. USDA Forest Service. 331 pp.

32.Chamberlain, S.G. 1993. A 26.2 million pixels CCD image sensor, SPIE Electronic Imaging Conference, Feb. 1993.

33.Chandler, J.H., Cooper, M.A. and Robson, S. 1988. Analytical aspects of small format surveys using oblique aerial photographs. In *Small Format Aerial Surveys and their Applications*. London: 18pp.

34.Chanond, C. and Leekbhai, C. 1986. Small format aerial photography for analyzing urban housing problems: a case study in Bangkok. *ITC Journal*, 3, 197–205.

35.Chantana Chanond and Chamnian Leekbhai. 1986. SFAP for analyzing urban housing problems. *ITC Journal*, 3.

36.Clegg, R.H. and Scherz, J.P. 1975. a comparison of 9 inch, 70 mm, and 35 mm cameras. *Photogrammetric Engineering and Remote Sensing*, 41, 1487–1500.

37.Clements, H.B., Ward, D.E. and Adkins, C.W. 1983. Measuring fire behaviour with photography. *Photogrammetric Engineering and Remote Sensing*, 49, 213–217.

38.Croze, H. 1972. A modified photogrammetric technique for assessing age-structures of elephant populations and its use in Kidepo National Park. *East African Wildlife Journal*, 10, 91–115.

39.CSIRO 1981. *Window Mount for Aerial Photography* CSIRO Indust. Res. News. Jan, No. 144.

40.Cubbage, J.C. and Calambokidis, J. 1987. Size-class segregation of bowhead whales discerned through aerial photogrammetry. *Marine Mammal Science*, 3, 179–185.

41.Curran, P.J. 1982. Multispectral photographic remote sensing of green vegetation biomass and productivity. *Photogrammetric Engineering and Remote Sensing*, 38, 243–250.

42.Curran, P.J. 1983. Estimating green LAI from multispectral aerial photography. Photogrammetric Engineering and Remote Sensing, 49, 1709–1720.

43.Dalman, D.W. 1977. *The Utility of Supplementary Aerial Photography in the Management of Natural Resources in National Parks: Case Study Point Pelee National Park, Ontario* Parks Canada, Ottawa.

44.Dalman, D.W.1. 1978. Supplementary aerial photography (SAP) in the planning and management of national parks. In *Fifth Canadian Symposium on Remote Sensing*, 391–395. Victoria, B.C., Canada.

45. Dempf, E.M. 1994. *Digital Monoplotting for the Capture of Snow Fields*. M.S., Technische Universität München (in German).

46.Disperati, A.A. 1991. *Obtençäo e Usu de Fotografias Aéreas de Pequeno Formato*. Universidade Federal do Paranä, Fundaçao de Pesquisas Florestais, Curitiba., 290 pp. (in Portugese).

47.Disperati, A.A., Rosot, N.C. and dos Santos, J.R. 1986. Mapping bracatinga stands of different ages using 35 mm aerial photographs. *Acta For. Brasil*, 1, 65–74.

48.Dolstra, O and Galema, M. 1987. Accuracy in counting houses using small format aerial photographs. *ITC Journal*, 3, 254–259.

49.Donnelly, B.E. 1988. *Film Flatness in 35 mm Cameras*. M.S., University of Newcastle.

50.Donnelly, B.E. and Fryer, J.G. 1989. Film unflatness and small format photogrammetry. *Australian Journal of Geodesy, Photogrammetry and Surveying*, 51, 57–71.

51.Draeger, W.C. and McClelland, D.T. 1975. *A Selected Biography Remote Sensing Applications in Agriculture* Technicolor Graphic Services, Inc.

52.Duncan, G. 1992. *The Focal Plane Shutter and Photogrammetry*. MSc Thesis, University College, London. Dec. 1992.

53.Dunford, C., Slaymaker, D.M. and Smith, E.. 1983. *Comparison of 35 mm and 70 mm Camera Systems for Measurement of Semiarid Vegetation Cover*. Office of Arid Land Studies, Tucson, Arizona.

54.Edwards, R.W. and Brown, M.W. 1960. An aerial photographic method for studying the distribution of aquatic marcophytes. *Journal of Ecology*, 48, 161–163.

55.Ekin, W.H. 1984. The development of an inexpensive retractable vertical camera rig for light aircraft. *Photogrammetric Record*, 11, 311–317.

56.Ekin, W.H. 1988. A video tracking system for light aircraft. *Photogrammetric Record*, 12, 575–588.

57.Ekin, W.H. and Deans, N.D. 1986. Further developments of an inexpensive retractable vertical camera rig for light aircraft. *Photogrammetric Record*, 12, 227–236.

58.El Hassan, I.M. 1981. Analytical techniques for use with reconnaissance frame photography. *Photogrammetric Engineering and Remote Sensing*, 47, 1733–1738.

59.Elfick, M.H. 1986. MPS-2 – a new analytical photogrammetric system for small format photogrammetry. *International Archives of Photogrammetry and Remote Sensing*, 26, 8.

60.Erwin, R.M., Dawson, D.K. Stotts, D.B., McAllister, L.S. and Geissler, P.H. 1991. Open marsh water management in the mid-Atlantic region: aerial survey of waterbird use. *Wetlands*, 11, 209–228.

61.Evans, B. 1982. Aerial photogrammetric analysis of septic system performance. *Photogrammetric Engineering and Remote Sensing*, 48, 1707–1712.

62.Evans, B.M., Kern, J.R. and Stingelin 1983. *Low Altitude Photointerpretation Manual for Surface Mine Operations*. EROS Data Center, U.S. Geological Survey.

63.Evans, B.M. and Malta, L. 1984. Acquisition of 35-mm oblique photographs for stereoscopic analysis and measurement. *Photogrammetric Engineering and Remote Sensing*, 50, 1581–1590.

64.Everitt, J.H., Alaniz, M.A., Escobar, D.E. and Davis, M.R. 1992. Using remote sensing to distinguish common (Isocoma coronopifolia) and Drummond goldenweed (*Isocomoa drummondii*). *Weed Science*, 40, 621–628.

65.Everitt, J.H., Gerberman, A.H., Alaniz, M.A. and Bowen, R.L. 1980. Using 70-mm aerial photography to identify rangeland sites. *Photogrammetric Engineering and Remote Sensing*, 46, 1339–1348.

66.Fagerlund, E. and Gunnerhed, M. 1975. *Systems Analysis and Development of a Mini-RVP for Reconnaissance (The "Skatan" Project)* No. D3002-E1. National Defence Research Institute Stockholm, Sweden.

67.Faig, W. 1976. Photogrammetric potentials of non metric cameras. *Photogrammetric Engineering and Remote Sensing.* 42, 47–49.

68.Farmer, L.D. and Robe, R.Q. 1977. Photogrammetric determination of iceberg volumes. *Photogrammetric Engineering and Remote Sensing,* 43, 183–189.

69.Ferguson, E.L. and Gilmer, D.S. 1980. Small-format cameras and fine grain film used for waterfowl population studies. *Journal of Wildlife Management,* 44, 691–694.

70.Ferguson, E.L., Jorde, D.G. and Sease, J.J. 1981. Use of 35 mm color aerial photography to acquire mallard sex ratio data. *Photogrammetric Engineering and Remote Sensing,* 47, 823–827.

71.Firth, J. 1987. Keeping a close eye on the resource. *NZ Forest Industries,* 54.

72.Fisher, J.J. and Stever, E.Z. 1973. 35 mm quadricamera. *Photogrammetric Engineering,* 39, 573–578.

73.Flight International 1993. Cessna and Piper promise growth. *Flight International,* October, p.9.

74.Fleming, J. and Dixon, R.G. 1981. *Basic Guide to Small-Format Hand-Held Oblique Aerial Photography.* Canadian Centre for Remote Sensing. 63 pp.

75.Folke, E. 1992 *Large scale photogrammetry with the transverse heliborne twin camera system.* M.S., University of Washington.

76.Foster, H.D. n.d. *A 35 and 70 mm stereoanalytical compilation-graphic system* No. H. Dell Foster Assoc., San Antonio, Texas.

77. Fouché, P.S. and Booysen, N.W. 1989. Remotely piloted aircraft for low altitude aerial surveillance in agriculture. In *Image Processing '89 and 12th Color Photography and Videography Workshop.*

78.Fraga, G.W. 1978. *Low Altitude Aerial Surveillance for Water Resources Control Manual of Practice* California State Water Resources Control Board.

79.Francis, R.E. 1969. Ground markers aid in procurement and interpretation of large scale 70 mm aerial photography. *Journal of Range Management,* 23, 66–68.

80.Frazier, B.E. and Hooper, G.K. 1983. Use of chromogenic film for aerial photography of erosion features. *Photogrammetric Engineering and Remote Sensing,* 49, 1211–1217.

81.Frazier, B.E., McCool, D.K. and Engle, C.F. 1983. Soil erosion in the Palouse: an aerial perspective. *Journal of Soil and Water Conservation,* 38, 70–74.

82.Fryer, J.G. 1983. A simple system for photogrammetric mapping in shallow water. *Photogrammetric Record,* 11, 203–208.

83.Fryer, J.G. 1992. Photogrammetric monitoring of cliffs. *The Australian Surveyor,* 37, 270–274.

84.Fryer, J.G., Clarke, T.A and Chen, J. 1994. Lens distortion for Simple C-mount lenses. In *ISPRS Commission V,* Intercongress Symposium.

85.Fryer, J.G., Kniest, H. and Donnelly, B.E. 1993. Affine or conformal? Fiducials or not! *Aust. J. Geog. Photogram. Surv.,* 23–35.

86.Fryer, J.G., Kniest, H.T. and Donnelly, B.E. 1990. Radial lens distortion and film unflatness in 35 mm cameras. *Australian Journal of Geodesy, Photogrammetry and Surveying,* 15–28.

87.Fryer, J.G., Kniest, H.T. and Donnelly, B.E. 1992. Photogrammetry with the Contax RTS III: a 35 mm camera with a vacuum. *The Australian Surveyor,* 37, 41–45.

88.Garner, J.B. and Mountain, L.J. 1978. The potential of 16 mm and 35 mm time lapse photography taken from a helicopter for traffic studies at complex intersections. *Photogrammetric Record,* 9, 523–535.

89. Georgopoulus, A.C. 1980. A simple coordinameter for 35 mm negatives. *Photogrammetric Record,* 10.

90.Gherardi, L., Mancioppi, I. and Paganucci, L. 1992. The trial of alternative methods in large scale, low altitude, aerial photography for field monitoring in forestry. In *ISPRS Congress,* XXIX, 79–87. Washington, D.C.: Committee of the XVII International Congress for Photogrammetry and Remote Sensing.

91.Gillen, L.G. n.d. *Analytical photogrammetry from small format photography* HDF/MACO, H. Dell Foster Assoc., San Antonio, Texas.

92.Goba, N., Pala, S. and Narraway, J. 1982. *An Instruction Manual on the Assessment of Regeneration Success by Aerial Survey.* Ontario Centre for Remote Sensing.

93.Goba, N.L. and Senese, E.M. 1992. The status of supplementary aerial photography in Ontario. *Photogrammetric Record.* **80**, 283–291.

94.Graham, R.W. 1980. The ITC multispectral camera system with respect to crop prognosis in winter-wheat. *ITC Journal*, **2**, 235–254.

95.Graham, R.W. 1987. The case for microlights in aerial surveys. *Pilots International*, 20–23.

96.Graham, R.W. 1988*a*. Small format aerial surveys from light and microlight aircraft. *Photogrammetric Record*, **12**, 561–573.

97.Graham, R.W. 1988*b*. CFM Shadow. *Pilots International*, February, 1988, 32–33.

98.Graham, R.W. 1992. Multispectral photography in remote sensing. *The British Journal of Photography*, 23–25.

99.Graham, R.W. and Dasmal, K. 1992. Testing Agfa-Gevaert Aviphot Pan 200S PEI air film processed by rewind spool in G5c developer. *Photogrammetric Record*, **14**, 343–350.

100.Graham, R.W. and Mills, J. 1995. *Photogrammetric Record*, April, **15**, p.2.

101.Graham, R.W. and Read, R.E. 1984. Small format aerial photography from microlight platforms. *Journal of Photographic Sciences*, **32**, 100–110.

102.Graham, R.W. and Read, R.E. 1985. Aerial photography from microlights. *Land and Minerals Surveying*, **3**, 12–14.

103.Graham, R.W. and Read, R.E. 1986*a*. *Manual of Aerial Photography.* Focal Press, London.

104.Graham R.W. and Read, R. 1986*b*. Small-format aerial photography from microlight platforms. In *Manual of Aerial Photography*, 305–315. London: Butterworth and Co. Ltd.

105.Graham R.W. and Read, R. 1987. Aerial photography. *The British Journal of Photography*, **12**, 676–692.

106.Graham, R.W., Read, R.E. and Kure, J. 1985. Small format microlight surveys. *ITC Journal*, **1**, 14–20.

107.Graham, R.W. and Thomson, G.H. 1989. Considerations of specifications for small format aerial photography. *Photogrammetric Record*, **13**, 225–227.

107a. Graham, R.W. 1995. Kodak digital cameras for small format aerial photography. *Photogrammetric Record*, **15**, 325–327.

108.Gregoire, J.M., Hubaux, A. and Zeyen, R. 1988. Microlight aircraft for radiometric surveying applied to land resource assessment and monitoring in Mali (West Africa). *Photogrammetria*, **43**, 37–44.

109.Gregoire, J.M. and Zeyen, R. 1986. An evaluation of ultralight aircraft for remote sensing applications in West Africa. *International Journal of Remote Sensing*, **7**, 1075–1081.

110.Gruen, A. 1985. Data processing methods for amateur photographs. *Photogrammetric Record*, **11**, 567–579.

111.Grumpstrup, P., Meyer, M., Gustafson, R. and Hendrickson, E. 1980. *Assessment of Powerline Structure Impact Upon Agricultural Crop Production with Small format Aerial Photography* (IAFHE RSL No. 80-3). Univ. of Minn.

112.Grumstrup, P. and Meyer, M. 1977. *Applications of Large-Scale 35 mm Color and Color-Infrared Aerial Photography for Analysis of Fish and Wildlife Resources* Remote Sensing Lab., Univ. of Minn., St. Paul, MN.

113.Grumstrup, P.D., Meyer, M.P., Gustafson, R.J. and Hendrickson, E.R. 1982. Aerial photographic assessment of transmission line structure impact on agricultural crop production. *Photogrammetric Engineering and Remote Sensing*, **48**, 1311–1317.

114.Guftason, T.D. and Adams, M.S. 1973. Remote sensing of Myriophyllum spicatum L in a shallow lake. In K.P. Thomson, R.K. Lane, & Casllany (Eds.), *Remote Sensing and Water Resources and Management,* 387–391. Urbanna, Ill.

115.Hagan, G.F. and Smith, J.L. 1986. Predicting tree groundline diameter from crown measurements made on 35 mm aerial photography. *Photogrammetric Engineering and Remote Sensing*, **52**, 687–690.

116.Hahn, J., Miller, N. and Essex, B. 1981. Application of growth simulation small format photography to forest resource inventories. In *Principle and Practices Workshop*, Orono, ME: Univ. of Maine.

117.Haine, J.W., Ratnaswamy, M.J., Kenney, R.D. and Winn, H.E. 1992. *The fin whale, Balaenoptera physalus, in waters of the northeastern United States continental shelf.* Report of the International Whaling Commission. No. 42: 653–669.

118.Hådem, I., and Skråmo, G. 1970. Fixed-base photogrammetry with wing-tip mounted cameras. *International Archives of Photogrammetry and Remote Sensing*, 23, 520–527.

119.Hall, R.J. 1984. *Use of Large-Scale Aerial Photographs in Regeneration Assessments.* Information Report No. NOR-X-264. Canadian Forest Service, North. For. Res. Cent.

120.Hall, R.J. and Aldred, A.H. 1992. Forest regeneration appraisal with large-scale aerial photographs. *The Forestry Chronicle*, 68, 142–150.

121.Hall, R.J. and Fent, L. 1991. Relating forestry interpreter preference to sensitometric parameters of black and white and normal color aerial films. *ISPRS Journal of Photogrammetry and Remote Sensing*, 46, 328–345.

122.Hall, R.J. and Hiscoks, P. 1990. A microcomputer-based camera control system. *Photogrammetric Engineering*, 56, 443–446.

123.Hall, W.B. and Walsh, T.H. 1977. Color oblique stereo aerial photographs for planning rapid geological reconnaissance and other types of geological programs. *Wyoming Geological Association Guidebook*, 741–760.

124.Hamann, R., Johnson, W., Moody, N. and Meyer, M. 1984. *Small Scale 35 mm Aerial Photography for Aspen Delineation* (IAFHE Report No. 84-3). Univ. Of Minn. College of Forestry.

125.Hampton, J.N. 1977. Aerial reconnaissance for archaeology uses of the photographic evidence. *Photogrammetric Record*, 9, 265–272.

126.Hampton, J.N. 1978. The mapping and analysis of archaeological evidence provided by air photographs. *Aerial Archaeology*, 2, 18–24.

127.Hampton, J.N. 1979. The work of the Air Photographs Unit of the Royal Commission on Historical Monuments. In *Proceedings of the International Symposium on Aerial Photography and Geophysical Prospection in Archaeology*, 129-146. Brussels.

128.Hampton, J.N. and Palmer, R. 1977. Implications of aerial photography for archaeology. *The Archaeological Journal*, 134, 157–193.

129.Harding, N.B. 1989. Model aircraft as survey platforms. *Photogrammetric Record*, 13, 237–240.

130.Harris, J.R. and Haney, T.G. 1973. *Techniques of Oblique Aerial Photography of Agricultural Field Trials.* Soils Tech. Paper No. 19. CSIRO, Australia.

131.Harris, J.W. 1971. Aerial photography (35 mm): aid to forest pest surveys. *Bi-Monthly Research Notes* No.27 (3). Canadian Forest Service.

132.Harris, J.W. 1978. Detecting windthrow, potential for bark beetle infestation by simple aerial photographic techniques. *Bi-Monthly Research Notes* No. 34 (5). Environment Canada, Forest Service, Victoria.

133.Harris, J.W. and Dawson, A.F. 1979, *Evaluation of Aerial Forest Pest Damage Survey Techniques in British Columbia* No. BC-X-198. Environment Canada, Forest Service, Victoria.

134.Heer, R.C. and Smith, J.L. 1986. Estimation of density in young pine plantations using 35 mm aerial photography. In *ACSM-ASPRS Annual Convention*, 80–84. Washington, D.C.: ASPRS–ASPRS.

135.Heiman, G. 1972. *Aerial Photography.* New York. Macmillan.

136.Heimes, F.J., Brechtken, R. and Puruckherr, R. 1992. Computer controlled survey flight based on a low cost GPS C/A code receiver. *Photogrammetric Record*, 80, 293–301.

137.Heimes, F.J., Poole, P., Brechtken, R and Pururckherr, R. 1993. LEO: Local Earth Observation, In *International Symposium "Operation of Remote Sensing".* Enschede, The Netherlands: ITC.

138.Heller, R.C., Aldrich, R.C. and Bailey, W.F. 1959. Evaluation of several camera systems for sampling forest insect damage at low altitude. *Photogrammetric Engineering*, 25, 137–144.

139.Hempenius, S.A. and Xuan Jia-Bin. 1986. On the equivalent pixel-size and meaningful bit-number of air photographs. *Proceedings of the ISPRS Symposium of Comm. 1, "Progress in Imaging Sensors"*. ESA-SP-252. 451–464.

140.Hiby, A.R., Thompson, D and Ward, A.J. 1988. Census of grey seals by aerial photography. *Photogrammetric Record*, 12, 589–594.

141.Hinckley, T.K. and Walker, J.W. 1993. Obtaining and using low-altitude/large-scale imagery *Photogrammetric Engineering and Remote Sensing*, 59, 310–318.

142.Hinckley, T.K. 1992. Teaching low-altitude/large-reconnaissance. In *ASCM-ASPRS 58th Annual Convention*, 1, 133–138: Albuquerque, NM.

143.Hofstee, P. 1984. Small format aerial photography: simple and cheap do-it-yourself technique. *Cities*, 1, 243–247.

144.Hofstee, P. 1985*a*. An introduction to small format aerial photography for human settlement analysis. *ITC Journal*, 2, 121–127.

145.Hofstee, P. 1985*b*. *Small Format Aerial Photography Applications*. ITC Urban Survey Department. Enschede, The Netherlands: ITC.

146.Holloway, A. 1981. *The Handbook of Photographic Equipment*. New York: Alfred A. Knopf. 215 pp.

147.Honey, F.R. 1980. Modifications to interpretoskop optics for stereoviewing of 70 mm aerial photography. *Photogrammetric Engineering and Remote Sensing*, 46, 239–240.

148.Johnson G.W. and Kase, E.W. 1977. Mapping an ancient trade route with balloon photography. *Photogrammetric Engineering and Remote Sensing*, 43, 1489–1493.

149.Johnson, R.E. 1980. Operation Skywatch. In *6th Canadian Symposium on Remote Sensing*, 103–104. Halifax.

150.Johnson, R.E. and Mulvaney, J.M. 1978. The use of low-level oblique aerial for environmental management in Elliot Lake area. In *5th Canadian Symposium on Remote Sensing*, 4 pp.

151.Jones, M and Schoch, H. n.d. Heritage Building Survey. *MPS-2 Application* No. 5. Adam Technology.

152.Juppenlatz. M. 1994. Director, Australian Institute of Spatial Information Sciences, Land Information Centre, Bathurst.

153.Kannegieter, A. 1980. An experiment using multispectral photography for the detection and damage assessment of disease in winter. *ITC Journal*, 2, 189–233.

154.Karara, H.M. 1980. Non-metric cameras. In Atkinson, K.B. (ed) *Developments in Close Range Photogrammetry – 1*, 63–80, London. Applied Science Publishers Ltd.

155.Keller, J.K. 1990. Using 70 mm aerial photography to model species-habitat relationship. In *Ecosystem Mgt: Rare Species and Significant Habitats*. N.Y. State Museum Bulletin, 471, 34–46.

156.Kiefer, R.W. 1970. Effects of date photography on airphoto interpretation using color and color-infrared films. In *Int. Sym. of Photography and Navigation*, 1000–1117.

157.Killmayer, A and Epp, H. 1983. Use of small format aerial photography for land use mapping and resource monitoring. *ITC Journal*, 4, 285–290.

158.Kippen, F.W. and Sayn-Wittgenstein 1964. *Tree Measurements on Large-Scale Vertical, 70 mm, Air Photographs* No. 1053. Environment Canada, Forest Research Branch.

159.Kirby, C.L. 1980. *A Camera and Interpretation System for Assessment in Forest Regeneration*. Inf. Report NOR-X-221. Canadian Forest Service.

160.Klein, H.W. 1970. Mini-aerial photography. *Journal of Forestry*, 68, 475–478.

161.Klimes, D., Oslansky, J., Ross, D., Senses, E. and Zsilinszky, V. n.d. *Colour Infrared Negative Aerial Film Technology: An Operational Remote Sensing Tool* Ontario Centre for Remote Sensing.

162.Kodak 1982. *Kodak Data for Aerial Photography*. Rochester, N.Y. Kodak.

163.Kodak 1985. *Photography from Lightplanes and Helicopters*. Rochester, N.Y. Kodak.

164.Kölbl, O.R. 1976. Metric or non-metric cameras. *Photogrammetric Engineering and Remote Sensing*, 42, 103–113.

165.Konecny, *et al.* 1982. Investigations into the interpretability of images by different sensors and platforms for small scale mapping. *Proceedings ISPRS Commission 1 Symposium*, Canberra, 11–22.

166.Koo, T.K. 1993. Low altitude, small format aerial photogrammetry. *The Australian Surveyor*, 38, 294–297.

167.Koski, W.R., Davis, R.A., Miller, G.W. and Withrow, D.E. 1992. *Growth rates of bowhead whales as determined from low-level aerial photogrammetry*, International Whaling Commission, No. 42: 491–499.

168.Lee, Y.J. and McKelvey, R.W. 1984. Digitized small format aerial photography as a tool for measuring food consumption by trumpeter swans. *Photogrammetric Engineering and Remote Sensing*, 50, 215–219.

169.Long, D.S., Taylor, J.E. and McCarthy, J. 1986. Cessna aircraft cabin door mount for photographic and videographic cameras. *Photogrammetric Engineering and Remote Sensing*, 52, 1753–1755.

170.Lukman, A. 1982. *The Use of Small Format Aerial Photographs in the Production of Large Scale Maps of Urban Areas in Regions of Moderate Relief, with Particular Reference to the Requirements of Developing Countries.* M.S., ITC, Enschede, The Netherlands.

171.Lyon, J.G., McCarthy, J.F. and Heinen, J.T. 1986. Video digitization of aerial photographs for measurement of wind erosion damage on converted rangeland. *Photogrammetric Engineering and Remote Sensing*, 52, 373–377.

172.Lyons, E.H. 1961. Preliminary studies of two camera, low-elevation stereo-photography from helicopters. *Photogrammetric Engineering*, 27 72–76.

173.Lyons, E.H. 1964. Recent developments in 70 mm stereophotography from helicopters. *Photogrammetric Engineering*, 30, 750–756.

174.Lyons, E.H. 1966. Fixed-base 70 mm photography, a new tool for forest sampling. *Forest Chronicles*, 42, 420–431.

175.Lyons, E.H. 1967. Forest sampling with 70 mm fixed air-base photography from helicopters. *Photogrammetria*, 22, 213–231.

176.Makarovic, B., and Tempfli, K. 1979. Digitizing images, automatic processing in photogrammetry. *ITC Journal*. 107–126.

177.Marks, A.R. 1989. Aerial photography from a tethered helium filled balloon. *Photogrammetric Record*, 13, 257–261.

178.Marlar, T.L. and Rinker, J.N. 1967. A small four-camera system for multi-emulsion studies. *Photogrammetric Engineering*, 33, 1252–1257.

179.Mason, G.N. and Walsh, M.J. 1979. Camera mount assembly for small format aerial photography. *Southern Journal of Applied Forestry*, 152–154.

180.McCarthy, J., Olson, C.E. and Witter, J.A. 1982. Evaluation of spruce-fir forests using small-format photographs. *Photogrammetric Engineering and Remote Sensing*, 48, 771–778.

181.Mead, R.A. and Gammon, P.T. 1981. Mapping wetlands using orthophotoquads and 35-mm aerial photographs. *Photogrammetric Engineering*, 47, 649–652.

182.Meiklejohn, I.R. n.d. *The Kite Project – A Low Cost Method of Remote Sensing in the High Arctic.* JARIC, RAF Brampton, Huntington, Cambs. England.

183.Mennis, B.J. 1978. *Aerial Photography Using Miniature Cameras.* Surveys and Envt. Tech. Bull. No. 1. Papua New Guinea Dept. Lands.

184.Meyer, M. 1977. *A Feasibility Study of 35 mm CIR Aerial Photography Applications to Monitoring Change in a 600-foot BLM Range Resource Transects in Montana* (IAFHE RSL No. 76-6). Univ. of Minn.

185.Meyer, M., Batson, F. and Whitmer, D. 1982. *Helicopter-borne 35 mm Aerial Photography Applications to Range and Riparian Studies* (IAFHE No. 82-1). Univ. Minn, College of Forestry.

186.Meyer, M and Grumstrup, P. 1978. *Operating Manual for the Montana 35 mm Aerial Photography System (2nd Revision)* (IAFHE RSL No. 78-1). Univ. of Minn.

187.Meyer, M., Heitlinger, M and Grumpstrup 1980. *Monitoring and Mapping Natural Area Grassland Vegetation with Small Format Aerial Photography* (IAFHE No. 80–5). Univ. of Minn., College of Forestry.

188.Meyer, M., Miller, N and Hackett, R. 1981. *Application of 35 mm Aerial Photography to Forest Land Use Change Analysis in the Upper Penninsula of Michigan* (IAFHE No. 81–2). Univ. of Minn., College of Forestry.

189.Meyer, M., Opseth, S., Moody, N. and Bergestrom, L. 1982. *Large-area Forest Land Management Applications of Small Scale 35 mm Aerial Photography* (IAFHL No. 82–3). Univ. of Minn, College of Forestry.

190.Meyer, M.P. 1982. Place of small-format aerial photography in resource surveys. *Journal of Forestry*, **80**, 15–17.

191.Meyer, M.O. and Gerbig, B.H. 1974. *Remote Sensing Applications to Forest and Range Resource Surveys and Land Use Classification on the Motta District, BLM, Montana* (IAFHE-RSL No. 74–1). Bureau of Land Management, St. Paul, Minn.

192.Meyer, M.P. *et al.* 1975. 35 mm aerial photograph applications to wildlife population and habitat analysis. In *Workshop on Remote Sensing of Wildlife*, (12 pp). Quebec, Canada.

193.Meyers, J.W. 1978. Low altitude prospecting and recording for land and underwater sites from a captive balloon platform. In *18th International Symposium on Archaeometry and Archaeological Prospection*, Bonn.

196.Milfred, C.J. and Kiefer, R.W. 1976. Analysis of soil variability with repetitive aerial photography. *Soil Science Journal*, **40**, 553–557.

195.Miller, G.W., Davis, R.A., Koski, W.R., Crone, M.J., Rugh, D.W., Withrow, D.E. and Fraker, M.A. 1992. *Calving intervals of bowhead whales – An analysis of photographic data.* International Whaling Commission, No. 42: 501–506.

196.Miller, N. and Meyer, M.P. 1981. Applications of 35 mm color aerial photography to forest land change detection. In *8th Bienn. Workshop Aerial Color Photog. in Plant Science*, Luray, Va. American Society of Photogrammetry.

196a. Mills, J. and Newton, I. 1995. A new approach to the verification and revision of large scale mapping. Publication pending in *Photogrammetric Engineering and Remote Sensing.*

196b. Mills, J.P., Graham, R.W. and Newton, I. 1996. Aerial photography for survey purposes with a high resolution, small format, digital camera. *Photogrammetric Record*, April,.

197.Mintzer, O.W. and Spragg, D. 1978. Mini-format remote sensing for civil engineering. *Transportation Engineering Journal*, 847–858.

198.Morgan, K.M., Morris-Jone, D.R., Lee, G.B. and Kiefer, R.W. 1979. Cropping management using color and color infrared aerial photographs. *Photogrammetric Engineering and Remote Sensing*, **45**, 769–774.

199.Morgan, K.M., Morris-Jones, D.R., Lee, G.B. and Kiefer, R.W. 1980. Airphoto analysis of erosion control practices. *Photogrammetric Engineering and Remote Sensing*, **46**, 637–640.

200.Morlan, J.B. 1993. Hi-shots aerial photography (balloon) system. 1040 Airport Road, Salem, Illinois 62881. USA.

201.Moser, J.S. and Fritz, N.L. 1975. Films for small-format aerial photography. In *Effective Utilization and Application of Small-Format Camera Systems*, **58**, 31–37. Anaheim: SPIE.

202.Muraro, S.J. 1970. *Slash Fuel Inventories from 70 mm Low-Level Photography.* Canadian Forest Service Publication No. 1268. Canadian Forest Service.

203.Murray, K.J. 1989. Medium and small format photography for the maintenance of national mapping. *Photogrammetric Record*, **13**, 85–94.

204.Murtha, P.A. 1983. Some air-photo scale effects on Douglas-fir damage type interpretation. *Photogrammetric Engineering and Remote Sensing*, **49**, 327–335.

205.Myers, B.J. 1977, Development in the use of colour aerial photography in Australian forestry. *Australian Forestry*, 268 273.

206.Nash, M.R., Meyer, M.P. and French, D.W. 1977. *Detection of Dutch Elm Disease using Oblique 35 mm Aerial Photography* (IAFHE-RSL No. 77–9). Univ. of Minnesota.

207.Needham, D. and Smith, J. 1987. Stem count accuracy and species determination in loblolly pine plantations using 35 mm aerial photography. *Photogrammetric Engineering and Remote Sensing*, **53**, 1675–1678.

208.Needham, T.D. and Smith, J.L. 1984. Consequences of enlarging 35 mm aerial photography. *Photogrammetric Engineering and Remote Sensing*, **50**, 1143–1144.

209.Nelson, H.A. 1977. Small format color photography for forest plantation planning in the Southeast. In *6th Bienn. Workshop Aerial Color Photography in Plant Science*, Fort Collins, CO.

210.Neustein, S. and Waddell, J. 1972. Some investigations in the use of 35 mm aerial photography. *Scottish Forestry*, **26**, 196–204.

211.Niedzwiedz, W.R. 1986. Hand-held color oblique 35 mm slides: A practical alternative for littoral zone mapping. In *ACSM-ASPRS Annual Convention*, **5**, 18–24. Washington, D.C.: ACSM-ASPRS.

212.Niedzwiedz, W.R. 1990. Assessing permit compliance in residential areas using color 35 mm aerial photography. *Photogrammetric Engineering and Remote Sensing*, **56**, 207–210.

213.Niedzwiedz, W.R. and Ganske, L.W. 1991. Assessing lakeshore permit compliance using low altitude oblique 35 mm aerial photography. *Photogrammetric Engineering and Remote Sensing*, **57**, 511–518.

214.Nohara, S. 1991. A study on annual changes in surface cover of floating-leaved plants in a lake using aerial photography. *Vegetatio*, 125–136.

215.Norton-Griffiths, M. 1973. Counting the Serengeti migratory wildebeest using two-stage sampling. *East African Wildlife Journal*, **11**, 35–49.

216.Norton-Griffiths, M. 1978. *Counting Animals, 2nd Edition*. Nairobi: African Wildlife Federation.

217.Norton-Griffiths, M. 1988. Aerial point sampling for land use surveys. *Journal of Biogeography*, **15**, 149–156.

218.Opseth, S.R. 1987. The dendropolyplotter. *Journal of Forestry*, **85**.

219.Paine, D.P. 1981. *Aerial Photography and Image Interpretation for Resource Management*. New York: John Wiley & Sons. 571 pp.

220.Paine, D.P. and McCadden 1988. Simplified forest inventory using large-scale 70 mm photography and tariff tables. *Photogrammetric Engineering and Remote Sensing*, **54**, 1423–1427.

221.Panzer, K and Rhody, B. 1980. Applicability of large-scale aerial photography to the inventory of natural resources in the Sahel of Upper Volta. In: *Arid Land Resources Inventories: Developing Cost-efficient Methods* (General Tech Report No. WO-28). USDA Forest Service.

222.Parker, R.C. and Johnson, E.W. 1970. Small camera aerial photography – the K-20 system. *Journal of Forestry*, **68**, 152–155.

223.Parker, W.H., van Niejenhuis, A. and Van Damme, L. 1988. Base-line selection of black spruce by large-scale aerial photography. *Canadian Journal of Forest Resources*, **18**, 380–383.

224.Perryman, W. and Lynn, M.S. 1993*a*. Examination of stock and school structure of striped dolphin (*Stennela coeruleoalba*) in the eastern Pacific from aerial photogrammetry. *Fishery Bulletin*, 122–131.

225.Perryman, W.L and Lynn, M.S. 1993*b*. Identification of geographic forms of common dolphins (*Delphinus delphis*) from aerial photography. *Marine Mammal Science*, 9, 119–137.

226.Piggott, D. 1989. CFM Streak Shadow. *Pilot*, September, 31–33.

227.Pitt, D.G. 1984. *Large-Scale 70 mm Photo Sampling for Operational Estimates of Timber Volumes; a Comparison to Conventional Ground Sampling*. H.B.Sc.F., Lakehead Univ., Thunder Bay, Ont.

228.Pitt, D.G. and Glover G.R. (1993). Large scale 35 mm aerial photography for assessment of vegetation management research photos in Eastern Canada. *Canadian Journal of Forest Research*. 23, 2159–2169.

229.Pokrant, H.T. 1981. Building a small format in-house aerial photography system. In W.G. Best & S. Westlake (Ed.), *7th Canadian Symposium of Remote Sensing*, 410–415. Winnipeg, Manitoba.

230.Pollé, V.F.L. 1980. The size of the net residential areas on aerial photographs. *ITC Journal*, **3**.

231.Pollé, V.F.L. 1984. Population estimation of non-homogenous residential areas. *ITC Journal*, **2**.

232.Poole, P.J. 1989. The prospects for small format photography in Arctic animal surveys. *Photogrammetric Record*, **13**, 229–236.

233.Rasher, M.E., and Weaver, W. 1990. *Basic Photo Interpretation*. US Dept. of Agriculture, Soil Conservation Service. 348 pp.

234.Ratnaswamy, M.J. and Winn, H.E. 1993. Photogrammetric estimations of allometry and calf production in fin whales, *Balaenoptera physalus*. *Journal of Mammalogy*, **74**, 323–330.

235.Read, R.E. 1983. The aeroplane as a camera. *The Journal of Photographic Science*, **31**, 212–216.

236. Read, R.E. 1984. *User-Directed Aerial Photography Using Microlight Aircraft*. Enschede, The Netherlands: ITC.

237.Read, R.E. 1989. Navigation for small format operations. *Photogrammetric Record*, **13**, 241–247.

238.Retuebuch, S.E., Folke, E and Fridley, J.L. 1992. Very large-scale aerial stereo photography using a twin camera helicopter boom. In *1992 International Meeting of the American Society of Agricultural Engineers*, Nashville, Tenn.: The American Society of Agricultural Engineers.

239.Rhody, B. 1977. A new, versatile stereo-camera system for large scale helicopter photography of forest resources in Central Europe. *Photogrammetria*, **32**, 183–197.

240.Rinehardt, G.I. and Scherz, J.P. 1972. *A 35 mm Aerial Photographic System No.13*. Institute for Environmental Studies, Univ. of Wisconsin.

241.Rinker, J.N. and Corl, P.A. 1984. *Air Photo Analysis*. (No. ETL-0329). U.S. Army Corps of Engineers – Engineer Topographic Laboratories. 375 pp.

242.Roberts, A and Griswold, L. 1986. Practical photogrammetry from 35 mm aerial photography. *Photogrammetric Engineering and Remote Sensing*, **52**, 501–508.

243.Roberts, A and Hiscoks, P. 1981. A computer based camera control system. *Photogrammetric Engineering and Remote Sensing*, **47**, 53–57.

244.Ross, H.F. 1986. A new comparator for SEM stereophotogrammetry. *Scanning*, **8**, 216–220.

245.Rukavina, N.A. 1978. *Air-Reconnaissance, Great Lakes' Shorelines* (Technical Notes No. 78–12). Hydraulics Research Div., Environment Canada, Burlington.

246.Sabins, F.F. 1973. Aerial camera mount for 70 mm stereo. *Photogrammetric Engineering*, **39**, 579–582.

247.Sarossy, A. n.d. BHP Iorn Ore – Neswman (*MPS-2 Application* No. 1). Adam Technology.

248.Sarossy, A and Jones, M. n.d. Complex Geological Mapping (*MPS-2 Application* No. 3). Adam Technology.

249.Sayn-Wittgenstein, L. and Aldred, A.H. 1969. A forest inventory by large scale aerial photography. *Pulp and Paper Magazine of Canada*, Sept.–Dec., 92–95.

250.Sayn-Wittgenstein, L, and Aldred, A.H. 1972. Tree size from large-scale photos. *Photogrammetric Engineering and Remote Sensing*, **38**, 971–973.

251.Scheierl, R. and Meyer, M.P. 1976. *Evaluation and Inventory of Waterfowl Habitats of the Copper River Delta, Alaska* (IAFHE-RSL No. 76–3). Univ. of Minnesota.

252.Scherz, J.P. 1972. *Final Report on Infrared Photography Applied Research Program*. No. 12. Institute for Environmental Studies, Univ. of Wisconsin.

253.Scherz, J.P., Singh, R and Rinehardt, G. 1975. 35 mm photography, viewing and cataloguing system for remote sensing data. *The Canadian Surveyor*, **29**, 201–208.

254.Schoch, H. and Jones, M. n.d. Perth Central Business District (*MPS-2 Application* No.4). Adam Technology.

255.Schollar, I. 1975. Transformation of extreme oblique aerial photographs to maps or plans by conventional means or by computer. In D.R. Wilson (Ed.), *Aerial Reconnaissance for Archaeology*. London.

256.Scott, G.P. and Winn, H.E. 1980. *Comparative evaluation of aerial and shipboard sampling techniques for estimating the abundance of humpback whales (Megaptera novaengliae)* No. PB81-109852. National Technical Information Service. 96 pp.

257.Seeley, H.E. 1962. The value of 70 mm air cameras for winter aerial photography. *Pulp and Paper Magazine of Canada*, 3-6.

258.Seevers, P.M. and Wiegand, V.L. 1978. *An Evaluation of Colour Infrared Photography for Monitoring of Cropping Problems*. Farmland Industries, Inc.: Univ. of Nebraska.

259.Shafer, R.V. and Deglers, S.A. 1986. 35-mm photography: an inexpensive remote sensing tool. *Photogrammetric Engineering and Remote Sensing*, **52**, 833-837.

260.Sherstone, D.A. 1978. Small format camera systems for hydrologic research: Background studies and a report on preliminary work within the glaciology division. In *Fifth Canadian Symposium on Remote Sensing*, Ottawa: Inland Waters Directorate, Dept. of the Environment.

261.Shipside, S. 1993. Kodak's shooting star (Photo CD). July, 83-88.

262.Short, T. 1992. The calibration of a 35 mm non-metric camera and the investigation of its potential use in photogrammetry. *Photogrammetric Record*, **80**, 313-322.

263.Sing, R.S. and Scherz, J.P. 1974. A catalog system for remote sensing data. *Photogrammetric Engineering*, **40**, 709-720.

264.Slama, C.C. 1980. *Manual of Photogrammetry* (4th ed.). Falls Chruch, Va.: American Society of Photogrammetry. 1056 pp.

265.Smith, J., Campbell, C. and Mead, R. 1986. Imaging and identifying loblolly pine seedlings after the first growing season on 35 mm aerial photography. *Canadian Journal of Remote Sensing*, **12**, 19-27.

266.Smith, M.J. 1986. *Photogrammetric Techniques for Archaeological Mapping Using Oblique Non-Metric Photography*. Ph.D., University of London.

267.Smith, M.J. 1989. A photogrammetric system for archeological mapping using oblique non-metric photography. *Photogrammetric Record*, **13**, 95-105.

268.Spencer, R.D. 1974. Supplementary aerial photography with 70 mm and 35 mm cameras. *Australian Forestry*, 115-124.

269.Spencer, R.D. 1978*a*. Map intensification from small format camera photography. *Photogrammetric Engineering and Remote Sensing*, **44**, 697-707.

270.Spencer, R.D. 1978*b*. Film trials of aerial photography for forestry in Victoria, Australia. *Photogrammetric Record*, **9**, 391-403.

271.Spencer, R.D. 1979. Fixed-base large-scale photographs for forest sampling. *Photogrammetria*, **35**, 117-140.

272.Spencer, R.D. and Hall, R.J. 1988. Canadian large-scale aerial photographic systems (LSP). *Photogrammetric Engineering*, **54**, 475-482.

273.Stringham, A. n.d. Small format aerial photography with Kodak's Photo CD system. Landcare Aviation Inc., USA.

274.Springan, M., Meyer, M and Beissel, D. 1982. *Inventory and Assessment of Agricultural Irrigation Systems with Small-Format (35 mm) Aerial Photography* (IAFHE RSL No. 82-2). Univ. of Minn.

275.Steffensen, D.A. and McGregor, F.E. 1976. The application of aerial photography to estuary ecology. *Aquatic Botany*, **2**, 3-11.

276.Stevens, A.A. 1972. Application of small format color and color infrared aerial photography to Dutch elm disease detection. In *38th Annual Meeting of American Society of Photogrammetry*, 349-357. Washington: ASP.

277.Strandberg, C.H. 1964. *35 mm Aerial Photography for Measurement Analysis Presentations, 2nd Edition*. U.S. Public Health Service, Division of Water Supply and Pollution Control.

341

278.Thom, C. and Jurvillier, I. 1993. (IGN Paris) Photogrammetric week 1993, Stuttgart.

279.Thomson, G.H. 1988. Evaluating image quality of small format aerial photography system. *Photogrammetric Record*, 12, 595–603.

279a.Thomson, G.H. 1994. A practical method of determining the Ground Sampled Distance in small scale aerospace photography. *The Journal of Photographic Science*, 42, 129–32.

280.Thomson, J.W. Thomson, M.R.A. and Norris, G.N. 1992. Mapping the British Antarctic Territory using a 70 mm reconnaissance camera and satellite imagery. *Photogrammetric Record*, 14, 277–282.

281.Tomlins, G.F. and Lee, Y.J. 1983. Remotely piloted aircraft – an expensive option for large-scale aerial photography in forestry applications. *Canadian Journal of Remote Sensing*, 9, 76–85.

282.Trinder, J. 1987. Measurements in digitised images. *Photogrammetric Engineering and Remote Sensing*. 55, 315–321.

283.Tueller, P.T., Lent, P.C., Stager, R.D., Jacobsen, E.A. and Platou, K.A. 1988. Rangeland vegetation changes measured from helicopter-borne 35 mm aerial photography. *Photogrammetric Engineering and Remote Sensing*, 54, 609–614.

284.Ulliman, J.J. 1986. Small format aerial photography is filling a need. In *1986 ASPRS-ACSM Fall Convention*, 213–224. Anchorage, Alaska: ASPRS-ACSM.

285.Ulliman, J.J. and French, D.W. 1977. Detection of oak wilt with color IR aerial photography. *Photogrammetric Engineering and Remote Sensing*, 43, 1267–1272.

286.Ulliman, J.J. Latham, R.P. and Meyer, M.P. 1970. 70 mm quadricamera system. *Photogrammetric Engineering*, 36, 49–54.

287.Uren, J. and Thomas, P.R. 1992. Adam Technology MPS-2: What the users think. *Photogrammetric Record*, 80, 351.

288.van Eck, P.I. and Bihuniak, P. 1978. A two-camera intervalometer with a sampling option. *Photogrammetric Engineering and Remote sensing*, 44, 285–287.

289.van Wijk, M.C. and Zieman, H. 1976. The use of non-metric cameras in monitoring high speed processing. *Photogrammetric Engineering and Remote Sensing*, 42, 91–102.

290.Vooren, A. 1985. An ultralight aircraft for low-cost, large-scale stereoscopic aerial photographs. *Biotropica*, 17, 84–88.

291.Walker, J.W. 1985. Ultra-light reconnaissance, another tool. In *51st Annual Meeting ASP*, 1, 371–380.

292.Walker, J.W. 1988a. Low altitude, large-scale reconnaiss: Detail/expense, airborne reconnaissance. In *XII, 1988 SPIE Annual Conference.*

293.Walker, J.W. 1988b. An update on low altitude, large-scale reconnaissance. In *ASCM-ASPRS Annual Convention*, 3, 128–136.

294.Walker, J.W. 1992. Camera mount (aircraft) improvements for low altitude large-scale reconnaissance (LALSR). In *1992 ASPRS-ACSM Annual Convention*, 496–505. Albuquerque, NM:

295.Walker, J.W. 1993. *Low Altitude Large Scale Reconnaissance: A Method of Obtaining High Resolution Vertical Photographs for Small Areas*. Denver, Colorado, USA: National Park Service.

296.Waller, S.S., Lewis, J.K., Brown, M.A., Heintz, T.W., Butterfield, R.I. and Gartner, F.R. 1978. Use of 35 mm aerial photography in vegetation sampling. In *Proceedings First International Rangeland Conference*, Denver, CO.

297.Walsh, H.T. and Hall, W.B. 1978. *Pocket Guide for Making Colour Oblique Stereo Aerial (COSA) Photographs with 35 mm Cameras* University of Idaho.

298.Wanzke, H. 1984. The employment of a hot-air ship for the stereophotogrammetric documentation of antique ruins. *International Archives of Photogrammetry and Remote Sensing*, 24, 746–756.

299.Warner, W.S. 1988. A PC-based analytical plotter designed for forestry photogrammetry. *Journal of Forestry*, Dec.

300.Warner, W.S. 1989a. A complete small-format aerial photography system for GIS data entry. *ITC Journal*, 2, 121–129.

301. Warner, W.S. 1989*b*. Benefits of small-format aerial photography. *Norwegian Journal of Geography*, **43**, 37–44.

302. Warner, W.S. 1990*a*. Accuracy and small-format surveys: the influence of scale and object definition on photo measurements. *ITC Journal*, **1**, 24–28.

303. Warner, W.S. 1990*b*. A study in the use and accuracy of 35 mm aerial photos: problems encountered and magnified when surveyed ground control is unavailable. Institute for Georesources and Pollution Research (GEFO), 1432 As-NLH, Norway. 1–21.

304. Warner, W.S. 1993. Considerations when measuring from a single photograph: positional uncertainty of digital monoplotting. *Norwegian Journal of Geography*, **47**, 39–50.

305. Warner, W.S. 1994*a*. Application of 35 mm oblique aerial photography for forest mapping. In G. Hildebrandt (Ed.), *Photogrammetry and Forestry*, 347–354. Freiburg, Germany: Albert-Ludwigs University.

306. Warner, W.S. 1994*b*. Evaluating a low-cost, non-metric aerial mapping system for waste site investigators. *Photogrammetric Engineering & Remote Sensing*, **60**, 983–988.

307. Warner, W.S. 1994*c*. Measuring and mapping crop loss with 35 and 70 mm aerial photography. *Norwegian Journal of Agricultural Sciences*, **8**, 37–47.

308. Warner, W.S. and Andersen, Ø. 1992. Consequences of enlarging small-format imagery via a color copier. *Photogrammetric Engineering and Remote Sensing*, **58**, 353–355.

309. Warner, W.S., Andersen, S. and Særland, S. 1993. Surveying a waste site with 35 mm oblique aerial photography: monoplotting with a digitizing tablet. *Cartography and Geographical Information Systems*, **20**, 237–243.

310. Warner, W.S. and Blankenberg, L.E. 1995. Bundle adjustment for 35 mm oblique aerial photography. *Photogrammetric Record*, **15**, 217–227.

311. Warner, W.S. and Carson, W.W. 1989. Creating digital terrain models from 35 mm photography. *Photogrammetric Record*, **13**, 249–255.

312. Warner, W.S. and Carson, W.W. 1991. Improving interior orientation for a small standard camera: creating fiducials for the Pentax 645. *Photogrammetric Record*, **13**, 909–916.

313. Warner, W.S. and Carson, W.W. 1992. Development of a monoscopic measurement system for small format oblique photography. *Photogrammetric Record*, **80**, 303–311.

314. Warner, W.S., Carson, W.W and Bjørkelo, K. 1993. Relative accuracy of monoscopic 35 mm oblique photography. *Photgrammetric Engineering Remote Sensing*, **59**, 101–106.

315. Warner, W.S. and Fry, G. 1990. Evaluating small-format photogrammetry for forest and wildlife surveys: Euclideans vs. fractal geometry. *Forest Ecology and Management*, **31**, 101–108.

316. Warner, W.S. and Carson, W. 1992. Mapping monoscopically: an innovative system for vertical and oblique aerial photographs. *ITC Journal*, **3**, 228–233.

317. Warner, W.S, and Blankenberg, L. 1995. Bundle adjustment for 35 mm Oblique Aerial Photography. *Photogrammetric Record*, **XV**, No. 86.

318. Warren, P.L. and Dunford, C. 1986. Sampling semiarid vegetation with large-scale aerial photography. *ITC Journal*, **4**, 273–279.

319. Weigh, R., Nord, G. and Meyer, M. 1984. *Application of 35 mm Aerial Photography to Evaluate Post-Harvest Aspen Regeneration* (IAFHL No. 84-2). Univ. on Minn., College of Forestry.

320. Weir, M.J. 1988. *Evaluation of the MPS-2 Analytical Plotter*. ITC. Enschedes, The Netherlands.

321. Wester-Ebbinghaus, W. 1980. Aerial photography by radio controlled model helicopter. *Photogrammetric Record*, **10**, 85–92.

322. Whitehead, H. and Payne, R. 1981. New techniques for assessing populations of Right whales without killing them. In *Mammal in the Seas*, 189–209. Rome: FAO.

323. Whiting, M.L., DeGloria, S.D., Benson, A.S. and Wall, S.L. 1987. Estimating conservation tillage residue using aerial photography. *Journal of Soil and Water Conservation*, **42**, 130–132.

324. Wildman, W.E. 1984. *Do-it-yourself Aerial Photography for Detecting and Managing Crop Problems* Dept. of Land, Air and Water Resources, Univ. of Calif., Davis.

325. Willett, A.M. and Ward, B.K. 1978. Forest insect and disease surveys by remote sensing.

Bulletin of the Remote Sensing Association of Australia, 11–12.

326. Williams, P. 1978. Wingtip stereo photography. In *ASP Symposium on Remote Sensing for Vegetation Damage Assessment*, 127–134. Seattle, Washington: ASP.

327. Williams, P.G. 1975. A light aircraft remote sensing system. In *Workshop on Remote Sensing of Wildlife*. Quebec, Canada.

328. Willingham, J.W. 1959. Obtaining vertical aerial photographic coverage with a 35 mm camera. *Journal of Forestry*, **57**, 108–110.

329. Withrow, D. and Angliss, R. 1992. *Length frequency of bowhead whales from spring aerial photogrammetric surveys in 1985, 1986, 1989 and 1990*. International Whaling Commission, Report No. **42**: 463–467.

330. Wolf, P.R. 1983. *Elements of Photogrammetry* (2nd ed.). New York: McGraw-Hill. 562 pp.

331. Woodcock, W.E. 1976. Aerial reconnaissance and photogrammetry with small cameras. *Photogrammetric Engineering and Remote Sensing*, **42**, 503–511.

332. Wracher, D.A. 1973. Small format aerial photography. *Mining Engineering*, **27**, 47–48.

333. Zhang Xin and Cheng Jing 1992. Ultra-light aircraft low altitude photography. *ISPRS 1992 Vol. XXIX: Commission 1, B1*, 50–55.

334. Zsilinszky, V.G. 1969/70. Supplementary aerial photography with miniature cameras. *Photogrammetria*, **25**, 27–38.

335. Zsilinszky, V.G. 1972*a*. Camera mounts for 35 mm mono and multi-spectral photography. In *First Canadian Symposium on Remote Sensing*. Ottawa.

336. Zsilinszky, V.G. 1972*b*. Fisheye lens for plot location. *Photogrammetric Engineering*, **38**, 773–775.

337. Zsilinszky, V.G. 1972*c*. Resource surveys with miniature cameras. In *Twelfth Congress I.S.P., Commission 7*. Ottawa.

338. Zsilinszky, V.G. 1979. A user's notes on remote sensing application. In *International Symposium on Remote Sensing for Natural Resources*, Moscow.

339. Zsilinszky, V.G., Giannelia, A.M. and Rafelson, M.J. 1979. A review of the supplementary aerial photography program of the Ontario Ministry of Natural Resources. In *Remote Sensing Symposium Canada – Ontario Joint Forest Research Committee*. Toronto.

340. Zsilinszky, V.G., Ross, D.I. and Klimes, D. 1985. The capabilities of colour infrared film as a negative. *Photogrammetria*, **40**, 179–192.

Index